# WOMEN
## FROM THE GREEKS TO THE FRENCH REVOLUTION

# WOMEN
## FROM THE GREEKS TO THE
## FRENCH REVOLUTION

Edited by SUSAN GROAG BELL

Stanford University Press, Stanford, California

Stanford University Press, Stanford, California
© 1973 by Susan Groag Bell
First published by Wadsworth Publishing Company in 1973
Reissued by Stanford University Press in 1980
Printed in the United States of America
Cloth ISBN 0-8047-1094-5
Paper ISBN 0-8047-1082-1
Last figure below indicates year of this printing:
01  00  99  98  97  96  95

# PREFACE to the Stanford Edition, 1980

My intention in compiling this anthology in 1970 was that it should serve to integrate the history of women into traditional academic courses and particularly into surveys of Western civilization and Western culture.  In the ensuing ten years, countless courses in different academic disciplines have been taught on women, thanks to the concerted efforts of feminist scholars.  In 1980, the integration of these courses and their subject matter into the mainstream of academic endeavor is no longer the dream of a few but an issue of concern to the wider educational community.

I am grateful to Stanford University Press for its timely reprinting of this book, which I hope will continue to be a useful aid for integrating women into our vision of Western society.  Since ten years of intensive research have enriched our understanding of a history created by women as well as by men, the Press has given me the opportunity to refer to some of this research by adding a new section of Suggested Further Reading at the end of the original Bibliography.

Susan Groag Bell
Center for Research on Women,
Stanford University

# PREFACE to the Wadsworth Edition, 1973

This anthology brings together introductory material documenting the historical position of women in Western civilization from the classical Greek era to the end of the eighteenth century, during which period society molded basic traits and life patterns of Western women. The material aims to clarify our understanding of the position of women at the time when the great push for the emancipation of Western women began—the early nineteenth century.

Because the historical literature covering the lives of women and men's attitudes to women for the early period is often inaccessible, a single-volume collection should be a convenience. It is hoped that this collection will serve as an introduction to courses on women's position in Western society, whether these courses focus on history, on social sciences, or on literature, and also that it may be used as an addition to courses on the history of Western civilization, where the role of women has been almost totally ignored.

The selections have been chosen for a variety of reasons: readability, effective condensation, or thought-provoking presentation of a controversial point of view. They have been culled from the works of historians and writers who have made notable contributions to the subject, including some recent scholars as well as earlier contributors to historical scholarship on women. Excerpts from contemporaneous literature illustrating the lives of women and men's views of women throughout the centuries develop the theme of the book.

The anthology is divided into seven sections, each dealing with a specific historical period or an underlying theme in a period. A brief introduction sets the historical stage for each section. Individual readings are introduced with a few paragraphs that indicate their significance and occasionally draw the reader's attention to the author's possible prejudice. No author can be entirely free of the bias of his or her time, environment, and personality, and because this book is concerned with the history of women, readers will naturally be alert to the feminist or antifeminist tone of the selected passages. Some selections have obviously been chosen to represent (for their fundamental historical importance) the antifeminist

viewpoints of influential thinkers (see, for example, the excerpts from Aristotle in Part 1, section B). Some selections (for example, 6 A and 7 B) were written by authors whose attitudes are explicitly sympathetic, although they implicitly classify women as *the other*, to use Simone de Beauvoir's term. The feminist or antifeminist bias in many selections will be obvious to the thoughtful reader, and in these cases it seems unnecessary to endorse it by editorial comment. In the limited space available, it is more important to sketch the historical circumstances surrounding particular selections.

The list of counselors and helpers even for such a slender volume is very long. Professors William R. Hitchcock (University of California, Santa Cruz), Lyn Lofland (University of California, Davis), Timothy O'Keefe (University of Santa Clara), Anne Firor Scott (Duke University), and Lewis W. Spitz (Stanford University) read the original draft and made many valuable suggestions. Penny Gold and Karen Offen, of Stanford, helped to clear up (at least to my satisfaction) some awkward points on the twelfth and the eighteenth centuries, respectively. Members of the 1972 Santa Cruz Meeting of the West Coast Association of Women Historians also brushed a few cobwebs from my befuddled brain. My students at the University of California Extension in San Francisco, the University of Santa Clara, and Cañada College (Holbrook-Palmer Park group) were invaluable as a testing ground for the material and offered many helpful ideas. Margaret Haile Harris; Barbara Schilling; my mother, Edith Louise Groag; and my husband helped in different ways.

I regret that because of the lack of space the selected authors' often extensive footnotes have been omitted. The interested reader is urged to pursue this further information in the original works.

# CONTENTS

# WOMEN
## FROM THE GREEKS TO THE FRENCH REVOLUTION

# INTRODUCTION

The more deeply we penetrate the historical world of Western women the more we suspect that the reality of everyday experience and the abstraction of philosophical and moral speculation lacked cohesion. The conflict between the actual position and the abstract position of women thus forms one of the puzzles of history that teases the historian and the student of modern women alike. When I first discussed a possible subtitle for this book with the publisher, "lots of myth and some reality" at first seemed too strong a statement, but because the delays of publishing give an author time for reassessment, this definition of the available background material on the history of Western woman now sounds reasonably accurate. The mythical element, which is found mainly in the pontifications of philosophers and theologians, is plentiful and available; but the reality is coming to the surface very slowly, although the process is accelerating now that a concerted effort on women's history is finally being made.

The aim of this book is to introduce the reader to the lives of women and to men's views of women in Western patriarchal society from 400 B.C. to A.D. 1800—a time span ranging from the famous Athenian democracy, which has been so influential in the development of Western civilization, to the French Revolution. During this period, everyday experience and philosophical and moral speculation molded Western woman and society's attitude toward her.

Before the nineteenth century—that is, throughout the period before the political and economic revolutions of the eighteenth century—all women played a vital part in the development of society. However, their contribution was unevenly divided among roles that we can classify roughly as "nurturing," "inspirational," and "nonconformist." For the entire period covered by this book the basic nurturing role, in effect and in theory, was a full-time, well-defined, sometimes more and sometimes less respected role for women. This historical view emerges clearly from Aristotle's writings (1 B), from the Hebrew Proverbs (2 A), from the medieval analysis of women (4 F), and from the writings of Rousseau (7 C).

1

Until the Industrial Revolution of the eighteenth century, the nurturing role as part of the family structure was basic and all-encompassing; no alternative (apart from medieval nunneries) was available.  The nurturing role was twofold.  It included the whole area of economic production and industry, in which women worked side by side with men or in which they shouldered the entire burden and which throughout the centuries revolved around the family and the home.  It also (and almost incidentally) included the bearing and raising of children.  However, motherhood as a full-time occupation is a concept that emerged only after the nurturing role was no longer completely engrossing—that is, after the Industrial Revolution had taken production of economic necessities out of the domestic sphere.

The traditional organization of economic production in family units and estates before 1800 used women in their dual capacity.  Because the infant mortality rate was high and working hands were in demand, children were born in close succession. A woman too old to bear children was still an important factor in family industry, however; in many cases she assumed control in the absence of a master.  "Housework" was creative because without it society would have been hungry, naked, and without remedies against sickness.

Although of supreme importance to the continuity of the race, the nurturing role of women in Western society is rarely mentioned in the writings of historians.  The reasons for the long neglect of women's labor for society are many.  For centuries women's effect on military, political, diplomatic, ideological, and artistic matters was not a major factor (although a careful search of the sources shows more female participation than one would suppose from the absence of women's names in the history books).  Most important, however, is the fact that economic history only became a legitimate field of study in the late nineteenth century, and thus women's basic contribution to the economy was not recognized until then.  However, even now this important early contribution of women to their societies is given little space in the history books because historians are largely concerned in describing movement and change—a history book reiterating the fact that the women were bearing and rearing children and concerning themselves with the sowing and hoeing, milking and shearing, spinning and weaving, preserving and cooking as usual would make a very dull book indeed.  Yet this very stability of women's work underpinned the movement and change that occurred in ideas, in politics, in diplomacy, and in art throughout the centuries.

The second of women's three roles, the inspirational role, was a response to psychological (as distinct from purely biological and economic) pressures and appears most clearly in well-defined periods of history.  These were periods when for women of the upper classes the nurturing role was no longer all-

consuming, and at the same time, alternative outlets for women's energies and intellectual capabilities were few. Thus the inspirational role became prominent in the Middle Ages and again in the eighteenth century. The birth of chivalric literature and the cult of the Virgin in the twelfth century (4 B and C), the ascendancy of the lady of the salon in the seventeenth and eighteenth centuries (7 A and B), and the hymns to "femininity" of romantic philosophers such as Rousseau (7 C) were partly answers to women's needs for spiritual and intellectual fulfillment. One might well conclude that women fell into a trap by accepting and fostering this role, but with no viable alternative before the nineteenth century, the inspirational role represented a means to fill a void which in men could be satisfied by the acquisition of ecclesiastical authority, by political and military adventures, and by growing specialization represented by "the professions."

The inspirational role for women, fed by chivalric attitudes and romantic philosophy, literature, and art, was perhaps a convenient way to comfort women about their lack of autonomy. Many women accepted a concept which, however illusory, gave them status in a world in which writers and politicians constantly stressed feminine inferiority and the virtues of submissiveness. The concept of this inspirational function worked its way deeply into Western consciousness. When the great drive for women's autonomy began in the nineteenth century, it was strongly opposed by the image of the inspirational role. This role, now in the guise of the "cult of true womanhood," featured piety, purity, submissiveness, and domesticity. Its nineteenth century male and female proponents claimed that women were the moral guardians of the race and could not remain in that position if they were to become involved in the sordid male world of business.[1]

What of the women who did not conform to the pattern that a combination of domestic production, Western philosophers, moralists, and politicians had formulated for them—the women who followed a nonconformist role? Throughout the period before the Industrial Revolution, women proved by example that not all members of the feminine sex must marry, bear and raise children, and occupy themselves exclusively with the business of nurture and preservation. Before considering such women, however, it is necessary to recognize the fact that with isolated exceptions, such as the peasant girl Joan of Arc, the women whose activity

---

[1]See Barbara Welter, "The Cult of True Womanhood:  1820-1860," *American Quarterly*, 18 (Summer 1966), 151-74; see also Kate Millet's section on Ruskin in *Sexual Politics* (New York: Doubleday and Company, Inc., 1970).

is *recorded* in the world of affairs or literature before the
nineteenth and twentieth centuries were mostly of the upper
classes.  This is not surprising.  In the centuries before the
advent of meritocracy, force, inheritance, or education were
almost the only steps by which men could advance in society.
Because force was seldom a woman's tactic, this left inheritance
and education, and these were prerogatives of the upper classes.

During the medieval period, the church was indeed a ladder
for social mobility.  However, women were shut out from the
priestly office and were able to advance only within the clois-
ter (Part 3).  Through the cloister, medieval Western society
offered an official alternative to women who did not desire mar-
riage or could not afford the dowries demanded for marriage.
Girls could be educated and could enjoy creative and intellectu-
ally satisfying lives in nunneries.  Although the early period
offered monasticism as a refuge to women of all classes, the
majority of those nuns whose background is known were women from
the upper strata of society.  In the latter part of the Middle
Ages particularly, women from the lower strata could be part of
the monastic community as domestics or field hands, but the in-
tellectual and administrative work was usually performed by the
daughters of the aristocracy.

By entering a nunnery these women moreover adopted a privi-
leged and socially acceptable position.  They followed the
Church Fathers' advocacy of a life of celibacy (2 C and D), and
the Church Fathers' writings (of the late Roman Empire) were the
basis of social theory throughout the Middle Ages.  Thus while
many medieval nuns proved themselves capable of "masculine"
intellectual, administrative, and political work, their efforts
were sanctioned by an ecclesiastical hierarchy in a world where
the power of the Church was almost never disputed.  These nuns
did not conform to the basic nurturing role of Western women,
and they are unique in having performed this type of work with
the approval of men.

The attitude of the Renaissance humanists toward women's
learning and capabilities is a landmark in the intellectual his-
tory of women (Part 5).  Many of the humanists had a monastic or
clerical background; hence they had had an opportunity to observe
and respect the intellectual capabilities of women in nunneries.
Because many humanists favored reform and the possible dissolu-
tion of nunneries, they recommended that women outside the clois-
ter should receive an education equal to that of men.

The question of why there are no women comparable to the
"great" men in history is often raised.  The only woman of whom
we know enough so that she can confidently be cited as an exam-
ple of outstanding genius—Queen Elizabeth I of England (1533-
1603) (Part 6 D)—was a product of the two privileges cited
earlier:  inheritance and education.  It is not incidental that
Elizabeth was the daughter and granddaughter of two of the most

aggressively competent Renaissance kings of England and that her education was administered by the best humanist scholar of her time. Elizabeth proved that women, if given the same educational and occupational opportunity, could become as significant as men in the most demanding positions, and few would disagree that she was as successful a "king" as most of her male peers. However, Elizabeth had no children, and it is significant that she declared to the House of Commons one year after her accession that she had no intention of marrying. She made no pronouncements and instigated no precedents that would have put women in general in a position to take a more effective part in public life or in the professions. To Elizabeth, the proper role for the average woman was very positively that of wife and mother.

The Renaissance is said to have been an age in which transition was accelerated.[2] From the feminine point of view it might be said that the humanist vision of women's enlightenment and the Renaissance princes' translation of this vision into practice was accelerated so rapidly that the people at large were unable to take its challenge in their stride. Elizabeth, with the wisdom of good leadership, understood the limitations of her people and her time. Thus, although many Renaissance ladies throughout England and the rest of Europe became as well (if not better) educated as their brothers and husbands, their example was not followed by women of the lower strata of society. In the following centuries, moreover, state and church alike returned to advocating for women the roles of absolute domesticity and obedience to men. Two hundred years after Elizabeth's reign, at the end of the eighteenth century, a young Scottish mathematician, Mary Somerville (1780-1872), was struggling to educate herself against strong parental opposition. She discovered to her great surprise and pleasure that in the "ancient times" of the sixteenth century there had been women scholars proficient in some of the areas she wanted to master. Only in the nineteenth century did the concerted drive for higher education of women, which would make it possible for them to enter professional life, begin. Thus, although rare individuals in special circumstances and special periods illustrated that women could perform intellectual and administrative tasks of the highest professionalism, societal pressures before the nineteenth century contrived to prevent the use of these talents other than in the purely domestic sphere.

When we consider the history of women, it is clear that we are not justified in assuming that women in general have consciously resented their "place" and have constantly striven for

---

[2]Lewis W. Spitz, *The Renaissance and Reformation Movements* (Chicago: Rand McNally and Co., 1971), pp. vii-viii.

autonomy and equality with men.  That there were women who suc-
cessfully carried the autonomous role and others who actively
expressed a desire for it before the nineteenth century emerges
from a study of the early period.  It is scarcely surprising,
however, that these women were a minority.  The questions are
often asked why, since women were in charge of bringing up their
sons as well as their daughters, they did not take this oppor-
tunity to alter the relationship between men and women, and why,
if they really felt burdened by the yoke of male supremacy, they
did not by persuasion and example inspire their sons and daugh-
ters to improve the lot of women.

Psychology has confirmed the suggestibility of human beings
in their infancy, a fact familiar throughout the period covered
by this book and expressed by Plato *c*. 400 B.C. (1 A), by St.
Jerome *c*. A.D. 400 (2 D), and by humanists such as Vives *c*.
A.D. 1500 (5 A).  Had the majority of women themselves become
convinced of the Aristotelian and patristic view of the inferi-
ority of the female (1 B and 2 C)?  Beginning with John Stuart
Mill's analysis, *The Subjection of Women* (1869), a number of
authors have shown how persistent the conditioning of women to
accept their position has been through the centuries.[3]

Tradition undoubtedly impressed on each new generation of
girls that their place in society was below that of men.  Never-
theless, lively young female minds undoubtedly wondered why they
were not allowed to compete with their brothers in the affairs
of the world.  From the limited number of women whose history is
recorded, we know that this was so.  We also know, from the rare
cases when pre-nineteenth century women wrote about their own
education, how mothers often were unwilling to let their daugh-
ters become too interested in nondomestic pursuits.  Christine
de Pizan (*b*. 1364) described a quarrel between her father, who
wanted to educate his daughter, and her mother, who did not.
The astronomer Caroline Herschel (*b*. 1750) recounts how her
father tutored her in secret while her mother was out of the
house.

How can we account for this attitude?  It is hard to be-
lieve that women en masse had been bamboozled into believing in

---

[3]Virginia Woolf's *A Room of One's Own* (London:  Hogarth
Press, 1928) is a witty example of this genre.  Among the many
recent contributions are Simone de Beauvoir, *The Second Sex* (New
York: Knopf, 1953); Kate Millet, *Sexual Politics*; Germaine Greer,
*The Female Eunuch* (New York:  McGraw-Hill, 1970); and Sandra
and Daryl Bem, "Training the Woman to Know Her Place:  The Power
of a Nonconscious Ideology," in *Roles Women Play:  Readings
Toward Women's Liberation*, ed. by Michelle Hoffnung Garskof
(Belmont, Calif.:  Brooks/Cole Publishing Company, 1971).

the inferiority of their own sex. The picture that emerges from the available historical evidence is rather one of men theorizing, speculating, and preaching while women lived a practical life, often doing as they pleased. Why, for example, should the Church Fathers overemphasize the need for feminine submissiveness (2 C), the Reformation preachers stress the need to chastize women (see the Homily on Matrimony in 6 D), or Rousseau lecture on woman's place being that of servant to man (7 C) unless women were indeed in a position of some practical (though not legal or political) power. Unbridled Roman matrons (1 F), Radegund of Poitiers (3 B), the Wife of Bath (4 D), and Madame Geoffrin (7 B), among others, bear out this point. However, practical and responsible mothers would be very careful not to encourage their daughters to step outside their accepted roles into a society where there were no alternatives for women. The home and family were the center of the world of production, in which women played a vital and demanding part, and in most of Western society constant childbearing was essential because of the high rate of infant mortality. In these circumstances a woman who broke away from the norm, like Virginia Woolf's hypothetical sister of William Shakespeare, laid herself open to ridicule, charges of witchcraft, acute misery, and quite likely starvation. No mother would willingly expose her daughter to such a life.

However, as demonstrated by the snowballing of women's social movements in the nineteenth century, a latent drive preexisted in women for a less restrictive life and burst out as soon as the confining forces of economic circumstances began to weaken. The period covered by this anthology ends on the threshold of women's great drive for legal, professional, and political equality with men. As soon as the Industrial Revolution opened the door to economic independence for working women and simultaneously gave more leisure to middle-class housewives, and as soon as constant procreation was no longer an imperative condition of life, women began to work together to establish opportunities for themselves and their daughters in the intellectual, professional, and economic world and to consolidate their legal and political rights.

Compared with millenia of traditional emphasis on the nurturing and inspirational roles, only a hundred and fifty years have passed since the concerted drive for women's autonomy began—a minimal period in the long history of Western women. Entrenched attitudes built up over centuries have resisted every move toward female independence. It is a tribute to the caliber of the men and women who have worked for women's autonomy that so much has been achieved in this short period. But although ample precedents have existed since the nineteenth century, the autonomous role is still not universally accepted as a normal option for Western women. The heritage of millenia of human experience lingers on.

**1**

# WOMEN IN THE ANCIENT WORLD:   GREECE AND ROME

Some four hundred years after Greece had become steeped in Homeric myths, Athens produced a veritable constellation of philosophers (among them Socrates, Plato, and Aristotle), dramatists (for example, Sophocles, Euripides, and Aristophanes), and scientists and artists (such as Phidias).  This period, roughly covering the years 450 to 350 B.C., has become known as the Golden Age of Athens.  Because the men of that time and their world to a large extent shaped Western civilization as we know it, including its attitude toward women, it is enlightening to understand their view of women and to understand the lives led by women in that influential community.

Athens and Sparta were the two most important independent city-states of Greece at that time.  From 431 to 404 B.C. they and their allies were locked in military struggle.  This war was described by the contemporary historian Thucydides, whose History of the Peloponnesian War became a model for later chroniclers.  Perhaps this helps us to understand why women have played such an insignificant role in the history books of the ages:  Thucydides devoted a minimum of space to the mothers, wives, daughters, and women friends of the men who lived in the time of the great war, and most of his references to women point out that the wives of defeated warriors were sold into slavery.  In the most famous passage referring to women, he recommended that they should be neither seen nor heard.  His opinion was that wailing widows were an unhealthy symbol for a community engaged in fighting for its life.  In this context the passage is defensible; however, because it is part of the statesman Pericles' most famous speech, its significance has been given great weight.  Moreover, it is endorsed by Aristotle's contention that:  "Silence is a woman's glory."

The Athens of most of the Golden Age was ruled by a democratic assembly that was outstanding for its time.  However, this democracy was restricted to a minority of male citizens, and its economy was based on slavery, as was that of the entire Mediterranean world of ancient times.  The women workers in most of the Athenian households were slaves, and much of the great drama of the period (for example, Trojan Women and Andromache)

8

*highlights the enslavement of women whose men have been killed in war.*

*The selections dealing with this vital period in Greek history encompass the practical social and economic background of women's lives in fifth-century Athens (1 C), Plato's utopian view of how an elite stratum of women might live in an ideal state (1 A), and a series of quotations delineating Aristotle's view of women (1 B). This last selection is perhaps the most significant for the development of ideas on femininity because Aristotle has been considered the philosopher par excellence until modern times—that is, for more than ten centuries beginning a thousand years after his death—and his views of women and their capabilities have become deeply ingrained in Western culture.*

*Shortly after the Golden Age of Athens, the Romans began their conquest of the Mediterranean world. Many Greek thinkers came into the Roman ambit as slaves (often used as domestic tutors), and the Greek intellectual tradition became part of Roman thought. As the Roman Empire grew to include vast stretches of southeastern and western Europe, much of Greek scholarship found its way into those areas.*

*Three major achievements of the ancient Romans had far-reaching effects: the Pax Romana (the imperial rule over and pacification of enormous reaches of conquered territory); feats of engineering such as arterial roads, bridges, and viaducts; and the promulgation and codification of a vast body of law. This last achievement vitally concerned women during the Roman eras of the kingdom (753-494 B.C.), the republic (494-49 B.C.), and the empire (23 B.C.-A.D. 476). It equally affected women in many of the countries where Roman domination left a permanent imprint, and by this circuitous route Roman law has found its way into modern American civilization. The effect on modern life is seen in the territories added by the acquisition of the Louisiana Purchase from France and the states in the Southwest added by conquest from former Spanish dominion. There laws of divorce and community property are based on Roman (that is, French and Spanish) laws rather than on New England or Virginian laws, which are of Anglo-Saxon origin. The many different types of marriage, legal and illegal, in ancient Roman society are discussed in Part 1, section D. From this it is evident that social class and legal position vitally affected women's lives and status.*

*In the religious life of the state, Roman women played an important and inspiring part. As matrons, they tended the family and household gods in the early period; and until the Empire, by which time an overall religious skepticism had set in, women functioned as priestesses in many of the public religious rites of the state. Part 1, section E, describes the part played by the vestal virgins, a small but symbolically influential group of women.*

*Politically, women in the Roman state were somewhat more active than the Greek women of contemporary periods. Feminine influence on Roman rulers is well documented,[1] and an isolated case of unified public female interference in the Senate's law making (195 B.C.) shows that women were able to take a stand in public affairs (1 D).*

## A.   WOMEN EQUAL RULERS WITH MEN—AN IDEAL

The Republic *was one of the greatest works of the fourth century Athenian philosopher Plato.  In dialogue form he deline-ated his vision of an ideal state where justice will reign supreme.  The Republic was written soon after Athens had been defeated by Sparta in the Peloponnesian War, and many of the details of his work are modeled on his idealized view of con-temporary Spartan customs.  For example, unlike Athenian women, the Spartan women competed in athletics and wrestling in order to prepare themselves to become the mothers of strong warriors. The selected passage from the fifth book of* The Republic *shows how specially bred and educated male and female "guardians" might equally share the government of the state.*

*It is worthy of note that Plato, like his follower Aristotle, thought women in general were inferior to men.  However, this view did not prevent him from wishing to see the most talented of both sexes as guardians of the state.*

*Plato's ideas on women expressed in* The Republic *are impor-tant not so much for what they reflect about the situation of women in ancient Greece (except to a limited degree about the situation of Spartan women) but for what they project as possi-ble.  With* The Republic *a new and different conception of women's potential entered Western thought.  Although this con-ception was mostly ignored in theory throughout the centuries and was totally ignored in practice until the nineteenth century, Plato's ideal was nonetheless present and was eagerly grasped by women when its feasibility became a fact.*

---

[1]See, for example, J. P. V. D. Balsdon, *Roman Women:  Their History and Habits* (New York:  John Day Co., 1963).

THE REPUBLIC, Book V

Plato

". . . The men have fully played their part on our stage and made their exit; and now perhaps it would be right to call in the women, especially since you invite me to do it.

"For people then, born and educated as we explained, the only right way, in my opinion, for them to get and use children and women is the way we started them to go.  You remember we tried in our discourse to establish the men as it were guardians of a herd."

"Yes."

"Then let us follow up by giving the women birth and train-ing like theirs, and see if it is proper for us or not."

"How?" he asked.

"Thus; do we think that the females of the guardian dogs ought to share in the guard which the males keep?  Ought they to join in the hunt and whatever else they do?  Or should the fe-males keep kennel indoors, as being unable because of the birth and training of pups, and should the males do the hard work and have all the care of the flocks?"

"They ought to do everything together," he said, "except that we treat the males as stronger and the females as weaker."

"But is it possible," I said, "to use animals for the same things, if you do not give them the same training and educa-tion?"

"Impossible."

"Then if we are to use the women for the same things as the men, we must teach them the same things."

"Yes."

"Now music and gymnastic were taught to the men."

"Yes."

"So we must teach the women those same two arts, and mat-ters of war too, and use them in the same way."

"That seems fair from what you say," he replied.

"Well then," said I, "perhaps much in our present pro-posals would appear funny in contrast with usual custom, if they were done in the way we say."

"Likely enough," he said.

"And what will be the biggest joke of all?" I asked.
"Surely to see naked women in the wrestling schools exercising

Plato, *The Republic*, in *Great Dialogues of Plato*, trans. by W. H. D. Rouse (New York:  The New American Library, Inc., 1956, A Mentor Classic), excerpts from pp. 249-55.  Reprinted by per-mission of The New American Library.

with the men—not only the young women, but even the older ones
too?  Like old men in the gymnasium, all over wrinkles and not
pleasant to look at, who still fancy the game!"

"You are right, upon my word!" said he; "it would seem
funny as things are now!"

"Very well," said I, "since we have set out to speak, let
us not fear the jests of refined people.  Let them talk how they
like and say what they like of such an upheaval, about gymnastic
and music, and not least about wearing armour and riding on
horseback."

"Quite right," said he.

"But since we have begun let us march on to the rough part
of our law.  We will entreat these wits to leave their usual
business and be serious for once; we will remind them that it
is not so very long since Hellenes thought it ugly and funny,
as most barbarians do still, to see men naked; and when the
Cretans began naked athletics, and the Lacedaimonians followed,
the clever people then were able to make fun of the thing.
Don't you agree?"

"Yes, I do."

"But we found by experience that it was better to strip
than to hide all such things; and soon the seeming funny to the
eyes melted away before that which was revealed in the light of
reason to be the best.  It showed also that he is a vain fool who
thinks anything ridiculous but what is evil; and he is a fool who
tries to raise laughter against any sight, as being that of some-
thing funny, other than the sight of folly and evil; or in earnest
sets up any other mark to aim at than what is honourable and good."

"By all manner of means," he said.

"Then surely we must decide first whether this is possible
or not.  Next, we must open the debate to all, whether a man
chooses to argue in jest or in earnest; and let them discuss
whether the female nature in mankind allows women to share the
same work with men in everything, or in nothing, or only in
some things, and if in some, to which class war belongs.  Would
not this be the best beginning which would lead most likely to
the best end?"

"Much the best," he said.

"Are you willing, then," said I, "that we should defend
the others against ourselves, and not take the fort of the coun-
terargument undefended?"

"There's nothing to hinder that," he replied.

"Then let us say on their behalf, 'You need no others to
dispute with you, Socrates and Glaucon; you yourselves at the
first foundation of your city admitted that each single person
must do his own one business according to nature.'  'We admitted
it, I think; of course.'  'Is there not all the difference in the
world between man and woman according to nature?'  'There is a
difference, certainly.'  'Then further, is it not proper to

appoint work for each according to the nature of each?' 'What
then?' 'Then you are mistaken surely, and contradict yourselves,
when you say now that men and women must do the same things, al-
though their natures are very different!' 'Come on now, answer
me that and I will thank you!"

"What! all of a sudden!" he said.  "That's not altogether
easy; but I beg and pray you to interpret our argument for us,
whatever that may be."

"That is what I expected, my dear Glaucon," said I, "and
there are many other such objections, which I foresaw long ago;
that is why I feared and shrank to touch the law about getting
and training women and children."

"No, by heaven, it does not look like an easy thing," said
he.

"And it is not," said I, "but it's like this:  If anyone
tumbles into a small swimming pool, or if into the middle of the
broad sea, he has to swim all the same."

"Certainly."

"Then we must swim too, and try to save ourselves out of
the argument; we may hope for some dolphin to take us on his
back, or some other desperate salvation."

"So it seems," he said.

"Come along then," said I, "see if we can find the way out
anywhere.  We agreed, you know, that a different nature ought
to practise a different work, and that man and woman have dif-
ferent natures; now we say that these different natures must do
the same work.  Is that the accusation against us?"

"Exactly."

"How noble is the power, my dear Glaucon," said I, "of the
art of word controversy!"

"How so?" he said.

"Because," I said, "so many seem unable to help falling
into it; they think they are arguing, when they are only striv-
ing quarrelsomely.  The reason is that they don't know how to
split up a given utterance into its different divisions, but
pursue simply a verbal opposition to what is uttered.  They
bandy words with each other, instead of using reasoned discus-
sion."

"That certainly does happen," he said, "in many cases; but
surely it does not apply to us in this case?"

"It does, by all manner of means," I said; "at any rate we
appear to have got into a word controversy without meaning to."

"How?"

"That *different* natures ought not to engage in the *same*
practices; we have been chasing the words about with plenty of
courage and eristic wrangling, and never thought of enquiring
in any way what was the sense of 'different nature' and what
was the sense of 'same nature,' and what we were aiming at in
our definition when we allotted to a different nature different

practices, and to the same nature the same."

"True, we did not," said he.

"It seems we might just as well ask ourselves," I said, "whether the natures of bald men and hairy men are the same or opposite; and in case we agree that they are opposite, we might forbid long-haired men to make shoes if bald men do, and forbid bald men if long-haired men do."

"That would be ridiculous," he said.

"Yes, ridiculous," I said, "but only because we did not then mean the words 'different' and 'same nature' absolutely; we were thinking only of that kind of sameness or difference which had to do with their actual callings. Thus we meant that a man and a woman who have a physician's mind have the same nature, didn't we?"

"Yes."

"But a man physician and a man carpenter different natures?"

"Yes, I suppose so."

"Now," said I, "take the male and the female sex; if either is found to be better as regards any art or other practice, we shall say that this ought to be assigned to it. But if we find that they differ only in one thing, that the male begets and the female bears the child, we shall not take that difference as having proved any more clearly that a woman differs from a man for what we are speaking of; but we shall still believe that our guardians and their wives should practice the same things."

"And rightly so," he said.

"Next, we shall call upon the man who says the opposite, to tell us just this—any art or practice, of those which furnish our city, for which the nature of woman and man is not the same but different."

"That is fair, at least."

"The other man's reply might very likely be what you said a little while ago, that he can't easily answer properly all of a sudden, but give him time to think and it will not be hard."

"Yes, he might say that."

"Then if you please shall we ask our opponent kindly to follow us, and see if we can show him that there is no practice peculiar to woman in the management of a city?"

"Certainly."

"We will say to him then, 'Come along, answer. Was it this that you meant by having or not having a natural gift for any-thing—that one learned easily, the other with difficulty? One after short learning was very inventive in what he learnt, the other after long learning and practice could not even remember what he had learnt? In one the body served the mind properly, in the other it opposed the mind? Was there anything else by which you distinguished good and bad natural gifts for various things?"

"No one will find anything else," he said.

"Well, do you know anything at all practiced among mankind, in which in all these respects the male sex is not far better than the female?  Or should we make a long story of it—take weaving, and the careful tending of cakes and boiling pots, in which women think themselves somebody and would be most laughed at if beaten?"

"You are right," he said, "that one sex is much better than the other in almost everything.  Many women, it is true, are better than many men in many things, but generally it is as you say."

"Then, my friend, no practice or calling in the life of the city belongs to woman as woman, or to man as man, but the various natures are dispersed among both sexes alike; by nature the woman has a share in all practices, and so has man, but in all, woman is rather weaker than man."

"Certainly."

"Then shall we assign all to man and none to woman?"

"Why, how can we?"

"No, for as I believe, we shall say one woman is musical by nature, one not, one is medical by nature, one not."

"Of course."

"But are we not to add—one woman is athletic or warlike, and another is unwarlike and unathletic?"

"Indeed we are."

"Shall we not say the same of philosophy and misosophy, one loves wisdom and one hates it?  One has high spirit, one no spirit?"

"That is so also."

"Then there may be a woman fit to be a guardian, although another is not; for such was the nature we chose for our guardian men also?"

"Yes it was."

"Then both woman and man may have the same nature fit for guarding the city, only one is weaker and one stronger."

"So it seems."

"Such women, then, must be chosen for such men, to live with them and to guard with them, since they are fit for it and akin to them by nature."

"Certainly."

"Practice and calling must be assigned to both sexes, the same for the same natures?"

"Just the same."

"So we have come round to where we began, and we agree that it is not against nature to assign music and gymnastic to the wives of the guardians."

"By all means."

"Then our law was not impossible, not only like a pious dream; the law we laid down was natural.  But rather, it seems, what happens now, the other way of doing things, is unnatural."

"So it seems."

"Our question then was:  Is our proposal possible, and is
it best?"

"Yes, that was it."

"It is possible, we are both agreed, aren't we?"

"Yes."

"Then the next thing is to agree if it is best."

"Clearly."

"Well, for a woman to become fit to be a guardian, we
shall not need one education to make men fit and a different
one to make women fit, especially as it will be dealing with
the same nature in both?"

"No; the same education."

"Then what is your opinion about the following?"

"What?"

"About the notion in your mind that one man is better,
another is worse.  Or do you think all men are alike?"

"Not by any means."

"In the city that we were founding, then, which do you
think we formed into better men, the guardians educated as we
described, or the cobblers educated in cobbling?"

"A ridiculous question," said he.

"I understand," said I, "but tell me—are not the guardians
the best of all the citizens?"

"Much the best."

"Very well, will not these women be the best of the women?"

"Again the very best," he said.

"And is there anything better for a city than that both
women and men in it should be as good as they can be?"

"There is not."

"But this will be brought about by the aid of music and
gymnastic, as we have described?"

"Of course."

"Then the plan we proposed is not only possible, but best
for the city?"

"Just so."

"So the women of the guardians must strip, since naked they
will be clothed in virtue for gowns; they must share in war and
in all the guarding of the city, and that shall be their only
work. But in these same things lighter parts will be given to
women than men because of the weakness of their sex.  And the
man who laughs at naked women, exercising for the greatest good,
plucks an unripe fruit of wisdom from his laughter; he apparent-
ly does not know what he laughs at or what he is doing.  For it
is and will be the best thing ever said, that the useful is
beautiful and the harmful is ugly."

"Assuredly so."

"There goes, let us say, the first wave we have to meet in
discussing our women's law—and we are alive!  The flood has not
quite swallowed us up after ordaining that our guardians and

guardianesses must have all their doings in common. The argument makes a humble bow to itself, and admits that what itself says is possible and useful too."

"Yes indeed," he said, "that is no small wave you are surviving."

"No big one, you will say," I answered, "when you see the next."

"Go on, let me see it," he said.

"Another law," said I, "follows this and the others before it, I think."

"What, pray?"

"These women are to be all common to all these men; no one must have a private wife of his own, and the children must be common too, and the parent shall not know the child nor the child its parent."

"A much bigger wave indeed than the other," said he. "It makes one doubt about the possibility and the usefulness of this proposal."

"Oh, about useful," I said, "there would be no doubt there, I think; no one will deny it would be the greatest good to have women in common and children in common. But is it possible? I think there would be the greatest dispute about whether it is possible or not."

"Both would be disputed," he said, "hot and strong."

## B. ARISTOTLE'S VIEW OF WOMEN

*Aristotle (384-322 B.C.) was Plato's most brilliant student, although he disagreed with many of his master's theories, one of which was Plato's admiration of Spartan ideas and procedures. Thus in one of his most important series of lectures, the* Politics, *Aristotle set out to argue against Plato's proposals in* The Republic. *Aristotle's view of women emerges in the* Politics, *and in some of his other works, such as* Generation of Animals *and* Nicomachean Ethics.

*In his vast output of ideas, Aristotle did not say a great deal specifically about women, so many of his comments on women are excerpted here. He sincerely believed that women were inferior to men, that their place on the social ladder was above slaves but below men. He based his view on contemporary Athenian life, for his whole philosophy was to take things as they are rather than as they ought to be.*

*Aristotle's portrait of women is of tremendous importance in Western thought. It became a guide for women in general, and because of his influence in the following millenia, it became entrenched in Western culture.*

GENERATION OF ANIMALS

Aristotle

. . . The female, in fact, is female on account of inability of a sort, viz it lacks the power to concoct semen. . . . [p. 103]

Now of course [in conceiving] the female, qua female is passive, and the male, qua male is active. . . . [p. 113]

. . . Wherever possible and so far as possible the male is separate from the female, since it is something *better* and more divine in that it is the principle of movement for generated things, while the female serves as their matter.  [p. 133]

Young parents, and those which are older too, tend to produce female offspring rather than parents which are in their prime; the reason being that in the young their heat is not yet perfected, in the older, it is failing.  [pp. 395-96]

Some offspring take after their parents. . . . Males take after their father more than their mother. . . . Others do not take after a human being at all in their appearance, but have gone so far that they resemble a monstrosity. . . . The first beginning of this deviation is when a female is formed instead of a male, though (a) this indeed is a necessity required by Nature, since the race of creatures which are separated into male and female has got to be kept in being; and (b) since it is possible for the male sometimes not to gain the mastery either on account of youth or age or some such cause, female offspring must of necessity be produced by animals. [pp. 401-3]

. . . While still within the mother the female takes longer to develop than the male does; though once birth has taken place everything reaches its perfection sooner in females than in males—e.g., puberty, maturity, old age—because females are weaker and colder in their nature; and we should look upon the female state as being as it were a deformity, though one which occurs in the ordinary course of nature.  [p. 406]

---

Aristotle, *Generation of Animals*, trans. by A. L. Peck, The Loeb Classical Library (Cambridge, Mass.:  Harvard University Press, 1943).  Reprinted by permission of Harvard University Press.

ETHICS

Aristotle

The man is master, as is right and proper, and manages
everything that it falls to him to do as head of the house.
But whatever can be suitably performed by the wife he hands
over to her. . . . But sometimes it is the wife who takes
charge, as may happen when she is an heiress.  In that event
authority does not go by merit but by money and influence. . . .
[Bk. 8, ch. 10, p. 247]

The affection between husband and wife is the same as that
which exists between the government and the governed in an aris-
tocracy.  For the degree of it is measured by the relative mer-
its of husband and wife, the husband who is superior in merit,
receiving the larger share of affection, and either party
receiving what is appropriate to it.  And the claims of justice
in this relationship are satisfied in the same way.  [Bk. 8,
ch. 11, p. 248]

The love between husband and wife is evidently a natural
feeling, for Nature has made man even more of a pairing than a
political animal. . . . But human beings cohabit not only to
get children but to provide whatever is necessary to a fully
lived life.  From the outset the partners perform distinct
duties, the man having one set, the woman another.  So by pool-
ing their individual contributions they help each other out.
Accordingly there is general agreement that conjugal affection
combines the useful with the pleasant.  [Bk. 8, ch. 12, p. 251]

Others describe a friend as . . . one who shares the joys
and sorrows of his friend—this trait is also specially charac-
teristic of mothers.  [Bk. 9, ch. 4, p. 266]

---

Aristotle, *The Ethics of Aristotle*, trans. by J. A. K.
Thomson (Baltimore, Md.:  Penguin Books, 1953).  Reprinted by
permission of George Allen & Unwin Ltd.

POLITICS

Aristotle

A husband and father rules over wife and children, both free,[1] but the rule differs, the rule over his children being royal, over his wife a constitutional rule.  For although there may be exceptions to the order of nature, the male is by nature fitter for command than the female. . . . [Bk. 1, ch. 12, p. 21]

[In] the relation of the male to the female . . . the inequality is permanent.  [Bk. 1, ch. 12, p. 21]

A similar question may be raised about women and children, whether they too have virtues:  ought a woman to be temperate and brave and just . . .?  [Bk. 1, ch. 13, p. 21]

A slave has no deliberative faculty at all; the woman has, but it is without authority. . . .  [Bk. 1, ch. 13, p. 22]

Clearly, then, moral virtue belongs to all of them; but the temperance of a man and of a woman, or the courage and justice of a man and of a woman, are not, as Socrates maintained, the same; the courage of a man is shown in commanding, of a woman in obeying. . . .  [Bk. 1, ch. 13, p. 22]

All classes must be deemed to have their special attributes; as the poet says of women,
*"Silence is a woman's glory,"*
but this is not equally the glory of man.  [Bk. 1, ch. 13, p. 23]

For a man would be thought a coward if he had no more courage than a courageous woman, and a woman would be thought loquacious if she imposed no more restraint on her conversation than the good man; and indeed their part in the management of the household is different, for the duty of the one is to acquire, and of the other to preserve.  [Bk. 3, ch. 4, p. 65]

Women should marry when they are about eighteen years of age, and men at seven and thirty; then they are in the prime of

---

Aristotle, *Aristotle's Politics and Poetics*, trans. by B. Jowett and T. Twining (New York:  Viking Press, Compass Books Edition, 1957).  Reprinted by permission of The World Publishing Company.

[1]As opposed to slaves, who are not free [Ed.].

life, and the decline in the powers of both will coincide.
[Bk. 7, ch. 16, p. 202]

As to the exposure and rearing of children, let there be a
law that no *deformed* child shall live, but that on the ground
of an *excess* in the number of children, if the established cus-
toms of the state forbid this (for in our state population has
a limit), no child is to be exposed, but when couples have chil-
dren in excess, let abortion be procured before sense and life
have begun; what may or may not be lawfully done in these cases
depends on the question of life and sensation. [Bk. 7, ch. 16,
p. 203]

## C. WOMEN IN DEMOCRATIC ATHENS

*In these selections the classicist W. K. Lacey combines the
latest scholarship with his own research on the position of women
in Athens during the Golden Age. Lacey bases his conclusions on
evidence from recorded legal cases of the orators (lawyers), on
evidence from the dramatic, philosophic, and historical litera-
ture of the Golden Age, and on evidence from its artistic re-
mains. He is careful to point out that one must distinguish
between women of different historical periods and social classes
when considering the question rather than use "Greek" or even
"Athenian" women as the basic example.*

*The passages show that Athenian citizen women of the Golden
Age, like its men, were an integral part of the* polis *and the
family structure, and they were treated as such and not as indi-
viduals. Lacey covers such themes as the protection of women
against the roughness of contemporary male society,[1] and against
legal abuse; the importance of legal heirs for each family,
which necessitated virginity in girls and carefully guarded
wives; married women's lives; the education of daughters; and
the types of work carried out by women of all classes at the
time. He also cites evidence for his belief that infanticide
among this group of Athenians was extremely limited and that in*

---

[1]It is debatable whether Athenian women wanted to be pro-
tected from raucous male society. Classical scholarship is not
agreed upon whether women attended the Attic theater or not.
However, readers of Aristophanes' plays *Lysistrata* and *Women in
Assembly* will find it difficult to reconcile the vulgarity of
these plays and their women characters' participation with the
need for protecting Athenian women of the same period from
masculine vulgarity.

*fact girls were exposed less often than boys. Finally he gives
a factual account of the practice of homosexuality in this
period that tends to discredit sweeping statements that homo-
sexuality was a large factor in Greek life that must have
adversely affected the lives and needs of its women.*

## THE FAMILY IN CLASSICAL GREECE

## W. K. Lacey

### RELEVANT COMPARISONS

Scholars have . . . tended to put Homer's women beside
those of classical Athens to the detriment of the latter; one
might as well compare the lady of a medieval manor with a
Victorian lower-middle-class housewife—or a modern factory-
worker; the qualities of the patterns of life are utterly dif-
ferent.  The heroic woman enjoyed great social freedom within
her husband's house and the domain of his power, but her posi-
tion depended entirely on his success as a warrior and his
ability to maintain his family's independence in a jealously
competitive world in which failure brought slavery or starva-
tion, or both; her position in respect to her husband was also
wholly dependent on his pleasure, or the ability and willing-
ness of her relations to bring pressure to bear on him.  In
Athens, in the aristocratic period, the upper classes retained
some features of the heroic pattern; the great families enjoyed
a comparable freedom of social intercourse, which lasted at
least as far as the time of Cimon and Elpinice in the mid-fifth
century.  But the Homeric élite, the upper strata of society,
were supported by a nameless, forgotten population of serfs
and other semi-free poor folk, who lived on the borders of
starvation, and who appear but rarely in literature, and in
history only on occasions when, as in pre-Solonian Athens, the
élite had monopolized such an excessive share of the community's
wealth that the small, independent, fighting man who was, after
all, the backbone of the state, began to be affected.

---

W. K. Lacey, *The Family in Classical Greece* (Ithaca, N.Y.:
Cornell University Press, 1968), excerpts from pp. 153-76.
ⓒ 1968 Thames and Hudson.  Reprinted by permission of Cornell
University Press.

## THE IMPACT OF DEMOCRACY

By the mid-fifth century the Athenian democracy had under-
mined the way of life of this élite.  The laws, and the courts
which enforced them, imposed controls upon their freedom of
action in many fields, for example in augmenting their posses-
sions, or in acquiring wives and concubines at will and regard-
ing whom they would as their heirs.  Later, the Peloponnesian
War caused immense losses to the older, landed families because
of its demands on the citizens' pockets, its cutting off of
their income from their lands for a decade, and the wastage
which customarily followed the death of the father of a family
on military service. . . .

This does not mean that there were no rich men in demo-
cratic Athens; there undoubtedly were, both in the fifth century
and in the fourth, but by then they were not, in general, the
old landed nobility, since their incomes will have failed to
keep pace with inflation because they had not the means (or
probably the ability and inclination) to introduce better farm-
ing techniques, and a supply of abundant, and hence relatively
cheap, grain was a cornerstone of the state's policy.  We meet
soldiers of fortune like Conon, whose wealth was enormous, and
we hear that wealth could be quickly made by similar successful
adventurers.  Demosthenes' father, who had inherited consider-
able wealth from his mother, increased it by his successful
direction of two factories manned by slaves, a certain Comon
also made money by factory-owning, employing slave-workmen, and
so did several people quoted in one of Xenophon's tales. . . .

A citizen's interests were therefore best served by main-
taining friendly relations with a wide circle of men, including
friends as well as neighbours and relations, and this necessar-
ily involved him in associations and social gatherings with
these friends rather than with his family; in consequence, the
family normally did not provide the central focus of a citizen's
social life. . . .

## HOMOSEXUALITY

We are sometimes told that the Greeks were fully bisexual,
enjoying both homosexual and heterosexual intercourse, and that
romantic love in Greece was associated with attachments to boys
and not to girls.  Whatever the truth of the latter statement,
there can be no doubt that, while the Greeks had a deep admira-
tion for the physical beauty of the young male, in Athens the
practice of sodomy was strictly circumscribed by the law.  Boys
still at school were protected against sexual assaults by a law
(said to go as far back as Dracon and Solon), and we hear of
strict regulations about schools with this in mind; schoolboys

always had a *paidagogos* escorting them; in art the *paidagogos*
is always depicted as carrying a long and heavy stick; what was
this for if not to protect their charges?  Adult citizens
(those enrolled on the deme-registers) who were catamites, or
had been catamites as adults, suffered some diminution of civic
rights; those who procured free boys for sodomy are said to
have been punishable by law.  This evidence may give a clue to
the truth of the situation, which was perhaps that free Athen-
ians practised homosexual intercourse only for a short period
of their lives—between the period when they cut their hair
(about the age of sixteen) and started to frequent the gymna-
sium and wrestling-school as part of the process of strengthen-
ing their bodies for military training (when they were the tar-
get of lovers), during military training and for a short period
thereafter (when they were the lovers).  Sodomy was thought
reprehensible for older men even when the catamite was not a
citizen, as is clear from a speech of Lysias, but it was not
illegal; it may be thought that the law in this field is likely
to have been similar to that about adultery; what was quite
legal with slaves and other non-citizens was illegal with citi-
zens, and the law took notice of the private morals of individ-
uals, and punished offenders.

Paederasty was expensive; whether this was because the
youths' admirers wanted to compete in generosity for favours or
the youths were able to use the law virtually to blackmail their
admirers no doubt varied in individual cases, but the result of
the expense was to make paederasty a habit of the upper class
and of those who imitated them, and hence suspect to the common
people and a means of arousing prejudice in legal cases.
Plato's attack on sodomy, especially in the *Laws*, reveals that
the practice was not unknown to him, and that it was more repug-
nant to his ideals than heterosexual intercourse outside mar-
riage, since this latter (if secret) was tolerated in the *Laws*
as a second-best to the ideal of virginity till marriage and
sexual intercourse only within marriage for the purpose of
breeding children.

## THE PROTECTION OF WOMEN

The citizenship law of Pericles, re-enacted in the archon-
ship of Eucleides in 403/2 BC, combined with the Athenians'
litigiousness and covetousness and with the activities of the
informers in restricting the freedom of the women in social
intercourse.  It was of such overriding importance not to allow
the least breath of suspicion to fall on young girls that they
were not virgins, or on young wives that their child was not
properly conceived in wedlock, that they were protected to what
to our minds is a wholly unreasonable degree.  Isomachus' bride

had lived "under strict supervision in order that she might see
as little as possible, hear as little as possible and find out
as little as possible . . . she knew only about the working of
wool herself and what could be expected of a slave, . . . but
she also had had a really good training in management of the
food, which seems to me to be the most important accomplishment
to have, both for a man and his wife."  So Xenophon writes.  A
speaker can claim that his sister and nieces in the women's
quarters in his house had lived "with so much concern for their
modesty that they were embarrassed even to be seen by their
male relatives."  Other speakers claim that wives do not go out
to dinner with their husbands, and do not even eat with their
husbands when they are entertaining male visitors, unless they
are relatives.

     This last was not perhaps as unreasonable as it might
appear at first sight; male company was not always as orderly
as a modern mixed dinner party; the orators narrate some par-
ties at which no doubt women would not have wished to be pres-
ent.  Other passages speak of quarrels arising "through drunk-
enness, quarrelsomeness or playfulness, arising out of abuse,
or fighting over a mistress," and Athenaeus cites several ex-
tracts on this theme.  Orators also deny they had even been to
their opponents' houses for such reasons; one denies that he
had ever been one of the young men who go in for gaming and
drink; even in the circle of Plato we find that the philosophi-
cal discussion on love was agreed upon partly because all of
those present at the symposium except Socrates were suffering
from sore heads as a result of previous excesses.  It is to be
remembered that since gay parties and serenadings were regarded
as the mark of a kept woman, this provided yet another reason
for a wife not to wish to attend.

     But citizen-women took part in such business activities as
the making of wills; apart from the wife and daughters of Poly-
euctus, . . . Lysias in a memorable passage tells how Diogeiton's
daughter stood up in a family council to remonstrate with her
father over the treatment of her two sons, who were at the same
time his nephews and his grandchildren:  "The boys' mother,"
says the orator, "kept begging me and imploring me (their sis-
ter's husband) to call a meeting consisting of her father and
their friends, saying that even if she had not been in the
habit before of speaking amongst men, the extreme degree of
their ill-fortune would compel her to reveal all the details of
the wrongs which they had suffered. . . ."

### VIRGINITY AND MARRIAGE

     The civic necessity for virginity also ensured that girls
were married very young; we have no statistical information on

the customary age; all that we can say is that the law on
*epikleroi* appears to have made them legally possessed of their
property (in so far as they ever truly possessed it) at the age
of fourteen, and this must have coincided with their marriage.
Xenohpon's Isomachus, himself a fully mature man of about
thirty, married a girl of fourteen, but Xenophon, like Hesiod,
Plato, Aristotle and Plutarch (or his source), thought that the
customary age of marriage was too young, and that the customary
age in Sparta (eighteen to twenty) was much more satisfactory.
. . . A girl's *kyrios*[1] usually took the initiative in obtaining
her a husband; when her future husband was one of her relatives,
she was presumably already acquainted with him, however slightly,
and will certainly have known of him by repute.  When he was not
a relative we cannot be certain that she had ever met him face
to face before her betrothal.  It is improbable that she did;
even in modern Greece a girl may well not meet her prospective
husband until he has come to terms with the head of her family.
Xenophon, it is true, speaks of marrying a beautiful girl as
being desirable, and we have a hint that a girl who was not
even moderately passable to look at (ὁπωστιοῦν μετρίαν . . .
ὄψιν) might not get a husband, and of course this could only be
determined by the husband-to-be if he had seen her in person,
but personal descriptions of the bride might well have been
part of the duty of the match-maker, as it is in India today.

From the point of view of society and social life, one
inevitable and evil result of the immaturity of Athenian brides,
and the wide gap in age that was normal between husband and wife,
lay in that they were most unlikely to have any common friends;
Aristotle did not consider this aspect of friendship at all in
his treatment of the subject, and there is more than a hint of
paternalism rather than partnership underlying the whole of
Xenophon's treatment of the customary husband and wife relation-
ship in Athens in his own day.

## THE EDUCATION OF GIRLS

Athenian girls were also less well educated than boys;
while there is plenty of evidence that many were taught to read
and write, few received any higher education even when boys be-
gan to get it, from about the middle of the fifth century. Most
of the more highly educated women of whom we hear were non-
citizens like Aspasia, or belong to the Hellenistic age like
Hipparchia, who lived as the wife of Crates the Cynic, and whose
behaviour would probably provoke the intervention of the law

---

[1]Head of the family.

even in twentieth century Britain.  Xenophon attributes wives'
lack of education to their extreme youth at marriage; the often-
quoted question, "Is there anyone with whom you hold fewer dis-
cussions than with your wife?", and its answer, "If there is
anyone, there are not many at all events," is prefaced by illus-
trations (from sheep and horses) that it is the fault of the
person in charge if what is under his care is in ill condition,
and the argument that a husband must teach his wife to manage
his property, since she is entrusted with more of his valuable
possessions than anyone else.  "And," says his Socrates, "did
you not marry her as just a young girl who had seen and heard
as little as possible?  Is it then not much more to be wondered
at if she understands any of the things she ought to say and do
than if she fails to do so?", and goes on "And I think that a
wife who is a good partner in an *oîkos*[2] is in every way as
important to its well-being as her husband."  Though his treat-
ment is patronizing in that he assumes that a bride has no
education and therefore needs to be taught, he explains the
need in terms of her youth, not of her capacity to learn, and
therefore is, to modern ways of thought, somewhat in advance of
Plato, who states unequivocally his view that a woman's capacity
to learn is less than that of a man.[3]

### FAMILY LIMITATION AND ECONOMICS

The economic demands of the Athenian *oîkos* must also be
taken into account; there is a marked contrast between the
economic position of those Homeric families of whom we hear and
the Athenian families.  The Homeric families had an abundance
of provisions; they could afford to entertain handsomely and to
consume large quantities of meat (though it should be noted that
all feasts had some purpose except for those in the house of
Odysseus which by definition were mere wastage), and did not
have to consider where the next meal was coming from.  Many of
the citizens of democratic Athens of whom we hear had much less
margin between sufficient to eat and want.  The loss of a day's
pay is represented as a serious matter in comedy, since this
trifling sum was what the family depended upon for its supper.
The needs of the *oîkos* therefore prescribed strict limits to
the family's ability to choose its way of life.
In the first place economic considerations dictated the
size of the family parents could rear; there can be no doubt
whatever that the exposure of surplus children was practised

---

[2]Family, including property as well as human members.

[3]See Part 1, section A.

throughout antiquity, though too many discussions of this prac-
tice have failed to take into account the possibility that dif-
ferent strata in different societies in different eras may have
produced differences in practice.  In Athens, anything like an
accurate assessment of the extent to which exposure was gener-
ally practised can emerge only from a consideration of the
*oikoi*, and the contrasting demands for enough children to ensure
its continuance, and sufficiently few for the *oikos* to be able
to support them.

There can be little doubt that the first child of a mar-
riage (whichever its sex) was never exposed if it was healthy.
. . . Certainly, when children were more numerous than two, the
economic resources of the family must have been an important
factor in deciding whether or not to rear additional children.
Five children are not uncommon among the families who employed
the orators whose works have survived. . . .

It has been argued that girls were more likely to be ex-
posed than boys from evidence of two kinds, one by transference
from the Hellenistic period, when this seems to have been so,
the other by an argument from silence—that we hear only of the
sons born to famous Athenians—however, this latter argument is
worthless when we can quote the example of Cleomenes, of whom
Herodotus says:  "he died childless, leaving an only daughter
called Gorgo," and observe that in modern Greece a man habitu-
ally ignores his daughters when enumerating his children.  In
Classical Athens moreover, when family ties were still very
strong, it must have been on economic grounds that a decision
as to whether or not to rear a baby will have been made, and
here a girl might have had a stronger claim to be reared than
a boy, since she might be found a husband with only a small
portion, whereas a boy would be able to claim his full share in
the family *oikos*, a division the *oikos* might not be able to
stand.  The mother's feelings might also have been a little
relieved by the fact that an exposed boy might have more chance
of being acquired as a supposititious child, since a father who
longed for a son will have been more willingly hoodwinked than
others.

So much is speculative; the families whose estates are dis-
puted by the orators' clients give no hint of any preference
either way—nor, in fact, of exposure being practised at all.
In addition, if exposure was freely practised, it seems odd
that the disposal of her children in this way does not form part
of any of the women's tirades against men in the literary sources
such as those of Euripides' *Medea*, or Aristophanes' *Lysistrata*
and other female spokesmen.  It might indeed be the case that
very few healthy legitimate citizen-children were in fact ex-
posed, although there may have been some change in the climate
of opinion in the fourth century, as there certainly was in the
period after Alexander.

There were other means of limiting families; natural steril-
ity played a part, also sterility induced by ancient gynaecologi-
cal methods, and by abortion, which was also practised; surplus
children were probably also avoided by refraining from sexual
intercourse.  The evidence for this is of course indirect, but
it is consistent; Xenophon's declaration that men do not get
married for sexual satisfaction but to procreate children is
supported by the advice to marry at about the age of thirty, an
age at which the most peremptory sexual desires are over.
Writers also speak of the desirability of not having over-sexed
wives; if these writers were only the comic poets, such state-
ments could be ignored as wishful thinking, or mere jesting, but
they are not; Aristotle regards it as established, both in his
bioligical writings and in his *Politics*, that girls married too
young are sexually demanding.  It stands to reason that a wife
who demands frequent sexual satisfaction from her husband is
liable to become pregnant frequently; a wife who is prepared to
bear a small family and then allow her husband to expend his
surplus sexual appetite elsewhere does not encourage the pro-
creation of legitimate children who have to be exposed.
   These, however, must be regarded as the standards of the
dominant middle- and lower-middle-classes; the poor must have
both lost an even greater proportion of their babies from natural
causes and bad hygiene, and probably have resorted to exposure
more frequently; however, the largest number, and the highest
proportion, of exposed infants will have been those produced by
unions formed out of wedlock, the bastards of slave girls, cour-
tesans and prostitutes of all classes, though not even all of
these were necessarily exposed. . . .

## MARRIED WOMEN'S LIFE

In their rearing girls were treated less generously than
boys; Xenophon tells us that they were brought up on a sparse
diet, with very little protein (and we hardly need to add that
this meant next to no meat) and scarcely any wine, unless it was
well watered; this must surely have been dictated by the economic
needs of the family, from whose point of view it was more essen-
tial that the boys should be strong and able to maintain the
*oikos* when they grew up.  As married women too in such families
we find that borrowing, mortgaging and pledging property were
part of their (and their husband's) ordinary family life—for
this the evidence of comedy rings true.  Consequently, to be a
good manager, to be economical and thrifty, to prevent stealing,
to make the family independent in the production of clothes and
to have something in reserve were thought to be cardinal virtues
in a wife.  All these activities required her presence at home,
and in response to civic duty and the economic demands of their

family some Athenian women remained in their houses to such an
extent that it was even possible for unscrupulous orators to
pretend that they did not exist.  Among the law court speeches
which have survived there are two in which the orator brings
evidence to prove that a woman who had married and borne chil-
dren had actually existed; it is clear that the opposition had
cast doubts on her existence. . . .

   This is not to say that wives never went out; comedy may
complain that it is hard for a woman to get out of the house,
and it appears that they did not normally do the shopping but
we do hear of them going out for walks with their maids; they
carried spinning-baskets and had parasols; they went out to the
neighbours to borrow, and to get a light if their own had gone
out.  Elderly women also went to attend women in labour, but it
was at religious festivals that women were principally seen by
men, not only the state festivals for which they could dress up
in their best clothes, such as the great processions with their
maiden participants, but also the simpler rustic Dionysia, and
other family occasions such as marriages and funerals, although
in the latter case at least we know that women attending had to
be close relatives of the deceased or older women, over the age
of 60.  But the Athenians assumed that a woman's life would
mainly be spent at home, and in consequence often in no great
comfort, since town houses were small and probably dark, if we
may judge from that of Euphiletus.  The house of a trierarch in
the suburbs, however, was much more pleasant, having as it did
a courtyard garden in which the mistress of the house and her
children had meals and may have played games, the much richer
Xenophon, who lived in the country, had a spacious and comfort-
able villa.

   During the day a wife would see little of her husband
since he was normally away from home by day—Xenophon at least
regarded it as disgraceful for a man to remain in the house
during the day, and in this he seems not to have been exception-
al—and for company she was thus largely dependent on the slaves
of the household whose work she was responsible for supervising.
Often however she also had elderly relatives living in the
house, and the wife of one trierarch brought an old faithful
retainer, a freed-woman, to live with her while her husband was
on service, to act as housekeeper.

   A woman also had her children in their early years; not
even Plato wanted (in the *Laws*) to deprive the children of
their mothers, and both he and Aristotle wanted women to be
educated as being "half of the free population."  Moreover,
that the women's influence over the children did not end when
they went to school is illustrated by one of Xenophon's
vignettes, which provides a text for Socrates to give a strik-
ing tribute to motherhood:  Lamprocles, Socrates' son, com-
plained of how harsh his mother was to him; Socrates replied,

basing his argument in typically practical fashion ultimately
upon the obligation to return good to those from whom you have
received it; gratitude is due to a mother "who receives the
(her husband's) seed, and carries it within her, and is weighed
down with the burden of it, and risks her life for it, and gives
it a share of the food by which she herself is fed; and after
bringing it forth after much labour she feeds it and looks after
it, an act which is not in return for any good service, and no
more is the baby aware of the source of the benefits it receives,
or capable of indicating what it wants, but the mother herself
has in view what is appropriate and pleases her child, and tries
to satisfy its wants; and she feeds it for a long time, keeping
up her labours through the day and night without knowing what
gratitude she will receive in return." And when Lamprocles
declined to be convinced, Socrates pointed out that all her
scoldings were designed only for his good.

## THE BIRTH OF CHILDREN

The high value placed on children also made a fertile wife
much valued; the description of his relations with his wife
given by Euphiletus speaks volumes: "when I married, for a time
my behaviour was not to bear down on her, but not to leave it to
her too much to do just what she liked; I looked after her as
well as I could, and paid attention to her as was reasonable.
But when a child was born, I at once began to trust her entirely
and handed over to her all I possessed." Clearly he expected
the jury to accept as normal this change of attitude to his
wife on the birth of his son. No wonder that we hear of suppo-
sititious children being smuggled in by wives who were either
barren or miscarried, or whose children were still-born or died
soon after birth. . . .

## WORKING WOMEN

A typical virtue for this class is that of a husband who
can afford to keep his wife so that she does not have to go out
to work; this attitude was prevalent in Athens too, where poorer
women did go out to work. The tale of Aristarchus in Xenophon's
*Memorabilia* epitomizes this attitude; when his sisters, nieces,
and cousins took refuge with him in a crisis, it never occurred
to them that they might help or work, since they were brought up
"as befits free people." Since there were fourteen of them, the
economic drain on his resources was severe, and Aristarchus was
driven to desperation. Socrates reminded him of how profitable
men found it to have slaves working for them, and, arguing that
free men and women are better than slaves, told him to get his

relatives to work.  They all knew how to work wool, so they
worked morning and afternoon in return for their keep, and were
content.  This tale is as significant in illustrating the soli-
darity of the family, in that Aristarchus accepted all these
women-folk into his house, as it is for showing the women's
lack of independence in that they sought a male relative to
shelter them in the civil war situation prevailing in 404-3.
The story further contrasts other men's slaves who worked as a
matter of course, and the gentlefolk who did not think to work
until they were asked.  Xenophon moreover criticizes the Athen-
ians for making girls sit still all the time working wool, and
bids his young wife not to sit still at home herself all day,
but to take part in the housework and keep her youthful beauty
by getting some exercise, mixing flour, kneading dough, shak-
ing the blankets, and standing at the loom demonstrating, and
learning herself from other slaves who do something better
than she; it improves the appetite he says, and makes her more
attractive (than the slave girls) to her husband—a most
revealing sentence.

Poor women went out to work; citizen-women were engaged
mainly in retail trade, and seem to have had, if not a monopoly,
at least a privileged position in the market-place; the soldier's
widow plaited and sold garlands; the mother of Euxitheus (speak-
er of Demosthenes LVII) sold ribbons at one time, and worked as
a wet-nurse at another; Euxitheus stresses her poverty.  All
kinds of comestibles were sold by women, both retail and as
café or inn-keepers; these were generally less well thought of
than workers of wool, most of whom were thought to be poor but
honest.  One woman vase-painter is known but, as with the
market-women, we cannot be sure that she was a citizen.  It
used to be argued that trade was not possible for citizen-women,
since the limit of their contractual competence was the value of
one *medimnos* of barley; it has however now been shown that this
was not a paltry sum, but equivalent in value to more than a
poor petty-trader's stock-in-trade, and enough to provide food
for a family for several days.  In the country, obviously,
peasant women helped in the fields as they have done from
Hesiod's day to our own.

Non-citizens, both foreigners and slaves, worked as enter-
tainers such as flute-girls and courtesans, who provided the
female company at men's dinners and riotous parties, also as
kept women of various kinds, from regular concubines down to
prostitutes of the lowest sort.  The successful were able to
obtain their freedom, retire and keep brothels or schools to
train other courtesans, and we hear of one such who acted as a
go-between in business deals of men.  An impoverished freed-
woman, a widow, was taken in by her old master's family when her
husband died because the son whom she had nursed felt himself
obliged (or so he says) not to allow her to be in want; other

freed-women in the fourth century are attested by inscriptions; these consist mainly of wool workers, nurses and retailers, though there is surprisingly one cobbler among them.

## WOMEN'S INFLUENCE

Many wives doubtless were dominated by their husbands, many no doubt were neglected, and others were discontented with their lot; some reacted by taking to drink, some took lovers, some became scolds, as Socrates is said to have been nagged by his wife, though, to judge by the ages of their children, she must have been very much younger than he; old Euctemon's wife com- plained—perhaps not too unreasonably—of his behaviour in going off to stay with his children from Callippe and the old freed-woman ex-prostitute who looked after them.  Alcibiades' wife, we know, walked out on him because he brought courtesans to the house while she was at home; on the other hand we hear that Lysias was ashamed to bring an *hetaira*[4] to his own house because of his wife (who was also his niece) and his old mother who lived with him.  That Apollodorus, a married man, had bought the freedom of one *hetaira*, and procured the marriage of another is regarded as a prejudicial allegation, as is not to have mar- ried at all, but to have kept an *hetaira* in luxury.

Some wives, however, had a habit of getting their own way. Aristophanes portrays Strepsiades' high-born wife as having much influence on how her son should be named, and the decisive voice in his mode of education and upbringing; in the family of Macartatus, his mother's anxiety to have kinsmen to succeed in her deceased relatives' family prevailed over the family's attachment to the father's side; the Athenian law found it necessary to provide that the persuasion of a woman was a cause sufficient to invalidate a man's legal acts along with senility, drugs, disease or constraint.  Plato and Aristotle both thought that marriage was intended to promote happiness, and this is in truth also the picture of comedy despite occasional misogynistic remarks, and gross distortions for comic effect.  On the other hand husbands and wives did quarrel, as they do in every society. . . .

Married women also maintained social contacts with their neighbours; Euphiletus' wife said she went to borrow a light for the lamp at night from her neighbours; Aristophanes speaks of loans of garments, jewellery, money, drinking-cups—all

---

[4]Female companion; usually not an Athenian citizen and thus unable to marry an Athenian man; often better educated than Athenian wives and daughters.

without witnesses too; in the country we hear of the mothers of
a speaker and his opponent enjoying a common social life, visit-
ing each other and enjoying social relationships before their
sons quarrelled.  The fact that this was in the country may
account for the greater degree of social freedom enjoyed by the
women, or perhaps the fact that they were, obviously, women of
mature age.
     . . . We cannot say, but we can provide some evidence that
the women took an interest in public affairs.  "Some women do
not allow their husbands to give false evidence," says one
orator.  "Well then, surely your wives will be furious with you
when you go home and say you have acquitted Neaira," says
Apollodorus (in effect).  Such evidence can only mean that
women did talk to their husbands about public affairs, and take
an interest in them, as Aristophanes confirms.

## LEGAL FACTORS

     In law, too, the Athenian married woman had an economic
security not enjoyed even by the modern married woman; her
property was securely settled on her, and if she left her matri-
monial home, as she could do if she wanted, her husband had to
return her property or pay interest on it; if she did not leave
her home, her husband had to support her.  Granted, this was no
guarantee against her being made penniless if her husband lost
his all and died, but there was protection against the wayward
husband of the modern divorce-courts who could support his
family but refuses to do so.  Ancient Athens also tried (whether
consciously or not) to cope with the problem of loneliness; the
mother left to live on her own is an unknown phenomenon because
of the action for maintenance, and the spinster aunt almost
unknown, unless her father had met with financial ruin.  Women,
other than courtesans, did not live on their own.

## OLDER WOMEN

     As women grew older they became more independent, especial-
ly if they were widowed. . . .
     Still older women had more freedom of movement within the
city; their age protected them against assault, and the family
had lost interest in them as contributors of children to the
next generation, so that they moved freely, as midwives and
bearers of messages, and, when above the age of sixty, they
were allowed to take part in the funerals of persons not closely
related to them, perhaps as professional mourners.

## EMOTIONAL APPEALS

Orators could make emotional appeals through wives and mothers as well as through children, and defendants brought their wives as well as their children into court to excite pity. Demosthenes pleads with the jury:  "by your children, by your wives, by all the good things you possess." . . .

## WOMEN AS PART OF THE OIKOS AND POLIS

To sum up, we may say that the middle-class standards demanded by the democracy deprived the aristocratic families of the freedom of social intercourse they had enjoyed in Homeric society and other aristocratic societies like that of Sparta, and even in Athens before the day of Pericles.  Within this middle class, however, women were probably as well protected by the law as in any century before our own, and, granted a reasonable husband or father, enjoyed a life not much narrower and not much less interesting than women in comparable classes of society elsewhere.  Emancipated women nowadays, naturally have much more personal freedom but less protection against unscrupulous males.

It should also not be forgotten that in some fields Athenian men too had much less freedom in regard to their families than modern men; divorce and extra-marital love affairs were easier for the Athenians, but their choice of wife was limited to citizens' daughters, the law obliged them to support their parents, they could only with the greatest difficulty disinherit their sons, they might be obliged to marry a cousin or a niece or to endow her with an estate so that she might marry someone else, and it may be doubted whether even modern taxation, especially of the middle class, is as severe as that in Athens in times of crisis.  Athenian women as much as Athenian men were regarded as part of the city, so that they too were expected to subordinate their duty to themselves to their duty to the state and to the *oikos* to which at their marriage they would come, or had already come.  This duty comprised bearing the next generation of warriors and wives and mothers, and being their husband's partner in maintaining the economic power of the *oikos* and perpetuating its religious life.  Plato's *Republic* was not so vast an intellectual jump from the society in which he lived as it is sometimes thought to have been.

## D. THE WOMEN'S REVOLT AGAINST THE OPPIAN LAW (195 B.C.)

*The ancient Mediterranean world used sumptuary laws to force its citizens to economize in luxuries, especially in wartime. These laws, which could range over a wide spectrum of social customs, usually affected women more immediately than men. Sumptuary laws were much used by all types of government during the Middle Ages, and were still in evidence during the Reformation and in the Puritan colonies of America.*

*During the Punic Wars between Rome and Carthage, the tribune C. Oppius initiated a law forbidding Roman women to wear their jewels, purple or gold embroidery (symbols of rank and status), and to drive in carriages in the city. After the Roman defeat of the Carthagenian leader Hannibal in 202, Roman women became indignant that the Oppian law was still in force for them, whereas their husbands had not been similarly deprived. They marched on the Senate en masse in 195 B.C., hoping to persuade the senators to repeal the law. In the following excerpt from* Roman Women, *quotations from the Roman historian Livy reproduce Senate speeches showing the arguments against and for repeal of the Oppian law.*

*The modern sympathizer of women's emancipation might deplore the argument which the tribune L. Valerius put forward on behalf of the women of Rome almost as much as one might deplore Senator Cato's entrenched conservatism, which has come echoing down the centuries. For L. Valerius won the repeal of the Oppian law by saying in effect: "Give the women their baubles, these will satisfy their trivial minds and keep them from interfering in more serious matters." To be fair, it should also be pointed out that there seems to be no record of any similar instance in Roman history where women used a political device to promote some more worthwhile social project. This of course may be due to the fact that the activities of women have more often than not escaped the historians' notice.*

ROMAN WOMEN:   THEIR HISTORY AND HABITS

J.P.V.D. Balsdon

## MORAL DECLINE IN A POST-WAR PERIOD

From 200 B.C. onwards the history of current events was
being written by contemporary Roman historians; and though
their works have not survived, they were available to Livy and
other writers whose books we ourselves can read.  At last our
feet are—very nearly—on firm ground.

Among the historians who wrote towards the middle of the
second century B.C. and whose work has perished, was that self-
confident and boorish embodiment of austere moral rectitude,
the elder Cato.  It was his view, and the view of other Roman
historians too, that they lived in a period of increasing moral
decline.  Opinions differed only as to the moment at which the
rot set in.  Some traced its origins to the relief and relaxa-
tion which followed the defeat of Hannibal in 202 B.C., the
end of the anxious years of the second Punic war.  Others
thought the defeat of Macedon in the third Macedonian war at
the battle of Pydna in 168 to be the critical moment, since the
victorious armies on their return infected Roman Italy with a
taste for the art and civilized luxury of the Greek-speaking
world.  Others were to think that 146 was the vital date, for
then Carthage was utterly destroyed and Rome was left without a
rival in the Mediterranean world whose power she needed any
longer to fear.

The increasing emancipation and self-assertion of women
was symptomatic, and in 195 B.C. a tremendous issue was made in
the Senate of the repeal of the Oppian law.  Passed twenty years
earlier under the critical stress of war, it appeared to women
and to those who shared their views to have lost its *raison
d'être*.  Women even went as far as to behave like early twentieth-
century suffragettes—to demonstrate publicly in the streets at
the time of the debate.  This in itself was enough to persuade
the recalcitrant Cato, consul in this year, to believe that, as
a matter of principle, a firm stand should be made.  He was the
man who once said bitterly, "All men rule their wives, we rule
all men—and who rule us?  Our wives."  Livy gives the text of
the long and pompous speech which he made.

Cato's History (*Origines*) included the period of his own
career and in it he is known to have inserted the texts of his

_____

J. P. V. D. Balsdon, *Roman Women: Their History and Habits*
(New York:  John Day Co., 1963), pp. 32-37.  Reprinted by permis-
sion of David Higham Associates, Ltd.

own public speeches; so, as Cato's History was used by the his-
torians on whom Livy depended, and indeed read by Livy himself,
it might be hoped that in Livy we could read the speech which
Cato actually made in the Senate in 195; and scholars of repute
have argued that this is indeed the case. On the whole, how-
ever, the view prevails that this is not a genuine speech, but
is the invention either of Livy or of the historian (probably
Valerius Antias) on whom he depended. But if it is fiction, it
is good fiction, for the speech is one which, however deplorably,
Cato would have been happy to have composed. So, with a few
adaptations, would many an eminent Victorian.

"If every married man had been concerned to ensure that
his own wife looked up to him and respected his rightful posi-
tion as her husband, we should not have half this trouble with
women *en masse*. Instead, women have become so powerful that
our independence has been lost in our own homes and is now
being trampled and stamped underfoot in public. We have failed
to restrain them as individuals, and now they have combined to
reduce us to our present panic. . . . It made me blush to push
my way through a positive regiment of women a few minutes ago in
order to get here. My respect for the position and modesty of
them as individuals—a respect which I do not feel for them as
a mob—prevented my doing anything as consul which would suggest
the use of force. Otherwise I should have said to them, 'What
do you mean by rushing out in public in this unprecedented
fashion, blocking the streets and shouting out to men who are
not your husbands? Could you not have asked your questions at
home, and have asked them of your husbands? Or have you a
greater appeal in public than in your homes, a greater appeal
to other women's husbands than to your own?' And at home if
women were modest enough to restrict their interests to what
concerns them, they should properly be completely uninterested
in knowing what laws were being passed or rescinded in this
House. . . .

"Woman is a violent and uncontrolled animal, and it is no
good giving her the reins and expecting her not to kick over
the traces. No, you have got to keep the reins firmly in your
own hands; otherwise you will find that this present issue is
quite a minor one compared with the other restrictions, whether
of convention or of law, whose impositions women detest and
resent. What they want is complete freedom—or, not to mince
words, complete licence. If they carry this present issue by
storm, what will they not try next? Just consider the number
of regulations imposed in the past to restrain their licence and
to subject them to their husbands. Even with these in force,
you still can hardly control them. Suppose you allow them to
acquire or to extort one right after another, and in the end to
achieve complete equality with men, do you think that you will
find them bearable? Nonsense. Once they have achieved equality,

they will be your masters. . . .

"For some of their dissatisfactions I can see neither
rhyme nor reason.  It might perhaps seem natural for one woman
to feel ashamed or angry if she was denied some possession which
another woman was allowed; but now that the regulations about
dress apply universally, how can any one woman be frightened by
the thought of the finger of scorn being pointed at *her*?  Living
economically or being poor are the last things that anyone should
feel ashamed of; but, thanks to the law, you need not feel
ashamed on either account.  What you have not got, you are not
allowed by law to have.  This very equality, of course, is what
the rich woman resents.  Why, she asks, can she not be a woman
who attracts everybody's attention because of the gold and pur-
ple that she is wearing?  Why can other women who could not
afford such splendour shelter behind this law and create the im-
pression that that is how they would themselves be dressed, if
only it was legal? ✶I ask you, do you want to inaugurate a period
of dress-competition—rich women wanting clothes which nobody
else in the world can afford, poor women spending beyond their
means, because otherwise they would be looked down on?  Once you
start to feel ashamed without proper cause, you cease to feel
any shame at all when you should.  When a woman can afford some-
thing, she will buy it; when she can't, she will go to her hus-
band for the money.  Pity then the poor husband, whether he
capitulates to his wife, or whether he does not.  If *he* does not
find the money, some other man will. . . ." ✶

The speech made on the other side by the tribune L.
Valerius was no less spirited.

"While everybody else is to enjoy the recovery of our na-
tional prosperity, our wives alone, it seems, are to receive no
benefits from the restoration of peace-time conditions.  Men,
of course, will have purple on their togas if they are magis-
trates or priests; so will our sons; and so will the big-wigs
of the country towns and, here in Rome, even the district offi-
cials who, after all, are not the cream of society.  To that we
shall raise no objection at all—not in their lifetime merely,
but even to the extent of their being cremated in their purple
when they are dead. ✶But women, if you please, are to be for-
bidden to wear purple.  You, being a man, can have a purple
saddle-cloth; the lady who presides over your household will be
forbidden to wear a purple cloak; and so your horse will be bet-
ter turned out than your wife.✶

"Still, purple wears out and is perishable, and here I can
see some grounds, unfair though they are, for your obstinacy.
But what about gold?  You may have to pay a goldsmith for the
work he does, but gold itself never loses its value.  And both
for the private individual and for the state—as recent experi-
ence has shown—it is a useful form of capital.

"But—to take Cato's next point—in a state where nobody

possesses gold, no jealous rivalry exists between one woman and
another.  And what is the present state of affairs?  One in
which every single woman feels distressed and angry.  They look
at the wives of our Latin allies, and what do they see?  These
women are allowed the ornaments which Roman women are forbidden;
these women are a striking sight in their gold and purple;
these women drive through Rome, while *they* have to walk, as if
it was the Latin allies, not Rome, that ruled the Empire.  This
is an experience which men would find distressing enough.  What
of women, whom even trifles can upset?  Women cannot be magis-
trates or priests, celebrate triumphs or acquire decorations or
the gifts or spoils of war.  Elegance, jewellery and beauty-
culture—those are the distinctions that a woman prizes; those
constitute what an earlier generation called 'a woman's toilet.'
What is it that women leave off when they are in mourning?
Purple and gold.  And when they go out of mourning, these are
what they wear again.  How do they mark festivities and holi-
days?  By changing their dresses, and wearing their best clothes
for the occasion.

"I turn to Cato's next argument—that, if you repeal the
lex Oppia, you will never be free to impose a single one of
those restrictions which the law now imposes; and that you will
find that you no longer have the same control over your daugh-
ters, your wives and even your sisters.  To this I answer that,
as long as her menfolk are alive, a woman never seeks to escape
from her dependence.  The independence which they acquire if
they lose their parents or if they are left widows is a thing
from which they pray to be spared.  Where their personal appear-
ance is concerned, they would rather accept your dictation than
the law's.  And you on your part should not make slaves of your
women and be called their masters; you should hold them in your
care and protection and be spoken of as their fathers or as
their husbands."

For good or ill, the liberal view prevailed.  Valerius
Maximus, writing more than two centuries later at the time of
the emperor Tiberius, looked back on this as a black day in the
history of Rome:  "The end of the second Punic war . . . encour-
aged a looser way of living—when married women did not shrink
from blockading the tribunes M. and P. Junius Brutus in their
houses because they were prepared to veto the abrogation of the
Oppian law. . . . They succeeded, and the law which had been
continuously effective for twenty years was rescinded.  This
was because the men of the period had no conception of the ex-
travagance to which women's indomitable passion for novelty in
fashion would lead or of the extremes to which their brazen-
ness would go, once it had succeeded in trampling on the laws.
Had they been able to foresee the sort of fashions which would
appeal to women, hardly a day passing without the invention of
some further expensive novelty, they would have set their faces

firmly against the devastating spread of extravagance at the
moment of its introduction.  But why speak of women?  Lacking
strong mental powers and being denied the opportunity of more
serious interests, they are naturally driven to concentrate
their attention on creating more and more startling effects in
their appearance.  What of men? . . ."

# E. THE VESTAL VIRGINS AND ROMAN PRIESTESSES

*The ancient Romans gave a place of grave importance to
women in the religious life of the state.  In contrast parti-
cularly to the Hebrews, where women had no part in the reli-
gion, Roman women actively participated in a variety of
religious rites and ceremonies both in public and in their
homes.  Womanhood as the symbol of piety and purity, the moral
base of most periods of later Western society, might be said
to have its origins in ancient Roman attitudes to the sacred
role of women.  Vesta, the Roman goddess of fire, was served by
six priestesses known as the vestal virgins, whose main duty
was to keep a sacred flame continually alight.  If the flame
were extinguished, immediate calamity was thought to threaten
the state.  The vestal virgins were a peculiar and interesting
example of the part played by women in the religious life of
ancient Rome.  Their duties and status in society were excep-
tional.  They were few in number but their importance in the
national religious life was very great.  In the following pas-
sage, Balsdon describes the position of the vestal virgins and
some special priestesses as the "emblem of the state's moral-
ity" and an insurance against disaster.*

## HOLY WOMEN

## J.P.V.D. Balsdon

The Vestal Virgins exercise their powerful fascination
still on historians and novelists alike.  To invent a parallel,
you would have to imagine that in the whole of modern Italy

J. P. V. D. Balsdon, *Roman Women:  Their History and Habits*
(New York:  John Day Co., 1963), pp. 235-43.  Reprinted by per-
mission of David Higham Associates, Ltd.

there was only one body of Nuns, and that there were a mere six
members of that body.  And you would have to imagine them as
performing their holy duties under the careful watch of the
government in Rome.

At the south-east of the ancient Roman forum there were
Precincts.  There, in close contiguity, were the Regia, the
Chapter-House of the Pontifex Maximus and the College of Pon-
tiffs; the official residences (*domus publicae*) of the Pontifex
Maximus and the Flamen Dialis; the Temple of Vesta (a partial
restoration of which still stands), whose fire the Vestal Vir-
gins tended; and the House of the Vestals, the Atrium Vestae,
where today the tourist dawdles to watch the goldfish and where,
in antiquity, the Vestal Virgins lived.  The official residence
of the Rex Sacrorum was a little distance away.

The activities of all these functionaries represented, in
commission, the religious functions of the primitive royal
house.  The Vestal Virgins either, in the person of the Chief
Virgin, the Virgo Vestalis Maxima, represented, for religious
purposes, the wife of the primitive King (himself now partly
transmogrified into a Pontifex Maximus) or, as a College, they
represented the daughters of the original royal house; the
issue is one on which scholars disagree.  There is no disagree-
ment, however, about their activities; they drew water, they
had the heavy responsibility of ensuring that the sacred fire
in the temple of Vesta never went out, and their presence was
necessary at a number of the most deeply-rooted religious cere-
monies of the State.  "In all the public duties performed by
them a reference can be traced to one leading idea—that the
food and nourishment of the State, of which the sacred fire was
the symbol, depended for its maintenance on the accurate per-
formance of their duties."  It also depended, of course, on
their remaining virgins without spot or blemish.

The election of a Vestal Virgin was not an everyday affair;
it happened no more frequently on an average than once in every
five years.  Twenty candidates—girls between six and ten years
old, both of whose parents must be living—were selected by the
Pontifex Maximus, and from these one was chosen by lot.  Under
the Republic daughters of the noblest families alone were eli-
gible, at first only patricians.  There was no dearth of candi-
dates in the early and middle republic; but times changed, and
Augustus lowered the social qualification greatly when in A.D. 5
he was forced to admit the daughters of freedmen as candidates.

At the dramatic moment when the lot had made its choice,
the child was "taken" by the Pontifex Maximus who addressed her
as "Amata" and pronounced the traditional formula for admission
to the Order.  Immediately she passed out of her father's con-
trol (*patria potestas*), and indeed right out of her family;
after this she would not count as one of the next of kin if
even her closest blood-relative died intestate; nor, if she

herself died intestate, did her property pass to her blood-
relations.  It went, instead, to the State.  But she could make
a will, for she acquired legal independence on becoming a Vestal
Virgin; and, indeed she became from the start a young woman of
property.  For she was given money—the equivalent perhaps of a
dowry—at the start.  By the time of the early Empire this sum,
voted by the Senate, might be as large as two million sesterces,
twice the amount of a rich girl's normal dowry; and there was
even a case where an unsuccessful candidate was given a million
sesterces.  If candidates no longer came forward willingly, it
was necessary to attract them by bribes.  This is a not unfam-
iliar principle of public economy.

So, with little understanding of the trials and temptations
which lay ahead, the child was committed to thirty years of vir-
ginity.  When she was forty, or a year or two younger, she would
be free to leave the Atrium and live a normal life—even, if she
could find a husband, to marry.  It is not surprising that, when
the time came, many preferred to continue—as they were allowed,
if they wished, to continue—their unnatural life, and perhaps
win, for chill reward, a place in the history books; like Occia,
who started as a novice in 38 B.C. and died, after fifty-seven
years of service, in A.D. 19, or Junia Torquata who was a
Vestal Virgin for sixty-four years.  Those who returned to the
world rarely married; there was a superstition that such mar-
riages were never happy.

The child, aged six to ten, entered the diminutive feminine
community; of her five colleagues, the senior might be in their
late thirties, or indeed, a great deal older than that.  For
thirty years, if her health remained good, the Atrium was to be
her home, which she could leave only in the service of the State;
and for at least eight hours out of every twenty-four she had,
with one of her fellows, the terrifying responsibility of keep-
ing the sacred fire alight.  Within the College, the "Three
Seniors" had certain privileges, and the Senior Vestal Virgin of
all, the Virgo Vestalis Maxima, enjoyed undisputed power and
prestige.

They were all of them, in the last resort, under the con-
trol of the College of Pontiffs, whose president was the Ponti-
fex Maximus.  If one of the Virgins fell sick and had to be sent
out of the Atrium for nursing, the Pontiffs met to approve the
household—one under the presidency of a respectable matron—to
which she should be sent.  And if grave charges were brought
against them, the Pontiffs, under the Pontifex Maximus, were
their judges.

There was, through the year, a succession of religious fes-
tivals which the Vestal Virgins attended officially, and there
were many vital religious functions, all concerned with the
earth and the fundamentals of living, which they alone could
perform.  On May 14th or 15th they threw straw figures into the

Tiber from the *pons sublicius*, the oldest bridge in Rome, and
for the novices this must have been the best occasion of the
year.   Their storehouse (*penus*) was, symbolically, the store-
house of the State, and was open to inspection from June 7th
until June 14th.   From October 15th a jar in the penus contained
the blood which flowed from the head of the slaughtered "October
horse"; on April 15th it acquired the ashes of the calves which
were torn by attendants of the Chief Virgin from the corpses of
the thirty-one cows slaughtered in calf on the festival of
Fordicidia and then cremated.   The ashes and blood were mixed,
and poured on to burning straw, over which people jumped at the
Parilia on April 21st.   Between May 7th and 14th the three
seniors collected ears of spelt on alternate days, roasted them
and, from their flour, salted cakes—*mola salsa*—were made for
consumption at the Vestalia (on June 9th), on the ceremonies of
September 13th and at the Lupercalia on February 15th.

     To compensate for these often, no doubt, monotonous opera-
tions, the Vestal Virgins enjoyed dignified and pleasing privi-
leges.   There were dinner parties, for one thing.   We have an
account of a banquet at which on August 24th, 69 B.C., four
Vestal Virgins were present—the four seniors, it may be assumed,
while the two juniors, like a pair of Cinderellas, stayed at
home to look after the fire.   The dinner celebrated the instal-
lation by an augur of a new Flamen Martialis.   The pontiffs
occupied two tables, the ladies (who included the wife of the
new Flamen and his mother-in-law) occupied a third.   The menu is
preserved too; and by comparison the banquet of the most apolaus-
tic of City Companies would appear to be a frugal meal.   Its
thirty dishes included asparagus, oysters (as many as anyone
could eat) and delicious *pâtés* of all kinds.

     Vestal Virgins travelled through the streets of Rome in
carriages at public festivals.   They were attended in public by
a lictor.   When they gave evidence in court, they were exempted,
together with the Flamen Dialis, from the necessity of taking an
oath.   They could annul the death sentence of a prisoner whom
they encountered, as long as it was by accident, on his way to
execution.   And under Augustus and his successors they not only
attended the theatre, but sat there in privileged seats, where
they were joined by the ladies of the imperial house.   And when
the greatest of these imperial ladies, the widow of Augustus,
was consecrated, they were made responsible for her cult.

     Their public importance, especially at moments of crisis,
was indisputable.   It was through the senior Vestal Virgin that
the Empress Messalina in her last desperation sought to influ-
ence Claudius.   And when in A.D. 69 Vitellius hoped to arrest
for a moment the march of the victorious Flavian army on Rome,
the Vestal Virgins carried his letter to the Flavian commander.
Their sacrosanctity gave the security of a strong room; and so
they guarded important documents, the wills of leading states-

men, for instance, and even the wills of emperors, who were
themselves High Priests.

What of their relation with men—who, as a sex, were
allowed to enter the Atrium by day, but never by night?

✗The purity of the Vestal Virgins was the token and guaran-
tee of the good health and salvation of Rome itself; how often,
knowing this, they must have prayed to Vesta that they might
not succumb to temptation.✗ There were many forms in which the
temptation might come. There were times when, with the highest
standards of integrity prevailing in the College, a girl,
through no fault of her own, fell violently in love. There
were undoubtedly periods of persistent religious and moral lax-
ity when the whole College was corrupt, and from early days the
novice was exhorted not to be a prig, but to follow the example
of the rest; it was perfectly safe, she would be told. Safe,
indeed, if there was not a national calamity or some political
ferment in which politicians would expose the scandals of the
Vestal Virgins if by this means they could win political kudos
for themselves.

The disaster of Cannae in 216 B.C. was such a national
calamity. Inevitably it was suggested that the battle was lost
not on the field but in Rome; that there was a rottenness at
the core. So, guilty or not, two Vestal Virgins were denounced
and declared guilty. Corruption of the whole College was
alleged at the end of the second century B.C., and in 114 the
Pontiffs held an inquiry and condemned one of the Vestal Vir-
gins; in the following year, on the motion of the tribune
Peducaeus, who accused the Pontiffs of partiality, a secular
court was set up to hold a re-trial, and two of the Vestal
Virgins who had been acquitted a year earlier were condemned.
Domitian, too, in his acts of A.D. 83 and 90 claimed that the
College was a sink of corruption which his father and brother
had neglected to reform.

There were times when even innocence had cause for fear.
Immorality was sometimes suspected for no better reason than
that the sacred fire went out or that a Vestal Virgin's dress
and manners were thought to be a little on the gay side; at
other times innocent Vestal Virgins might find themselves the
victims of scheming politicians. The Roman history books con-
tained splendid, if improbable, stories of charges which were
made in the remote past and proved false. A certain Aemilia,
whose morals were suspect because she let the fire go out,
prayed to Vesta, and threw a piece of linen on the stone-cold
embers. The sudden miraculous blaze which followed placed her
innocence beyond the reach of doubt. And there was another,
Tuccia, who, in a similar predicament, proved her innocence by
carrying from the Tiber a sieveful of water from which not a
drop leaked. . . .

When the Pontiffs accepted a charge, usually based on

information provided by a slave, the suspected Vestal Virgin was suspended from her duties and forbidden to part with any of her slaves—for "incest," the charge brought against her, and high treason, were the only cases in which the evidence of slaves could be taken under torture against their employers. She was then tried before the Pontiffs.

Whereas if a Vestal Virgin was found to have let the sacred fire go out, she suffered nothing worse than a thrashing by the Pontifex Maximus, if she was found guilty of sexual immorality, the partner in her guilt was flogged to death—like a slave, *sub furca*—in the Comitium and she was immured alive in an underground chamber under the Campus Sceleratus by the Colline Cate. If, by contrast, a *bona fide* secular virgin was doomed to death by strangulation—like the young daughter of Sejanus, who was supposedly implicated in her father's scheming in A.D. 31—she was debauched by her executioner when the rope was already around her neck, because it was inauspicious to execute a virgin.

Plutarch gives this grim description of the erring Vestal Virgin's doom.

> A small underground chamber is constructed with access from above by a ladder. It contains a bed, a lighted lamp and small portions of the bare necessities of existence—bread, water in a jar, milk and oil; so that the Romans may feel easy in their consciences and nobody can say that by starvation they have murdered a woman consecrated by the most sacred ritual.
>
> Inside a litter enclosed by curtains, bound and gagged so that her voice may not be heard, they carry the victim through the Forum. People make way without a word, and escort the procession in utter silence and deep dejection. There is no spectacle in the world more terrifying and in Rome no day of comparable horror.
>
> When the cortège reaches the end of its journey, the attendants undo the bonds and, after he has prayed in silence, stretching out his hands to the gods to explain the necessity of his act, the Pontifex Maximus takes her by the hand, a thick cloak hiding her face, and sets her on the ladder. He and the rest of the Pontiffs turn away while she descends the ladder. Then the ladder is pulled up and the entry to the chamber closed and covered with deep earth level with the surrounding ground.

This was not, obviously, an everyday happening in Rome. Indeed, there are less than ten occasions in the whole of Roman

history when this punishment is known to have been exacted.
. . .
    Just as the halls of women's Colleges in Oxford and in
Cambridge have, hanging on their walls, the portraits of former
Principals, so round the Atrium Vestae stood portrait statues
of Senior Vestal Virgins on inscribed pedestals, many of which
survive in Rome today.
    While the Pontifex Maximus was free, within the normal
rules of social decorum, to marry whomever he wished and how-
ever he wished (a fact which shows that, in remote antiquity,
he was something of an upstart), the Priests of Juppiter, Mars
and Quirinus must have for their wives women whose parents had
been married by the elaborate formality of *confarreatio*, and
must have married in accordance with the same formalities.
Even so, the wives of the Flamen Quirinalis and of the Flamen
Martialis themselves exercised no priestly functions.
    The wife of the Rex Sacrorum (the Regina Sacrorum) and the
wife of the Flamen Dialis (the Flaminica), on the other hand,
were priestesses—the latter Priestess of Juno—and, as such,
had to observe rigorous formalities in their dress and were
subject to a number of engaging tabus.  The Flaminica Dialis
might not climb more than three rungs of a ladder, unless it
was a "Greek ladder" (whatever that was); she might not bathe
in May or comb her hair in the first half of June or on those
days in March when the Priests of Mars (Salii) were dancing;
she might not cut her nails in the first half of June either.
So vital was she to her husband's exercise of his office that,
to hold the priesthood, he had to be a married man; he was not
allowed to divorce his wife; and he was compelled to resign his
priesthood if his wife died.
    Under the Empire the spread of emperor-worship brought
into existence a number of priestesses in the provinces,
charged with the cult of the women of the imperial family who
had been consecrated.
    In Rome itself, in Republic and Empire alike, there were
times when the incidence of public calamity or reported prodi-
gies of quite abnormal horror drove the government to inquire
from the appropriate priests what propitiatory offerings should
be made.  When the priests in their wisdom discovered that Juno
in particular was the goddess who required propitiation, a call
was made sometimes on "thrice nine" unmarried girls ("virgines"),
sometimes on married women ("matronae").  In 207 B.C. twenty-
seven virgins, clad in long gowns, sang in Juno's honour a song
which to later taste seemed barbarously uncouth, beating out
the time with their feet.  Twenty-seven girls were pressed into
service for a similar purpose seven years later.  After the
great fire in Rome in A.D. 64 married women were required to
perform a number of propitiatory acts.

## F. THE EMANCIPATION OF THE ROMAN MATRON

*It is almost inevitable that Roman women of ancient times are compared with those of Greece, and the comparison always points up the greater freedom of the Roman matron. Her "religious" function as a "materfamilias" and her participation in her husband's social life was certainly more positive than that of an Athenian citizen-woman of the Golden Age. However, the "higher" level of education of Roman women by the second century B.C. must be compared with the education of Athenian women of the same period—and it is known that from the middle of the fourth century B.C. (that is, the period after the Golden Age), Athenian girls went to school with their brothers. The Roman Cornelia of the second century B.C., who as the mother of the famous Gracchi is one of history's early examples of an educated woman, may well have had an unsung counterpart in Greece.*

*In considering the lives of women in ancient Rome it is also important to remember that the phrase "ancient Rome" covers a period of approximately twelve hundred years (770 B.C.- A.D. 476). The laws and customs of the ancient Romans changed and developed continuously, as one would expect over such a long period and throughout succeeding political regimes. The selections from Carcopino's* Daily Life in Ancient Rome *mostly describe the position of women at the height of the empire (A.D. 50-150).*

*The author summarizes the laws of inheritance and the legal or binding agreements that constituted the different forms of marriage. He points out that the severe rules by which patriarchy had functioned in the early Roman periods (of monarchy and republic) gradually declined. Carcopino describes the different ways in which women exhibited their new independence, contrasting the "wifely" strength of some with the demoralization and intrigues of others. He points out with some disapproval that many women of Imperial Rome neglected their primary nurturing role and even began to adopt some of the attitudes previously reserved by men for themselves. Divorce, no longer merely a husband's tool, was now granted with ease and was also available to the Roman matron to free herself of an undesirable spouse. The author further sketches the intimate routine of daily life and lack of occupation of the women of the upper strata of society.*

*Carcopino declares that the women at the height of the Roman Empire enjoyed an independence equal to if not superior to that claimed by contemporary (French, 1940) feminists. Simone de Beauvoir, who published her* Second Sex *still pleading for the independence of women in 1948, considered that the Roman woman of the period under discussion "was emancipated only in a negative way, since she was offered no concrete*

*employment of her powers.    [For these women] economic freedom remained abstract, since it produced no political power."*

## DAILY LIFE IN ANCIENT ROME

Jerome Carcopino

## THE WEAKENING OF PATERNAL AUTHORITY

In the second century of our era the ancient law of the *gens* had fallen into disuse, and nothing but the memory—the "archaeological memory" one might almost say—remained of the principles on which the patriarchal family of ancient Rome had been based:   relationship through the male line and the un-limited power of the *pater familias*.

Whereas in former days the only recognised relationship was that created by male descent, relationship was now recognized through the female line and extended beyond legitimate marriage.

This is clearly illustrated by the laws governing inherit-ance.   According to the ancient code of the Twelve Tables, a mother had no right of succession to a son who had died intes-tate.   Under Hadrian, the *senatus consultum Tertullianum* admitted her as a legitimate heir on the condition that she possessed the *ius liberorum*, which rested on her having had three children (four, if she was a freedwoman).   Then, by the *senatus consultum Orphitianum* passed under Marcus Aurelius, children were entitled to inherit from their mother, whatever the validity of the union from which they sprang, and to take precedence of other relatives in this matter.

This completed the development which had undermined the ancient system of civil inheritance, wrecking the fundamental conception of the Roman family and recognising instead the claims of "blood" in the sense in which our modern societies have accepted them.   The Roman family is henceforth based on the *coniunctio sanguinis*, because, according to the lofty con-ception of Cicero in the *De Officiis*, this natural tie was the

Jerome Carcopino, *Daily Life in Ancient Rome*, trans. from the French by E. O. Lorimer (New Haven, Conn.:   Yale University Press, 1940), pp. 76-100, 166-70, 180-83.   Copyright © 1940 by Yale University Press.   Reprinted by permission of Yale Univer-sity Press.

Parenthetical Latin terms have been omitted from these excerpts for easier reading.

best qualified to find human beings in affection and mutual goodwill. . . .

During the same period the two essential weapons of the *patria potestas* were gradually blunted: the father's absolute authority over his children, and the husband's absolute authority over the wife placed "in his hands" (*in manum*) as if she were one of his daughters. By the second century of our era they had disappeared completely. The *pater familias* had been deprived of the right of life or death over his children which had been granted him by the Twelve Tables and the sacred, so-called Royal Laws. But until the beginning of the third century, when abandoning a child was considered the equivalent of murder, he might expose his new-born child to perish of cold and hunger or be devoured by dogs on one of the public refuse dumps, unless it was rescued by the pity of some passer-by. No doubt a poor man still had recourse as readily as heretofore to this haphazard form of legal infanticide, despite the isolated protests of Stoic preachers like Musonius Rufus. We may assume that he continued remorselessly to expose his bastards and his infant daughters, since the records of Trajan's reign show the entries for public assistance given to young children for the same city and the same year as 179 legitimate children (145 boys and 34 girls) and only two bastards, a boy and a girl. These discrepancies can best be explained by assuming that a large proportion of bastards and girl babies were victims of "exposure." . . .

## BETROTHAL AND MARRIAGE

While the *patria potestas* of the father over his children grew progressively weaker, it also ceased to arm the husband against his wife. In the old days, three separate forms of marriage had placed the wife under her husband's *manus*: the *confarreatio*, or solemn offering by the couple of a cake of spelt in the presence of the Pontifex Maximus and the priest of the supreme god, the *Flamen Dialis*; the *coemptio*, the fictitious sale whereby the plebeian father "mancipated" his daughter to her husband; and finally the *usus*, whereby uninterrupted cohabitation for a year produced the same legal result between a plebeian man and a patrician woman. It appears certain that none of these three forms had survived till the second century A.D. The *usus* had been the first to be given up, and it is probable that Augustus had formally abolished it by law. *Confarreatio* and *coemptio* were certainly practiced in the second century A.D., but seem to have been rather uncommon. Their place had been taken by a marriage which both in spirit and in external form singularly resembles our own, and from which we may be permitted to assume that our own is derived.

This more modern form of marriage was preceded by a be-
trothal, which, however, carried no actual obligations.
Betrothals were so common in the Rome of our epoch that Pliny
the Younger reckons them among the thousand-and-one trifles
which uselessly encumbered the days of his contemporaries.  It
consisted of a reciprocal engagement entered into by the young
couple with the consent of their fathers and in the presence of
a certain number of relatives and friends, some of whom acted
as witnesses, while the rest were content to make merry at the
banquet which concluded the festivities.  The concrete symbol
of the betrothal was the gift to the girl from her *fiancé* of a
number of presents, more or less costly, and a ring which was
probably a survival of the *arra* or earnest money, a preliminary
of the ancient *coemptio*.  Whether the ring consisted of a circle
of iron set in gold or a circle of gold, the girl immediately
slipped it, in the presence of the guests, onto that finger on
which the wedding ring is still normally worn.  The French
speak of *le doigt annulaire* (*anularius*) with no recollection of
the reason why this finger was originally chosen by the Romans.
Aulus Gellius has laboriously explained it:

> When the human body is cut open as the Egyptians
> do and when dissections, or ἀνατομαί as the Greeks
> phrase it, are practised on it, a very delicate nerve
> is found which starts from the annular finger and
> travels to the heart.  It is, therefore, thought seem-
> ly to give to this finger in preference to all others
> the honour of the ring, on account of the close con-
> nection which links it with the principal organ.

. . . Except for the bleeding sacrifice and the flaming
splendour of the bridal veil, might we not well imagine that
[the] Roman ceremonial has survived till our own day, and that
with trifling modifications it has formed the model for our
modern weddings?  As Monseigneur Duchesne recently remarked,
with an insight all the more striking for being rare: "Except
for the taking of the auspices, Christian ritual has preserved
entire the Roman nuptial rite.  Everything is there down to the
bridal wreaths. . . . The Church is essentially conservative
and in this type of ceremony has modified only such details as
are incompatible with her teaching." . . .
The ancient Roman—whom Gaius already speaks of as a van-
ished type—condemned woman, in view of her natural frailty, to
live in perpetual tutelage.  By the marriage *cum manu* she
escaped the *manus* of her father and his male relations only to
fall into the *manus* of her husband.  The marriage *sine manu*
made her the ward of a so-called "legitimate guardian" who had
to be chosen from among her male relations if the direct male
line of her progenitors had died out. When, however, the marriage

*sine manu* had completely supplanted the *cum manu* marriage, the
"legitimate guardianship" which had been its inseparable accom-
paniment began to lose its importance.  By the end of the
republic, a ward who chose to complain of the absence of her
guardian—however short that absence might have been—was able
to get another appointed for her by the praetor.  When, at the
beginning of the empire, the marital laws which are associated
with the name of Augustus were passed, the "legitimate guard-
ians" were sacrificed to the emperor's desire to facilitate
prolific marriages, and mothers of three children were exempted
from guardianship.  In Hadrian's day a married woman did not
need a guardian even to draft her will, and a father no more
dreamed of forcing his daughter to marry against her will than
of opposing a marriage on which she had set her heart, for, as
the great jurist Salvius Iulianus maintained, a marriage could
not be made by constraint, but only by consent of the parties
thereto, and the free consent of the girl was indispensable.
. . .

## THE ROMAN MATRON

It can be understood that this new definition of marriage
revolutionised its nature.  There are certain causes which in-
evitably entail certain consequences.  In our own days we have
seen the French legislator first minimise and finally abolish
all obstacles to the triumphant wishes of a marrying couple.
All remnants of parental authority disappeared with the parents'
right to oppose a match desired by their children.  The same
phenomenon occurred in the Roman empire.  Having shaken off the
authority of her husband by adopting the marriage *sine manu*,
the Roman matron was freed from the leading strings of guardian-
ship by the free choice the times allowed her in contracting a
union.  She entered her husband's home of her own free will and
lived in it as his equal.
Contrary to general opinion—which colours the conditions
existing under the empire with memories of the early days of
the republic and of long-lapsed republican customs—it is cer-
tain that the Roman woman of the epoch we are studying enjoyed
a dignity and an independence at least equal if not superior to
those claimed by contemporary feminists.  More than one ancient
champion of feminism under the Flavians, Musonius Rufus for one,
had claimed for women this dignity and independence on the
ground of the moral and intellectual equality of the two sexes.
The close of the first century and the beginning of the second
include many women of strong character, who command our admira-
tion.  Empresses succeeded each other on the throne who were
not unworthy to bear at their husband's side the proud title of
Augusta which was granted to Livia only after her husband's

death.  Plotina accompanied Trajan through the Parthian wars and shared alike his glories and responsibilities.  When the *optimus princeps* lay at death's door, having only in secret appointed Hadrian to succeed him, it was Plotina who interpreted and reinforced his last wishes; and it was she who ensured that Hadrian enter in peace and without disturbance on the sovereign succession of the dead emperor.  Sabina's character remains untouched by the ill-natured gossip of the *Historia Augusta*, which is refuted by a mass of inscriptions commemorating her kindnesses, and by the numerous statues which deified her even in her lifetime.  Hadrian, who is wrongly supposed to have been on bad terms with her, carefully surrounded her with so much deference and gracious consideration that the *ab epistolis* Suetonius forfeited overnight his "Ministry of the Pen" for having scanted the respect due to her.  The great ladies of the aristocracy in their turn were proud to recall as immortal models the heroines of past evil reigns who, having been the trusted confidantes of their husbands, sharing their commands and their politics, refused to be parted from them in the hour of danger and chose to perish with them rather than leave them to fall uncomforted under the tyrant's blow.

Under Tiberius, Sextia would not survive Aemilius Scaurus, nor Paxaea her Pomponius Labeo.  When Nero sent Seneca the fatal command, the philosopher's young wife Paulina opened her veins together with her husband; that she did not die of haemorrhage like him was solely because Nero heard of her attempt to commit suicide and sent an order to save her life at any cost; she was compelled to let them bandage her wrists and close the wounds. The record which the *Annales* have preserved for us of this moving scene, the portrait they paint of the sad and bloodless face of the young widow who bore to her dying day the marks of the tragedy, express the deep emotion which the memory of this drama of conjugal love still inspired in the Romans of Trajan's day after the lapse of half a century.  Tacitus felt the same admiration for the loyalty of Paulina that his friend Pliny the Younger felt for the courage of the elder Arria, to whom he does homage in the most beautiful of his letters.

I must be pardoned for once more borrowing at length from Pliny's celebrated pages.  Arria the Elder had married the senator Caecina Paetus.  In tragic circumstances she showed of what stoic devotion her love was capable.  Both Paetus and his son were ill, and it was believed that there was no hope for either.  The young man died.  He was endowed with rare beauty and with a moral purity rarer still, and his parents loved him even more for his qualities than because he was their son. Arria prepared her son's obsequies and herself arranged the funeral so that her sick husband should be spared the knowledge of it.  Returning to Paetus' room she acted as if the boy were living still and were better, and when the father asked news of

him again and yet again "she would answer that he had rested
well or had eaten with appetite." Then feeling the pent-up
tears coming in spite of her, she slipped away and gave herself
to her sorrow. When she had cried her fill she dried her eyes,
repaired the ravages to her face, and came in again to her hus-
band, as though leaving every pang of bereavement on the thresh-
old. By this superhuman effort of self-control Arria saved her
husband's life.

But she could not save him from the imperial vengeance
when in 42 A.D. he was implicated in the revolt of Scribonianus,
and was arrested before her eyes in Illyricum where she had
accompanied him. She begged the soldiers to take her too. "You
cannot do less than let a consul have slaves to serve him at
table, to dress him, and to put on his shoes. All this I will
do for him myself." When her prayers proved vain she hired a
fishing boat and in this frail craft followed the ship on which
they carried Paetus. It was useless. At Rome Claudius proved
adamant. Arria announced that she would die with her husband.
At first her son-in-law Thrasea sought to dissuade her. "What,"
he said, "should you agree, if I were one day to die, that your
daughter should perish with me?" Arria would not allow her
stern resolution to be weakened. "If my daughter in her turn
had lived as long with you and in the same happiness as I with
Paetus, I should consent," she said. To cut the argument short
she flung herself headlong against the wall and fell unconscious
to the ground. When she came to herself she said: "I warned
you that I should find some road to death, however difficult, if
you refused to let me find an easy one." When the fatal hour at
last arrived she drew a dagger from her robe and plunged it in
her breast. Then, pulling the weapon out again, she handed it
to her husband with the immortal words: "It does not hurt,
Paetus."

I have dwelt on these famous episodes because they show in
a certain type of woman of Imperial Rome one of the fairest ex-
amples of human greatness. Thanks to such women, proud and free
as Arria, ancient Rome, in the very years when she was about to
receive the bloody baptism of the first Christian martyrs,
scaled one of the loftiest moral heights humanity has conquered.
Not only had their memory become a veritable cult in the second
century of our era, but their example still from time to time
found imitators. It is true that the justice of the emperors
now spared matrons the sacrifices which the wrath of Claudius
and the ferocity of Nero had inflicted on them; but the cruelty
of daily life still left all too many opportunities for at least
the aristocrats to prove that Roman woman had not degenerated.
. . .

## FEMINISM AND DEMORALISATION

Alongside the heroines of the imperial aristocracy, the irreproachable wives and excellent mothers who were still found within its ranks, it is easy to cite "emancipated," or rather "unbridled," wives, who were the various product of the new conditions of Roman marriage.  Some evaded the duties of maternity for fear of losing their good looks; some took a pride in being behind their husbands in no sphere of activity, and vied with them in tests of strength which their sex would have seemed to forbid; some were not content to live their lives by their husband's side, but carried on another life without him at the price of betrayals and surrenders for which they did not even trouble to blush.

Whether because of voluntary birth control, or because of the impoverishment of the stock, many Roman marriages at the end of the first and the beginning of the second century were childless.  The example of childlessness began at the top.  The bachelor emperor Nerva, chosen perhaps for his very celibacy, was succeeded by Trajan and then by Hadrian, both of whom were married but had no legitimate issue.  In spite of three successive marriages, a consul like Pliny the Younger produced no heir, and his fortune was divided at his death between pious foundations and his servants.  The *petite bourgeoisie* was doubtless equally unprolific.  It has certainly left epitaphs by the thousand where the deceased is mourned by his freedmen without mention of children.  Martial seriously holds Claudia Rufina up to the admiration of his readers because she had three children; and we may consider as an exceptional case the matron of his acquaintance who had presented her husband with five sons and five daughters.

If the Roman women showed reluctance to perform their maternal functions, they devoted themselves on the other hand, with a zeal that smacked of defiance, to all sorts of pursuits which in the days of the republic men had jealously reserved for themselves.  In his sixth satire Juvenal sketches for the amusement of his readers a series of portraits, not entirely caricatures, which show women quitting their embroidery, their reading, their song, and their lyre, to put their enthusiasm into an attempt to rival men, if not to outclass them in every sphere.  There are some who plunge passionately into the study of legal suits or current politics, eager for news of the entire world, greedy for the gossip of the town and for the intrigues of the court, well-informed about the latest happening in Thrace or China, weighing the gravity of the dangers threatening the king of Armenia or of Parthia; with noisy effrontery they expound their theories and their plans to generals clad in field uniform while their husbands silently look on.  There are others who seek literary fame in preference to

the conspiracies of diplomats or exercises in strategy; inex-
haustibly voluble, they affect a ridiculous pedantry in Greek
and Latin, and even at table confound their interlocutors by
the accuracy of their memory and the dogmatism of their opin-
ions.  "Most intolerable of all is the woman who . . . pardons
the dying Dido and pits the poets against each other, putting
Virgil in the one scale and Homer in the other."  There is no
appeal against her presumption.  "The grammarians make way
before her; the rhetoricians give in; the whole crowd is
silenced."  Pliny the Younger would certainly have fallen
under the spell of woman's erudition, if we remember the praise
he bestows on Calpurnia and the enthusiasm he expresses for the
education and good taste of the wife of Pompeius Saturninus,
whose letters were so beautifully phrased that they might pass
for prose versions of Plautus or Terence.  Juvenal, on the other
hand, like Molière's good Chrysale, could not endure these
"learned women."  He compares their chatter to the clashing of
pots and bells; he abhors these *"précieuses"* who reel off the
Grammar of Palaemon, "who observe all the rules and laws of
language," and adjures his friend:  "Let not the wife of your
bosom possess a style of her own. . . . Let her not know all
history; let there be some things in her reading which she
does not understand."
     So much for the intellectuals.  But the outdoor types
arouse even more ridicule than the blue stockings.  If Juvenal
were alive today he would be pretty sure to shower abuse on
women drivers and pilots.  He is unsparing of his sarcasm for
the ladies who join in men's hunting parties, and like Mevia,
"with spear in hand and breasts exposed, take to pig-sticking,"
and for those who attend chariot races in men's clothes, and
especially for those who devote themselves to fencing and
wrestling.  He contemptuously recalls the *ceroma* which they
affect and the complicated equipment they put on—the cloaks,
the armguards, the thighpieces, the baldrics and plumes.  "Who
has not seen one of them smiting a stump, piercing it through
and through with a foil, lunging at it with a shield and going
through all the proper motions? . . . Unless indeed she is
nursing some further ambition in her bosom and is practising
for the real arena."  Some, perhaps, who today admire so many
gallant female "records" will shrug their shoulders and accuse
Juvenal of poor sportsmanship and narrow-mindedness.  We must
at least concede that the scandal of his times justified the
fears which he expressed in this grave query:  "What modesty
can you expect in a woman who wears a helmet, abjures her own
sex, and delights in feats of strength?"  The feminism which
triumphed in imperial times brought more in its train than
advantage and superiority.  By copying men too closely the
Roman woman succeeded more rapidly in emulating man's vices
than in acquiring his strength.

For three hundred years women had reclined with their hus-
bands at the banquets.  After they became his rival in the
*palaestra*, they naturally adopted the regimen of an athlete
and held their own with him at table, as they disputed the palm
with him  in  the  arena.  Thus other women, who had not the ex-
cuse of sport, also adopted the habit of eating and drinking as
if they took daily exercise.  Petronius shows us Fortunata, the
stout mistress of Trimalchio, gorged with food and wine, her
tongue furred, her memory confused, her eyes bleared with
drunkenness.  The great ladies—or the women who posed as such
on the strength of their money-bags—whom Juvenal satirizes,
unashamedly displayed a disgusting gluttony.  One of them pro-
longs her drinking bouts till the middle of the night and "eats
giant oysters, pours foaming unguents into her unmixed Falernian
. . . and drinks out of perfume bowls, while the roof spins
dizzily round and every light shows double."  Another, still
more degraded, arrives late at the *cena*, her face on fire,

> and with thirst enough to drink off the vessel contain-
> ing full three gallons which is laid at her feet and
> from which she tosses off a couple of pints before her
> dinner to create a raging appetite; then she brings it
> all up again and souses the floor with the washings of
> her insides. . . . She drinks and vomits like a big
> snake that has tumbled into a vat.  The sickened hus-
> band closes his eyes, and so keeps down his bile.

No doubt such cases were repulsive exceptions.  But it is
bad enough that satire should be able to draw such types and
expect readers to recognise them.  Moreover, it is evident that
the independence which women at this time enjoyed frequently
degenerated into license, and that the looseness of their morals
tended to dissolve family ties.  "She lives with him as if she
were only a neighbour. . . ."
Before long women began to betray the troth which they
should have plighted to their husband, and which many of them
in marrying had had the cynicism to refuse him.  "To live your
own life" was a formula which women had already brought into
fashion in the second century.  "We agreed long ago," says the
lady, "that you were to go your way and I mine.  You may con-
found sea and sky with your bellowing, I am a human being after
all. . . ."
Not only the *Epigrams* of Martial and the *Satires* of Juvenal
bear witness to the prevalence of adultery.  In the chaste cor-
respondence of Pliny the Younger a whole letter is dedicated to
relating the ups and downs of a case which came before Trajan
in his capacity as supreme commander-in-chief of the army.  A
centurion was convicted of having seduced the wife of one of
his superior officers, a senatorial tribune in the same legion

as himself.  What amazes Pliny is certainly not the adultery
itself, but the unusual set of circumstances which surrounded
it:   the flagrant breach of discipline it involved, which en-
tailed the immediate "breaking and banishing" of the centurion;
the reluctance of the tribune to vindicate his honour by de-
manding the condemnation which his wife deserved and which the
emperor was officially bound to pronounce.

It is obvious that unhappy marriages must have been
innumerable in a city where Juvenal as a matter of course
adjures a guest whom he has invited to dinner to forget at his
table the anxieties which have haunted him all day, especially
those caused by the carryings on of his wife, who "is wont to
go forth at dawn and to come home at night with crumpled hair
and flushed face and ears."

A hundred years before, Augustus had in vain tried stern
measures against adulterers by passing a law which deprived them
of half their fortune and forbade them marriage with each other
for all time.  From a modern point of view this marked a dis-
tinct advance on the ancient law.   In the time of Cato the Cen-
sor, for instance, a woman's adultery was recognised as a crime
which her outraged husband was entitled to punish with death,
but the man's adultery was considered negligible, and he got off
scot free as if he were innocent.   The imperial legislation was
both more humane, since it annulled the husband's right to take
justice so cruelly into his own hand, and more equitable, since
it dealt out equal punishment to both sexes.   But the fact that
the new law submitted the offence to a special court is an indi-
cation of the frequency with which adultery was committed, and
we may be very sure that the law did little to curb it.   By the
end of the first century the *Lex Iulia de adulteriis* had been
very nearly forgotten.   Before applying it, Domitian was
obliged solemnly to re-enact its provisions.   Martial outdoes
himself in sycophantic praise of the "Greatest of Censors and
Prince of Princes" who had passed this edict, which—if we
are to believe him—Rome prized above triumphs, temples, spec-
tacles, and cities:   "Yet more Rome owes thee, in that she is
chaste. . . ."

But it seems that when Domitian was gone his edict moul-
dered along with the *Lex Iulia* under the dust of the archives
and the indifference of the judges.   A few years later Juvenal
ventures to scoff at Domitian as "the adulterer," who "after
lately defiling himself by a union of the tragic style, revived
the stern laws that were to be a terror to all men, ay even to
Mars and Venus."   And two generations after Juvenal, Domitian's
law had fallen into so much discredit that Septimius Severus
had to recast Domitian's work, as Domitian had endeavoured to
recast that of Augustus.   To be frank, if the frequency of
adultery had diminished in the second century, this was not due
to the intermittent severities of the law but because facilities

for divorce had, as it were, legitimised adultery by anticipation.

## DIVORCE AND THE INSTABILITY OF THE FAMILY

Classic Rome loved to recur in thought to the legendary days of old where she could see an ideal image of herself, an image which every day became less and less like the reality. But even in those times the Roman marriage had never been indissoluble.  In the marriage *cum manu* of the first centuries of Rome, the woman placed under the man's authority could in no wise repudiate her husband, while on the other hand the husband's right to repudiate his wife was inherent in the absolute power which he possessed over her.  In the interest, no doubt, of the stability of the family, custom had, however, introduced some modifications into the application of this principle; and until the third century B.C.—as we see by specific examples which tradition has preserved—this repudiation was in fact confined to cases in which some blame attached to the wife.  A council held by the husband's family then solemnly condemned her. The Twelve Tables have probably handed down a scrap of the formula of this collective sentence which permitted a husband to demand from his wife the surrender of the keys that had been entrusted to her as mistress of the house from which she was now to be ejected without appeal. . . .  In 307 B.C. the censors deprived a senator of his dignities because he had dismissed his wife without first having sought the judgment of his domestic tribunal.  A century later, about 230 B.C., the senator Sp. Carvilius Ruga was still able to scandalise his colleagues by putting away a wife with whom he had no other fault to find than that she had given him no children.

But soon men in his position no longer needed to fear such odium as he had incurred, and following generations of Roman husbands could shake off their wives on a trumpery pretext without arousing indignation or protest:  one had perhaps gone out without her veil; one had stopped in the street to speak to a freedman of unsavoury reputation; another had attended the public games without express permission.  It was better to invoke no pretext at all than such mean and petty ones; and while the husband had usurped the right to dissolve at will the union he had entered into, it happened that, by the end of the republic, the marriage *sine manu* conferred the equivalent freedom on the woman.  If she had embarked on marriage under the protection of her male progenitors or near relations, they needed only to say the word in order to break her bonds and take her home to them. If she had lost all male relations and depended solely on herself, it rested with her to pronounce the word that set her free.

So far had things progressed that in the time of Cicero

divorce by consent of the two parties or at the wish of one had
become the normal course in matrimonial affairs.  The aging
Sulla took a young divorced woman as his fifth wife, a certain
Valeria, half-sister of the orator Hortensius.  Pompey, twice
widowed, having lost both Aemilia and Julia, had been divorced
before marrying Aemilia and was again divorced after the death
of Julia.  His first divorced wife was Antistia; he had asked
her hand with the object of winning the favour of the praetor
on whom depended the livery of seisin of her immense paternal
fortune, but later this connection threatened to hamper
his political career.  The second was Mucia, whose behaviour
during his long absence on his overseas campaigns had left much
to be desired.  Having lost his wife Cornelia, the daughter of
Cinna, Caesar married Pompeia, but repudiated her for the simple
reason that mere innocence was not enough:  "Caesar's wife must
be above suspicion."  The virtuous Cato of Utica, after being
divorced from Marcia, felt no shame in taking her back when her
private fortune was augmented by that of Hortensius, whom she
had married and lost in the interval.  And the fifty-seven-year-
old Cicero unblushingly discarded the mother of his children,
after thirty years of married life with her, in order to replen-
ish his bank account by taking to wife the young and rich Pub-
lilia.  Cicero's Terentia, however, seems to have borne this
disgrace with fortitude, for she married again twice, first
Sallust and later Messala Corvinus, and died a centenarian.

From this time on, we witness an epidemic of divorces—at
least among the aristocracy whose matrimonial adventures are
documented—and in spite of the laws of Augustus, or perhaps
rather on account of them, the disease tended to become endemic
under the empire.  Augustus had intended by his *Lex de ordinibus
maritandis* only to check the fall of the birth rate among the
upper classes.  By the disability imposed on offenders he hoped
to bring pressure to bear on divorced people to marry again;
but he was far from intending to prevent ill-assorted couples
from dissolving an unhappy marriage and speedily substituting a
happier and more fruitful union.  He forbade the breach of a
betrothal because he had observed that hard-boiled bachelors
took advantage of a series of engagements, capriciously cancel-
ling one after the other, to postpone the wedding indefinitely.
By continually announcing it but never celebrating it they
evaded at once his commands and the punishment with which he
threatened the refractory.  He could not prevent couples from
divorcing each other, nor did he wish to do so.  He contented
himself with attempting to regularise the procedure.  First, he
conceded that the wish of the married pair should, as heretofore,
suffice to dissolve a marriage, and insisted only that this wish
should be publicly expressed in the presence of seven witnesses
and announced by a message.  This message was usually delivered
by a freedman of the house.  Later he thought wise to permit the

divorced wife to take an action, known as the *"actio rei uxoriae,"*
to reclaim her dowry, even when from negligence or overtrustful-
ness she and her kin had omitted the precaution of stipulating
for such restitution.  The right of a wife to claim repayment of
her dowry was henceforth undisputed except in the case of such
dowry property as the judge allowed the husband to retain either
for the maintenance of the children who remained in his care, or
in compensation for damages caused by the wife by her extrava-
gance, malversation, or misconduct.

In passing these laws Augustus was prompted by the same
impulse that had made him withdraw from the husband's adminis-
tration any part of the dowry which was invested in land in
Italy.  In both cases his concern was to safeguard a woman's
dowry—the unfailing bait for a suitor—so as to secure for her
the chance of a second marriage.  It turned out, however, as he
ought to have foreseen, that his measures, conformable though
they were to his population policy and socially unexceptionable,
hastened the ruin of family feeling among the Romans.  The fear
of losing a dowry was calculated to make a man cleave to the
wife whom he had married in the hope of acquiring it, but
nothing very noble was likely to spring from calculations so
contemptible.  In the long run avarice prolonged the wealthy
wife's enslavement of her husband. . . .

While progressively lowering the dignity of marriage, this
legislation succeeded in preserving its cohesion only up to the
point where a husband, weary of his wife, felt sure of capturing,
without undue delay, another more handsomely endowed.  In these
circumstances, the vaunted laws of Augustus must bear part of
the responsibility for the fact, which need surprise no one,
that throughout the first two centuries of the empire Latin lit-
erature shows us a great many households either temporarily
bound together by financial interest or broken up sometimes in
spite of, sometimes for the sake of, money.

Thus the Roman matron, mistress of her own property in
virtue of her *sine manu* status, was certain, thanks to the
Julian laws, of recovering the bulk if not the whole of her
dowry.  Her husband was not free to administer it in Italy
without her consent, nor to mortgage it anywhere even with her
acquiescence.  Duly primed by her steward, who assisted her
with advice and surrounded her with obsequious attention—this
"curled spark" of a procurator whom we see under Domitian al-
ways "clinging to the side" of Marianus' wife—the wealthy lady
dispatched her business, made her dispositions, and issued her
orders.  As Juvenal predicts: "No present will you ever make
if your wife forbids; nothing will you ever sell if she objects;
nothing will you buy without her consent."  The satirist con-
tends that there is nothing on earth more intolerable than a
rich woman. . . .

Prisoner not of his affections but of a dowry, the husband

—if his sovereign lady did not give him his congé herself—
sooner or later escaped from one gilded cage into another.  In
the city as at the court the ephemeral households of Rome were
perpetually being disrupted, or rather were continually dis-
solving to recrystallise and dissolve again till age and death
finally overtook them.  The freedman whom Augustus' law charged
with the duty of conveying the written order of divorce had
never suffered so little from unemployment.  Juvenal does not
fail to leave us a picture of this busybody fussing on his
errand:  "Let three wrinkles show themselves on Bibula's face,"
and her loving Sartorius will betake himself in haste to other
loves.  "Then will his freedman give her the order:  'Pack up
your traps and be off!  You've become a nuisance . . . be off
and be quick about it!'"  In such a case the outraged wife had
no redress; there was nothing for her to do but to obey the
order which the poet slightly paraphrases.  Gaius has preserved
the legal formula for us:  *"Tuas res tibi agito* (take your
belongings away!)."  She took care to take with her nothing
that strictly belonged to her husband, whose right to his own
goods she recognised in the parting formula she used to him:
"Keep your belongings to yourself!"

We must not imagine that it was always the man who took the
initiative in these matters.  Women in their turn discarded
their husbands and abandoned them without scruple after having
ruled them with a rod of iron.  Juvenal points the finger of
scorn at one of these:  "Thus does she lord it over her husband.
But before long she vacates her kingdom; she flits from one home
to another wearing out her bridal veil. . . . Thus does the tale
of her husbands grow; there will be eight of them in the course
of five autumns—a fact worthy of commemoration on her tomb!"
Martial's Telesilla was another such.  Thirty days, or perhaps
less, after Domitian had revived the Julian laws, "she is now
marrying her tenth husband . . . by a more straightforward
prostitute I am offended less."  In vain the Caesars now tried
setting an example of monogamy to their subjects.  But instead
of following in the steps of Trajan and Plotina, Hadrian and
Sabina, Antoninus and Faustina, imperial couples faithful to
each other for life, the Romans preferred to ape the preceding
emperors, all of whom, even Augustus, had been several times
divorced.

Divorces were so common that—as we learn from the jurists
of the time—a series of them not infrequently led to the fair
lady and her dowry returning, after many intermediate stages,
to her original bridal bed.  The very reasons which today would
doubly bind an affectionate woman to her husband's side—his
age or illness, his departure for the front—were cynically
advanced by the Roman matron as reasons for deserting him.  It
is an even graver symptom of the general demoralisation that
these things had ceased to shock a public opinion grown

sophisticated and inhuman.  Thus in the Rome of the Antonines
Seneca's words were cruelly just:  "No woman need blush to break
off her marriage since the most illustrious ladies have adopted
the practice of reckoning the year not by the names of the con-
suls but by those of their husbands.  They divorce in order to
re-marry.  They marry in order to divorce. . . ."

How far removed from the inspiring picture of the Roman
family in the heroic days of the republic!  The unassailable
rock has cracked and crumbled away on every side.  Then, the
woman was strictly subjected to the authority of her lord and
master; now, she is his equal, his rival, if not his *imperatrix*.
Then, husband and wife had all things in common; now, their
property is almost entirely separate.  Then, she took pride in
her own fertility; now, she fears it.  Then, she was faithful;
now, she is capricious and depraved.  Divorces then were rare;
now they follow so close on each other's heels that, as Martial
says, marriage has become merely a form of legalised adultery.
"She who marries so often does not marry; she is an adultress
by form of law. . . ."

## THE ROMAN WOMAN DRESSES

. . . Whether she slept in a room of her own or shared a
room with him, the Roman woman's morning toilet closely
resembled her husband's.  Like him, she kept on her undergar-
ments in bed at night:  her loin cloth, her brassiere (*stro-
phium, mamillare*) or corset (*capitium*), her tunic or tunics,
and sometimes, to the despair of her husband, a mantle over all.
Consequently she, like him, had nothing to do when she got up,
but to draw on her slippers on the *toral* and then drape herself
in the *amictus* of her choice; and her preliminary ablutions
were as sketchy as his.  Pending the hour of the bath, the
essential *cura corporis* for her as for him consisted of atten-
tions which we should consider accessory.  In matters of toilet
the Roman lady of the empire resembled the oriental lady of
today; she considered the superfluous thing the most necessary.

It is the jurists who, in laying down an inventory of
female inheritance, best help us to arrange in order the unequal
and successive planes on which the Roman woman's coquetry set up
its batteries.  The personal objects which a woman left behind
her were legally divided into three categories: toilet articles
(*mundus muliebris*), adornments (*ornamenta*), and clothes (*vestis*).
Under the heading *vestis* the lawyers enumerate the different
garments which women wore.  To the toilet belonged everything
she used for keeping clean:  her wash-basins, her mirrors of
copper, silver, sometimes even of glass backed not with mercury
but with lead; and also, when she was fortunate enough to be
able to disdain the hospitality of the public bath, her bathtub.

Her "adornments" included the instruments and products which
contributed to her beautification, from her combs and pins and
brooches to the unguents she applied to her skin and the jewels
with which she adorned herself.  At bathing time her *mundus* and
her *ornamenta* were both needed; but when she first got up in the
morning it was enough for her to "adorn" herself without wash-
ing. . . .

She began by dressing her hair.  At the period which is now
engaging our attention this was no small affair.  Women had long
since given up the simplicity of the republican coiffure—
restored to honour for a space by Claudius—in which a straight,
even parting divided the hair in front and a simple chignon
gathered it together at the back.  They were no longer content
with braids raised on pads above the forehead, such as we see
in the busts of Livia and Octavia.  With Messalina there came
in those complicated and high-piled methods of hairdressing
which are familiar to us from illustrations of women during the
Flavian period.  In later years, though the ladies of the court
who set the fashion, Marciana, sister of Trajan, Matidia, his
niece, gave up these styles, they nevertheless preserved the
custom of dressing their hair in diadems as high as towers.
"Behold," says Statius in one of his *Silvae*, "behold the glory
of this sublime forehead and the stagings of her coiffure."
Juvenal makes merry in his turn about the contrast between the
height of a certain fine lady and the pretentiousness of her
piled-up hair to which there seemed no limit:  "So numerous are
the tiers and stories piled one upon another on her head!  In
front you would take her for an Andromache; she is not so tall
behind; you would not think it was the same person."

Roman women were as dependent on their *ornatrix* as their
husbands on the *tonsor*.  The skill of the tire-woman was indis-
pensable for erecting these elaborate scaffoldings, and the
epitaphs of many *ornatrices* tell us the dates of their death
and the families by whom they were employed.  The woman had to
devote as much time to her *séance* with the *ornatrix* as her hus-
band had to give to the barber; and she suffered as much on
these occasions as he did, especially if like the Julia of whom
Macrobius tells she bade her tire-woman pitilessly tear out the
greying hairs.  The post of *ornatrix* was far from being a sine-
cure.  Not infrequently the torturer became a martyr, if per-
chance her mistress, worn out by holding one pose everlastingly,
suddenly decided that the result of so much suffering still
left much to be desired.  Epigrams and satires are full of the
cries of angry matrons and the groans of serving women in
distress.

If Madame has an appointment and wishes to be turned
out more nicely than usual [writes Juvenal] . . . the
unhappy Psecas who does her hair will have her own

hair torn, and the clothes stripped off her shoulders
and her breasts. "Why is this curl standing up?" she
asks, and then down comes a thong of bull's hide to
inflict chastisement for the offending ringlet!

Martial for his part relates: "One curl of the whole round of
hair had gone astray, badly fixed by an insecure pin. This
crime Lalage avenged with the mirror in which she had observed
it and Plecusa, smitten, fell because of those savage locks!"
Happy, in these circumstances, was the *ornatrix* whose mistress
was bald! With a minimum of risk she could adjust the artifi-
cial tresses, or at need an entire wig. Sometimes the false
hair was dyed blond with the *sapo* of Mainz obtained by blending
goat's fat with beech ash; sometimes it was an ebony black,
like the cut hair imported from India in such quantities that
the imperial government entered *capilli Indici* among the com-
modities which had to pay customs duty.

The *ornatrix's* duties did not end there, however. She had
still to remove her mistress's superfluous hair, and above all
to "paint" her: white on brow and arms with chalk and white
lead; red on cheeks and lips with ochre, *fucus*, or the lees of
wine; black with ashes or powdered antimony on the eyebrows and
round the eyes. The tire-woman's palette was a collection of
pots and flagons, Greek vases and alabaster jars, of *gutti* and
pyxes from which as ordered she extracted liniments, pomades,
and make-up. The mistress of the house normally kept this
arsenal locked in a cupboard in the nuptial room. In the morn-
ing she spread out everything on the table beside the powdered
horn which, following Messalina's example, she used to enamel
her teeth. Before calling her *ornatrices* to get to work, she
took care to secure the door, for she knew from Ovid that art
does not beautify a woman's face unless it be concealed. When
she set out for the bath she took all her apparatus with her,
each pot and jar in its own compartment in a special little box,
sometimes made of solid silver, which was called by the generic
name of *capsa* or *alabastrotheca*; these various jars contained
her daytime face, which she made up on rising, made up again
after her bath, and did not un-make until after nightfall at
the last moment before going to bed: "You lie stored away in
a hundred caskets, and your face does not sleep with you!"

Once made up, the fashionable lady, always assisted by
her *ornatrices*, chose her jewels, set with precious stones, and
put them on one by one: a diadem on her hair, and ear-rings in
her ears; a collar or trinkets round her neck; a pendant on her
breast; bracelets on her wrists; rings on her fingers, and cir-
clets on her ankles like those which the Arab women of the
sheik's tent wear. Next her chamberwomen hastened to the res-
cue and helped to dress her. They slipped over her head her
long upper tunic, sign of her exalted rank, round the hem of
which was stiched a braid embroidered in gold. They tied her

belt, and finally enveloped her either in a long shawl which
covered her shoulders and reached down to her feet, or in the
*palla*—the woman's counterpart of the man's *pallium*—a big
square cloak with rhythmic folds and of some dazzling colour.

Woman's dress in Rome was not distinguished from man's by
the cut, but rather by the richness of the material and the
brilliance of the colour.  To linen and wool she preferred the
cotton stuffs that came from India after the Parthian peace,
assured by Augustus and confirmed by the victories of Trajan,
had guaranteed the security of imports; above all she loved
the silks which the mysterious Seres exported annually to the
empire from the country which we nowadays call China.  Since
the reign of Nero silk caravans had come by the land routes
across Asia, then from Issidon Scythica (Kashgar) to the Black
Sea, or else through Persia and down the Tigris and Euphrates
to the Persian Gulf, or by boat down the Indus and then by
ship to the Egyptian ports of the Red Sea.  Silk materials
were not only more supple, lighter, and iridescent, they also
lent themselves better than all others to skillful manipulation.
The *affectores* with their ingredients reinforced the original
colours; the *infectores* denaturalised them; and the various
dyers, the *purpurarii*, *flammarii*, *crocoterii*, *violarii*, knew
cunning dyes equalling in number the vegetable, animal, and
mineral resources at their disposal; chalk and soapwort and
salt of tartar for white; saffron and reseda for yellow; for
black, nut-gall; woad for blue; madder, archil, and purple for
dark and lighter shades of red.  Mindful of Ovid's counsels,
the matrons adapted their complexions to the colours of their
dresses and harmonised them so skillfully that when they went
into the city they lit the streets with the bravery of their
multicoloured robes and shawls and mantles, whose brilliance
was often further enhanced by dazzling embroideries like those
which adorned the splendid *palla* of black in which Isis appeared
to Apuleius!

It was the matron's business to complete her costume with
various accessories foreign in their nature to man's dress,
which further accentuated the picturesqueness of her appearance.
While a man normally wore nothing on his head, or at most, if
the rays of the sun were too severe or the rain beat too fiercely
down, threw a corner of his toga or *pallium* over his head or drew
down the hood of his cloak, the Roman woman, if not wearing a
diadem or *mitra*, passed a simple bandeau of crimson through her
hair, no longer imprisoned in its net, or else a *tutulus* similar
to the bandeau of the *flaminicae*, which broadened in the centre
to rise above the forehead in the shape of a cone.  She often
wore a scarf knotted at the neck.  The *mappa* dangling from her
arm served to wipe dust or perspiration from her face.  We must,
however, beware of assuming that the practice of blowing the
nose came in early, for the only Latin word which can fairly be

translated as handkerchief is not attested before the end of
the third century.  In one hand she often flourished a fan of
peacocks' feathers, with which she also brushed away the flies.
In fine weather she carried in her other hand, unless she
entrusted it to a serving woman by her side or to her escort, a
sunshade, usually covered in bright green.  She had no means of
closing it at will, as we can ours, so she left it at home when
there was a wind.

Thus equipped, "the fair" could face the critical eye of
their fellow women and challenge the admiration of the passers-
by.  But it is certain that the complexity of their array, com-
bined with a coquetry not peculiar to their day, must have
drawn out the time demanded by their morning toilet far beyond
that needed by their husbands.  This was, however, a matter of
no account, for the women of Rome were not busy people like
their men, and to confess the truth they took no part in the
public life of Rome except in its hours of leisure. . . .

## OCCUPATIONS

. . . Further, these humming hives of workshops were almost
exclusively male.  Feminism under the Antonines was an extra-
ordinary and aristocratic phenomenon peculiar to the upper
classes.  The great ladies in vain took pride in emulating men
in every sphere of life; they found no imitators or disciples
among their humbler sisters, who had no mind at all to fling
themselves into the struggle for existence.  The ladies might
devote themselves to music, literature, science, law, or phil-
osophy, as they threw themselves into sport—as a method of
passing the time; they would have thought it beneath them to
stoop to working at a trade.  Among the thousands of epitaphs
of the Urbs collected by the editors of the *Corpus Inscriptionum
Latinarum* I have found scarcely any women earners:  one *libraria*
or woman secretary, three clerks, one stenographer, two women
teachers against eighteen of the other sex, four women doctors
against fifty-one *medici*.  For the great bulk of Roman women the
civil registers would have required the entry—less and less
familiar in ours—"no profession."  In the urban epigraphy of
the empire we find women either simply fulfilling the duties for
which man is by nature unfitted, of seamstress, woman's hair-
dresser, midwife, and nurse; or resigning themselves gradually
to those occupations for which women have always been better
qualified or more expert than men.

I have discovered only one fishwife, one female coster-
monger, one dressmaker—against twenty men tailors or *vestifici*—
three women wool distributors, and two silk merchants.  We need
feel no surprise at the absence of women jewellers; for one
thing, at Rome there was no clear demarcation between the

*argentarii* who sold jewellery and the *argentarii* who took charge
of banking and exchange; and for another, all banking operations
had been forbidden to women by the same praetorian legislation
that had deprived them of the right to sue on each other's
behalf.  Women never figure even in the corporations for which
the emperors tried to stimulate recruitment:  outfitting and
maintaining ships in the time of Claudius and baking under
Trajan.  I could find no *pistrix* amongst the *pistores* of the
city; nor has any woman's name crept into the lists of shippers
which have survived to our times.  If any matrons yielded to
the exhortations of Claudius, who had gone so far as to promise
the privileges pertaining to the mother of three children (*ius
trium liberorum*) to any wealthy woman, whether married or child-
less or single, who would consent to outfit a cargo boat at her
own expense, they can have done so only indirectly, through the
intermediary of some man of straw, a *procurator*, or some other
business agent.  Nothing gives stronger proof that the Roman
woman, despite all the moral and civil emancipation which had
fallen to her under the empire, preferred to remain in the
sheltered security of her own home, far from the hurly-burly
of the Forum and the noise of trade.
     The Roman woman of those days was so deeply rooted in
indolence that she apparently was not much oftener seen in
shops as a purchaser than as an employee.  It was—beyond a
doubt—the proletarian husband himself, not his wife, who went
on the stated day to knock at the portico of Minucius and re-
ceive the card, or rather the little wooden tablet which proved
him entitled to the bounty of Annona.  A historical bas-relief
in the Museo dei Conservatori, which in all probability commemo-
rates the liberal distributions of Hadrian, shows the emperor
standing on a dais announcing his largesse to the Roman people,
who are typified by three figures representing citizens of vari-
ous ages:  a child, a youth, and a grown man.  The relief sug-
gests no female recipient, nor was there probably any in the
actual distributions of the imperial largesse.  Women are equal-
ly absent from most of the paintings of Herculaneum and Pompeii,
and from the funerary bas-reliefs where the sculptor has pic-
tured scenes in the streets and represented to the life the
animation of buyers and sellers.  We find woman depicted only
in scenes where her presence was more or less obligatory and
inevitable:  where the fuller brought back the clean clothes to
the lady of the house; when a widow came to the marble merchant
to order a tomb for her dead husband; when the bootmaker tried
on shoes one by one; and lastly at the dressmaker's and in the
novelty shops which the Roman lady of the time of Trajan appears
to have frequented diligently and eagerly.  Sometimes she is
shown making her choice while her husband sits on a bench at
her side—as in the bas-reliefs of the Uffizi Museum at Florence
—sometimes with a chosen companion or a whole train of women
friends, as in certain frescoes from the Campagna.

On the other hand, in the Saepta Iulia, which the lethargy of the Comitia had turned into a promenade where the bronze founders, the jewellers, and the antique dealers exhausted their ingenuity in fleecing the amateur, the bargainers and the passers-by were only men: Eros the collector, the miserly Mamurra, aged Auctus. And in the bakery, at the butcher's, in the eating shop, we find only men as buyers and sellers.

In the pictures of public places which the Pompeians have left us, the women pass in their finery, sometimes alone, some-times—as in the famous painting from the house known as Livia's on the Palatine—accompanied by a child. But their hands are empty, unemcumbered by either shopping bag or basket; they are obviously idle, walking about for pleasure, without care and without responsibility. We must accept the facts. In Imperial Rome women mixed in outdoor affairs as little as the Moslem woman of today in the cities of Islam. It was the Roman hus-band's business, as it is today among middle-class Mussulmans, to do the shopping and supply the provisions for the house.

But if this idleness of the Roman woman lends the Urbs an exotic, oriental air, the conditions under which the Roman man worked recall the most advanced Western practices of today. . . .

# 2

## EARLY CHRISTIAN ATTITUDES TO FEMININITY

*The important and controversial question of whether the advent of Christianity raised or lowered the position of women in Western society is much debated by apologists and scholars. The debate ranges from James Cleugh, who considers St. Paul "a bald, bandy-legged, and beetle-browed renegade Jew"[1] whose negative attitude to women and sex is due to his rejection as a suitor, to Joseph A. Grassi, who states that "Paul frequently acknowledged the work of women as active collaborators in the apostolate as well as assistants in good works"[2] and who stresses Paul's dictum: "There does not exist among you Jew or Greek, slave or freeman,* male or female. *All are one in Jesus Christ" (Galatians 3:28).*

*Christianity, a product of the period of the early Roman Empire, is a mixture of the beliefs and ideals of a variety of cultures of the time. After the death in A.D. 430 of St. Augustine, the greatest of the Church Fathers, and the fall of the Western Empire in A.D. 476, the body of Christian dogma was well established and contained much of the Hebrew, Greek, and Roman intellectual tradition and ritual. Its development had also been shaped by contemporary social, economic, and political events—in other words, by the history of the times.*

*The founder of this new religion, Jesus Christ (d. A.D. 30), was a Jew living in the eastern part of the Roman Empire. Raised in the strict rabbinic tradition, his interest in reform tended more toward the social than the ritual aspects of the life of his coreligionists. One might well label Jesus a "radical feminist" because he made a point of divulging the most significant ideas and events of his life (for example, the Resurrection) to women. His radicalism lay in the fact that in Hebrew society*

---

[1]*Love Locked Out* (London:  Anthony Blond, 1963), p. 12.

[2]"Women's Liberation:  The New Testament Perspective," *The Living Light: A Christian Educational Review*, 8, no. 2 (Summer 1971), 29.

*women took no part whatever in the religious ritual or in the discussion of ideas, and by revealing himself to them Jesus was in effect breaking a taboo (see also 2 B). In spite of this, it is significant that those known as Jesus' closest disciples were all men.*

*After the crucifixion of Jesus, the young religion spread through the enthusiasm of the disciples to the western part of the empire and to Rome itself. Within a generation the greatest apostle of Christianity, Paul of Tarsus (d. A.D. 66), had promoted the Christian ideal far and wide across the empire. Because Paul was a Roman citizen with a strong grasp of the significance of the Pax Romana, his vision of Christianity molded the new religion into a universal system with an organization that proved viable for millenia to come.*

*During the later centuries of the Roman Empire, Christianity, based on the ideals of Jesus and the organization of Paul of Tarsus, gradually developed into the official religion of the Roman state. At first, however, it was on a par with the illegal mystery cults which flourished in the empire, appealing to the poor, the slaves, and the underprivileged in general. This illegitimate status forced early Christians to worship in secret, and as they became more numerous and the appeal of their message spread from the lower to the upper strata of Roman society, successive imperial governments ordered their persecution. Throughout the rise of Christianity the people of the Roman Empire also suffered repeated Barbarian invasions from the north and east. All these influences are incorporated in the scholarly writings of the leaders of the early Christians, which present a commentary of suitable Christian behavior under the combined stresses of persecution from within the state and military invasion from without.*

*The leaders of the early Christians throughout the first four centuries A.D. are known as the Fathers of the Church. Some of the greatest of these were Tertullian (155-222), Origen (185-254), Jerome (345-420), Chrysostom (c. 345-407), and Augustine (354-430). By and large the writings of the Church Fathers see this world as a "vale of tears," no more than a preparation for the heavenly world after death. The patristic literature is also critical of the degenerate life of the Roman upper classes, of which the Christian Fathers disapproved as pagan, militaristic, materialistic, and sexually immoral. As already noted in Part 1, section D, the strict early Roman moral and legal codes concerning sexual relations had become more flexible during the later republic and even looser during the empire. The persecutions and the precarious existence of the early Christians under imperial rule made them strongly aware that in order to survive, their own moral behavior must be beyond reproach.*

*In these unhappy straits, the early Christians were hesitant to bring children into the world. Among them procreation was to*

be discouraged, and because the Roman practices of contraception
and abortion were considered criminal (the soul was believed
already to exist in the fetus, whereas the Platonic soul came
to life only at birth), intercourse was to be avoided.

The external influences against procreation were re-
enforced in the early centuries of Christianity by two influ-
ences inherent in the faith itself:  the belief that with the
Second Coming of Christ (the Parousia), the world as the early
Christians knew it, would end, and the Neoplatonic and Gnostic
elements that infiltrated Christianity at this time.   Gnosticism
was inherent in the belief of a number of Eastern religious cults
which vied for the adherence of the people of the Roman Empire.
The Gnostics thought the material world worthless and concen-
trated their efforts on a spiritual ladder, seeking an eventual
Platonic purity.   Their religious philosophy led to a strict
asceticism, where any kind of bodily pleasure was considered
evil, as was marriage and sexual propagation.   It is notable
that those Christian Fathers who wrote most violently against
the dangers of females and sexual temptation came from the
eastern part of the empire or were those who had been immersed
in the study of Gnosticism (Origen, Tertullian) or its successor,
Manichaeanism (Augustine).

## A.  THE LEGACY OF JUDAISM

Both Jesus of Nazareth and Paul of Tarsus were raised as
Jews, had carefully studied the Laws, and were steeped in the
Judaic tradition.   The entire Christian edifice rests on the
Hebraic base of its founders.   This base expected of women great
practical competence in the business of life but excluded them
entirely from a man's real work—the study of the word of God.
"Everyone that talketh much with a woman causes evil to himself,
and desists from words of Torah, and his end is he inherits
Gehinnom," says the Talmud.

The excerpts from the Old Testament (King James Version)
show some of the leading Hebraic trends related to the lives of
women that infused Christian thought in Western society.

Genesis, the first book of the Old Testament, indicates
the ambivalence with which women have been regarded throughout
the centuries.   In adjacent chapters but contrasting passages
the authors of Genesis depict woman as created equally with man
in God's own image and as **part** of man designed to be his
helper.

## GENESIS 1:26-28

26   And God said, Let us make man in our image, after our likeness:   and let them have dominion over the fish of the sea, and over the fowl of the air, and over the cattle, and over all the earth, and over every creeping thing that creepeth upon the earth.

27   So God created man in his own image, in the image of God created he him; male and female created he them.

28   And God blessed them, and God said unto them, Be fruitful, and multiply, and replenish the earth, and subdue it: and have dominion over the fish of the sea, and over the fowl of the air, and over every living thing that moveth upon the earth.

## GENESIS 2:18-25

18   And the Lord God said, It is not good that the man should be alone; I will make him an help meet for him.

19   And out of the ground the Lord God formed every beast of the field, and every fowl of the air; and brought them unto Adam to see what he would call them:   and whatsoever Adam called every living creature, that was the name thereof.

20   And Adam gave names to all cattle, and to the fowl of the air, and to every beast of the field; but for Adam there was not found an help meet for him.

21   And the Lord God caused a deep sleep to fall upon Adam, and he slept:   and he took one of his ribs, and closed up the flesh instead thereof;

22   And the rib, which the Lord God had taken from man, made he a woman, and brought her unto the man.

23   And Adam said, This is now bone of my bones, and flesh of my flesh:   she shall be called Woman, because she was taken out of Man.

24   Therefore shall a man leave his father and his mother, and shall cleave unto his wife:   and they shall be one flesh.

25   And they were both naked, the man and his wife, and were not ashamed.

*In the third chapter of Genesis woman emerges as temptress; the innocence of mankind is destroyed because woman insisted on tasting the fruit from the forbidden tree.   Because of her*

*eagerness for knowledge and wisdom, Eve is forever guilty of the original sin, and she will therefore suffer in childbirth and be subservient to her husband till the end of time.*

### GENESIS 3:1-24

Now the serpent was more subtil than any beast of the field which the Lord God had made.  And he said unto the woman, Yea, hath God said, Ye shall not eat of every tree of the garden?
2  And the woman said unto the serpent, We may eat of the fruit of the trees of the garden:
3  But of the fruit of the tree which is in the midst of the garden, God hath said, Ye shall not eat of it, neither shall ye touch it, lest ye die.
4  And the serpent said unto the woman, Ye shall not surely die:
5  For God doth know that in the day ye eat thereof, then your eyes shall be opened, and ye shall be as gods, knowing good and evil.
6  And when the woman saw that the tree was good for food, and that it was pleasant to the eyes, and a tree to be desired to make one wise, she took of the fruit thereof, and did eat, and gave also unto her husband with her; and he did eat.
7  And the eyes of them both were opened, and they knew that they were naked; and they sewed fig leaves together, and made themselves aprons.
8  And they heard the voice of the Lord God walking in the garden in the cool of the day:  and Adam and his wife hid themselves from the presence of the Lord God amongst the trees of the garden.
9  And the Lord God called unto Adam, and said unto him, Where art thou?
10  And he said, I heard thy voice in the garden, and I was afraid, because I was naked; and I hid myself.
11  And he said, Who told thee that thou wast naked?  Hast thou eaten of the tree, whereof I commanded thee that thou shouldest not eat?
12  And the man said, The woman whom thou gavest to be with me, she gave me of the tree, and I did eat.
13  And the Lord God said unto the woman, What is this that thou hast done?  And the woman said, The serpent beguiled me, and I did eat.
14  And the Lord God said unto the serpent, Because thou hast done this, thou art cursed above all cattle, and above every beast of the field; upon thy belly shalt thou go, and

dust shalt thou eat all the days of thy life:

15 And I will put enmity between thee and the woman, and between thy seed and her seed; it shall bruise thy head, and thou shalt bruise his heel.

16 Unto the woman he said, I will greatly multiply thy sorrow and thy conception; in sorrow thou shalt bring forth children; and thy desire shall be to thy husband, and he shall rule over thee.

17 And unto Adam he said, Because thou hast hearkened unto the voice of thy wife, and hast eaten of the tree, of which I commanded thee, saying, Thou shalt not eat of it; cursed is the ground for thy sake; in sorrow shalt thou eat of it all the days of thy life;

18 Thorns also and thistles shall it bring forth to thee; and thou shalt eat the herb of the field;

19 In the sweat of thy face shalt thou eat bread, till thou return unto the ground; for out of it wast thou taken: for dust thou art, and unto dust shalt thou return.

20 And Adam called his wife's name Eve; because she was the mother of all living.

21 Unto Adam also and to his wife did the Lord God make coats of skins, and clothed them.

22 And the Lord God said, Behold, the man is become as one of us, to know good and evil: and now, lest he put forth his hand, and take also of the tree of life, and eat, and live for ever:

23 Therefore the Lord God sent him forth from the garden of Eden, to till the ground from whence he was taken.

24 So he drove out the man; and he placed at the east of the garden of Eden Cherubims, and a flaming sword which turned every way, to keep the way of the tree of life.

*Eve's crime was disobedience and the desire for knowledge; it was not a crime of sensuousness. Although the Old Testament inveighs against harlotry and adultery, it is permeated with the concept that man shall form a family—"be fruitful and multiply." Sexual asceticism within marriage is not a Hebrew legacy. Included here is the collection of marriage songs known as the Song of Solomon or the Song of Songs, from approximately the third century B.C. They contain some of the most sensuous love poetry in Western literature, extolling equally the desire of man for woman and of woman for man.*

SONG OF SONGS 2:1-17

I am the rose of Sharon, and the lily of the valleys.
2  As the lily among thorns, so is my love among the
daughters.
3  As the apple tree among the trees of the wood, so is
my beloved among the sons.  I sat down under his shadow with
great delight, and his fruit was sweet to my taste.
4  He brought me to the banqueting house, and his banner
over me was love.
5  Stay me with flagons, comfort me with apples: for I am
sick of love.
6  His left hand is under my head, and his right hand doth
embrace me.
7  I charge you, O ye daughters of Jerusalem, by the roes,
and by the hinds of the field, that ye stir not up, nor awake
my love, till he please.
8  The voice of my beloved! behold, he cometh leaping upon
the mountains, skipping upon the hills.
9  My beloved is like a roe or a young hart:  behold, he
standeth behind our wall, he looketh forth at the windows,
shewing himself through the lattice.
10  My beloved spake, and said unto me, Rise up, my love,
my fair one, and come away.
11  For, lo, the winter is past, the rain is over and gone;
12  The flowers appear on the earth; the time of the singing
of birds is come, and the voice of the turtle is heard in our
land;
13  The fig tree putteth forth her green figs, and the vines
with the tender grape give a good smell.  Arise, my love, my
fair one, and come away.
14  O my dove, that art in the clefts of the rock, in the
secret places of the stairs, let me see thy countenance, let
me hear thy voice; for sweet is thy voice, and thy countenance
is comely.
15  Take us the foxes, the little foxes, that spoil the
vines; for our vines have tender grapes.
16  My beloved is mine, and I am his:  he feedeth among the
lilies.
17  Until the day break, and the shadows flee away, turn my
beloved, and be thou like a roe or a young hart upon the moun-
tains of Bether.

## SONG OF SONGS 5:10-16

10 My beloved is white and ruddy, the chiefest among ten thousand.

11 His head is as the most fine gold, his locks are bushy, and black as a raven.

12 His eyes are as the eyes of doves by the rivers of waters, washed with milk, and fitly set.

13 His cheeks are as a bed of spices, as sweet flowers: his lips like lilies, dropping sweet smelling myrrh.

14 His hands are as gold rings set with the beryl: his belly is as bright ivory overlaid with sapphires.

15 His legs are as pillars of marble, set upon sockets of fine gold: his countenance is as Lebanon, excellent as the cedars.

16 His mouth is most sweet: yea, he is altogether lovely. This is my beloved, and this is my friend, O daughters of Jerusalem.

## SONG OF SONGS 7:1-12

How beautiful are thy feet with shoes, O prince's daughter! the joints of thy thighs are like jewels, the work of the hands of a cunning workman.

2 Thy navel is like a round goblet, which wanteth not liquor: thy belly is like an heap of wheat set about with lilies.

3 Thy two breasts are like two young roes that are twins.

4 Thy neck is as a tower of ivory; thine eyes like the fishpools in Heshbon, by the gate of Bath-rabbim: thy nose is as the tower of Lebanon which looketh toward Damascus.

5 Thine head upon thee is like Carmel, and the hair of thine head like purple; the king is held in the galleries.

6 How fair and how pleasant art thou, O love, for delights!

7 This thy stature is like to a palm tree, and thy breasts to clusters of grapes.

8 I said, I will go up to the palm tree, I will take hold of the boughs thereof: now also thy breasts shall be as clusters of the vine, and the smell of thy nose like apples;

9 And the roof of thy mouth like the best wine for my beloved, that goeth down sweetly, causing the lips of those that are asleep to speak.

10 I am my beloved's, and his desire is toward me.

11   Come, my beloved, let us go forth into the field; let us lodge in the villages.

12   Let us get up early to the vineyards; let us see if the vine flourish, whether the tender grape appear, and the pomegranates bud forth:  there will I give thee my loves.

*The final Old Testament selection is part of the last chapter of Proverbs, which describes the ancient Hebrew concept of the perfect wife.  The perfect wife has total responsibility for the material well-being of the family.  However, she is responsible for far more than the immediate needs of the family.  She has the option of selling the excess domestic and agricultural production, and the fruits of her labor are hers to use as she will.  Although "wisdom" is an asset in the perfect wife, it is notable that she is not expected to partake of the spiritual or intellectual life of the society.*

### PROVERBS 31:10-31

10   Who can find a virtuous woman?  for her price is far above rubies.

11   The heart of her husband doth safely trust in her, so that he shall have no need of spoil.

12   She will do him good and not evil all the days of her life.

13   She seeketh wool, and flax, and worketh willingly with her hands.

14   She is like the merchants' ships; she bringeth her food from afar.

15   She riseth also while it is yet night, and giveth meat to her household, and a portion to her maidens.

16   She considereth a field, and buyeth it:  with the fruit of her hands she planteth a vineyard.

17   She girdeth her loins with strength, and strengtheneth her arms.

18   She perceiveth that her merchandise is good:  her candle goeth not out by night.

19   She layeth her hands to the spindle, and her hands hold the distaff.

20   She stretcheth out her hand to the poor; yea, she reacheth forth her hands to the needy.

21   She is not afraid of the snow for her household:  for all her household are clothed with scarlet.

22   She maketh herself coverings of tapestry; her clothing is silk and purple.

23   Her husband is known in the gates, when he sitteth among the elders of the land.

24   She maketh fine linen, and selleth it; and delivereth girdles unto the merchant.

25   Strength and honour are her clothing; and she shall rejoice in time to come.

26   She openeth her mouth with wisdom; and in her tongue is the law of kindness.

27   She looketh well to the ways of her household, and eateth not the bread of idleness.

28   Her children arise up, and call her blessed; her husband also, and he praiseth her.

29   Many daughters have done virtuously, but thou excellest them all.

30   Favour is deceitful, and beauty is vain:  but a woman that feareth the Lord, she shall be praised.

31   Give her of the fruit of her hands; and let her own works praise her in the gates.

## B.  PAUL OF TARSUS AND EARLY CHRISTIANITY

*In the following excerpt from* Women in Antiquity, *the Cambridge classicist Charles Seltman summarizes the early Christian attitude to women.  He quotes collectively the three most relevant passages from St. Paul's letters to the Corinthians, which were endlessly recited and embroidered in the later writings of the Church Fathers and again by the sixteenth- and seventeenth-century reformers.  These Pauline passages became the basis for the entire Christian view of woman.*

*In addition to Dr. Seltman's suggestions for the reasons behind Paul's attitude to women, two others ought not to be ignored.  First, Paul of Tarsus was a Greek Jew who had been raised very firmly in the Jewish ritual tradition.  His insistence on women's silence in church and covering in public are an integral part of his background.  Second, Paul's relevant passages on women are addressed almost exclusively to the people of Corinth.  This seaport was known throughout ancient times as the seat of the temple of Aphrodite, the goddess whose handmaidens prostituted themselves with travelers and sailors as part of the religious cult of Aphrodite.  This type of religious behavior would certainly clash with Paul's conception of a devout woman.  He therefore reemphasized in his letters to the Corinthians the conventional Hebrew view of women in a place of worship.*

WOMEN IN ANTIQUITY

Charles Seltman

Round about the middle of the 1st century of our era a
new, idealistic, and Utopian conception of the cosmos began to
exert upon the civilised world a slow, levelling pressure, as
of an iron passed over fine linen.  The content of this un-
official and unpopular concept, though of Jewish origin, was
leavened by Hellenism, and it arose from the example, precept,
and teaching of Jesus of Nazareth, who was crucified outside
the walls of Jerusalem at the age of thirty-three in the year
A.D. 30, and was claimed by His followers to be the unique
divine manifestation on earth.  From our point of view what
matters is this:  according to the received Gospels, it is
clear that Jesus was a feminist to a degree far beyond that of
His fellows and followers.  An early public appearance was at
a wedding; there are parables and episodes—not always clearly
differentiated—with women as central figures:  the widow seek-
ing her mite, or giving it; the woman of Samaria with the out-
look of a Greek girl-companion; a little girl, Jairus' daughter,
brought back to health; the woman with a "bloody flux" who
touched the hem of His garment; Mary and her sister Martha; the
"woman taken in adultery"; another who bathed His feet in per-
fume and dried them with her hair; His Mother and the woman at
the foot of the Cross; the opened tomb discovered by Mary of
Magdala—the twentieth chapter of the Gospel according to St.
John is pure poetry.  From the youngest to the oldest, from
little children—half of them presumably little girls—whom He
bade His followers to leave beside Him, up to the sick old
woman, St. Peter's mother-in-law, whom He cured, the Messiah was
ever concerned with females as much as with men.  No other West-
ern prophet, seer, or would-be redeemer of humanity was so de-
voted to the feminine half of mankind.  This cannot be too much
emphasised because of the perversities of doctrine which ensued
among male creatures professing not only to adore the First and
Third Persons of the Trinity, but also to imitate the example
of the Second.
     The observation has frequently been made that a beginning
of somewhat nonsensical anti-feminism was due, in the first
instance, to Paul of Tarsus, though subsequently others, taking
up the theme, wrote far more ungraciously about women than ever
Paul had done.  Several factors require consideration:  the

Charles Seltman, *Women in Antiquity* (London and New York:
Thames and Hudson, 1956), pp. 184-88.  Reprinted by permission
of Thames and Hudson, Ltd.

background of Graeco-Roman civilisation, with its real respect
for women; the legal status achieved by women and their ability
to fill responsible posts in civil life; the continuing love of
female beauty expressed alike by poets, painters, and sculptors;
and, lastly, a freedom in matters of sex—rarely indulged to
excess—inherent in a society uninhibited at all class levels.

For a variety of reasons, all this really appears to have
been repugnant to Paul of Tarsus.  Conceivably the circum-
stances leading to his conversion had something to do with his
attitude, since he witnessed the death of Stephen, the proto-
martyr, a young man of great beauty, and his mind could have
been temporarily unhinged by the sight of the torture.  Indeed,
it seems likely that Paul and Plato had something in their men-
talities which was alike.  That the former preferred male
society seems beyond dispute as much as the fact that he shrank
from anything like women in authority.  It has been suggested
that the time which he spent in Ephesus between A.D. 52 and
A.D. 54 had something to do with crystallising his attitude to
women.  In such circumstances, Paul, a genius in rebellion
against society, was bound to run into trouble; and letters he
wrote from Ephesus prove that he spent some time in prison and
believed his life endangered, though his Roman citizenship
assured him of relative immunity.  If he wrote some of those
letters from prison, a good deal becomes clear; and a number of
modern scholars hold that, while in confinement there, he pro-
duced two letters to the Corinthians, as well as a letter to
the Colossians, and a letter to Philemon about a runaway
slave-boy.

The letters to the Corinthians seem to reveal certain pre-
occupations that troubled Paul during his comparatively long
residence in Ephesus.  He had worries about money, idols, sex,
and female liberty, and indeed he was most upset about sex and
female liberty because he observed the absolute freedom, greater
than anywhere else, enjoyed by the women of the city, and of
all Ionia and Phrygia.  But to Paul it all seemed great wicked-
ness; and, endowed as he was with infinite courage, he dared to
denounce it.  His feeling came through in his letters from
Ephesus to the churches of his foundation.  Thus to the Corin-
thians he wrote:

> To the unmarried and to widows I would say this:
> it is an excellent thing if, like me, they remain as
> they are.  Yet if they cannot contain, let them marry,
> for it is better to marry than to burn [with passion].
> . . .[1]

---

[1] 1 Corinthians 7:8-9.

> Let those who have wives live as if they had
> none; let mourners live as though they were not
> mourning; let the joyful live as if they had no
> joy.
>    Man ought not to cover his head, for he repre-
> sents the likeness and supremacy of God; but woman
> represents the supremacy of man.  Man was not made
> from woman, woman was made from man; and man was not
> created for woman, but woman for man.  Therefore, in
> view of the angels, woman must wear a symbol of sub-
> jection on her head. . . . Is it proper for an un-
> veiled woman to pray to God?[2]
>    Women must keep quiet at gatherings of the
> church.  They are not allowed to speak; they must
> take a subordinate place, as the Law enjoins.  If
> they want any information let them ask their hus-
> bands at home; it is disgraceful for a woman to
> speak in church.[3]

And to the Colossians:

> Wives, be subject to your husbands; that is
> your proper duty in the Lord.
>    Husbands, love your wives, do not be harsh
> to them.

For Paul sex was indeed a misfortune withdrawing man's
interest from heavenly things.  Yet, in spite of all this, it
would be a mistake to overstress Paul's preoccupation with
inescapable misogyny, even if it was part of his own make-up.
He, the Apostle of the Gentiles, produced long passages of
superb writing which have ever since inspired mankind.

*In his letter to the Ephesians Paul reiterated the sub-
missiveness and reverence wives owe to their husbands but
emphasized the positive strain that entered Western thought
with Christianity.  This strain negated the ancient Middle-
Eastern concept that wives were merely possessions of their
husbands, bought with a bride-price for the sake of forming
or strengthening a family.  Husbands, said Paul, should love
their wives as they love themselves.*

---

[2] 1 Corinthians 11:7-15.

[3] 1 Corinthians 14:34-35.

EPHESIANS 5:22-33

22  Wives, submit yourselves unto your own husbands, as
unto the Lord.
23  For the husband is the head of the wife, even as
Christ is the head of the church:  and he is the saviour of
the body.
24  Therefore as the church is subject unto Christ, so
let the wives be to their own husbands in every thing.
25  Husbands, love your wives, even as Christ also loved
the church, and gave himself for it;
26  That he might sanctify and cleanse it with the washing
of water by the word,
27  That he might present it to himself a glorious church,
not having spot, or wrinkle, or any such thing; but that it
should be holy and without blemish.
28 ·So ought men to love their wives as their own bodies.
He that loveth his wife loveth himself.
29  For no man ever yet hated his own flesh; but nour-
isheth and cherisheth it, even as the Lord the church:
30  For we are members of his body, of his flesh, and of
his bones.
31  For this cause shall a man leave his father and mother,
and shall be joined unto his wife, and they two shall be one
flesh.
32  This is a great mystery:  but I speak concerning Christ
and the church.
33  Nevertheless let every one of you in particular so love
his wife even as himself; and the wife see that she reverence
her husband.

## C. PATRISTIC ANTIFEMINISM FROM THE SECOND
## TO THE FIFTH CENTURY A.D.

*In the introduction to her* History of Misogyny in Literature
*Katherine M. Rogers summarizes the patristic attitude to women.
Because the patristic literature formed the major part of Chris-
tian reading during the Middle Ages and beyond, it is important
to see how the Fathers expressed themselves on the subject of
women.  In order to understand the Fathers' attitude, it is
equally important to visualize their urgent rhetoric against
sexual temptation as part of the total historical scene of the
Christian community within the Roman Empire.  An indication of
this scene was sketched in the introductory passage to Part 2.
It would seem that the relentless patristic antifeminism
should have produced a feeling of inferiority and submissiveness*

*in women, but history does not offer evidence to show that women
of the early Christian era felt repressed.  Of course women did
not write history, but a number of strong women of the period
appear to have found satisfaction in the faith whose contempor-
ary literature described femininity in daunting terms.  One of
these women is Helena, the mother of Emperor Constantine, who
designated Christianity as the official religion of the Roman
Empire.  Another was Monica, the mother of Augustine, who is
known as the greatest Christian protagonist of all.  Augustine
was slow to accept Christianity, and in his* Confessions *he
credits his mother with his conversion to the faith.  St. John
Chrysostom's mother, Anthusia, an aristocrat of Antioch, was
also responsible for her famous son's entry into the Christian
fold.*

## THE TROUBLESOME HELPMATE:  A HISTORY OF MISOGYNY IN LITERATURE

Katherine M. Rogers

By the time of Tertullian (160-230), the Christian aver-
sion to sex had hardened into universally accepted dogma.
Although in youth Tertullian had made the unfortunate mistake
of getting married, he later felt deep remorse for his lapse
and ultimately joined the Montanists, a sect even harsher in
sexual matters than the orthodox Christians.  (Some of his
views are now considered heretical, but he is still recognized
as an important authority.)  His three treatises against re-
marriage, which show progressively more rigor as he moved into
the Montanist camp, are primarily a repudiation of sex, but
also of women.  Even in the first treatise, he assumed that
women were ruled by unworthy motives and did not consider the
possibility of loving companionship in marriage.  Dissuading
his wife from remarriage if he should predecease her, he listed
as her only possible motives lust and the desire to rule another
man's household and spend his hard-earned money.  If she longs
for children she should remember that only the childless, those
with "no burdensome fruit of marriage heaving in the womb, none
in the bosom," will be able to serve the Lord at his second
coming.

---

In his tracts on women's dress, Tertullian's condemnation
of the female sex became explicit.  Although addressed to his
"best beloved sisters," "On the Apparel of Women" soon abandons
any pretense of gentleness.  Any woman who realized her (that
is, woman's) condition, he says, would "affect meanness of
appearance, walking about as Eve mourning and repentant, in
order that by every garb of penitence she might the more fully
expiate that which she derives from Eve,—the ignominy . . . of
the first sin and the odium of . . . human perdition."  The
judgment of God upon women, that is, labor pains and subjection
to men, endures even today; and so does their guilt:

> *You* are the devil's gateway . . . *you* are the first
> deserter of the divine law; *you* are she who persuaded
> him whom the devil was not valiant enough to attack.
> *You* destroyed so easily God's image, man.  On account
> of *your* desert—that is, death—even the Son of God
> had to die.

A woman must not only refrain from enhancing her appearance, but
also "by concealment and negligence" erase the signs of natural
beauty as "equally dangerous" to anyone she meets.  While physi-
cal beauty is not actually a crime, "it is to be *feared*, just on
account of the injuriousness and violence of suitors."  Every
woman must wear a veil—a mother for her sons' sakes, a sister
for her brothers', a daughter for her father's—since "All ages
are perilled" in her person.

While Tertullian's attitude toward women was unusually
vindictive, all of its elements—a low conception of woman's
motives and functions, disparagement of motherhood, dread of
female attractiveness, heavy emphasis on woman's responsibility
for the Fall—may be found in his contemporaries and successors
among the Fathers.  All of them followed to the letter St. Paul's
dictates on the subjection of women.  St. Augustine quoted with
approval what his sainted mother, Monica, said to women who cri-
ticized their husbands in her presence:  that they should con-
sider their matrimonial contracts "as legal forms by which they
had become slaves," and should conduct themselves accordingly.

All the Church Fathers accepted as axiomatic that marriage
was a state morally inferior to virginity and that sexual inter-
course could be justified only by the obligation to procreate.
The unique excellence of virginity was a favorite subject for
moral tracts; at least one discourse on this subject appears in
the works of almost every prolific writer.  St. Augustine in-
geniously proved that the Old Testament patriarchs had sexual
intercourse solely because they were obliged to procreate;
Jacob, indeed, would have preferred to abstain from begetting
children, and only did so because his wives insisted.

The connection between condemnation of sex and misogyny

becomes obvious in an anecdote which St. Augustine related in
his "Soliloquies." One day his reason convinced him "How vile,
how detestable, how shameful, how dreadful" was "the embrace of
a woman." That very night, he admitted, he indulged in sensual
fantasies; but the following day he was again convinced that
there is "nothing which brings the manly mind down from the
heights more than a woman's caresses and that joining of bodies
without which one cannot have a wife." Although they believed
theoretically that sexual relations were equally defiling for
both sexes, the Fathers naturally, as men, emphasized women's
corrupting influence on men rather than men's on women.

St. John Chrysostom, a mild and gentle man whose writings
consist mainly of sermons addressed to a worldly flock at
Antioch, did not indulge in excoriations of women. But he
shared the general belief in their degrading influence: "How
often do we, from beholding a woman, suffer a thousand evils;
returning home, and entertaining an inordinate desire, and
experiencing anguish for many days. . . . The beauty of woman
is the greatest snare." A son, he advised, should be kept away
from all women, except possibly some charmless old maidservant;
"from a young woman shield him as from fire." This is no young
monk, it is important to realize, but a boy who is to marry and
lead an ordinarily virtuous life in this world; and the whole
treatise, far from displaying rancor, is a gentle exhortation.

When St. John was concerned with monks' relationships with
women he used far stronger language. Although he had adapted
himself to the world, he was ascetic by nature and believed
virginity to be the only really good life. So when a young man
abandoned his monastic vocation and became engaged to be mar-
ried, St. John was moved to write "An Exhortation to Theodore
After His Fall." Theodore should think carefully about the
probable consequences of association with women, about David's
adultery and Solomon's apostasy. And he should consider the
true nature of that female beauty for which he is about to cast
off his virtue:

> . . . if you consider what is stored up inside those
> beautiful eyes, and that straight nose, and the mouth
> and the cheeks, you will affirm the well-shaped body
> to be nothing else than a whited sepulchre; the parts
> within are full of so much uncleanness. Moreover when
> you see a rag with any of these things on it, such as
> phlegm, or spittle you cannot bear to touch it with
> even the tips of your fingers, nay you cannot even
> endure looking at it; and yet are you in a flutter of
> excitement about the storehouses and depositories of
> these things?

So why not "release yourself from your accursed bondage, and
return to your former freedom?"

In some ways St. Jerome was more favorably disposed toward
women than any other Father of the Church.  He enjoyed teaching
women and found his closest friends, such as Paula and her
daughter Eustochium, among them.  He stoutly defended his
friendships with women on the ground that there was no cause
for shame in associating with that sex from which the Virgin
Mary had come.  Yet, as a fanatical advocate of virginity, he
attacked married life in withering terms and warned men against
women's seductive powers.  He himself, even while starving as
an ascetic in the desert, was often tormented by visions of
dancing girls.  He warned a clergyman against allowing a woman
to enter his house or sitting alone with one in a quiet place:
"You cannot be a man more saintly than David, or more wise than
Solomon.  Remember always that a woman drove the tiller of
Paradise from the garden that had been given him."  St. Jerome
reveals a curious split between real admiration for virgins
and widows who abstained from remarriage—women seen as spiri-
tual companions—and distaste for them as sexual objects.

When a man named Helvidius dared to take literally the
Biblical reference to Jesus' brothers, concluding that Mary
must have had relations with Joseph after the virgin birth, St.
Jerome was moved to fury by the obscene blasphemy:  ". . . you
have defiled the sanctuary of the Holy Spirit from which you
are determined to make a team of four brethren and a heap of
sisters come forth."  How inexpressibly disgusting to think of
Mary behaving like an ordinary wife, being agreeable to her
husband and having about her "children watching for her word
and waiting for her kiss"!  St. Jerome saw nothing in the least
attractive in motherhood:  pregnant women he considered "a re-
volting sight," and he could not imagine why anyone would want
progeny, "a brat . . . to crawl upon his breast and soil his
neck with nastiness."

Thus, while St. Jerome esteemed certain women, he exalted
them at the expense of their sex.  His violent depreciation of
women'a most important and most prized biological function is
at least an indirect expression of strong hostility.  It took
furious indignation against Jovinian, who had dared to maintain
that marriage was as virtuous a state as virginity, to bring
St. Jerome's latent misogyny into the open.  After overwhelming
Jovinian with Biblical arguments proving that marriage is a
defilement resulting from the Fall, St. Jerome appealed to the
authority of Solomon, as one thoroughly experienced in conjugal
affairs.  And he then proceeded to misinterpret texts from
Proverbs so as to show through the experiences of a man "who
suffered through them, what a wife or woman is."  He justified
his citing of three texts about whores and one about a termagant
as general characterizations of wives by this argument:  "What

necessity rests upon me to run the risk of the wife I marry
proving good or bad? . . . How seldom we find a wife without
these faults [contentiousness and passion], he knows who is
married." Where Proberbs mentions the insatiability of the
barren womb, obviously referring to a barren woman's longing
for children, St. Jerome read that woman's sexual desire is
never satisfied. Where Proverbs lists an odious wife among
the four things which the earth cannot bear, St. Jerome
interpreted that "a wife is classed with the greatest evils."
Then, after quoting at length from Theophrastus' lost book
on the disadvantages of marriage, a book "worth its weight
in gold," he triumphantly drew up a long list of bad wives,
including Terentia who married three times, railing Xanthippe
who emptied dirty water on Socrates' head, Metella who was
openly unchaste, drunken Actoria Paula who defied her husband
Cato, Olympias who shut Philip of Macedon out of his own
bedroom.

Because they were following in the tradition of St. Paul
and were all overconcerned with woman as a potential seducer,
even the gentlest of the Fathers could not resist an occa-
sional reference to Eve's responsibility for the Fall, which
passed as a hereditary taint to all her daughters. St.
Augustine's account of the Fall in the *City of God* was typi-
cal in exonerating Adam as much as possible. Just like Solomon,
who was not "deceived into believing in the worship of idols,
but was merely won over to this sacrilege by feminine flattery,"
"Adam transgressed the law of God, not because he was deceived
into believing that the lie was true, but because in obedience
to a social compulsion he yielded to Eve, as husband to wife,
as the only man in the world to the only woman." It was be-
cause of Eve's guilt that Christ was born of a woman, an other-
wise inexplicable fact. If he had not been:

> . . . women might have despaired of themselves, as
> mindful of their first sin, because by a woman was
> the first man deceived, and would have thought that
> they had no hope at all in Christ. . . . The poison
> to deceive man was presented him by woman, through
> woman let salvation for man's recovery be presented;
> so let the woman make amends for the sin by which
> she deceived the man, by giving birth to Christ.

It went without saying that Christ had to be male, but woman was
allowed to make some small contribution to the redemption of
humanity. Besides, Christ, being divine, could not be defiled
by contact with the female sex.

While the Fathers were by no means all Tertullians, most of
them not only enthusiastically followed St. Paul's teaching on
man's Fall and the consequent subjection of women, but accentuated

and elaborated the Biblical material on their own. Every one of
the major Christian writers from the first century through the
sixth assumed the mental and moral frailty of women, dwelt upon
the vexations of marriage, and reviled the body and sexual de-
sire. This attitude was to pervade the medieval Church and
persists into religious writings even today.

It is unfortunate that the exponents of Christian thought
during these early centuries were clerical celibates, men whose
attitude toward women would almost necessarily be distorted.
Even those who could bring themselves to associate with women
insisted that they desexualize themselves, branding any distinc-
tively feminine characteristics as degrading and polluting.
Under the guidance of the Fathers, Christian literature became
misogynistic to a degree unequaled in the Western world before
or since. It had reached the point where Christ's association
with women had to be explained away on the ground that other-
wise the sin-laden female sex could not even hope for redemption.

Although the Fathers may have derived from Jewish tradition
their fear of woman's seductive influence and their belief that
she is frailer than man and should be kept subject to him, the
major cause of their misogyny was undoubtedly their condemnation
of sexual desire. From the myth of the Fall, from the stories
of Samson, David, and Solomon, from a number of apparently
neutral Biblical texts, they derived the conviction that woman's
attractiveness is the greatest possible peril to man's soul. In
an effort to nullify her pernicious influence, they repeatedly
insisted that the female body is not really an attractive object,
but a vessel of filth, and that the production of children is
not a joyful and rewarding experience, but a degradation.

## D. ST. JEROME: A GIRL'S EDUCATION

*Of all the Fathers of the Church, St. Jerome (340-420) was
the most interested in scholarship. It is not surprising that
among his vast literary output (which includes the Latin Vulgate
translation of the Bible from Greek and Hebrew) there is a let-
ter formulating his thoughts on the education of girls.*

*Christians in search of greater spirituality had discovered
the monastic life, which during the fourth century began to have
great appeal. Jerome preached its virtues, attracting a number
of wealthy Roman matrons and widows who began to study the
Scriptures with him. Among these matrons was Paula and her
daughter Eustochium, who accompanied the scholar to Bethlehem.
There they founded three nunneries and a monastery, where
Jerome did most of his literary work. In 403 he wrote the
letter excerpted below to Paula's daughter-in-law, advising her
on the education of her newborn girl child. It was his hope*

*that the child would be brought up as a virgin dedicated to God.*

*Following Paul, like all the Church Fathers, Jerome believed that virginity and celibacy were the best road to salvation. His prescription for the little Paula guarded her carefully from persons or materials that might expose her to sexual temptation or cause her to become such a temptation to men. Because he was a true scholar, however, he wanted her to become involved in scholarly activity, and his advice on her early school training tells us much about early Christian methods of education and Jerome's intuitive understanding of child psychology. With his emphasis on what Paula should not be taught and what type of clothing, jewelry, and makeup should be avoided, Jerome also pinpoints the extravagances of imperial Roman women of his time.*

## LETTER ON A GIRL'S EDUCATION, A.D. 403

### St. Jerome

It was my intention, in answer to your prayers and those of the saintly Marcella, to direct my discourse to a mother, that is, to you, and to show you how to bring up our little Paula, who was consecrated to Christ before she was born, the child of prayers before the hour of conception. . . .
. . . let your child of promise have a training from her parents worthy of her birth. Samuel was nurtured in the Temple, John was trained in the Wilderness. The one inspired veneration with his long hair, took neither wine nor strong drink, and even in his childhood talked with God. The other avoided cities, wore a skin girdle, and fed on locusts and wild honey, clothing himself in the hair of the most twisted of all animals as a symbol of the repentance which he preached.
Thus must a soul be trained which is to be a temple of God. It must learn to hear nothing and to say nothing save what pertains to the fear of the Lord. It must have no comprehension of foul words, no knowledge of worldly songs, and its childish tongue must be imbued with the sweet music of the psalms. Let boys with their wanton frolics be kept far from Paula: let even her maids and attendants hold aloof from association with

Saint Jerome, *Select Letters*, trans. by F. A. Wright, The Loeb Classical Library (London: Putnam, 1933), pp. 343-65. Reprinted by permission of Harvard University Press and the Loeb Classical Library.

the worldly, lest they render their evil knowledge worse by
teaching it to her. Have a set of letters made for her, of
boxwood or of ivory, and tell her their names. Let her play
with them, making play a road to learning, and let her not
only grasp the right order of the letters and remember their
names in a simple song, but also frequently upset their order
and mix the last letters with the middle ones, the middle with
the first. Thus she will know them all by sight as well as by
sound. When she begins with uncertain hand to use the pen,
either let another hand be put over hers to guide her baby
fingers, or else have the letters marked on the tablet so that
her writing may follow their outlines and keep to their limits
without straying away. Offer her prizes for spelling, tempt-
ing her with such trifling gifts as please young children. Let
her have companions too in her lessons, so that she may seek to
rival them and be stimulated by any praise they win. You must
not scold her if she is somewhat slow; praise is the best sharp-
ener of wits. Let her be glad when she is first and sorry when
she falls behind. Above all take care not to make her lessons
distasteful; a childish dislike often lasts longer than child-
hood. The very words from which she will get into the way of
forming sentences should not be taken at haphazard but be
definitely chosen and arranged on purpose. For example, let
her have the names of the prophets and the apostles, and the
whole list of patriarchs from Adam downwards, as Matthew and
Luke give it. She will then be doing two things at the same
time, and will remember them afterwards.

For teacher you must choose a man of approved years, life
and learning. Even a sage is not ashamed, methinks, to do for
a relative or for a high-born virgin what Aristotle did for
Philip's son, when like some humble clerk he taught him his
first letters. Things must not be despised as trifles, if
without them great results are impossible. The very letters
themselves, and so the first lesson in them, sound quite differ-
ently from the mouth of a learned man, and of a rustic. And so
you must take care not to let women's silly coaxing get your
daughter into the way of cutting her words short, or of dis-
porting herself in gold brocade and fine purple. The first
habit ruins talk, the second character; and children should
never learn what they will afterwards have to unlearn. We are
told that the eloquence of the Gracchi was largely due to the
way in which their mother talked to them as children, and it
was by sitting on his father's lap that Hortensius became a
great orator. The first impression made on a young mind is
hard to remove. The shell-dyed wool—who can bring back its
pristine whiteness? A new jar keeps for a long time the taste
and smell of its original contents. Greek history tells us
that the mighty king Alexander, who subdued the whole world,
could not rid himself of the tricks of manner and gait which in

his childhood he had caught from his governor Leonides.  For it
is easy to imitate the bad, and you may soon copy the faults
of those to whose virtue you can never attain.  Let Paula's
foster-mother be a person neither drunken nor wanton nor fond
of gossip:  let her nurse be a modest woman, her foster-father
a respectable man.  When she sees her grandfather, she must
leap into his arms, hang on his neck, and sing "Alleluia"
whether he likes it or not.  Let her grandmother snatch her
away, let her recognize her father with a smile, let her
endear herself to all, so that the whole family may rejoice
that they have such a rosebud among them.  Let her learn too
at once who is her other grandmother and her aunt, who is her
captain and for whose army she is being trained as a recruit.
Let her crave their company and threaten you that she will
leave you for them.

Her very dress and outward appearance should remind her of
Him to whom she is promised.  Do not pierce her ears, or paint
with white lead and rouge the cheeks that are consecrated to
Christ.  Do not load her neck with pearls and gold, do not
weigh down her head with jewels, do not dye her hair red and
thereby presage for her the fires of hell.  Let her have other
pearls which she will sell hereafter and buy the pearl that is
of great price.  There was once a lady of rank named Praetextata,
who at the bidding of her husband Hymetius, the uncle of Eusto-
chia, altered that virgin's dress and appearance, and had her
hair waved, desiring thus to overcome the virgin's resolution
and her mother's wishes.  But lo! that same night in her dreams
she saw an angel, terrible of aspect, standing before her, who
threatened her with punishment and broke into speech thus:
"Have you dared to put your husband's orders before those of
Christ?  Have you presumed to lay sacrilegious hands upon the
head of God's virgin?  Those hands this very hour shall wither,
and in torment you shall recognize your guilt, until at the
fifth month's end you be carried off to hell.  Moreover, if you
persist in your wickedness, you shall lose both your husband and
your children."  All this was duly fulfilled, and a swift death
marked the unhappy woman's late repentance.  So it is that
Christ takes vengeance upon the violators of his temple, so he
defends his pearls and precious jewels.  I have told you this,
not with any wish to exult over the downfall of the wretched,
but to remind you with what anxiety and carefulness you must
watch over that which you have vowed to the Lord. . . .

When Paula begins to be a big girl, and like her Spouse
to increase in wisdom and stature and in favour with God and
man, let her go with her parents to the temple of her true
Father, but let her not come out from the temple with them.
Let them seek her upon the world's highway, amid crowds and
the company of their kinsfolk, but let them find her nowhere
save in the shrine of the Scriptures, inquiring there of the

prophets and apostles concerning her spiritual nuptials. Let
her take pattern by Mary whom Gabriel found alone in her cham-
ber, Mary who perchance was terrified because she saw a strange
man. Let her seek to rival that one of whom it is said: "All
the glory of the king's daughter is from within." Wounded with
love's arrow let her too say to her chosen: "The king hath
brought me into his chamber." At no time let her go out abroad,
lest those that go about the city find her, lest they smite her
and wound her and take away the veil of her chastity and leave
her naked in her blood. Nay rather, when one knocketh at her
door let her say: "I am a wall and my breasts are a tower. I
have washed my feet; how can I defile them?"

She should not take her food in public, that is, at her
parents' guest-table; for she may there see dishes that she will
crave for. And though some people think it shows the higher vir-
tue to despise a pleasure ready to your hand, I for my part
judge it part of the surer self-restraint to remain in ignorance
of what you would like. Once when I was a boy at school I read
this line: "Things that have become a habit you will find it
hard to blame." Let her learn even now not to drink wine "where-
in is excess." Until they have reached their full strength,
however, strict abstinence is dangerous for young children: so
till then, if needs must, let her visit the baths, and take a
little wine for the stomach's sake, and have the support of a
meat diet, lest her feet fail before the race begins. "I say
this by way of indulgence and not by way of command," fearing
weakness, not teaching wantonness. Moreover, what the Jewish
superstition does in part, solemnly rejecting certain animals
and certain products as food, what the Brahmans in India and the
Gymnosophists in Egypt observe on their diet of only porridge,
rice, and fruit, why should not Christ's virgin do altogether?
If a glass bead is worth so much, surely a pearl must have a
higher value. The child of promise must live as those lived
before her who were born under the same vow. Let an equal
favour bring with it also an equal labour. Paula must be deaf
to all musical instruments, and never even know why the flute,
the lyre, and the harp came into existence.

Let her every day repeat to you a portion of the Scriptures
as her fixed task. A good number of verses she should learn by
heart in the Greek, but knowledge of the Latin should follow
close after. If the tender lips are not trained from the
beginning, the language is spoiled by a foreign accent and our
native tongue debased by alien faults. You must be her teacher,
to you her childish ignorance must look for a model. Let her
never see anything in you or her father which she would do
wrong to imitate. Remember that you are a virgin's parents and
that you can teach her better by example than by words. Flowers
quickly fade; violets, lilies, and saffron are soon withered by
a baleful breeze. Let her never appear in public without you,

let her never visit the churches and the martyrs' shrines except
in your company.  Let no youth or curled dandy ogle her.  Let
our little virgin never stir a finger's breadth from her mother
when she attends a vigil or an all-night service.  I would not
let her have a favourite maid into whose ear she might frequent-
ly whisper: what she says to one, all ought to know.  Let her
choose as companion not a spruce, handsome girl, able to warble
sweet songs in liquid notes, but one grave and pale, carelessly
dressed and inclined to melancholy.  Set before her as a pat-
tern some aged virgin of approved faith, character, and chastity,
one who may instruct her by word, and by example accustom her to
rise from her bed at night for prayer and psalm singing, to
chant hymns in the morning, at the third, sixth, and ninth hour,
to take her place in the ranks as one of Christ's amazons, and
with kindled lamp to offer the evening sacrifice.  So let the
day pass, and so let the night find her still labouring.  Let
reading follow prayer and prayer follow reading.  The time will
seem short when it is occupied with such a diversity of tasks.

Let her learn also to make wool, to hold the distaff, to
put the basket in her lap, to turn the spindle, to shape the
thread with her thumb.  Let her scorn silk fabrics, Chinese
fleeces, and gold brocades.  Let her have clothes which keep
out the cold, not expose the limbs they pretend to cover.  Let
her food be vegetables and wheaten bread and occasionally a
little fish.  I do not wish here to give long rules for eating,
since I have treated that subject more fully in another place;
but let her meals always leave her hungry and able at once to
begin reading or praying or singing the psalms.  I disapprove,
especially with young people, of long and immoderate fasts,
when week is added to week and even oil in food and fruit are
banned.  I have learned by experience that the ass on the high
road makes for an inn when it is weary.  Leave such things to
the worshippers of Isis and Cybele, who in gluttonous abstinence
gobble up pheasants and turtle doves all smoking hot. . . .

If ever you visit the country, do not leave your daughter
behind at Rome.  She should have neither the knowledge nor the
power to live without you, and should tremble to be alone.  Let
her not converse with worldlings, nor associate with virgins
who neglect their vows.  Let her not be present at slaves' wed-
dings, nor take part in noisy household games.  I know that some
people have laid down the rule that a Christian virgin should
not bathe along with eunuchs or with married women, inasmuch as
eunuchs are still men at heart, and women big with child are a
revolting sight.  For myself I disapprove altogether of baths
in the case of a full-grown virgin.  She ought to blush at
herself and be unable to look at her own nakedness.  If she
mortifies and enslaves her body by vigils and fasting, if she
desires to quench the flame of lust and to check the hot de-
sires of youth by a cold chastity, if she hastens to spoil her

natural beauty by a deliberate squalor, why should she rouse a
sleeping fire by the incentive of baths?

Instead of jewels or silk let her love the manuscripts of
the Holy Scriptures, and in them let her prefer correctness and
accurate arrangement to gilding and Babylonian parchment with
elaborate decorations.  Let her learn the Psalter first, with
these songs let her distract herself, and then let her learn
lessons of life in the Proverbs of Solomon.  In reading Ecclesi-
astes let her become accustomed to tread underfoot the things
of this world; let her follow the examples of virtue and patience
that she will find in Job.  Let her then pass on to the Gospels
and never again lay them down.  Let her drink in the Acts of the
Apostles and the Epistles with all the will of her heart.  As
soon as she has enriched her mind's storehouse with these treas-
ures, let her commit to memory the Prophets, the Heptateuch,
the books of Kings and the Chronicles, and the rolls of Ezra and
Esther.  Then at last she may safely read the Song of Songs:  if
she were to read it at the beginning, she might be harmed by not
perceiving that it was the song of a spiritual bridal expressed
in fleshly language.

# 3

## NUNNERIES AS THE MEDIEVAL ALTERNATIVE TO MARRIAGE

*In the sixth century A.D. a new type of monasticism devel-*
*oped in Western Europe. Its format is generally ascribed to*
*Benedict of Nursia, known as St. Benedict. Benedict and his*
*sister Scholastica[1] founded a monastic system for men and women*
*in which austerity for its own sake was deemphasized. Benedic-*
*tine monks and nuns lived a communal, as opposed to a hermetic,*
*life. Their rule imposed a strict hourly timetable in which*
*religious devotion and manual and intellectual labor were care-*
*fully rotated to make each monastery spiritually and practi-*
*cally self-sufficient. The three basic tenets of the Bene-*
*dictine rule were chastity, poverty, and obedience. In due*
*course other new orders also came to relax their insistence on*
*austerity as a way of life. Thus throughout the Middle Ages*
*until the Reformation (sixteenth century), which outlawed all*
*monastic institutions in Protestant countries, the monastic*
*system served a dual purpose in European society: it offered*
*a satisfying life for men and women who felt a genuine vocation*
*to live according to the Christian precepts laid down by the*
*Church Fathers, and it offered an escape from the problems or*
*the tedium of the normal existence of medieval people.*
*For women particularly the monasteries offered certain*
*incentives. Among the early Christianized Franks and Anglo-*
*Saxons, for example, men were polygamous, and some strong-minded*
*women preferred to found or join nunneries rather than to live*
*as one of a retinue of women under masculine domination (3 B).*
*Another reason why women who had no particularly strong reli-*
*gious vocation could be drawn to the monastic life was that it*
*offered a possibility for a woman to gain recognition and power*
*in a society in which, but for occasional exceptions, the direc-*
*tion of great affairs was exclusively in the hands of men. Nuns*
*could and did achieve complete equality with men during the*
*Middle Ages, particularly between the sixth and twelfth centuries.*

---

[1]These figures may be legendary; recent historical scholar-
ship has cast doubts on their existence. However, the Rule of
St. Benedict is a historical fact.

As abbesses (the heads of the larger women's monasteries) they
were the pope's or king's representatives in a given area and
could take their place in political assemblies, such as the
Imperial Diet in Germany.  They ruled over large domains, held
their own judicial courts, and raised armies for their kings as
equals with lordly landowners.  They were educated to the height
of their abilities within the limits of contemporary education.
Because the monasteries were nearly the only places of education
and scholarship throughout most of the Middle Ages and were the
repositories of all classical and patristic literature, intel-
lectually inclined women could find satisfaction only in such
an environment.  Some abbesses sponsored and encouraged future
scholars, both male and female, within their realms of influ-
ence (3 C and D).  Other high-ranking nuns produced scholarly
works themselves (3 D).

   With the institutionalizing of the militaristic system of
feudalism, roughly corresponding in time to the Norman conquest
of England (1066), the the growth of the firmly masculine monas-
tic reform movement of Cluny (tenth and eleventh centuries), the
opportunities for women in the higher echelons of Benedictine
monasticism declined.  No new abbacies for women were created,
in contrast to the large number that were created for men.
Instead, prioresses in charge of (smaller and less important)
priories were subordinated to male abbots.  One of the last new
abbacies created for women was that of Fontevrault, which speci-
fied that the abbess should be a close member of the royal house
of France.  Some of the last of the great abbesses to have left
notably scholarly or administrative reputations were Herrad  (3
D), Hildegard of Bingen (1098-1179), and Heloise (1100-1160).
By 1387, when Chaucer fashioned his delightful and historically
accurate portrait of an English prioress in Canterbury Tales,
the whole monastic system was in a state of decay.  Poverty,
chastity, and obedience were often totally neglected, the most
perfunctory scholarship was no longer expected, and persons us-
ing the monasteries as an escape from the world far outnumbered
those who entered to follow a vocation.  Many parents put their
young daughters into nunneries for life in order to avoid hav-
ing to provide (often crippling) dowries.  This deterioration
of spiritual purpose prompted reformers like Martin Luther to
break with the Catholic Church (c. 1520).

   Although many of the nuns whose convents were dissolved at
the Reformation married (usually former monks), others were
totally disoriented after years of sheltered existence, and much
hardship ensued.  Finally the dissolution of nunneries left a
marked gap for women in Protestant countries, which lasted until
the nineteenth and twentieth centuries.  Not only had nunneries
provided a refuge for girls who had little to offer prospective
husbands but they had also provided an outlet for women whose
talents and interests were not primarily those of wives and

*mothers and a congenial atmosphere for many widows who ended
their years within a nunnery's spiritually and physically
comforting walls.*

# A. A BASIC RULE FOR NUNNERIES IN THE WEST

*One of the earliest regulations for nunneries known in
detail is that of Caesarius, the sixth-century bishop of Arles
in southern France.  Lina Eckenstein summarizes the main points
of Caesarius' rule in the following excerpt.  Some of the points
of the rule unintentionally tell us much about the history of
the time.  For example, the fact that Caesarius stresses that
girls shall not be brought into the convent purely to be raised
and educated there implies that this was common practice in
similar establishments in the sixth century.*

## WOMAN UNDER MONASTICISM

Lina Eckenstein

In the beginning of the 6th century a settlement of nuns
was founded in the south, where monasteries already existed,
perhaps as the result of direct contact with the east.  A rule
of life was drafted for this convent shortly after its founda-
tion.

Caesarius, bishop of Arles . . . , had persuaded his sister
Caesaria to leave Marseilles, where she dwelt in a convent asso-
ciated with the name of Cassian.  His plan was that she should
join him at Arles, and preside over the women who had gathered
there to live and work under his guidance.

Caesarius now marked out a scheme of life for his sister
and those women whom she was prepared to direct.  He arranged
it, as he says himself, according to the teachings of the
fathers of the Church and, after repeated modifications, he
embodied it in a set of rules, which have come down to us.
Great clearness and directness, a high moral tone, and much
sensible advice are contained in these precepts of Caesarius.
"Since the Lord," he says, addressing himself to the women,

Lina Eckenstein, *Woman under Monasticism* (Cambridge:  Cam-
bridge University Press, 1896), pp. 48-49.  Reprinted by per-
mission of Cambridge University Press.

"has willed to inspire us and help us to found a monastery for you, in order that you may abide in this monastery, we have culled spiritual and holy injunctions for you from the ancient fathers; with God's help may you be sheltered, and dwelling in the cells of your monastery, seeking in earnest prayer the presence of the Son of God, may you say in faith, 'we have found him whom we sought.' Thus may you be of the number of holy virgins devoted to God, who wait with tapers alight and a calm conscience, calling upon the Lord.—Since you are aware that I have worked towards establishing this monastery for you, let me be one of you through the intercession of your prayer."

Caesarius goes on to stipulate that those who join the community, whether they be maidens or widows, shall enter the house once for all and renounce all claims to outside property. Several paragraphs of the rule are devoted to settling questions of property, a proof of its importance in the mind of Caesarius. There were to be in the house only those who of their own accord accepted the routine and were prepared to live on terms of strictest equality without property or servants of their own.

Children under the age of six or seven were not to be received at all, "nor shall daughters of noble parentage or lowly-born girls be taken in readily to be brought up and educated."

This latter injunction shows how the religious at this period wished to keep the advantages to be derived from artistic and intellectual training in their own community. They had no desire for the spread of education, which forms so characteristic a feature of the religious establishments of a later date.

After their safe housing the instruction of the nuns at Arles was the most important matter dealt with in the "rule." Considerable time and thought were devoted to the practice of chants and to choir-singing, for the art of music was considered especially fitted to celebrate God. In an appendix to the rule of Caesarius the system of singing is described as similar to that adopted in the cœnobite settlement at Lerins. Apparently following Keltic usage, the chant was taken up in turn by relays of the professed, who kept it up night and day all the year round in perpetual praise of the Divinity. At this period melody and pitch were the subjects of close study and much discussion. The great debt owed by the art of music to the enthusiasm of these early singers is often overlooked.

The women who joined the community at Arles also learned reading and writing ("omnes litteras discant"). These arts were practised in classes, while domestic occupations, such as cooking, were performed in turns. Weaving, probably that of church hangings, was among the arts practised, and the women also spun wool and wove it into material with which they made garments for their own use.

There are further injunctions about tending the infirm,

and stern advice about the hatefulness of quarrels.  Intercourse
with the outside world is restricted, but is not altogether cut
off.

"Dinners and entertainments," says the rule, "shall not be
provided for churchmen, laymen and friends, but women from other
religious houses may be received and entertained."

In the year 506 Caesarius, the author of this rule, was
present at the synod of Agde at which it was decreed that no
nun however good in character should receive the veil, that is
be permanently bound by a vow, before her fortieth year.

## B.   A ROYAL NUN IN THE SIXTH CENTURY IN FRANCE

*One of the seven wives of the "Christianized" Frankish
chieftain Clothacar was Radegund, a descendant of the great
Gothic King Theodoric.  Radegund had an independent spirit.
She left her husband and in 559 founded the convent of the Holy
Cross in a house he had given her at Poitiers.  Her rules were
based on those practiced at Caesaria's women's convent at Arles,
which she first inspected as a model.  Radegund then appointed
an abbess for her convent.  She divided her own activities,
partly helping in the convent and partly trying to keep the
peace in her husband's domain, for this was fought over by
warring factions after his death.*

*There are three contemporary accounts of Radegund's life.
One of the two hundred nuns who made up the membership of "the
Holy Cross" at Radegund's death wrote an account of its found-
ress; the most prolific contemporary historian and a friend of
Radegund's, Gregory of Tours, left another; and the Roman poet
Fortunatus, for whom Radegund and her abbess performed many
kindnesses, left a third, from which a small portion is
excerpted below.*

*In other passages of his work, Fortunatus described how he
used to dine with Radegund and the abbess at the nunnery, eating
all kinds of delicacies and surrounded by a profusion of flowers.
Thus it appears that comfort and even luxury were not entirely
excluded from the self-sacrificing life described below.*

VITA RADEGUNDIS

Fortunatus

While all the nuns were still sleeping, Queen Radegund cleaned and polished shoes and returned them to each nun.  At all times, except on the days of Easter and high festivals or when sickness prevented her, she always led an austere life in sackcloth and ashes, rising for the singing before the congregation arose.  In regard to the convent duties nothing pleased her except to be the first to serve and she chastised herself if she performed a good act later than another nun.  So, sweeping in her turn the convent streets and the corners, cleaning whatever was foul, she did not shrink from taking away the loads whose sight makes others shudder.  Carrying logs in her arms; looking after the hearth with bellows and tongs; falling down and recovering, unhurt; serving the sick beyond her seven-day assignment of labor; cooking the food herself; washing the faces of the ailing; offering hot drinks; she visited those she nursed, returning to her cell fasting.

Who will explain with what eagerness she would keep running to the kitchen, performing her *septimana*?  Finally none of the nuns except herself brought in from the back door whatever wood was needed.  She carried water from the well and distributed it in pitchers.  Cleaning and washing the vegetables, poking up the fire with bellows, washing and bringing in the dishes.  When meals were over, wiping the dishes herself, tidying up the kitchen until it shone, carrying to an assigned spot outside whatever was soiled.  With the most sanctified humility bathing and kissing feet, and while still prostrated begging forgiveness from all for any negligence of which she was guilty.

## C. A NORTHUMBRIAN ABBESS AT THE TIME OF THE LINDISFARNE GOSPELS

*Christianity came to the British Isles by way of Ireland, Scotland, and Northumbria.*[1] *It was a Celtic brand of the faith*

---

Fortunatus, "Vita Radegundis," trans. by H. E. Wedeck, in *Dark and Middle Ages Reader*, ed. by H. E. Wedeck (New York: G. P. Putnam's Sons, Capricorn Books, 1964), p. 202.  Reprinted by permission of G. P. Putnam's Sons.

[1]Northumbria comprised that part of England which now contains the counties of Northumberland, Durham, and Yorkshire.

*that had gradually developed a system of its own while Angles
and Saxons were fighting for the rule of southern England after
the collapse of Romano-British imperialism (fourth century A.D.).
In 597 the Roman Church had sent an envoy (Augustine of Canter-
bury) to catholicize British Christianity, and in 664 at the
Synod of Whitby British Christianity came finally within the
Roman Catholic fold.*

*Whitby, the meeting place of this important ecclesiastical
conference, was in the jurisdiction of one of the most interest-
ing early English abbesses—the abbess Hild.  Hild had been per-
suaded to devote herself to the monastic life in Northumbria by
Aidan, the first bishop of Lindisfarne.  Her rule over the monas-
teries at Hartlepool and Whitby coincides not only with the
important Synod of Whitby but also with the great scholarly and
artistic period of British monasticism, which produced the*
Lindisfarne Gospels *and the* Book of Kells.

*The following passage on the seventh-century abbess Hild
is from Eckenstein's* Woman under Monasticism *and shows the
influential position of Hild in the monastic and ecclesiastical
community.  A number of men who rose to great scholarly and
administrative heights were originally trained under her guidance,
and she was also responsible for popularizing the Christian mes-
sage by her sponsorship of the poet Caedmon and her appreciation
of the power of his vernacular poetry.*

## HILD OF WHITBY

### Lina Eckenstein

[Aidan] now persuaded Hild, who was waiting in Anglia for
an opportunity to cross over to France, where she purposed join-
ing her sister, to give up this plan and to return to the north
to share in the work in which he was engaged.  Hild came and
settled down to a monastic life with a few companions on the
river Wear.  A year later, when Heiu retired to Calcaria, Hild
became abbess at Hartlepool.  She settled there only a few
years before the close of Aidan's career.  He died in 651
shortly after his patron Oswin, whose murder remains the great
stain on the life of his rival Oswiu.

---

Lina Eckenstein, *Woman under Monasticism* (Cambridge:  Cam-
bridge University Press, 1896), pp. 88-95.  Reprinted by permis-
sion of Cambridge University Press.

A 12th century monk, an inmate of the monastery of St. Beeves in Cumberland, has written a life of St. Bega, the patron saint of his monastery, whom he identifies on the one hand with the abbess Heiu, consecrated by Aidan, and on the other with Begu, a nun who had a vision of Hild's death at the monastery of Hackness in the year 680. His narrative is further embellished with local traditions about a woman Bega, who came from Ireland and received as a gift from the Lady Egermont the extensive parish and promontory of St. Beeves, which to this day bear her name.

There has been much speculation concerning this holy woman Bega, but it is probable that the writer of her life combined myths which seem to be Keltic with accounts of two historical persons whom Bede keeps quite distinct. There is no reason to doubt Bede's statements in this matter or in others concerning affairs in the north, for he expressly affirms that he "was able to gain information not from one author only but from the faithful assertion of innumerable witnesses who were in a position to know and remember these things; besides those things," he adds, "which I could ascertain myself." He passed his whole life studying and writing in the monasteries of SS. Peter and Paul, two settlements spoken of as one, near the mouth of the river Wear, close to where Hild had first settled. He went there during the lifetime of Bennet Biscop († 690), the contemporary of Hild and a shining representative of the culture the Anglo-Saxons attained in the 7th century.

Hild settled at Hartlepool about the year 647. Eight years later Oswiu finally routed the army of Penda, whose attacks had been for so many years like a battering ram to the greatness of Northumbria. And in fulfilment of a vow he had made that the Christian religion should profit if God granted him victory, he gave Hild the charge of his daughter Aelflaed "who had scarcely completed the age of one year, to be consecrated to God in perpetual virginity, besides bestowing on the Church twelve estates." Extensive property came with the child into the care of Hild, perhaps including the site of Streaneshalch, which is better known as Whitby, a name given to it at a later date by the Danes. Bede says that Hild here undertook to construct and arrange a monastery.

Bede thus expresses himself on the subject of Hild's life and influence during the term of over thirty years which she spent first as abbess of Hartlepool and then as abbess of Whitby:

"Moreover, Hild, the handmaid of Christ, having been appointed to govern that monastery (at Hartlepool), presently took care to order it in the regular way of life, in all respects, according as she could gain information from learned men. For Bishop Aidan, also, and all the religious men who knew her, were wont to visit her constantly, to love her

devotedly, and to instruct her diligently, on account of her
innate wisdom, and her delight in the service of God.

"When, then, she had presided over this monastery for some
years, being very intent on establishing the regular discipline,
according as she could learn it from learned men, it happened
that she undertook also to construct and arrange a monastery in
the place which is called Streaneshalch; and this work being en-
joined on her, she was not remiss in accomplishing it. For she
established this also in the same discipline of regular life in
which she established the former monastery; and, indeed, taught
there also the strict observance of justice, piety, and chastity,
and of the other virtues, but mostly of peace and charity,
so that, after the example of the primitive Church, there was
therein no one rich, no one poor; all things were common to all,
since nothing seemed to be the private property of any one.
Moreover, her prudence was so great that not only did ordinary
persons, but even sometimes kings and princes, seek and receive
counsel of her in their necessities. She made those who were
under her direction give so much time to the reading of the
Divine Scriptures, and exercise themselves so much in works of
righteousness, that very many, it appeared, could readily be
found there, who could worthily enter upon the ecclesiastical
grade, that is the service of the altar."

In point of fact five men who had studied in Hild's monas-
tery were promoted to the episcopate. Foremost among them is
John, bishop of Hexham (687-705) and afterwards of York († 721),
the famous St. John of Beverley, a canonised saint of the
Church, of whose doings Bede has left an account. In this we
hear of the existence of another monastery for women at Watton
(Vetadun) not far from Whitby, where Bishop John went to visit
the abbess Heriburg, who was living there with her "daughter
in the flesh," Cwenburg, whom she designed to make abbess in
her stead. We hear no more about Watton till centuries later,
but Bede's remark is interesting as showing how natural he felt
it to be that the rule of a settlement should pass from mother
to daughter.

Cwenburg was suffering from a swollen arm which John tells
us was very serious, "since she had been bled on the fourth day
of the moon," "when both the light of the moon and the tide of
the ocean were on their increase. And what can I do for the
girl if she is at death's door?" he exclaims. However his com-
bined prayers and remedies, which were so often efficacious,
helped to restore her.

Actla, another of Hild's scholarly disciples, held the see
of Dorchester, though perhaps only temporarily during the ab-
sence of Aegilberht. A third, Bosa, was archbishop of York be-
tween 678 and 686; Bede speaks of him as a monk of Whitby, a
man of great holiness and humility. Oftfor, another of Hild's
monks, went from Whitby to Canterbury, to study "a more perfect"
system of discipline under Archbishop Theodore († 690), and

subsequently became bishop of Worcester.

The career of these men shows that the system of discipline and education under Hild at Whitby compared favourably with that of other settlements. At the outset she had followed the usages of the Scottish Church, with which she was familiar through her intercourse with Aidan, but when the claims for an independent British Church were defeated at Whitby, she accepted the change and adopted the Roman usage.

The antagonism which had existed from the first appearance of Augustine in England between Roman Christianity and British Christianity as upheld by the Scottish and Welsh clergy took the form of open disagreement in Northumbria. On one side was the craving for ritual, for refinement and for union with Rome; on the other insistence by the Scottish clergy on their right to independence.

Aidan had been succeeded at Lindisfarne by Finnan, owing to whose influence discussion was checked for the time being. But after his death (661) the latent antagonism came to a head over the practical difficulty due to the different dates at which King Oswiu and Queen Eanflaed kept Easter. Thus the way was cleared for the Whitby synod (664), a "gathering of all orders of the Church system," at which the respective claims of Roman and of British Christianity were discussed.

The British interest was represented among others by Colman, Finnan's successor at Lindisfarne, who temporarily held the see at York, and by Aegilberht, bishop of Dorchester. The opposite side was taken by the protégé of Queen Eanflaed, Wilfrith, abbot of Ripon, whose ardour in the cause of Rome had been greatly augmented by going abroad with Bennet Biscop about the year 653. Besides these and other prelates, King Oswiu and his son and co-regent Ealhfrith were present at the synod. The abbess Hild was also there, but she took no part in the discussion.

The questions raised were not of doctrine but of practice. The computation of Easter, the form of the tonsure, matters not of belief but of apparently trivial externals, were the points round which the discussion turned. Owing chiefly to Wilfrith's influence the decision was in favour of Rome, and a strong rebuff was given for a time to the claim for an independent British Church in the north.

The choice of Whitby as the site of the synod marks the importance which this settlement had attained within ten years of its foundation. Those who have stood on the height of the cliff overlooking the North Sea and have let their gaze wander over the winding river course and the strand below can realize the lordly situation of the settlement which occupies such a distinguished place among the great houses and nurseries of culture at Hexham, Wearmouth, Jarrow, Ripon and York.

The property which the monastery held in overlordship

extended along the coast for many miles, and the settlement it-
self consisted of a large group of buildings; for there are
references to the dwellings for the men, for the women, and to
an outlying house for the sick.   These dwellings were gathered
round the ancient British Church of St. Peter, which was situ-
ated under the shelter of the brow of the cliff where King
Eadwin lay buried, and which continued to be the burial-place
of the Northumbrian kings.   Isolated chapels and churches with
separate bands of religious votaries belonging to them lay in
other parts of the monastic property, and were subject to the
abbess of Whitby.   We hear of a minor monastery at Easington
(Osingadun) during the rule of Aelflaed, Hild's successor, and
at Hackness (Hacanos) on the limit of the monastic property,
thirteen miles south of Whitby, a monastery of some importance
had been founded by Hild.   Bands of men and of women dwelt here
under the government of Frigith, and it was here that the nun
Begu had a vision of Hild on the night of her death, when she
saw her borne aloft by attendant angels.

The name of Hild and the monastery at Whitby are further
endeared to posterity through their connection with Caedmon,
the most celebrated of the vernacular poets of Northumbria and
the reputed author of the Anglo-Saxon metrical paraphrases of
the Old Testament.   It was his great reputation as a singer
that made Hild seek Caedmon and persuade him to join her com-
munity.   Here the practice of reading Holy Scripture made him
familiar with the stories of Hebrew literature in their grand
and simple setting, and he drank of the waters of that well to
which so many centuries of creative and representative art have
gone for inspiration.

Caedmon's power of song had been noticed outside the
monastery.

"And all concluded that a celestial gift had been granted
him by the Lord.   And they interpreted to him a certain passage
of sacred history or doctrine, and ordered him to turn it if he
could into poetical rhythm.   And he, having undertaken it,
departed, and returning in the morning brought back what he was
ordered to do, composed in most excellent verse.   Whereupon
presently the abbess, embracing heartily the grace of God in the
man, directed him to leave the secular habit, and to take the
monastic vow; and having together with all her people received
him into the monastery associated him with the company of the
brethren, and ordered him to be instructed in the whole course
of sacred history.   And he converted into most sweet song what-
ever he could learn from hearing, by thinking it over by him-
self, and, as though a clean animal, by ruminating; and by mak-
ing it resound more sweetly, made his teachers in turn his
hearers."

These passages are curious as showing that a singer of
national strains was persuaded to adapt his art to the purposes

of religion.  The development of Church music is usually held to
have been distinct from that of folk-music, but in exceptional
cases such as this, there seems to have been a relation between
the two.

Excavations recently made on several of the sites of
ancient northern monasteries have laid bare curious and inter-
esting remains which add touches of reality to what is known
about the houses of the north during this early period.  In a
field called Cross Close at Hartlepool near Durham skeletons of
men and women were found, and a number of monumental stones of
peculiar shape, some with runic inscriptions of women's names.
Some of these names are among those of the abbesses inscribed in
the so-called "Book of Life of Durham," a manuscript written in
gold and silver lettering in the early part of the 9th century.
Again, an ancient tombstone of peculiar design was found at
Healaugh; and at Hackness several memorial crosses are preserved,
one of which bears the inscription of the name Aethelburg, who
no doubt is the abbess of that name with whom Aelflaed, Hild's
successor at Whitby, in 705 travelled to the death-bed of King
Ealdfrith.

Finally on the Whitby coast on the south side of the abbey
a huge kitchen-midden was discovered.  A short slope here leads
to the edge of the cliff, and excavations on this slope and at
its foot, which was once washed by the tide, have revealed the
facts that the denizens of the original monastery were wont to
throw the refuse of their kitchen over the cliff, and that the
lighter material remained on the upper ledges, the heavier
rolling to the bottom.

Among the lighter deposits were found bones of birds,
oyster whelk and periwinkle shells, and two combs, one of which
bears a runic inscription.  Among the heavier deposits were
bones of oxen, a few of sheep, and a large number of the bones
and tusks of wild swine, besides several iron pot-hooks and
other implements; a bone spindle and a divided ink-horn are
among the objects specified.  An inscribed leaden bulla found
among the refuse is declared by experts to be earlier than the
8th century; it is therefore proof that these remains were
deposited during the earlier period of the existence of Hild's
monastery, possibly during her lifetime.

Hild died after an illness of several years on November 17,
680.  Would that there were more data whereby to estimate her
personality!  The few traits of her character that have been
preserved, her eagerness to acquire knowledge, her success in
imparting it to others, her recognition of the need of unity
in the Church, the interest she took in one who could repeat
the stories of the new faith in strains which made them intel-
ligible to the people, are indicative of a strong personality
and of an understanding which appreciated the needs of her
time.

Various myths, of which Bede knows nothing, have been attached to her name in course of time. According to a popular legend she transformed the snakes of the district into the ammonites familiar to visitors to those parts. And it is said that at certain times of the day her form can be seen flitting across the abbey ruins.

At her death the rule of the settlement passed to Aelflaed, the princess who had been given into her care as a child. After King Oswiu's death in 670 Queen Eanflaed joined her daughter in the monastery. The princess and abbess Aelflaed proved herself worthy of the influence under which she had grown up, and we shall find her among the persons of importance who took up a decided attitude in regard to the disturbances which broke out through the action of Bishop Wilfrith. The beginnings of these difficulties belong to the lifetime of Hild: we do not know that she took any interest in the matter, but judging from indirect evidence we should say that she shared in the feeling which condemned the prelate's anti-national and ultra-Roman tendencies.

## D.  A TWELFTH CENTURY SCHOLARLY ABBESS AND HER TEXTBOOK

*The twelfth century produced an impressive burgeoning of art and scholarship. Gothic cathedrals were being erected all over Europe and compendia of history, philosophy, theology, and science were written to parallel in books the mighty structures of the cathedral builders. The author of one such work,* Garden of Delights, *was the abbess Herrad of Hohenburg in Alsace. The only extant copy of her book was destroyed in the Franco-Prussian War of 1870, and without the interest of an early nineteenth-century scholar who copied large extracts of the book we should have known nothing about Herrad.*

*From the selection on the abbess Herrad, a great deal of information emerges about women's activities in the nunneries of the twelfth century. Herrad was not only a serious scholar but also produced the illuminated miniatures that illustrated her work. The description of the* Garden of Delights *gives us a glimpse of the basic curriculum that Herrad considered necessary for the education of the women under her care. It is also interesting that she intended it to serve a dual purpose. The book instilled a broad spectrum of history, religion, philosophy, and science, and it simultaneously taught Latin to her German readers in the most painless manner. Because Latin was the universal religious, scholarly, and diplomatic language of the Middle Ages, Herrad tried to make sure that her nuns had a good working knowledge of the language.*

HERRAD AND THE "GARDEN OF DELIGHTS"

Lina Eckenstein

A work produced at Hohenburg, a nunnery in Elsass, in the 12th century confirms the belief that given favourable conditions it is possible for women to produce good work and to help to accumulate knowledge. Herrad, the abbess of this house, conceived the idea of compiling for the use of her nuns an encyclopædic work which should embody, in pictures and in words, the knowledge of her age. The importance of this work has long survived the attainment of its original purpose, for with its hundreds of illustrations and its copious text it has afforded a wealth of information on the customs, manners, conceptions and mode of life of the 12th century, to which many students of archæology, art and philology have gone for instruction and for the illustration of their own books. "Few illuminated manuscripts had acquired a fame so well deserved as the 'Garden of Delights,' the *Hortus Deliciarum*, of Herrad," says the editor of the great collection of reproductions of the pictures which illustrated her work. . . .

. . . Herrad's "Garden of Delights" with its apt illustrations gave a complete picture of life in its domestic and out-of-door aspects as it presented itself in the 12th century. It showed what conceptions and ideas were then attractive to nuns and their estimation of knowledge, and it has given greater insight than any other production into the talents, the enthusiasm and the industry which were found at this period in a nunnery. . . .

From historical information recently collected by Roth we gather that a religious settlement of women existed on the Hohenburg as early as the 9th century. . . .

In the year 1154 Relind, abbess of Berg, a nunnery near Neuburg on the Danube, was appointed abbess at Hohenburg in accordance with the wish, it is said, of the emperor Friedrich Barbarossa (1152-1190). Her influence was most beneficial; many daughters of the surrounding gentry came to study under her, and among them Herrad of the family of Landsperg. The term nun must be applied to these women with a reservation; some writers speak of them as Austin canonesses on account of the liberties they enjoyed. In Herrad's "Garden" the picture of her nuns represents them wearing clothes that differ little from those worn by women in other walks of life. Their dresses are

Lina Eckenstein, *Woman under Monasticism* (Cambridge: Cambridge University Press, 1896), pp. 238-55. Reprinted by permission of Cambridge University Press.

of different colours, their cloaks are generally brown, and
their veils are always brilliantly coloured, some red, some
purple.  The only detail of dress which they have in common is
a white turban or head-dress, over which the veil is thrown.
They wear no wimples.  The establishment of the house under
Herrad's rule consisted of forty-seven nuns and thirteen novices
(or lay sisters?) who are represented as wearing clothes similar
to those of the nuns.

Herrad's admission to the house furthered its prosperity in
every way, for besides literary and artistic abilities she had
considerable powers of management.  She succeeded Relind as ab-
bess in 1167, and in 1181 she founded a settlement of Austin
canons at Truttenhausen, and later another at St. Gorgon, both
of which are situated not far below the summit of the hill.
The canons of these settlements took it in turn to read mass in
the women's chapel.  Roth speaks of other improvements which
Herrad carried out with the help of her diocesan, the bishop of
Strasburg. . . .

From these general remarks we turn to the great work of
Herrad's life, to which she herself gave the title of the
"Garden of Delights."  It consisted of 324 parchment leaves of
folio size, which contained an account of the history of the
world founded on the Biblical narrative, with many digressions
into the realm of philosophy, moral speculation, and contempo-
rary knowledge—and with numerous pictures in illustration of
it.

The book was so arranged that the pictures stood alongside
of the text; and the pages of the work which were devoted to
illustrations were in most cases divided into three sections by
lines across, so that the pictures stood one above the other.
The figures in each picture were about four inches high. There
were, however, a certain number of full-page illustrations with
larger figures, and it is among these that the greatest proofs
are given of Herrad's imaginative powers and the range of her
intellectual abilities. . . .

Engelhardt, to whom we are indebted for the fullest descrip-
tion of the "Garden of Delights," made tracings of a number of
pictures and copied their colouring.  He comments on the bril-
liant smoothness and finish of the original miniature paintings.
Only the silver, he says, was tarnished; the gold was undimmed
and all the colours preserved their full brilliancy, when he
had the work before him in the early part of this century.
According to him the method of painting was as follows.  First
the figures were drawn in dark outline, then the colouring was
filled in bit by bit; shadows and high lights were next laid on,
and then the dark outlines were again gone over.

The question has naturally arisen whether Herrad did the
whole of the work herself.  The text which stood at the begin-
ning and at the end of it referred to her as its sole author.

Students are generally agreed that the outline drawing and the
writing were entirely her work, but the colours may or may not
have been laid on by her.  For the work was wonderfully com-
plete in plan and execution—the conception of one mind, which
laboured with unceasing perseverance to realize the conception
it had formed.

The style in which the pictures were drawn has likewise
been the occasion of much comment.  We are here on the border-
land between the conventional Byzantine and the realistic
Gothic styles.  "We see very clearly," says Woltman, "how the
new ideas which scholastic learning and poetry had generated
required new modes of expression, and led to conceptions for
which the older art yielded no models and which had to be taken
from real life."  In most cases Herrad no doubt had a model
before her and adhered to the traditional rendering, but where
the model was wanting she may have drawn on her powers of imagi-
nation and supplied details from her surroundings.  Thus inci-
dents of Biblical history are represented by her in a manner
familiar to the student of early Christian art.  A grave and
serious dignity which recalls the wall mosaics at Ravenna char-
acterizes the figures of God, Christ, Mary, and the angels;
Engelhardt has pointed out the close similarity of Herrad's
picture of the Annunciation to that contained in a Greek MS. of
the 9th century.  But in other cases Herrad either composed her-
self or else drew from models which were nearer to her in time
and place. Thus the picture of the sun-god Apollo represents him
in a heavy mediaeval cart drawn by four horses, and the men and
women in many pictures are dressed in the fashion of the time.
The pictures drawn from real life especially delight the
archæological student. . . .

Herrad executed her work between 1160 and 1170, but addi-
tional entries were made as late as 1190.  This period falls in
the reign of the emperor Friedrich Barbarossa (1152-1190), which
followed upon that of the luckless Konrad III, and was one of
comparative quiet and prosperity in Germany.  The power of the
Pope had passed its climax, there was schism in the Papacy,
which was greatly aggravated by the line of conduct Friedrich
adopted, but the scene of their struggle had shifted to the
cities of northern Italy.  We shall see later on that political
changes were watched with much interest in some nunneries, and
that the conduct of the Emperor, the Pope, and the bishops was
keenly criticised among nuns.  It is difficult to tell how far
events affected Herrad.  The prose narrative which her work con-
tained, as far as we know, has perished and we have no definite
clue to her interpretation of contemporary affairs, but probably
she was content to devote her energies to rearranging and inter-
preting the intellectual wealth of the age without entering into
party conflicts.  The illustrations of the "Garden of Delights"
which have been preserved are invaluable for the study of

contemporary life, but they contain no information as to contemporary events.

The study and enjoyment of the work in its original form were facilitated by the addition to the picture of the name of every person and every implement in Latin or in German, sometimes in both; and in many cases an explanatory sentence or a moral maxim was introduced into the picture, so that the nun who studied the work naturally picked up Latin words and sentences. Through the industry of Engelhardt all these sentences and words have been preserved, and the coupling of implements with their names forms a valuable addition to our knowledge of terms as applied in early mediaeval times. The book also originally contained a continuous history in Latin for more advanced students, but unfortunately that is lost. Engelhardt says that it described the history of the world from the Creation to the coming of Antichrist, with many extracts from various writers. He enumerates twenty writers from whose works Herrad quotes. Among them are Eusebius Pamphili († $c$. 350), Jerome († 420), Isidor of Seville († 636), Bede († 735), Frechulf († 838), and others who were her contemporaries, such as Petrus Lombardus († 1164) and Petrus Comestor († 1198). When quoting from secular writers the abbess invariably made mention of the fact. In one instance she remarked that "all these things have been described by philosophers by aid of their worldly wisdom (per mundanam sapientiam), but this was the product of the Holy Spirit also."

The attitude which Herrad assumed towards learning generally can be studied in the pictures which deal with abstract conceptions. They are usually of folio size and contain illustrations which are instructive to the student of mediaeval scholasticism. Two pictures introduced into the history of the Tower of Babel which illustrate the falling away from the true faith deserve especial attention. The one is a representation of the "Nine Muses"; on it female heads of quaint dignity in medallions are arranged in a circle. The other represents the "Seven Liberal Arts," in accordance with the mediaeval interpretation of the teaching of Aristotle. On it Philosophy, a female figure, is seated in the centre of the picture wearing a crown with three heads. These heads are designated as "ethica, logica, phisica"; by means of these three branches of learning Philosophy adds to her powers of insight. Socrates and Plato, who are designated as "philosophers," sit below, and from the figure of Philosophy "seven streams of wisdom flow which are turned into liberal arts" as the text explains. These arts are personified as female figures in 12th century dress, and are so arranged that each figure stands in a separate division forming a circle round Philosophy and the philosophers. The Liberal Arts are robed in different colours, and each holds an emblem of her power. "Grammar," dressed in dark red, has a book and a birch rod; "Geometry," in

light red, has a measuring rod and a compass; "Arithmetic," in
light blue, holds a string of alternate white and black beads;
"Music," dressed in purple, has a lyre, a zither and a hurdy-
gurdy; "Astronomy," in dark green, holds a measure and looks up
at the stars; "Rhetoric," in dark blue, has a stilus and a writ-
ing-tablet (tabula); and "Dialectic," in light green, holds the
head of a howling dog. Each figure is encircled by a sentence
explaining the special nature of her power. In the lower part
of the picture are four men, seated at desks, with books, pens
and penknives, engaged in reading and writing. These are the
"poets or magi, who are filled with a worldly spirit"; black
birds appear to be whispering in their ears.

The whole of this picture is doubtless traditional; its
admission into the work shows that Herrad's conception of "pro-
fane" learning was one of distinct appreciation. The idea con-
veyed by means of the pictures to the young women students was
by no means superficial or derogatory to learning. On the con-
trary, we see them under the influence of a teacher through whom
their respectful attitude towards the means and modes of knowl-
edge was assured.

Another picture of folio size, called "The Ladder to Per-
fection," shows that Herrad accepted a critical attitude towards
the members of religion. A ladder is drawn diagonally across
the page and a number of figures are seen ascending it on their
way towards heaven. The highest rung has been reached by Chris-
tian love (Caritas) personified as a woman to whom a crown is
proffered from heaven. Below her stand the representatives of
different branches of the religious profession and laymen ar-
ranged in order of excellence, and with each is given a picture
of the temptation which prevents him from ascending further up
the ladder. Among these the hermit (heremita) stands highest,
but he is held back by the charms of his garden. Below him
stands the recluse (inclusus), whose temptation is slothfulness,
which is represented by a bed. Then comes the monk (monachus),
who leans towards a mass of gold; "he is typical of all false
monks," says Herrad, "whose heart is drawn from duties by the
sight of money, and who cannot rise above greed." The nun
(sanctimonialis) and the cleric (clericus) have reached the same
rung on the ladder. She is the representative of false nuns who
yield to the temptation of persuasion and gifts, and return to
their parents, never attaining the crown of life; he is drawn
away by the allurements of the table, and by a woman (amica) who
stands below. There are also figures of a lay woman and a soldier
who are respectively attracted by the charms of a city and of
war. They are absorbed by vanities, and we are told "rarely
reach the crown of life through contemplation." The picture is
further crowded with demons who are attacking and angels who are
defending the people on the ladder. The devil lurks below in
the form of a dragon ready to seize upon those who fall.

In further illustration of Herrad's attitude towards the clergy, Engelhardt cites a passage from her work in which she severely censures the customs which the clergy tolerate in church on festal days. In company with laymen and loose women they eat and drink, and indulge in jokes and games which invariably end in uproariousness. "How worthy of praise," she exclaims, "if the spiritual princes of the Church (principes ecclesiae spirituales) restored the evangelical teaching of early times in the place of such customs."

From these general remarks we turn to the pictures which illustrate the Biblical narrative in a number of scenes containing a store of imagery and a wealth of design. We cannot but admire the ready brush of the abbess and the courage with which she grappled with difficulties, drawing with equal skill human figures and divine personifications, dramatic incidents and allegorical combinations.

The pictures which illustrated the Creation were led up to by a number of diagrams and digressions on astronomy and geography, with lists of technical terms in Latin and their German equivalents. Among these was a picture of the signs of the zodiac and a "computus" or table for determining the festal days of the year. The desire to fix the date of incidents of Old and New Testament history absorbed much attention at this period, and Herrad's table of computation was looked upon as so important that it was recently used by Piper as the starting-point for an investigation on the Calendar generally. In Herrad's table the date of Easter was worked out for a cycle of 532 years, that is from 1175 till 1706; leap-years were marked, and the day of the week on which Christmas fell was given for the whole period.

The history of the Biblical narrative opens with a picture illustrating the creation of the animals. The lion, the elephant, the unicorn and the giraffe are most fantastic, but the ox, the ass, the horse, the domestic fowl, the sylvan animals of northern latitudes, and fish, are drawn with tolerable correctness. God is represented in classical robes moving slowly across a wave of the waters. In another picture He is depicted in a simpler manner seated and fashioning the small figure of Adam, which He holds between His knees. Again He is seen breathing life into Adam's nostrils, and then holding in His hand a rib out of which projects the head of Eve, while Adam is lying asleep on the ground. There is a series of pictures illustrating the temptation and expulsion from Paradise. A full-sized one gives the Tree of Life, which has many ramifications out of which human faces are peeping. Adam and Eve are throughout pictured as of the same height and are several times drawn in the nude. There is a very graceful picture in which Adam is seen delving while Eve spins. . . .

Some of the pictures which illustrate Solomon in his glory and Solomon's Vanity of Vanities have also been preserved.

Among them is Solomon lying on a sumptuous couch and surrounded
by his warriors.  A representation of two mannikins occurs
among the Vanities; these mannikins were moved by threads, ex-
actly like a modern toy.  The pictures illustrating the experi-
ences of the Church, the position of her members from Pope to
cleric, the means of repentance, and the coming of Antichrist,
all roused the enthusiasm of those who saw them; none of these
have till now been reproduced.  Gérard, who was probably the
last to see and handle the work of Herrad, was especially struck
by the pictures of the Last Judgment and of Heaven and Hell.
His descriptions of them were lying in the library at the time
of the bombardment, and were only rescued by the devotion of a
friend.  On the strength of these pictures he numbers Herrad
among the most imaginative painters the world has known.
Engelhardt also was greatly struck by them.  He describes a
picture of Hell in the following terms:

> A mass of rocks was arranged so as to make a frame-
> work to this picture, in the chasms of which rocks
> flames were flaring and the condemned were seen suffer-
> ing torments.  Rivers of flame divided the inner part
> of the picture into four divisions.  In the lowest of
> these, at the bottom of Hell, sat Lucifer or Satan in
> chains holding Antichrist in his lap.  Next to him a
> demon carried along a covetous monk, whose punishment
> was then represented:  he lay on his back without
> clothes and a demon poured molten gold into his mouth.
> In the second division counting from below two boiling
> caldrons hung suspended:  in the one were Jews, in the
> other soldiers (the text says "milites vel armati").
> Demons stood by holding men of either kind ready to add
> them to those already in the caldrons; other demons
> were stirring the caldrons with forks.  In front of the
> Jews' caldron a demon was depicted holding a naked sin-
> ner to whom he administered punishment by beating him.
> In the division above this a usurer had hot gold poured
> into his hand; a slanderer was made to lick a toad; an
> eaves-dropper had his ears pinched; a vain woman was
> assisted at her toilet by demons (they seemed to be
> lacing her); the woman who had murdered her child was
> forced to devour it.  The following peculiar picture
> filled the highest division:  a rope was drawn through
> chasms in the rocks so as to form a swing; on this a
> grinning demon sat swinging.  At the ends of the rope
> which hung on the other side of the rocks two sinners
> were hanging bound head and foot so as to balance each
> other; demons held them by the hair.  Another sinner
> hung suspended by his feet, with a block of stone
> hanging from his neck on which a demon was swinging.

Sensual pleasures personified were wound around and
bitten by snakes, and a man who had committed suicide
was depicted plunging a knife into his own body.

These pictures illustrated with forcible directness concep-
tions which were current throughout the religious world and
served as a means of teaching the lesson of reward and punish-
ment in the world to come.  Later on in treating of mysticism
we shall again see these conceptions stimulating the imaginative
powers of women living in convents.

Copies of the last pages of the "Garden of Delights," which
are devoted to a representation of the Hohenburg and of its
convent of women, have fortunately been preserved.  Here we see
the settlement as it presented itself to Herrad and the thoughts
she associated with it.  The picture is the size of two folio
pages.  High above in the centre stands Christ in front of the
convent church, holding in His right hand a golden staff which
is touched by the Virgin and St. Peter, and the end of which is
supported by Duke Eticho, whom Herrad looked upon as the father
of St. Odilia.  St. John the Baptist and St. Odilia are seen
standing on the other side of Christ.  A green hill is repre-
sented below roughly studded with bushes or brambles,—this is
the hill of the Hohenburg.  On one slope of it Duke Eticho is
seated, and he hands the golden key of the convent to St. Odilia,
who advances towards him followed by a band of women.  Relind,
Herrad's teacher and predecessor, also stands on the hill with
her hand resting on a cross on which are inscribed verses ad-
dressed to the nuns.  The fact that she restored the church
and the discipline at Hohenburg, which had fallen entirely into
decay, is commemorated in a sentence which is placed on the
other side of her.  Over against her stands Herrad herself, who
also holds verses addressed to the nuns.  And between these two
abbesses all the members of Herrad's congregation are drawn, six
rows of women's heads placed one above the other.  There is no
attempt at portraiture, but the name of each nun and each novice
is added to her picture.  Among these names are those of fami-
lies of the surrounding landed gentry, from which we gather that
the nunnery was chiefly for the upper classes.  The nuns in the
picture address lines to Christ begging Him to number them among
the elect.

Such in rough outline was the "Garden of Delights," the
loss of which is greatly to be deplored, both from the point of
view of culture in general, and from that of women in particular.
But even in its fragments the work is a thing to dwell upon, a
monument which bears the stamp of wide knowledge and lofty
thought.  It shows how Herrad found her life's interest in edu-
cating the young women given into her care, how anxious she was
that they should be right-minded in all things, and how she
strove to make their studies delightful to them.  The tone which

she took towards her congregation is apparent from the words in
which she directly addressed them. . . .

. . . "Herrad, who through the grace of God is abbess of
the church on the Hohenburg, here addresses the sweet maidens
of Christ who are working as though in the vineyard of the Lord;
may He grant grace and glory unto them.—I was thinking of your
happiness when like a bee guided by the inspiring God I drew
from many flowers of sacred and philosophic writing this book
called the 'Garden of Delights'; and I have put it together to
the praise of Christ and the Church, and to your enjoyment, as
though into a sweet honeycomb.  Therefore you must diligently
seek your salvation in it and strengthen your weary spirit with
its sweet honey drops; always be bent on love of your Bridegroom
and fortified by spiritual joys, and you will safely pass through
what is transitory, and secure great and lasting happiness.
Through your love of Christ, help me who am climbing along a
dangerous uncertain path by your fruitful prayer when I pass
away from this earth's experiences.  Amen."

Thus far we have followed Herrad in her work and in her
relations towards her nuns; the question naturally arises,
What inner experiences prompted her to her great undertaking
and in what spirit did she carry it through?  It has been
noticed that a sombreness is characteristic of certain parts of
the work, and is peculiar to some of her poems also.  Two short
verses which occur in the work seem to reflect her mental state.
The one urges great liberality of mind.  It discusses the basis
of purity, and comes to the conclusion that purity depends less
on actions than on the spirit in which they are done.  The
other follows the mind through its several stages of develop-
ment and deserves to be chronicled among the words of wisdom.
It runs as follows: "Despise the world, despise nothing,
despise thyself, despise despising thyself,—these are four good
things."

# VARIETIES OF WOMANHOOD IN THE MIDDLE AGES

*The Middle Ages is the name given to that period of Euro-
pean history that spans the time between the fall of the Western
Roman Empire and the Renaissance (c. 476-1400). Renaissance
scholars saw their own time as a rebirth (renaissance) of the
thought and art of the ancient Greco-Roman world. Thus, what
happened between the ancient period and their own was the "mid-
dle," the middle age, the medieval period. The scholars of the
Renaissance saw the Middle Ages as a static period, but in fact
this was a period of great movement and change in human activity.*
   *As the Roman Empire disintegrated, eastern tribes like the
Franks went to Roman Gaul (now France), the Lombards invaded
Italy, and Angles, Saxons, and later Danes settled in Britain.
These tribes brought their own laws and customs and partly
superimposed them on the previous laws and customs of the people
whose lands they had conquered. On the other hand, as indicated
in the previous sections, the imperial Roman religion of Chris-
tianity gradually became the official religion of the whole of
Western Europe. In fact, for some periods of the Middle Ages
God's earthly representative, the bishop of Rome (called the
Holy Father, il Papa, or the pope) was more powerful in a
worldly sense than the kings and emperors of emerging European
nations. Occasionally great power struggles arose between
worldly rulers and the pope—for example, the investiture contro-
versy in the eleventh century and the battle of Henry II of
England with the pope of his day (the twelfth century) over the
legal status of the clergy.*
   *The Church and Church doctrine became an integral part of
the life of every person in Europe throughout most of the Mid-
dle Ages, and its attitude to women ought therefore to be con-
sidered of central significance to their lives. During early
medieval centuries the Church based its doctrines mostly on the
patristic literature. In the eleventh and twelfth centuries
scholars rediscovered Aristotle, and in the thirteenth century
Thomas Aquinas, the greatest theologian of this age, reworked
Catholic doctrine, combining it with a renewed edition of
Aristotelian thought. Aquinas believed quite simply in the
inferiority of women. He wrote of "making use of a necessary*

*object, woman who is needed to preserve the species or to pro-*
*vide food and drink"; also, "her unique role is in conception,*
*. . . since for other purposes men would be better assisted by*
*other men."[1] (See Part 4, section A.) On the other hand, be-*
*cause of this inferiority, Aquinas felt that women needed to be*
*protected, particularly since they were the preservers of the*
*race. Thus men must concern themselves for their wives, and a*
*true marriage in which man takes care of his wife and children*
*was a vitally important part of his social duty.*

*During the centuries before the time of Thomas Aquinas*
*life in medieval Europe developed a pattern growing out of the*
*interdependence of conquerors and conquered. This pattern*
*hardened into a tight social, political, economic, legal, and*
*moral structure known as feudalism. Under the feudal system*
*each individual owed his land, some kind of service or monetary*
*obligation, and moral allegiance to an overlord. The service*
*performed by knights for their overlords was to fight the*
*overlords' battles. The French word for horse, cheval, makes*
*the knight a* chevalier—*hence the term* chivalry. *Chivalry,*
*whether in military affairs, in religion, or debatably in court-*
*ly love became the aristocratic ideal of feudalism. Its basis*
*was loyalty to the suzerain, whether he was an overlord in every-*
*day life, in religion (4 C), or in courtly love (4 B).*

*The highest overlord (suzerain) in the feudal system was*
*the king; the lowest individual or vassal was the peasant, or*
*rather the peasant's daughter. In between in the social hier-*
*archy were various gradations of nobility (including lord*
*bishops, lord abbots, lady abbesses, and other princes of the*
*Church). A vassal's property (the fief), held in trust from*
*his overlord, in theory reverted to the overlord if the vassal*
*died without male heirs. In practice, a daughter was found a*
*suitable husband by the overlord and she and the husband admin-*
*istered the fief. A good source of income for many overlords*
*was money or property offered by heiresses who did not wish to*
*marry a husband of the overlord's choosing and could "buy their*
*way out of marriage," as it were. The famous Magna Carta (1215),*
*whereby English barons first won a number of rights from the*
*king, also earned some concessions for women in the feudal*
*system. For example, widows were permitted to remain in their*
*homes for forty days after their husband's deaths before the*
*estate reverted to the overlord; they were also permitted to*
*wait one year after their husbands' deaths before having to*
*remarry a man of the overlord's choice. It is clear that mar-*
*riages were vitally important political maneuvers, as they*
*often combined strategically situated fiefs. One of the most*

---

[1]F. Heer, *The Medieval World* (Cleveland and New York:
World Publishing Co., 1961), p. 265.

*important marriages of this kind was that of Eleanor of Aquitaine to King Henry II of England, because it brought large parts of (present-day) France to the English crown in the twelfth century.*

*Children of neither sex were consulted on their preferences when their parents, guardians, or overlords arranged their marriages. Future husbands and wives were often still in their cradles when they were betrothed. Generally, the less of the fief that was at stake, the more freedom was given to prospective brides and grooms in choosing a partner. The information on the peasant's condition in this respect is very contradictory. On the one hand, it is argued that because no property was at stake, peasants could marry whomever they pleased; on the other, that a peasant girl's father, because he had no rights of his own, would insist on arranging her affairs and on choosing her husband. In any event, not all peasants bothered to marry. Aquinas' urgings on men to marry and to look after their wives and children indicates that by the thirteenth century marriage was not necessarily the norm for everyone. In addition, the exponent of courtly love, Andreas Capellanus, writing in the twelfth century, believed that peasants were capable only of brutish sensuality; from his point of view they would have had little interest in the personality of their marriage partners.*

*One of the most startling changes noticed by a visitor from classical Athens or ancient Rome to the medieval scene would have been the lack of cities. For the first four to five hundred years of the Middle Ages people lived scattered throughout the countryside. The nobility, who fought each other constantly for their landed property, lived in fortified burgs or castles, either on hillsides and mountains or behind moats and drawbridges. In such establishments they needed to be completely self-sufficient. Like the monasteries at the same period, the lord of each castle or manor organized his vassals around his premises so that he ran a self-supporting economy that was also fortified against military attack. The women on these estates, particularly the lady of the manor herself, were skilled in every possible agricultural and domestic pursuit and were vital to the economic structure. While some matrons of the Roman Empire had been able to partonize shops for most types of goods, the medieval lady had to be knowledgeable about producing every item needed for the household—medicinal, culinary, or sartorial —from raw materials. Moreover, she had to know how to grow the raw materials. Because military attacks were frequent and women were often left alone while their husbands, fathers, and sons were attacking other establishments (or in later centuries were traveling on crusades or pilgrimages), most women were also skilled in the military arts. Margaret Paston, the wife of an English wool merchant, was still fighting off such attacks on her home as late as the fifteenth century.*

*Before the development of the urban economy in the tenth*

*and eleventh centuries, even the greatest ladies of the nobility
would know the discomforts of constant smoke in the windowless,
cold, and clammy halls of their fortified castles. Privacy was
also hard to find, for everyone gathered in the one room that
housed the bed, which in most cases was the only comfortable seat
in the house.*

*In conclusion, the Middle Ages produced many changes in the
position of women that were reflected in attitudes or practical
everyday life. Feudalism was one of these. Another was the
development of the literature of chivalry, with its emphasis on
a softening attitude toward women both through an idealized sen-
sual love (4 B) and through the cult of the Virgin (4 C). Cru-
sades and pilgrimages opened up great avenues for travel and
adventure to intrepid women like Eleanor of Aquitaine or the
Wife of Bath (4 D). The development of trade and the growth of
cities also offered different employment and less sheltered
lives to women in the merchant communities (4 D and E). Only
in the rural economy, which, however, was the major part of Euro-
pean life, did women of the peasant and lower classes continue
their unchanging but all-encompassing work in the field, in the
dairy, in the kitchen, and at the ever-present spindle.*

## A. ST. THOMAS AQUINAS AND THE NATURE OF WOMAN

*It is particularly interesting to see what the almost uni-
versally highly praised philosopher-theologian of the thir-
teenth century had to say about women. The general reader is
awed by two factors in advance. First, Aquinas' strength,
according to many commentators, was his "fearless reasoning
and his ability to recognize and produce harmony and order."[1]
Second, St. Thomas' influence on Western thought was tremendous.*

*The following excerpt is from St. Thomas' Summa Theologica.
The similarity of his thought to that of Aristotle (see Part 1,
section B) is noteworthy.*

[1]David Knowles, *The Evolution of Medieval Thought* (New York:
Random House, 1962), p. 256.

SUMMA THEOLOGICA

St. Thomas Aquinas

As regards the individual nature, woman is defective and
misbegotten, for the active power in the male seed tends to the
production of a perfect likeness according to the masculine sex;
while the production of woman comes from defect in the active
power, or from some material indisposition, or even from some
external influence, such as that of a south wind, which is
moist, as the Philosopher observes.  On the other hand, as
regards universal human nature, woman is not misbegotten, but
is included in nature's intention as directed to the work of
generation.  Now the universal intention of nature depends on
God, Who is the universal Author of nature.  Therefore, in pro-
ducing nature, God formed not only the male but also the female.
Subjection is twofold.  One is servile, by virtue of which
a superior makes use of a subject for his own benefit; and this
kind of subjection began after sin.  There is another kind of
subjection, which is called economic or civil, whereby the
superior makes use of his subjects for their own benefit and
good; and this kind of subjection existed even before sin.  For
the good of order would have been wanting in the human family
if some were not governed by others wiser than themselves.  So
by such a kind of subjection woman is naturally subject to man,
because in man the discernment of reason predominates.

## B.  COURTLY LOVE AND CHIVALRY

*The concept of chivalry is one of the great obstacles to
the emancipation of women, emphasizing as it has through the
nineteenth and twentieth centuries a purely superficial rever-
ence for the "gentler" sex.  The origins of this concept,
labeled* courtly love *by a nineteenth century historian,[1] can
be found in the French lyrics and romances of the twelfth
century.  Hundreds of these lyrics extolling the yearning of
lovers for each other were sung by troubadours and minstrels
who wandered from court to court and from village to village.*

*Basic Writings of Saint Thomas Aquinas*, Vol. I, ed. by
Anton C. Pegis (New York:  Random House, 1945), p. 880.  Re-
printed by permission of Random House, Inc.

[1]Gaston Paris, "Lancelot du Lac:  Le Conte de la Charette,"
*Romania*, 12 (Paris, 1883), 460-534.

Romances like that of Tristan and Isolde were developed and embroidered by storytellers and poets of succeeding medieval generations.

The new common denominator of this literature was an emphasis on the beauty and tenderness of aspiring love rather than on battles and military conquests. The affections described in these poems often concern lovers who aim to marry against great obstacles or lovers who can never marry because one or both are already married or betrothed. One of the underlying currents is thus usually a theme of unattainability. Usually the male lover yearns for his "sweet friend," but in some poems and romances it is the lady who longs for an unreachable lover. This unattainable quality of the lady was overdeveloped and overemphasized in the ensuing centuries, bringing the concept out of literature and causing the knights of the fourteenth and fifteenth centuries to fight for the honor of their ladies in tournaments and to found orders of chivalry such as the Order of the Rose or the Order of the White Lady of the Green Shield, which eulogized homage rendered to women.

It is now debated whether the concept of chivalry as applied to courtly love had any basis in the actual lives of medieval men and women other than as escapist literature. The seriousness of the twelfth-century treatise, "The Art of Courtly Love" by Andreas Capellanus, is questioned by many scholars.[2] This treatise, until recently recognized as the formulation of twelfth-century ideas on acceptable love affairs, is now sometimes thought to be an exercise in literary irony. One problem is that Andreas extols adultery as the means to ennobling one's personality, whereas it is also a historical fact that adultery by women throughout the Middle Ages merited severe punishment, even death. How could these love affairs between married ladies and their attendant knights, supposedly sanctioned by Andreas' treatise, have taken place? Also adding to the skepticism with which Andreas' treatise on love must be viewed is the latter part of his work, which is an example of the misogyny so prevalent in medieval literature and which is again a great contrast to the delicacy of love supposedly engendered in a knight by his lady.

There is little evidence from the medieval period so far to show how the women of the time felt about the chivalrous code of literature. Women poets like the twelfth-century Countess of Dia appear human and not unattainable. Some women must have seen through the superficiality of the concept, but it might have been a refreshing change from the ecclesiastical and philosophical pronouncements on feminine inferiority and

---

[2]See F. X. Newman, ed., *The Meaning of Courtly Love* (Albany, N.Y.: State University of New York Press, 1968).

*viciousness.  The enthusiastic adoption of the concept of chival-*
*ry in the nineteenth century by poets and writers like Tennyson,*
*Ruskin, and Bulfinch, which is inextricably linked with the*
*cult of "true womanhood," can be seen as the reaction to the*
*emergence of the independence of women, both through their work*
*in industry and the women's movements that sought legal and*
*professional equality.  Many recent scholars consider that the*
*passion with which nineteenth-century protagonists embraced the*
*chivalrous cult was far greater than that inherent in the medi-*
*eval society that spawned the idea.*

    *Reprinted below are a twelfth-century love lyric by Jaufré*
*Rudel and one by the Countess of Dia, Andreas Capellanus'*
*"Twelve Rules of Love" from the first part of* The Art of Courtly
Love, *and a section from the third part of Capellanus'* The Art
of Courtly Love.

WHEN THE WATERS OF THE SPRING  *Quan lo rius de la fontana*

Jaufré Rudel

> When the waters of the spring
> Run clear once more,
> And the flower of the eglantine blooms,
> And the little nightingale on the branch
> Turns and repeats and modulates
> Its song, and refines it,
> It is right that I too should sing of my love.
>
> Love of a far-off land,
> For you my whole heart is aching,
> And I can find no relief
> Unless I hear your call
> To a sweet meeting of love
> In an orchard, or behind a curtain,
> With a beloved companion.
>
> Since always this chance is denied me,
> I do not wonder that I consume myself,
> For never, as God wills,
> Was there seen a lovelier woman,

    Angel Flores, ed., *An Anthology of Medieval Lyrics* (New York: Modern Library, 1962), pp. 25-26.  This poem translated by Maurice Valency.  Reprinted by permission of Angel Flores.

Christian, Jewess, or Saracen,
And the man is fed with manna
Who with aught of her love is rewarded.

The desire of my heart ever tends
Toward her whom most I love,
And I think that my wish abuses me
When by its vehemence it deprives me of her;
For more poignant than a thorn
Is the pain that only joy can cure,
And for that I ask no man's sympathy.

Without brevet of parchment
I send this song that we sing
In plain roman language
By Filhol to Don Hugo Brun:
It is good to hear that the people of Poitou,
Of Berry, and of Guyenne
Rejoice because of him, and those of Brittany.

LOVE SONG  *Estat ai en greu consirier*

Countess of Dia

I have been in bitter torment for a knight who was mine,
and I would have it known for all time how more than much
I loved him.  Now I see that I am betrayed because I did
not give myself to him in love, and great sorrow I have
had for it night and day.

Would that I could hold my knight once after dark in my
bare arms, and that he would be happy with me for his
pillow!  For I take more delight in him than ever Floris
did in Blanchaflor; I give him my heart and my love, my
mind, my eyes, and my life.

Fair lover, full of grace and goodness, when shall I have
you in my power?  When, in bed with you one night, can I
give you a kiss of love?  Believe me, I should be greatly
glad to have you in place of my husband, on only one

condition: that you had promised me to do all that I would have you do.

## TWELVE RULES OF LOVE

Andreas Capellanus

Know, then, that the chief rules in love are these twelve that follow:

I. Thou shalt avoid avarice like the deadly pestilence and shalt embrace its opposite.
II. Thou shalt keep thyself chaste for the sake of her whom thou lovest.
III. Thou shalt not knowingly strive to break up a correct love affair that someone else is engaged in.
IV. Thou shalt not choose for thy love anyone whom a natural sense of shame forbids thee to marry.
V. Be mindful completely to avoid falsehood.
VI. Thou shalt not have many who know of thy love affair.
VII. Being obedient in all things to the commands of ladies, thou shalt ever strive to ally thyself to the service of Love.
VIII. In giving and receiving love's solaces let modesty be ever present.
IX. Thou shalt speak no evil.
X. Thou shalt not be a revealer of love affairs.
XI. Thou shalt be in all things polite and courteous.
XII. In practicing the solaces of love thou shalt not exceed the desires of thy lover.

---

Andreas Capellanus, *The Art of Courtly Love*, ed. by J. J. Parry (New York: Columbia University Press, 1941), pp. 81-82. Reprinted by permission of Columbia University Press.

THE ART OF COURTLY LOVE

Andreas Capellanus

Again we confound lovers with another argument.  The
mutual love which you seek in women you cannot find, for no
woman ever loved a man or could bind herself to a lover in the
mutual bonds of love.  For a woman's desire is to get rich
through love, but not to give her lover the solaces that please
him.  Nobody ought to wonder at this, because it is natural.
According to the nature of their sex all women are spotted with
the vice of a grasping and avaricious disposition, and they are
always alert and devoted to the search for money or profit.  I
have traveled through a great many parts of the world, and al-
though I made careful inquiries I could never find a man who
would say that he had discovered a woman who if a thing was not
offered to her would not demand it insistently and would not
hold off from falling in love unless she got rich gifts in one
way or another.  But even though you have given a woman innumer-
able presents, if she discovers that you are less attentive
about giving her things than you used to be, or if she learns
that you have lost your money, she will treat you like a perfect
stranger who has come from some other country, and everything
you do will bore her or annoy her.  You cannot find a woman who
will love you so much or be so constant to you that if somebody
else comes to her and offers her presents she will be faithful
to her love.  Women have so much avarice that generous gifts
break down all the barriers of their virtue.  If you come with
open hands, no women will let you go away without that which
you seek; while if you don't promise to give them a great deal,
you needn't come to them and ask for anything.  Even if you are
distinguished by royal honors, but bring no gifts with you, you
will get absolutely nothing from them; you will be turned away
from their doors in shame.  Because of their avarice all women
are thieves, and we say they carry purses.  You cannot find a
woman of such lofty station or blessed with such honor or wealth
that an offer of money will not break down her virtue, and there
is no man, no matter how disgraceful and low-born he is, who
cannot seduce her if he has great wealth.  This is so because no
woman ever has enough money—just as no drunkard ever thinks he
has had enough to drink.  Even if the whole earth and sea were
turned to gold, they could hardly satisfy the avarice of a woman.

---

Andreas Capellanus, *The Art of Courtly Love*, ed. by J. J.
Parry (New York:  Columbia University Press, 1941), pp. 200-7.
Reprinted by permission of Columbia University Press.

Furthermore, not only is every woman by nature a miser, but she is also envious and a slanderer of other women, greedy, a slave to her belly, inconstant, fickle in her speech, disobedient and impatient of restraint, spotted with the sin of pride and desirous of vainglory, a liar, a drunkard, a babbler, no keeper of secrets, too much given to wantonness, prone to every evil, and never loving any man in her heart.

Now woman is a miser, because there isn't a wickedness in the world that men can think of that she will not boldly indulge in for the sake of money, and, even if she has an abundance she will not help anyone who is in need. You can more easily scratch a diamond with your fingernail than you can by any human ingenuity get a woman to consent to giving you any of her savings. Just as Epicurus believed that the highest good lay in serving the belly, so a woman thinks that the only things worth while in this world are riches and holding on to what she has. You can't find any woman so simple and foolish that she is unable to look out for her own property with a greedy tenacity, and with great mental subtlety get hold of the possessions of someone else. Indeed, even a simple woman is more careful about selling a single hen than the wisest lawyer is in deeding away a great castle. Furthermore, no woman is ever so violently in love with a man that she will not devote all her efforts to using up his property. You will find that this rule never fails and admits of no exceptions.

That every woman is envious is also found to be a general rule, because a woman is always consumed with jealousy over another woman's beauty, and she loses all pleasure in what she has. Even if she knows that it is the beauty of her own daughter that is being praised, she can hardly avoid being tortured by hidden envy. Even the neediness and the great poverty of the neighbor women seem to her abundant wealth and riches, so that we think the old proverb which says

> The crop in the neighbor's field is always more fertile,
> And your neighbor's cow has a larger udder.

seems to refer to the female sex without any exceptions. It can hardly come to pass that one woman will praise the good character or the beauty of another, and if she should happen to do so, the next minute she adds some qualification that undoes all she has said in her praise.

And so it naturally follows that a woman is a slanderer, because only slander can spring from envy and hate. That is a rule that no woman ever wanted to break; she prefers to keep it unbroken. It is not easy to find a woman whose tongue can ever spare anybody or who can keep from words of detraction. Every woman thinks that by running down others she adds to her own praise and increases her own reputation—a fact which shows very

clearly to everybody that women have very little sense.  For all
men agree and hold it as a general rule that words of dispraise
hurt only the person who utters them, and they detract from the
esteem in which he is held; but no woman on this account keeps
from speaking evil and attacking the reputation of good people,
and so I think we must insist that no woman is really wise.
Every quality that a wise man has is wholly foreign to a woman,
because she believes, without thinking, everything she hears,
and she is very free about insisting on being praised, and she
does a great many other unwise things which it would be tedious
for me to enumerate.

Every woman, likewise, is sullied by the vice of greedi-
ness, because every woman tries with all her might to get
everything good for herself, not only from other men but even
from a husband who is very suitable for her, and when she gets
them she tries to keep them so that they are of no use to any-
body.  So great is the avarice by which women are dominated
that they think nothing of running counter to the laws, divine
and human, and they try to enrich themselves at the expense of
others.  Indeed, women think that to give to no one and to
cling with all their might to everything, whether rightly or
wrongly acquired, is the height of virtue and that all men
ought to commend it.  To this rule there are no exceptions, not
even in the case of the Queen.

Woman is also such a slave to her belly that there is
nothing she would be ashamed to assent to if she were assured
of a fine meal, and no matter how much she has she never has
any hope that she can satisfy her appetite when she is hungry;
she never invites anybody to eat with her, but when she eats
she always seeks out hidden and retired places and she usually
likes to eat more than normal.  But although in all other re-
spects those of the feminine sex are miserly and hold with
might and main to what they have, they will greedily waste their
substance to gobble up food, and no one ever saw a woman who
would not, if tempted, succumb to the vice of gluttony.  We can
detect all these qualities in Eve, the first woman, who, al-
though she was created by the hand of God without man's agency,
was not afraid to eat the forbidden fruit and for her gluttony
was deservedly driven from her home in Paradise.  So if that
woman who was created by the hand of God without sin could not
refrain from the vice of gluttony, what about the others whom
their mothers conceived in sin and who never live free from
fault?  Therefore let it be laid down for you as a general rule
that you will rarely fail to get from a woman anything you de-
sire if you will take the trouble to feed her lavishly and often.

Woman is commonly found to be fickle, too, because no woman
ever makes up her mind so firmly on any subject that she will
not quickly change it on a little persuading from anyone.  A
woman is just like melting wax, which is always ready to take a

new form and to receive the impress of anybody's seal.  No woman
can make you such a firm promise that she will not change her
mind about the matter in a few minutes.  No woman is ever of
the same mind for an hour at a time, so that Martianus had good
resaon to say, "Come now, cease your delay, for a woman is
always fickle and changeable."  Therefore you must not hope to
get any satisfaction from any woman's promise unless you are
sure you already have the thing she promises you; it is not
expedient to rely upon the civil law for what a woman promises,
but you should always bring your bag with you, ready to take it.
When dealing with women there seems to be no exception to that
old saying, "Don't delay; putting off things you are ready for
always does harm."

We know that everything a woman says is said with the inten-
tion of deceiving, because she always has one thing in her heart
and another on her lips.  No man can pride himself on knowing a
woman so well or on being on such good terms with her that he
can know her secret thoughts or when she means what she says.  No
woman ever trusts any of her men friends, and she thinks every
one of them is a downright deceiver; so she always keeps herself
in the mood for deception, and everything she says is deceitful
and uttered with a mental reservation.  Therefore never rely upon
a woman's promise or upon her oath, because there is no honesty
in her; always be careful to keep your intentions hidden from
her, and never tell her your secrets; in that way you may cheat
one trick with another and forestall her frauds.  Samson's good
character is well enough known to everybody, but because he
couldn't keep his secrets from a woman he was, we read, betrayed
by her in the duplicity of her heart, was overcome by a troop of
his enemies, and was captured and deprived of both his bodily
strength and his eyesight.  We learn, too, of innumerable other
women who, according to the stories, have shamefully betrayed
husbands or lovers who were not able to keep secrets from them.

Every woman is likewise stained by the sin of disobedience,
because there isn't in the world a woman so wise and discreet
that, if anyone forbids her to misuse anything she will not
strive against this prohibition with all her might and do what
she is told not to.  Therefore the remark of the wise man, "We
strive for what is forbidden, and always want what is denied
us," should be applied to all women without exception.

We read, too, of a very wise man who had a wife whom he
hated.  Because he wanted to avoid the sin of killing her with
his own hand, and he knew that women always strive eagerly after
what is forbidden them, he prepared a very valuable flask into
which he put wine of the best and most fragrant kind, mixed with
poison, and he said to his wife, "My sweetest wife, be careful
not to touch this vessel, and don't venture to taste any of this
liquor, because it is poisonous and deadly to human beings."
But the woman scorned her husband's prohibition, for no sooner

had he gone away than she drank some of the forbidden liquor and
so died of the poison.  But why should we mention this, since
we know of worse cases?  Wasn't it Eve, the first woman, who,
although she was formed by the hand of God, destroyed herself
by the sin of disobedience and lost the glory of immortality and
by her offense brought all her descendants to the destruction of
death?  Therefore if you want a woman to do anything, you can
get her to do it by ordering her to do the opposite.

The feminine sex is also commonly tainted by arrogance, for
a woman, when incited by that, cannot keep her tongue or her
hands from crimes or abuse, but in her anger she boldly commits
all sorts of outrages.  Moreover, if anybody tries to restrain
an angry woman, he will tire himself out with a vain labor; for
though you may bind her, hand and foot, and fasten her into any
kind of instrument of torture, you cannot keep her from her evil
design or soften her arrogance of soul.  Any woman is incited to
wrath by a mild enough remark of little significance and indeed
at times by nothing at all, and her arrogance grows to tremen-
dous proportions; so far as I can recall no one ever saw a
woman who could restrain it.  And no woman has been found who
is an exception to these rules.

Furthermore, every woman seems to despise all other women—
a thing which we know comes only from pride.  No man could
despise another unless he looked down upon him because of pride.
Besides, every woman, not only a young one but even the old and
decrepit, strives with all her might to exalt her own beauty;
this can come only from pride, as the wise man showed very
clearly when he said, "There is arrogance in everybody and pride
follows beauty."  Therefore it is perfectly clear that women can
never have perfectly good characters, because, as they say, "A
remarkable character is soiled by an admixture of pride."

Vainglory also mightily possesses woman, since you cannot
find a woman in the world who does not delight in the praise of
men above everything else and who does not think that every word
spoken about her has to do with her praise.  This fault can be
seen even in Eve, the first woman, who ate the forbidden food
in order to have knowledge of good and evil.  Furthermore, you
cannot find a woman so lowly-born that she will not tell you she
has famous relatives and is descended from a family of great men
and who will not make all sorts of boasts about herself.  These
are the things that vainglory seeks for its own.

You will find, too, that every woman is a liar, because
there isn't a woman living who doesn't make up things that are
untrue and who doesn't boldly declare what is false.  Even for
a trifle a woman will swear falsely a thousand times, and for a
tiny gain she will make up innumerable lies.  Women indeed try
by every means to support their lies, and they usually cover up
the sin of one with that of others that are elaborately con-
cocted.  No man can have such a strong case against a woman that

she will confess her fault unless she is caught in the very
act.

Again, every woman is a drunkard, that is, she likes to
drink wine.  There is no woman who would blush to drink excel-
lent Falernian with a hundred gossips in one day, nor will she
be so refreshed by that many drinks of undiluted wine that she
will refuse another if it is brought her.  Wine that is turned
she considers a great enemy, and a drink of water usually makes
her sick.  But if she finds a good wine with no water in it,
she would rather lose a good deal of her property than forgo
drinking her fill of that; therefore there is no woman who is
not often subject to the sin of drunkenness.

## C.  THE CULT OF THE VIRGIN

*The Fathers of the early Church had not stressed the sig-
nificance of Mary as the mother of God.  The Eastern (or
Byzantine) section of Christianity revered the relationship
between the holy Mother and Christ, as evidenced in mosaics and
ivories, but Western Christianity in the early Middle Ages more
or less ignored Mary and concentrated on the masculine trinity
of Father, Son, and Holy Ghost.*

*The cult of the Virgin grew as a parallel concept to the
development of the code of chivalry in aristocratic circles.
The aristocratic background that nurtured chivalry also nur-
tured to a large extent the candidates who entered the ranks
of the Church and the monastic orders.  Bernard of Clairvaux,
the influential churchman of the twelfth century, was a man with
such a background.  He headed a monastic order that prescribed
severe adherence to the original precepts of poverty, chastity,
and obedience.  By his superb preaching he almost single-
handedly rallied the princes of Christendom to embark on the
Second Crusade against the Moslems in 1147, and he was also
instrumental in causing the upsurge of reverence for the Virgin
Mary.  Bernard's prayers and sermons invoked the grace, gentle-
ness, and tenderness of Mary, especially as a mediatrix between
man and a somewhat austere God.*

*Eventually the Virgin Mary was looked upon as a worker of
miracles, the most comforting and inspiring presence by the side
of God.  This view of the Virgin was represented in art, in lit-
erature, and in the everyday life of the people of the high
Middle Ages.  It can be found in the graceful and nodding sta-
tues, in paintings in Gothic book illustrations, in the multi-
tudinous lady chapels built in Gothic cathedrals, in the names
given to cathedrals (such as "Our Lady" or "Notre Dame"), in the
thousands of little wayside shrines erected to Mary throughout
Western Europe, and in romantic legends like that of "Our Lady's
Tumbler."*

*By promoting the female element to such heights, the Church
allowed a new emphasis, although there was no doctrinal pro-
nouncement.  Instead of emphasizing only the degrading image of
the temptress Eve, a new duality incorporated both Mary the com-
passionate intercessor and Eve.*

*The story of "Our Lady's Tumbler" at first depicts the
ecstatic abandonment with which the tumbler offers his craft
to the Virgin.  It also effectively reproduces the medieval up-
surge of humility before the "Dame who is the rarest Jewel of
God."  The Virgin's maternal tenderness, superimposed on the
gentle qualities required of the lady of chivalrous imagery,
comfort the tumbler in his physical exhaustion and help him to
overcome his feelings of inferiority and inadequacy.  An inter-
esting touch in this story is the element of secrecy, which
draws a parallel with the concept of courtly love.  As a spiri-
tual solace the cult of the Virgin provides a complement to the
Christian emphasis on a stern masculine God at the Last Judgment.*

## OUR LADY'S TUMBLER

Amongst the lives of the ancient Fathers, wherein may be
found much profitable matter, this story is told for a true
ensample.  I do not say that you may not often have heard a
fairer story, but at least this is not to be despised, and is
well worth the telling.  Now therefore will I say and narrate
what chanced to this minstrel.

He erred up and down, to and fro, so often and in so many
places, that he took the whole world in despite, and sought
rest in a certain Holy Order.  Horses and raiment and money,
yea, all that he had, he straightway put from him, and seeking
shelter from the world, was firmly set never to put foot within
it more.  For this cause he took refuge in this Holy Order,
amongst the monks of Clairvaux.  Now, though this dancer was
comely of face and shapely of person, yet when he had once
entered the monastery he found that he was master of no craft
practised therein.  In the world he had gained his bread by
tumbling and dancing and feats of address.  To leap, to spring,
such matters he knew well, but of greater things he knew nothing,
for he had never spelled from book—nor Paternoster, nor canti-
cle, nor creed, nor Hail Mary, nor aught concerning his soul's
salvation.

---

E. Mason, trans., *Aucassin and Nicolette and Other Medieval
Romances and Legends* (New York:  E. P. Dutton & Co., Inc., 1958),
pp. 59-73.  Published by E. P. Dutton & Co., Inc., in a paperback
edition and used with their permission.

When the minstrel had joined himself to the Order he marked
how the tonsured monks spoke amongst themselves by signs, no
words coming from their lips, so he thought within himself that
they were dumb.  But when he learned that truly it was by way of
penance that speech was forbidden to their mouths, and that for
holy obedience were they silent, then considered he that silence
became him also; and he refrained his tongue from words, so dis-
creetly and for so long a space, that day in, day out, he spake
never, save by commandment; so that the cloister often rang with
the brothers' mirth.  The tumbler moved amongst his fellows like
a man ashamed, for he had neither part nor lot in all the busi-
ness of the monastery, and for this he was right sad and sorrow-
ful.  He saw the monks and the penitents about him, each serving
God, in this place and that, according to his office and degree.
He marked the priests at their ritual before the altars; the
deacons at the gospels; the sub-deacons at the epistles; and the
ministers about the vigils.  This one repeats the introit; this
other the lesson; cantors chant from the psalter; penitents
spell out the Miserere—for thus are all things sweetly ordered
—yea, and the most ignorant amongst them yet can pray his
Paternoster.  Wherever he went, here or there, in office or
cloister, in every quiet corner and nook, there he found five,
or three, or two, or at least one.  He gazes earnestly, if so
he is able, upon each.  Such an one laments; this other is in
tears; yet another grieves and sighs.  He marvels at their sor-
row.  Then he said, "Holy Mary, what bitter grief have all
these men that they smite the breast so grievously!  Too sad of
heart, meseems, are they who make such bitter dole together.  Ah,
St. Mary, alas, what words are these I say!  These men are call-
ing on the mercy of God, but I—what do I here!  Here there is
none so mean or vile but who serves God in his office and degree,
save only me, for I work not, neither can I preach.  Caitif and
shamed was I when I thrust myself herein, seeing that I can do
nothing well, either in labour or in prayer.  I see my brothers
upon their errands, one behind the other; but I do naught but
fill my belly with the meat that they provide.  If they per-
ceive this thing, certainly shall I be in an evil case, for they
will cast me out amongst the dogs, and none will take pity on
the glutton and the idle man.  Truly am I a caitif, set in a
high place for a sign."  Then he wept for very woe, and would
that he was quiet in the grave.  "Mary, Mother," quoth he, "pray
now your Heavenly Father that He keep me in His pleasure, and
give me such good counsel that I may truly serve both Him and
you; yea, and may deserve that meat which now is bitter in my
mouth."

Driven mad with thoughts such as these, he wandered about
the abbey until he found himself within the crypt, and took
sanctuary by the altar, crouching close as he was able.  Above
the altar was carved the statue of Madame St. Mary.  Truly his

steps had not erred when he sought that refuge; nay, but rather,
God who knows His own had led him thither by the hand.  When he
heard the bells ring for Mass he sprang to his feet all dismayed.
"Ha!" said he; "now am I betrayed.  Each adds his mite to the
great offering, save only me.  Like a tethered ox, naught I do
but chew the cud, and waste good victuals on a useless man.
Shall I speak my thought?  Shall I work my will?  By the Mother
of God, thus am I set to do.  None is here to blame.  I will do
that which I can, and honour with my craft the Mother of God in
her monastery.  Since others honour her with chant, then I will
serve with tumbling."

He takes off his cowl, and removes his garments, placing
them near the altar, but so that his body be not naked he dons
a tunic, very thin and fine, of scarce more substance than a
shirt.  So, light and comely of body, with gown girt closely
about his loins, he comes before the Image right humbly.  Then
raising his eyes, "Lady," said he, "to your fair charge I give
my body and my soul.  Sweet Queen, sweet Lady, scorn not the
thing I know, for with the help of God I will essay to serve
you in good faith, even as I may.  I cannot read your Hours
nor chant your praise, but at the least I can set before you
what art I have.  Now will I be as the lamb that plays and
skips before his mother.  Oh, Lady, who are nowise bitter to
those who serve you with a good intent, that which thy servant
is, that he is for you."

Then commenced he his merry play, leaping low and small,
tall and high, over and under.  Then once more he knelt upon
his knees before the statue, and meekly bowed his head.  "Ha!"
said he, "most gracious Queen, of your pity and your charity
scorn not this my service."  Again he leaped and played, and
for holiday and festival, made the somersault of Metz.  Again
he bowed before the Image, did reverence, and paid it all the
honour that he might.  Afterwards he did the French vault, then
the vault of Champagne, then the Spanish vault, then the vaults
they love in Brittany, then the vault of Lorraine, and all these
feats he did as best he was able.  Afterwards he did the Roman
vault, and then, with hands before his brow, danced daintily
before the altar, gazing with a humble heart at the statue of
God's Mother.  "Lady," said he, "I set before you a fair play.
This travail I do for you alone; so help me God, for you, Lady,
and your Son.  Think not I tumble for my own delight; but I
serve you, and look for no other guerdon on my carpet.  My
brothers serve you, yea, and so do I.  Lady, scorn not your
villein, for he toils for your good pleasure; and, Lady, you
are my delight and the sweetness of the world."  Then he walked
on his two hands, with his feet in the air, and his head near
the ground.  He twirled with his feet, and wept with his eyes.
"Lady," said he, "I worship you with heart, with body, feet and
hands, for this I can neither add to nor take away.  Now am I

your very minstrel. Others may chant your praises in the church
but here in the crypt will I tumble for your delight. Lady, lead
me truly in your way, and for the love of God hold me not in
utter despite." Then he smote upon his breast, he sighed and
wept most tenderly, since he knew no better prayer than tears.
Then he turned him about, and leaped once again. "Lady," said
he, "as God is my Saviour, never have I turned this somersault
before. Never has tumbler done such a feat, and, certes, it
is not bad. Lady, what delight is his who may harbour with you
in your glorious manor. For God's love, Lady, grant me such
fair hostelry, since I am yours, and am nothing of my own."
Once again he did the vault of Metz; again he danced and tum-
bled. Then when the chants rose louder from the choir, he, too,
forced the note, and put forward all his skill. So long as the
priest was about that Mass, so long his flesh endured to dance,
and leap and spring, till at the last, nigh fainting, he could
stand no longer upon his feet, but fell for weariness on the
ground. From head to heel sweat stood upon him, drop by drop,
as blood falls from meat turning upon the hearth. "Lady," said
he, "I can no more, but truly will I seek you again." Fire con-
sumed him utterly. He took his habit once more, and when he was
wrapped close therein, he rose to his feet, and bending low be-
fore the statue went his way. "Farewell," said he, "gentlest
Friend. For God's love take it not to heart, for so I may I
will soon return. Not one Hour shall pass but that I will
serve you with right good will, so I may come, and so my ser-
vice is pleasing in your sight." Thus he went from the crypt,
yet gazing on his Lady. "Lady," said he, "my heart is sore
that I cannot read your Hours. How would I love them for love
of you, most gentle Lady! Into your care I commend my soul and
my body."
    In this fashion passed many days, for at every Hour he
sought the crypt to do service, and pay homage before the Image.
His service was so much to his mind that never once was he too
weary to set out his most cunning feats to distract the Mother
of God, nor did he ever wish for other play than this. Now,
doubtless, the monks knew well enough that day by day he sought
the crypt, but not a man on earth—save God alone—was aware of
aught that passed there. . . .
    Thus things went well with this good man for a great space.
For more years than I know the count of, he lived greatly at his
ease, but the time came when the good man was sorely vexed, for
a certain monk thought upon him, and blamed him in his heart
that he was never set in choir for Matins. The monk marvelled
much at his absence, and said within himself that he would
never rest till it was clear what manner of man this was, and
how he spent the Hours, and for what service the convent gave
him bread. So he spied and pried and followed, till he marked
him plainly, sweating at his craft in just such fashion as you

have heard. "By my faith," said he, "this is a merry jest, and
a fairer festival than we observe altogether. Whilst others are
at prayers, and about the business of the House, this tumbler
dances daintily, as though one had given him a hundred silver
marks. . . ."

The monk went straight to the Abbot and told him the thing
from beginning to end, just as you have heard. The Abbot got
him on his feet, and said to the monk, "By holy obedience I bid
you hold your peace, and tell not this tale abroad against your
brother. I lay on you my strict command to speak of this mat-
ter to none, save me. Come now, we will go forthwith to see
what this can be, and let us pray the Heavenly King, and His
very sweet, dear Mother, so precious and so bright, that in her
gentleness she will plead with her Son, her Father, and her
Lord, that I may look on this work—if thus it pleases Him—so
that the good man be not wrongly blamed, and that God may be the
more beloved, yet so that thus is His good pleasure." Then they
secretly sought the crypt, and found a privy place near the
altar, where they could see, and yet not be seen. From there
the Abbot and his monk marked the business of the penitent.
They saw the vaults he varied so cunningly, his nimble leaping
and his dancing, his salutations of Our Lady, and his springing
and his bounding, till he was nigh to faint. So weak was he
that he sank on the ground, all outworn, and the sweat fell
from his body upon the pavement of the crypt. But presently,
in this his need, came she, his refuge, to his aid. Well she
knew that guileless heart.

Whilst the Abbot looked, forthwith there came down from
the vault a Dame so glorious, that certainly no man had seen
one so precious, nor so richly crowned. She was more beautiful
than the daughters of men, and her vesture was heavy with gold
and gleaming stones. In her train came the hosts of Heaven,
angel and archangel also; and these pressed close about the
minstrel, and solaced and refreshed him. When their shining
ranks drew near, peace fell upon his heart; for they contended
to do him service, and were the servants of the servitor of
that Dame who is the rarest Jewel of God. Then the sweet and
courteous Queen herself took a white napkin in her hand, and
with it gently fanned her minstrel before the altar. Courteous
and debonair, the Lady refreshed his neck, his body and his
brow. Meekly she served him as a handmaid in his need. But
these things were hidden from the good man, for he neither saw
nor knew that about him stood so fair a company.

The holy angels honour him greatly, but they can no longer
stay, for their Lady turns to go. She blesses her minstrel with
the sign of God, and the holy angels throng about her, still
gazing back with delight upon their companion, for they await
the hour when God shall release him from the burden of the
world, and they possess his soul.

This marvel the Abbot and his monk saw at least four times, and thus at each Hour came the Mother of God with aid and succour for her man. Never doth she fail her servants in their need. Great joy had the Abbot that this thing was made plain to him. . . .

. . . Then [the tumbler] laid bare before the Abbot the story of his days, from the first thing to the last, whatsoever pain it cost him; not a word did he leave out, but he told it all without a pause, just as I have told you the tale. He told it with clasped hands, and with tears, and at the close he kissed the Abbot's feet, and sighed.

The holy Abbot leaned above him, and, all in tears, raised him up, kissing both his eyes. "Brother," said he, "hold now your peace, for I make with you this true covenant, that you shall ever be of our monastery. God grant, rather, that we may be of yours, for all the worship you have brought to ours. I and you will call each other friend. Fair, sweet brother, pray you for me, and I for my part will pray for you. And now I pray you, my sweet friend, and lay this bidding upon you, without pretence, that you continue to do your service, even as you were wont heretofore—yea, and with greater craft yet, if so you may."

## D. A MEDIEVAL BUSINESSWOMAN

*Reprinted below are passages from Chaucer's* Canterbury Tales *about the Wife of Bath. The Wife of Bath took part in the great pilgrimage to Canterbury (c. 1387). This robust merchant's wife presents a tremendous contrast to the unattainable delicacy ascribed to ladies by the fourteenth-century ideal of chivalry; she is an example of the vivid earthiness found in medieval life —a product of the provincial merchant class. She had traveled far from England, for she had been on three pilgrimages—to Jerusalem, to Rome, and to the famous shrine at Compostella in Spain. She carried on her husband's business, for she herself was active in the cloth manufacture; and her own attire testified to her comfortable income. Not only was she skilled in love, says Chaucer, but she also knew how to take care of "love's mischances" —that is, she was well versed in contemporary methods of contraception and abortion.*

*Allowing for some poetic license, Chaucer has presented a very credible woman. Other historical scholars have cited evidence regarding a number of strong-willed merchants' wives and widows (c. 1300-1500) who led similar lives[1] (four husbands*

---

[1]See, for example, Sylvia Thrupp, *The Merchant Class of Medieval London* (Ann Arbor: University of Michigan Press, 1948), pp. 169-74.

*each, trades as alewives, tailors, and so on). Chaucer's exam-*
*ple used all the tricks handed down from her godmother to trap*
*her men and then to defend herself against their importunities,*
*their faithlessness, and their attacks on the feminine state.*
*As a child of twelve (fourteen or fifteen was the average age)*
*she was married to her first wealthy, elderly husband. Later*
*married to three others, she always made sure that she added yet*
*another substantial legacy to her growing fortune. Her fifth*
*husband was twenty years old to her forty and it seems that the*
*tables were reversed. At last she had married for love, only to*
*find that her husband spent his time reading aloud from the mi-*
*sogynistic literature so popular in the thirteenth and four-*
*teenth centuries. It is against this background that the Wife*
*of Bath laments that books have been written only by men:  "By*
*God if women had but written stories!"*

CANTERBURY TALES

Geoffrey Chaucer

THE PROLOGUE

A worthy *woman* from beside *Bath* city
Was with us, somewhat deaf, which was a pity.
In making cloth she showed so great a bent
She bettered those of Ypres and of Ghent.
In all the parish not a dame dared stir
Towards the altar steps in front of her,
And if indeed they did, so wrath was she
As to be quite put out of charity.
Her kerchiefs were of finely woven ground;
I dared have sworn they weighed a good ten pound,
The ones she wore on Sunday, on her head.
Her hose were of the finest scarlet red
And gartered tight; her shoes were soft and new.
Bold was her face, handsome, and red in hue.
A worthy woman all her life, what's more
She'd had five husbands, all at the church door,
Apart from other company in youth;
No need just now to speak of that, forsooth.

Geoffrey Chaucer, *Canterbury Tales*, trans. by Nevill Coghill (Baltimore, Md.: Penguin Books, 1952), pp. 29-30, 274-96. Copyright by Nevill Coghill, 1951, 1952, 1958, 1969. Reprinted by permission of Penguin Books, Ltd.

And she had thrice been to Jerusalem,
Seen many strange rivers and passed over them;
She'd been to Rome and also to Boulogne,
St James of Compostella and Cologne,
And she was skilled in wandering by the way.
She had gap-teeth, set widely, truth to say.
Easily on an ambling horse she sat
Well wimpled up, and on her head a hat
As broad as is a buckler or a shield;
She had a flowing mantle that concealed
Large hips, her heels spurred sharply under that.
In company she liked to laugh and chat
And knew the remedies for love's mischances,
An art in which she knew the oldest dances.

## THE WIFE OF BATH'S PROLOGUE

'If there were no authority on earth
Except experience; mine, for what it's worth,
And that's enough for me, all goes to show
That marriage is a misery and a woe;
For let me say, if I may make so bold,
My lords, since when I was but twelve years old,
Thanks be to God Eternal evermore,
Five husbands have I had at the church door;
Yes, it's a fact that I have had so many,
All worthy in their way, as good as any.
. . .
But I can say for certain, it's no lie,
God bade us all to wax and multiply.
That kindly text I well can understand.
Is not my husband under God's command
To leave his father and mother and take me?
No word of what the number was to be,
Then why not marry two or even eight?
And why speak evil of the married state?
    'Take wise King Solomon of long ago;
We hear he had a thousand wives or so.
And would to God it were allowed to me
To be refreshed, aye, half so much as he!
He must have had a gift of God for wives,
No one to match him in a world of lives!
This noble king, one may as well admit,
On the first night threw many a merry fit
With each of them, he was so much alive.
Blessed be God that I have wedded five!
Welcome the sixth, whenever he appears.
I can't keep continent for years and years.

No sooner than one husband's dead and gone
Some other christian man shall take me on,
For then, so says the Apostle, I am free
To wed, o' God's name, where it pleases me.
Wedding's no sin, so far as I can learn.
Better it is to marry than to burn.
. . .
Show me a time or text where God disparages,
Or sets a prohibition upon marriages
Expressly, let me have it! Show it me!
And where did He command virginity?
I know as well as you do, never doubt it,
All the Apostle Paul has said about it;
He said that as for precepts he had none.
One may advise a woman to be one;
Advice is no commandment in my view.
He left it in our judgement what to do.
   'Had God commanded maidenhood to all
Marriage would be condemned beyond recall,
And certainly if seed were never sown,
How ever could virginity be grown?
Paul did not dare pronounce, let matters rest,
His Master having given him no behest.
There's a prize offered for virginity;
Catch as catch can! Who's in for it? Let's see!
. . .
   'I grant it you.  I'll never say a word
Decrying maidenhood although preferred
To frequent marriage; there are those who mean
To live in their virginity, as clean
In body as in soul, and never mate.
I'll make no boast about my own estate.
. . .
   'Tell me to what conclusion or in aid
Of what were generative organs made?
And for what profit were those creatures wrought?
Trust me, they cannot have been made for naught.
Gloze as you will and plead the explanation
That they were only made for the purgation
Of urine, little things of no avail
Except to know a female from a male,
And nothing else.  Did somebody say no?
Experience knows well it isn't so.
The learned may rebuke me, or be loath
To think it so, but they were made for both,
That is to say both use and pleasure in
Engendering, except in case of sin.
Why else the proverb written down and set
In books:  "A man must yield his wife her debt"?

What means of paying her can he invent
Unless he use his silly instrument?
It follows they were fashioned at creation
Both to purge urine and for propagation.
. . .
    'You wait,' she said, 'my story's not begun
You'll taste another brew before I've done;
You'll find it isn't quite so nice as beer.
For while the tale is telling you shall hear
Of all the tribulations man and wife
Can have; I've been an expert all my life,
That is to say, myself have been the whip.'
. . .
    'Madam, I put it to you as a prayer,'
The Pardoner said, 'go on as you began!
Tell us your tale, spare not for any man.
Instruct us younger men in your technique.'
'Gladly,' she answered, 'if I am to speak,
But still I hope the company won't reprove me
Though I should speak as fantasy may move me,
And please don't be offended at my views;
They're really only offered to amuse.
    'Now, gentlemen, I'll on and tell my tale
And as I hope to drink good wine and ale
I'll tell the truth.  Those husbands that I had,
Three of them were good and two were bad.
The three that I call 'good' were rich and old.
They could indeed with difficulty hold
The articles that bound them all to me;
(No doubt you understand my simile).
So help me God, I have to laugh outright
Remembering how I made them work at night!
And faith I set no store by it; no pleasure
It was to me.  They'd given me their treasure,
I had no need to do my diligence
To win their love or show them reverence.
They loved me well enough, so, heavens above,
Why should I make a dainty of their love?
    'A knowing woman's work is never done
To get a lover if she hasn't one,
But as I had them eating from my hand
And as they'd yielded me their gold and land,
Why then take trouble to provide them pleasure
Unless to profit and amuse my leisure?
I set them so to work, I'm bound to say;
Many a night they sang, "Alack the day!"
. . .
I governed them so well and held the rein
So firmly they were rapturously fain

To go and buy me pretty things to wear;
They were delighted if I spoke them fair.
God knows how spitefully I used to scold them.
. . .
But listen, Here's the sort of thing I said:
  '"Now, sir old dotard, what is that you say?
Why is my neighbour's wife so smart and gay?
She is respected everywhere she goes.
I sit at home and have no decent clothes.
Why haunt her house? What are you doing there?
Are you so amorous? Is she so fair?
What, whispering secrets to our maid? For shame,
Sir ancient lecher! Time you dropped that game.
And if I see my gossip or a friend
You scold me like a devil! There's no end
If I as much as stroll towards his house.
Then you come home as drunken as a mouse,
You mount your throne and preach, chapter and verse
—All nonsense—and you tell me it's a curse
To marry a poor woman—she's expensive;
Or if her family's wealthy and extensive
You say it's torture to endure her pride
And melancholy airs, and more beside.
And if she has a pretty face, old traitor,
You say she's game for any fornicator
And ask what likelihood will keep her straight
With all those men who lie about in wait.
  '"You say that some desire us for our wealth,
Some for our shapeliness, our looks, our health,
Some for our singing, others for our dancing,
Some for our gentleness and dalliant glancing
And some because our hands are soft and small;
By your account the devil gets us all.
. . .
  '"We women hide our faults to let them show
Once we are safely married, so you say.
There's a fine proverb for a popinjay!
  '"You say that oxen, asses, hounds and horses
Can be tried out on various ploys and courses;
And basins too, and dishes when you buy them,
Spoons, chairs and furnishings, a man can try them
As he can try a suit of clothes, no doubt,
But no one ever tries a woman out
Until he's married her; old dotard crow!
And then you say she lets her vices show.
. . .
Why do you hide the keys of coffer doors?
It's just as much my property as yours.
Do you want to make an idiot of your wife?

Now, by the Lord that gave me soul and life,
You shan't have both, you can't be such a noddy
As think to keep my goods and have my body!
One you must do without, whatever you say.
And do you need to spy on me all day?
I think you'd like to lock me in your coffer!
'Go where you please, dear wife,' you ought to offer,
'Amuse yourself! I shan't give ear to malice,
I know you for a virtuous wife, Dame Alice.'
We cannot love a husband who takes charge
Of where we go.  We like to be at large."
.  .  .
     'Such was the way, my lords, you understand
I kept my older husbands well in hand.
I told them they were drunk and their unfitness
To judge my conduct forced me to take witness
That they were lying.  Johnny and my niece
Would back me up.  O Lord, I wrecked their peace,
Innocent as they were, without remorse!
For I could bite and whinney like a horse
And launch complaints when things were all my fault;
I'd have been lost if I had called a halt.
First to the mill is first to grind your corn;
I attacked first and they were overborne,
Glad to apologize and even suing
Pardon for what they'd never thought of doing.
     'I'd tackle one for wenching, out of hand,
Although so ill the man could hardly stand,
Yet he felt flattered in his heart because
He thought it showed how fond of him I was.
I swore that all my walking out at night
Was just to keep his wenching well in sight.
That was a dodge that made me shake with mirth;
But all such wit is given us at birth.
Lies, tears and spinning are the things God gives
By nature to a woman, while she lives.
So there's one thing at least that I can boast,
That in the end I always ruled the roast;
Cunning or force was sure to make them stumble,
And always keeping up a steady grumble.
     'But bed-time above all was their misfortune;
That was the place to scold them and importune
And baulk their fun.  I never would abide
In bed with them if hands began to slide
Till they had promised ransom, paid a fee;
And then I let them do their nicety.
.  .  .
     'That's how my first three husbands were undone.
.  .  .

Now let me tell you of my last but one.
'I told you how it filled my heart with spite
To see another woman his delight,
By God and all His saints I made it good!
I carved him out a cross of the same wood,
Not with my body in a filthy way,
But certainly by seeming rather gay
To others, frying him in his own grease
Of jealousy and rage; he got no peace.
By God on earth I was his purgatory,
For which I hope his soul may be in glory.
God knows he sang a sorry tune, he flinched,
And bitterly enough, when the shoe pinched.
And God and he alone can say how grim,
How many were the ways I tortured him.
'He died when I came back from Jordan Stream
And he lies buried under the rood-beam,
Albeit that his tomb can scarce supply us
With such a show as that of King Darius
—Apelles sculped it in a sumptuous taste—
But costly burial would have been mere waste.
Farewell to him, God give his spirit rest!
He's in his grave, he's nailed up in his chest.
'Now of my fifth, last husband let me tell.
God never let his soul be sent to Hell!
And yet he was my worst, and many a blow
He struck me still can ache along my row
Of ribs, and will until my dying day.
'But in our bed he was so fresh and gay,
So coaxing, so persuasive. . . . Heaven knows
Whenever he wanted it—my *belle chose*
Though he had beaten me in every bone
He still could wheedle me to love, I own.
I think I loved him best, I'll tell no lie.
He was disdainful in his love, that's why.
We women have a curious fantasy
In such affairs, or so it seems to me.
When something's difficult, or can't be had,
We crave and cry for it all day like mad.
Forbid a thing, we pine for it all night,
Press fast upon us and we take to flight;
We use disdain in offering our wares.
A throng of buyers sends prices up at fairs,
Cheap goods have little value, they suppose;
And that's a thing that every woman knows.
'My fifth and last—God keep his soul in health!
The one I took for love and not for wealth,
Had been at Oxford not so long before
But had left school and gone to lodge next door,

Yes, it was to my godmother's he'd gone.
God bless her soul! *Her* name was Alison.
She knew my heart and more of what I thought
Than did the parish priest, and so she ought!
She was my confidante, I told her all.
For had my husband pissed against a wall
Or done some crime that would have cost his life,
To her and to another worthy wife
And to my niece, because I loved her well,
I'd have told everything there was to tell.
And so I often did, and Heaven knows
It used to set him blushing like a rose
For shame, and he would blame his lack of sense
In telling me secrets of such consequence.
    'And so one time it happened that in Lent,
As I so often did, I rose and went
To see her, ever wanting to be gay
And go a-strolling, March, April and May,
From house to house for chat and village malice.
    'Johnny (the boy from Oxford) and Dame Alice
And I myself, into the fields we went.
My husband was in London all that Lent;
All the more fun for me—I only mean
The fun of seeing people and being seen
By cocky lads; for how was I to know
Where or what graces Fortune might bestow?
And so I made a round of visitations,
Went to processions, festivals, orations,
Preachments and pilgrimages, watched the carriages
They use for plays and pageants, went to marriages,
And always wore my gayest scarlet dress.
    'These worms, these moths, these mites, I must confess,
Got little chance to eat it, by the way.
Why not? Because I wore it every day.
    —'Now let me tell you all that came to pass.
We sauntered in the meadows through the grass
Toying and dallying to such extent,
Johnny and I, that I grew provident
And I suggested, were I ever free
And made a widow, he should marry me.
And certainly—I do not mean to boast—
I ever was more provident than most
In marriage matters and in other such.
I never think a mouse is up to much
That only has one hole in all the house;
If that should fail, well, it's good-bye the mouse.
    'I let him think I was as one enchanted
(That was a trick my godmother implanted)
And told him I had dreamt the night away

Thinking of him, and dreamt that as I lay
He tried to kill me.  Blood had drenched the bed.
   "But still it was a lucky dream," I said,
"For blood betokens money, I recall."
It was a lie.  I hadn't dreamt at all.
'Twas from my godmother I learnt my lore
In matters such as that, and many more.
   'Well, let me see . . . what had I to explain?
Aha! By God, I've got the thread again.
   'When my fourth husband lay upon his bier
I wept all day and looked as drear as drear,
As widows must, for it is quite in place,
And with a handkerchief I hid my face.
Now that I felt provided with a mate
I wept but little, I need hardly state.
   'To church they bore my husband on the morrow
With all the neighbours round him venting sorrow,
And one of them of course was handsome Johnny.
So help me God, I thought he looked so bonny
Behind the coffin! Heavens, what a pair
Of legs he had! Such feet, so clean and fair!
I gave my whole heart up, for him to hold.
He was, I think, some twenty winters old,
And I was forty then, to tell the truth.
But still, I always had a coltish tooth.
Yes, I'm gap-toothed; it suits me well I feel,
It is the print of Venus and her seal.
So help me God I was a lusty one,
Fair, young and well-to-do, and full of fun!
And truly, as my husbands said to me
I had the finest *quoniam* that might be.
For Venus sent me feeling from the stars
And my heart's boldness came to me from Mars.
Venus gave me desire and lecherousness
And Mars my hardihood, or so I guess,
Born under Taurus and with Mars therein.
Alas, alas, that ever love was sin!
I ever followed natural inclination
Under the power of my constellation
And was unable to deny, in truth,
My chamber of Venus to a likely youth.
The mark of Mars is still upon my face
And also in another privy place.
For as I may be saved by God above,
I never used discretion when in love
But ever followed on my appetite,
Whether the lad was short, long, black or white.
Little I cared, if he was fond of me,
How poor he was, or what his rank might be.

'What shall I say? Before the month was gone
This gay young student, my delightful John,
Had married me in solemn festival.
I handed him the money, lands and all
That ever had been given me before;
This I repented later, more and more.
None of my pleasures would he let me seek.
By God, he smote me once upon the cheek
Because I tore a page out of his book,
And that's the reason why I'm deaf.  But look,
Stubborn I was, just like a lioness;
As to my tongue, a very wrangleness.
I went off gadding as I had before
From house to house, however much he swore.
Because of that he used to preach and scold,
Drag Roman history up from days of old,
How one Simplicius Gallus left his wife,
Deserting her completely all his life,
Only for poking out her head one day
Without a hat, upon the public way.
   'Some other Roman—I forget his name—
Because his wife went to a summer's game
Without his knowledge, left her in the lurch.
   'And he would take the Bible up and search
For proverbs in Ecclesiasticus,
Particularly one that has it thus:
"Suffer no wicked woman to gad about."
And then would come the saying (need you doubt?)
   *A man who seeks to build his house of sallows,*
   *A man who spurs a blind horse over fallows,*
   *Or lets his wife make pilgrimage to Hallows,*
   *Is worthy to be hanged upon the gallows.*
But all for naught.  I didn't give a hen
For all his proverbs and his wise old men.
Nor would I take rebuke at any price;
I hate a man who points me out my vice,
And so, God knows, do many more than I.
That drove him raging mad, you may rely.
No more would I forbear him, I can promise.
   'Now let me tell you truly by St Thomas
About that book and why I tore the page
And how he smote me deaf in very rage.
   'He had a book, he kept it on his shelf,
And night and day he read it to himself
And laughed aloud, although it was quite serious.
He called it *Theophrastus and Valerius.*
There was another Roman, much the same,
A cardinal; St Jerome was his name.
He wrote a book against Jovinian
Bound up together with Tertullian,

Chrysippus, Trotula and Heloise,
An abbess, lived near Paris.  And with these
Were bound the parables of Solomon,
With Ovid's *Art of Love* another one.
All these were bound together in one book
And day and night he used to take a look
At what it said, when he had time and leisure
Or had no occupation but his pleasure,
Which was to read this book of wicked wives;
He knew more legends of them and their lives
Than there are good ones mentioned in the Bible.
For take my word for it, there is no libel
On women that the clergy will not paint,
Except when writing of a woman-saint,
But never good of other women, though.
Who called the lion savage?  Do you know?
By God, if women had but written stories
Like those the clergy keep in oratories,
More had been written of man's wickedness
Than all the sons of Adam could redress.
. . .
    'Now to my purpose as I told you; look,
Here's how I got a beating for a book.
One evening Johnny, glowering with ire,
Sat with his book and read it by the fire.
And first he read of Eve whose wickedness
Brought all mankind to sorrow and distress,
Root-cause why Jesus Christ Himself was slain
And gave His blood to buy us back again.
Aye, there's the text where you expressly find
That woman brought the loss of all mankind.
    'He read me then how Samson as he slept
Was shorn of all his hair by her he kept,
And by that trechery Samson lost his eyes
And then he read me, if I tell no lies,
All about Hercules and Deianire;
She tricked him into setting himself on fire.
    'He left out nothing of the miseries
Occasioned by his wives to Socrates.
Xantippe poured a piss-pot on his head.
The silly man sat still, as he were dead,
Wiping his head, but dared no more complain
Than say, "Ere thunder stops, down comes the rain."
    'Next of Pasiphaë the Queen of Crete;
For wickedness he thought that story sweet;
Fie, say no more! It has a grisly sting,
Her horrible lust.  How could she do the thing!
    'And then he told of Clytemnestra's lechery
And how she made her husband die by treachery.

He read that story with a great devotion.
.  .  .
    'Of wives of later date he also read,
How some had killed their husbands when in bed,
Then night-long with their lechers played the whore,
While the poor corpse lay fresh upon the floor.
    'One drove a nail into her husband's brain
While he was sleeping, and the man was slain;
Others put poison in their husbands' drink.
He spoke more harm of us than heart can think
And knew more proverbs too, for what they're worth,
Than there are blades of grass upon the earth.
    '"Better," says he, "to share your habitation
With lion, dragon, or abomination
Than with a woman given to reproof.
Better," says he, "take refuge on the roof
Than with an angry wife, down in the house;
They are so wicked and cantankerous
They hate the things their husbands like," he'd say.
"A woman always casts her shame away
When she casts off her smock, and that's in haste.
A pretty woman, if she isn't chaste,
Is like a golden ring in a sow's snout."
    'Who could imagine, who could figure out
the torture in my heart?  It reached the top
And when I saw that he would never stop
Reading this cursed book, all night no doubt,
I suddenly grabbed and tore three pages out
Where he was reading, at the very place,
And fisted such a buffet in his face
That backwards down into our fire he fell.
    'Then like a maddened lion, with a yell
He started up and smote me on the head,
And down I fell upon the floor for dead.
    'And when he saw how motionless I lay
He was aghast and would have fled away,
But in the end I started to come to.
"O have you murdered me, you robber, you,
To get my land?" I said.  "Was that the game?
Before I'm dead I'll kiss you all the same."
    'He came up close and kneeling gently down
He said, "My love, my dearest Alison,
So help me God, I never again will hit
You, love; and if I did, you asked for it.
Forgive me!" But for all he was so meek
I up at once and smote him on the cheek
And said, "Take that to level up the score!
Now let me die.  I can't speak any more."
    'We had a mort of trouble and heavy weather

But in the end we made it up together.
He gave the bridle over to my hand,
Gave me the government of house and land,
Of tongue and fist, indeed of all he'd got.
I made him burn that book upon the spot.
And when I'd mastered him, and out of deadlock
Secured myself the sovereignty in wedlock,
And when he said, "My own and truest wife,
Do as you please for all the rest of life,
But guard your honour and my good estate,"
From that day forward there was no debate.
So help me God I was as kind to him
As any wife from Denmark to the rim
Of India, and as true. And he to me.
And I pray God that sits in majesty
To bless his soul and fill it with his glory.
. . .

## E. MEDIEVAL WOMEN AND TRADE

*The article "Women Traders in Medieval London" reprinted below gives us some factual information about women's part in the guild and business world in Chaucerian England. It points out the range of activities open to women and assesses the proportion of women engaged in nondomestic pursuits. The author correctly recognizes the correlation between an economic need for women's labor and the facility with which women have been able to work side by side with men. Wars, such as the First World War, when this article was written, have always been a high point on the thermometer of women's participation in the essential economy of society. The period covered by this article encompasses the Hundred Years' War between England and France as well as the aftermath of the Black Death and famines of the mid-fourteenth century.*

*The author's criticism of child labor and child apprenticeship in the Middle Ages has a quaintly progressive ring to it, for it is well established that girls not married by their mid-teens were "old maids." Further, it was only in the nineteenth century that child labor became an issue at all. Girls began work in the British coal mines at seven years of age or less, until female labor in the mines was abolished in 1842. In the medieval period and for hundreds of years afterward children of both sexes participated in earning the family's livelihood as soon as they were physically capable of doing so. There are book illustrations of the fifteenth century, for example, that depict Jesus as a toddler sweeping up the wood shavings in the family carpentry workshop. The mother's function in this type of*

*society was thus much more that of worker and instructor than that of playmate.*

## WOMEN TRADERS IN MEDIEVAL LONDON

## A. Abram

At the present time when women, in response to their coun-
try's call, are entering trades usually carried on by men, it
is encouraging to look back into the past and see how large a
part they played in the business life of England's greatest
city, in an age which, like our own, though for quite a differ-
ent reason, was a period of crisis.  The fourteenth and fifteenth
centuries witnessed an extraordinary expansion of English indus-
try and commerce, which made unprecedented demands upon the
nation's resources, and necessitated an increase in the number
of workers; and in London, the great centre of activity, it
seems to have been taken for granted that women should do their
share.  No trade was closed to them by law, and evidence exists
in the civic records of their employment in occupations of many
kinds.  Legally they were in a better position than men, after
1363, in one respect at least, for an Act passed in that year
ordered men to keep to one trade, while women were left free to
follow as many as they chose.
Some of their occupations were very trivial and insignifi-
cant; one was a flaoner, a maker of flauns, a light cake, not
unlike a pancake; another was a herb-wife, and others sellers
of old clothes.  On the other hand, they were also engaged in
some of the most important and remunerative trades; they were
mercers, drapers, grocers, and merchants, and sometimes had the
honour of serving the King.  Henry III paid Mariot, wife of
Robert de Ferars, over £75 for palfreys, horses, harness, and
other necessaries, and he bought lime, hurdles, and poles for
his palace at Westminster from women.  In 1301 Dyonisia, la
Rowere, provided wheels for the King's use in Scotland, and
silkwomen worked for Edward IV and Henry VII.  Many women,
however, were engaged in more homely work, and were threadwomen,
embroiderers, sempstresses or needlewomen, laundresses, and mid-
wives.  A large number were domestic servants; their remunera-
tion was apparently not on a very generous scale, and sometimes

A. Abram, "Women Traders in Medieval London," *Economic Journal* (London), No. 26, June 1916, pp. 276-85. Reprinted by permission of the Royal Economic Society, Cambridge, England.

of a curious description.  John Nyman and Edith, his wife,
claimed only £4 16s. wages for Edith for nine years, during
which she was continually with Walter Rawlys, and Robert de Eye
recovered a bed for the service of his wife in the capacity of
nurse for four years.  As a set-off to this we find that mas-
ters and mistresses frequently left legacies to their servants,
which were sometimes of considerable value; thus one had land
and houses, another a hall and two shops, another an annuity of
ninepence a week, and another twenty marks and the next vacancy
in the testator's almshouse.

In the course of the fifteenth century, Miss Clay tells us
in her interesting book on Medieval Hospitals, the work of women
amongst the sick developed.  In some institutions there were dis-
tinct grades of nursing women.  The poet Gower mentions in his
will the staffs of four London hospitals; he leaves money "to
every sister professed," and to each of them who is a nurse of
the sick, at St. Thomas', Southwark.  In some hospitals the
offices were honorary, but the officials were supplied with
food and clothing.

Women were also to be found in some employments which we
might perhaps have expected them to have left to men; we read
of women barbers, apothecaries, armourers, shipwrights, tailors,
spurriers, and even female water-bearers.  They were amongst
the barber-surgeons, who practised surgery side by side with
the surgeons proper, and who afterwards joined with them and
formed the Royal College of Surgeons.  Two girls were appren-
ticed to a public notary, and it would have been very extra-
ordinary if they had followed this calling, but one of them
died young, and the other married, so one could not, and the
other may not have attained to it.

One woman was apparently an artist, as in her will she
left her apprentice the third best part of copies and instru-
ments appertaining to the making of pictures, and one of her
best chests to hold them.

The trade which attracted the largest number of women was
"silkwerk," and it was almost entirely carried on by them.
They made fringe, tassels, ribbon, laces, girdles, and other
small articles of silk.  They were very jealous of foreign com-
petition, and seem to have been well able to look after their
own interests.  In 1368 certain "silkwymen" delivered a bill
to the Mayor and Aldermen complaining that Nicholas Sarduche,
a Lombard, had been buying all the silk he could find, and
raising the price of it; not content with this, they petitioned
the Crown, with the result that a writ was issued ordering the
civic authorities to do them justice; consequently an inquiry
was made, and Sarduche was found guilty.  In 1455 they again
petitioned the Crown, declaring that more than a thousand women
were employed in the craft, and begging that the importation
from abroad of the goods they made might be prohibited, and an

Act was passed in accordance with their wishes.

Beer and ale were very favourite beverages in the Middle Ages, and from quite early times women brewed and sold them. It used to be thought that this business was "almost wholly in the hands of females," but Dr. Sharpe has noted that in a list of three hundred brewers, given in *Letter-Book I*, in the year 1420, less than twenty were females, and in 1356, when thirty brewers were appointed to serve the king with ale, only one was a woman.  So it is clear that the brewers outnumbered the brewsters in London; nevertheless, the frequent allusions to them in the City records show that there were large numbers of them. Many women also kept ale-houses and inns.

Bakeresses were numerous in Medieval London; many were merely regratresses who bought bread from other bakers, and sold it again, carrying it round from house to house.  From the custom of giving them thirteen loaves for twelve the expression baker's dozen arose.  Some bakeresses, however, were in a better position and had carts, and some had bake-houses of their own.

Poultry-selling was another trade practised by women from early days.  Poulterers who lived outside the City often brought their goods into the market on horseback, and if they did not touch the ground their owners were not obliged to pay stallage.

A good many women were engaged in selling fish, for which there was a great demand, particularly on fast-days.  As in the case of bakeresses, some of them were poor women who went about crying their wares in the streets; these birlesters, as they were called, were not allowed to stand in any set place, but others sold in the market or in shops.

In nearly all trades fewer women than men seem to have been engaged; in 1283 ten candlemakers had selds in Chepe and only one was a woman, and in an enumeration of the trade marks of coopers (12 Edward IV—18 Henry VII) twenty-nine belonged to men and two to women.  Nevertheless, there must have been a considerable number of women employed in trade, taking them altogether; the Statutes of the Realm regulating the conditions of labour mention women as well as men, civic ordinances deal with girl apprentices and women traders, and corroborative evidence can be adduced from other sources.  London citizens sometimes left directions in their wills that their daughters should be taught trades, or money for this purpose, and as the orphans of freemen were under the care of the Mayor, records of their apprenticeship appear in the *Letter-Books*.

It must not be thought that the trade carried on by women was necessarily on a small scale; some of them did a large business.  Armour and other goods to the value of £200 were stolen from the house of Alice, wife of Thomas de Cantebrugge, so she must have had a good stock.  A piece of embroidered cloth, sold by Aleyse Darcy and Thomasin Guydichon to the Earl

of Lincoln was worth three hundred marks, and another piece
which Aleyse was preparing was estimated at the same price.
George Bulstrode, draper, of London, who had acted for Eliza-
beth Kirkeby, in Seville, for a year, made a claim of £4,000
for diverse merchandise and wares sent to her from there, and
even allowing for some exaggeration on his part the sum is
large.

Some women traded as "sole merchants," and this they could
do even if they were married, provided that their husbands did
not intermeddle in any way with their trade.  In such a case a
woman could hire a shop, and she alone was answerable for the
rent, and could be charged as a "femme sole" for it and any-
thing concerning her craft.  Should the plaintiff implead hus-
band and wife together, the wife was at liberty to plead as a
"femme sole," and to have all the advantages in pleading as
such; and she could "make her law" by swearing her innocence
with the assistance of compurgators or oath-helpers, who might
be men or women according to her will.  If she were condemned
to make payment, she was committed to prison till she had made
a composition with her creditor; the husband in the meanwhile
being left, both in person and property, wholly untouched.
This custom at first only applied to the wives of freemen, but
early in the sixteenth century it was extended to the wives of
non-freemen.  In *Letter-Books, A* and *B*, a number of recogni-
zances to pay sums of money are entered, and more than fifty
of them are made by women, and some seem to be for debts in-
curred in trade, but it is impossible to say exactly how many,
as the nature of the debt is not always stated.

If a married woman did not trade as a sole merchant she
could plead coverture, and then her husband was responsible
for her debts and misdeeds.  Thus in 1377 a man named John de
Pekham was imprisoned for a debt which it was alleged his wife
had contracted before her marriage.  In 1327 eight bakers and
two bakeresses were found guilty of stealing dough; the men
were put in the pillory, but the women said they had husbands
(which the neighbours attested), and that the deed was not
theirs, so they were sent back to Newgate until it should be
otherwise ordained.  On another occasion a bakeress was found
with bread deficient in weight, and it was adjudged forfeited
because her husband did not come and claim it.

If a married woman took an apprentice, whether she were
a sole merchant or not, the custom of London required that the
apprentice should be bound to her husband as well as to her,
even if he were practising a different craft, and knew nothing
whatever about hers.  The *Liber Albus* which sets forth this
custom speaks only of female apprentices, but unquestionably
women sometimes had male apprentices.  It is to be feared that
they did not always treat them very well; in an entry of the
*Plea and Memoranda Rolls* we find that Thomas Bunny complained to

the Mayor and Aldermen that Johanna Hunte, to whom he had been
turned over for the rest of his term by Thomas Rose, "sheder,"
had made him carry water in "tynes," whereby he had been injured,
and she had dismissed him from her service, but when he re-
covered she wanted him back again.  His tale was apparently true,
as the Court discharged him from serving her further.  An under-
taking given by the sureties for Agnes, wife of John Cotiller,
that she would not beat her girl apprentice with a stick or a
knife is unpleasantly suggestive.  No doubt apprentices were
sometimes very tiresome, and difficult to manage; in 1376 John
Shadewall, apprentice to Margaret Shadewell, was committed to
prison for bad behavior towards her, and in 1445 an apprentice
was flogged in the hall of the Goldsmiths' Guild for trying to
strangle his mistress.  It was fortunate that both parties could
appeal to the Gild officials, or to the Mayor and Aldermen, and
obtain redress of their grievances.  The fraternity of St. Mary
in the church of All Hallows, London Wall, gave legal or charit-
able assistance to any member whose son or daughter had been
unjustly treated by the person to whom he or she was apprenticed.
There was one abuse which occasionally escaped the vigilance of
the authorities, or was permitted by them:  the employment of
children of tender age.  One little orphan girl was apprenticed
when she was eleven, and another when she was only seven or
eight.
     Frequently husbands and wives worked together, the wife
acting for her husband in his absence, and helping him when he
was at home.  They sometimes had apprentices who served them
both, and were jointly responsible for debts.  The business
capacity of women was fully recognised, for it was the rule that
if a debt were made by the hand of the wife, the husband should
have her aid if a suit were brought against him, and should have
respite till the next court to take counsel with her.  A few
Gilds—the Girdlers, Braelers, and Pynners, passed restrictive
ordinances against women, and prohibited their employment, but
they all made exceptions in favour of wives and daughters, and
the Leathersellers allowed them to work for their husbands and
fathers even if they had not been bound apprentice to the trade.
Consequently, when a man died his wife was often quite capable
of continuing his business, and as by the custom of London the
widow of a freeman became free on his death, this frequently
happened.  In the wills enrolled in the Court of Husting there
are numerous bequests to their widows of the services of their
apprentices and the implements of their trades by craftsmen—
apothecaries, a baker, a burler, a carpenter, a cook, a currier,
drapers, a dyer, fishmongers, a fuster, a girdler, goldsmiths,
joiners, mercers, a pepperer, a skinner, a tanner, a tyler,
weavers, and others whose trades are not specified.  A few
testators added the proviso that their apprentices should only
serve their widows as long as they refrained from remarriage,

and three tanners left their places and tables in the Tannerseld
to their wives on the condition that they should remain single
or marry tanners.  Such stipulations seem rather odd to us, but
they were not unnatural in the Middle Ages, when second mar-
riages were extremely common, and when each trade was in the
hands of a gild whose members would not tolerate the intrusion
of a stranger.  The ordinances of the Grocers and the Gold-
smiths reflect the same spirit.  There are one or two instances
of daughters benefiting in a similar fashion under their fathers'
wills; thus one received the lease of a brewhouse for eight years,
and at the end of the term five quarters of malt to set herself
up in business, and another had implements and the services of
the dead man's apprentices.  Bequests of this kind probably
account in a large measure for the presence of women in somewhat
masculine employments, and for their male apprentices; the earli-
est of them occurs in a will enrolled in 1259, the latest in one
dated 1413, but the majority of them were made in the last three-
quarters of the fourteenth century.

   Women, Dr. Sharpe tells us, were admissible into every
trade or craft gild, but their position was not equally good in
all.  Most gilds showed as much solicitude for the spiritual
welfare of sisters as of brothers—they provided masses for
their souls, and tapers for their burial, and bore the cost of
their funerals if they died in great poverty.  Some gilds also
gave help to women members who fell into want through no fault
of their own; in 1414 the Merchant Taylors built almshouses for
"their poor brethren and sisters," and in 1432 rents were devised
for their relief and sustentation, and the Whittawyers granted a
pension to widows of members.  Women were often present at gild
feasts, sometimes in their own right, sometimes as their hus-
bands' companions, and in the latter case the fees for them were
paid by the husbands.  Widows of Grocers could attend the din-
ners, but were called upon to pay double if they were able.
There was a ladies' chamber attached to the Drapers' Hall, where
the sisters sometimes had separate dinners, but they were also
sometimes present at the feasts in the Common Hall.  The rules
regarding their admission to the livery of the companies varied:
there were thirty-nine women on the livery of the Brewers, in
the fifth year of the reign of Henry V, but in 1383, out of a
hundred and twenty-eight persons on the livery of the Grocers,
only one was a woman, and according to the Report of the Livery
Companies' Commission of 1884 no woman had ever been admitted
to the livery of the Armourers and Brasiers.  On the other hand,
they sometimes had the advantage of paying less quarterage than
men.  They held a very good position in the Carpenters' Company,
they not only received spiritual and pecuniary benefits, and
had "clothyng," but also, with the brethren, met four times a
year to ordain things needful and profitable for the brother-
hood.  In the Shearmen's Ordinances, dated 1452, the brothers

and sisters were directed to go to dinner together on the morrow
of the Sunday after the Assumption every year, and there to "make
their eleccion of three wardeyns," and within fourteen days they
were to be called together again and to make election of twelve
persons "to assiste, keepe, and councell" the wardens.  The
Ordinances of the Blacksmiths were subscribed by sixty-five
brethren and the wives of two of them.  Occasionally special
honour was paid to the wives of the Masters of the Company; in
some gilds it was customary for the old wardens who were going
out of office to set garlands on the heads of their successors;
on the day of election the Merchant Taylors crowned both the
incoming Master and his wife with roses.  The ceremony may,
perhaps, be thought a trifling act of courtesy, hardly worthy
of mention, but it is interesting because it shows a respect
for family ties, and a feeling for the unity of husband and wife.
In 1372 the ordinances of the Dyers of Leather were brought be-
fore the Court of Aldermen for ratification, and three men and
their respective wives were sworn to oversee the premises and
defaults, and to present them to the Mayor, but this choice of
women overseers appears to have been an isolated incident.

If we sum up the evidence gathered from the various sources
which have passed under our review, we are led to the conclusion
that the women traders of Medieval London were persons of strong
character and undeniable business ability, and that they played
a not inconsiderable and very useful part in the industrial life
of the city.

## F. ANALYSIS OF THE POSITION OF WOMEN IN THE LATE MIDDLE AGES

*The following reading is a chapter contributed to a book on
the Middle Ages published in 1926.  The author, Eileen Power, an
English historian, was one of the pioneers who attempted to re-
construct the lives of women in the Middle Ages.  Although this
essay is almost fifty years old and is mostly based on histori-
cal evidence from the later Middle Ages (the fourteenth and
fifteenth centuries in England and France), it is still one of
the most comprehensive and lucid expositions of the position of
women in the medieval period.  Occasionally Dr. Power assumes a
fair amount of historical background on the part of her readers,
and it is hoped that her allusive comments on such basic medi-
eval themes as feudalism, chivalry, and courtly love have been
covered by the previous items in this section.  The allusions
to "Griselda," a favorite figure in medieval literature, must
be clarified, however.*

*Griselda was the very antithesis of the Wife of Bath.  She
was a poor peasant girl, married to an Italian nobleman determined*

*to test her superhuman "feminine" virtues of patience and sub-
missiveness.  He insisted that she have both of her children
killed, simply to see whether she would obey his demands, and
required that she leave his house, returning to her family and
to poverty so that he might marry a new and beautiful young
wife.  Griselda agreed to all demands with humble submissive-
ness, and the story has a happy surprise ending.*

   *Dr. Power found that medieval women, like those of all
ages, presented a great variety.  The aristocratic ideal of
chivalry and the Church's ideal of feminine submissiveness were
indeed ideals.  In her daily life the average medieval woman
neither stood on a pedestal above men nor groveled submissively
below them but was treated as a "married friend."*

THE POSITION OF WOMEN

Eileen Power

   The position of women has been called the test point by
which the civilization of a country or of an age may be judged,
and although this is in many respects true, the test remains
one which it is extraordinarily difficult to apply, because of
the difficulty of determining what it is that constitutes the
position of women.  Their position in theory and in law is one
thing, their practical position in everyday life another.  These
react upon one another, but they never entirely coincide, and
the true position of women at any particular moment is an insi-
dious blend of both.  In the Middle Ages the proper sphere of
women was the subject of innumerable didactic treatises ad-
dressed to them, or written about them, and their merits and
defects were an evergreen literary theme, which sometimes gave
rise to controversies in which the whole fashionable literary
world of the day was engaged, such as the debate which raged
round Jean de Meun's section of the *Roman de la Rose* and Alan
Chartier's poem *La Belle Dame sans Merci* at the beginning of
the fifteenth century.
   The characteristic medieval theory about women, thus laid
down and debated, was the creation of two forces, the Church
and the Aristocracy, and it was extremely inconsistent.  The

Eileen Power, "The Position of Women," in *The Legacy of
the Middle Ages*, ed. by C. G. Crump and E. F. Jacob (New York:
Oxford University Press, 1926), pp. 403-33.  Reprinted by per-
mission of The Clarendon Press, Oxford.

Church and the Aristocracy were not only often at loggerheads
with each other, but each was at loggerheads with itself and
both taught the most contradictory doctrines, so that women
found themselves perpetually oscillating between a pit and a
pedestal.  Had the Church, indeed, been consistent in its
attitude towards them in the early days of its predominance,
their position might have been much better or much worse.  But
it was remarkably inattentive to the biblical injunction against
halting between two opinions.  Janus-faced it looked at women
out of every pulpit, every law book and every treatise, and she
never knew which face was turned upon her.  Was she Eve, the
wife of Adam, or was she Mary, the mother of Christ?  "Between
Adam and God in Paradise," says Jacques de Vitry (d. 1240),
"there was but one woman; yet she had no rest until she had suc-
ceeded in banishing her husband from the garden of delights and
in condemning Christ to the torment of the cross."  On the other
hand, "Woman," says a manuscript in the University of Cambridge,
"is to be preferred to man, to wit:  in material, because Adam
was made from clay and Eve from the side of Adam; in place,
because Adam was made outside paradise and Eve within; in con-
ception, because a woman conceived God, which a man could not
do; in apparition, because Christ appeared to a woman after the
Resurrection, to wit, the Magdalen; in exaltation, because a
woman is exalted above the choirs of angels, to wit, the Blessed
Mary."  It is extremely curious to follow the working of these
two ideas upon the medieval mind.  The view of woman as an instru-
ment of the Devil, a thing at once inferior and evil, found ex-
pression very early in the history of the Church, and it was the
creation of the Church; for while Rome knew the tutelage of woman,
and barbarism also placed her in man's *mund*, both were distin-
guished by an essential respect for her.  As the ascetic ideal
rose and flourished and monasticism became the refuge of many of
the finest minds and most ardent spirits who drew breath in the
turmoil of the dying Empire and the invasions, there came into
being as an inevitable consequence a conception of woman as the
supreme temptress, "ianua diaboli," the most dangerous of all
obstacles in the way of salvation.  It is unnecessary to enter
fully into the ramifications of this attitude.  Its importance
is that it established a point of view about woman which sur-
vived long after the secular conditions which created it had
passed away.  In practice it had little influence upon men's
daily lives; they continued marrying and giving in marriage and
invoked the blessing of the Church upon their unions.  But opin-
ion may change irrespective of practice and the monastic point
of view slowly permeated society.  Tertullian and St. Jerome
took their place beside Ovid in that "book of wikked wyves,"
which the Wife of Bath's fifth husband was wont to read aloud
nightly, with such startling results.  The clergy, who preached
the ascetic ideal, were for many centuries the only educated

and hence the only articulate section of the community, and it
is not surprising that the fundamental theory about women should
have been a theory of their essential inferiority.

This theory was accepted by the ordinary layman, but only
up to a point.  Outside the ranks of monastic writers and the
more extreme members of a celibate priesthood, no one, save pro-
fessional misogynists like the notorious Matheolus, took the
evil nature of women very seriously, and most men would probably
have agreed with the Wife of Bath's diagnosis,

> For trusteth wel, it is an impossible
> That any clerk wol speke good of wyves,—
> But if it be of hooly Seintes lyves,—
> Ne of noon oother womman never the mo.

What they did accept was the subjection of women.  The ideal of
marriage which inspires the majority of the didactic works ad-
dressed to women in the course of the Middle Ages is founded
upon this idea and demands the most implicit obedience.  It is
set forth in the stories of Patient Griselda and the Nut-Brown
Maid, and the possessive attitude towards women is nowhere more
clearly marked than in the remarks made upon feminine honour by
Philippe de Novaire (d. 1270) in his treatise *Des quatre tens
d'aage d'ome.*  "Women," he says, "have a great advantage in
one thing; they can easily preserve their honour if they wish
to be held virtuous, by one thing only.  But for a man many are
needful, if he wish to be esteemed virtuous, for it behoves him
to be courteous and generous, brave and wise.  And for a woman,
if she be a worthy woman of her body, all her other faults are
covered and she can go with a high head wheresoever she will;
and therefore it is in no way needful to teach as many things
to girls as to boys."

The subjection of women was thus one side of medieval
theory, accepted both by the Church and by the Aristocracy.
On the other hand, it was they also who developed with no appar-
ent sense of incongruity the counter-doctrine of the superiority
of women, that adoration (*Frauendienst*) which gathered round the
persons of the Virgin in heaven and the lady upon earth, and
which handed down to the modern world the ideal of chivalry.
The cult of the Virgin and the cult of chivalry grew together,
and continually reacted upon one another; they were both, per-
haps, the expression of the same deep-rooted instinct, that
craving for romance which rises to the surface again and again
in the history of mankind; and just as in the nineteenth cen-
tury the romantic movement followed upon the age of common
sense, so in the Middle Ages the turmoil and pessimism of the
Dark Ages were followed by the age of chivalry and of the
Virgin.  The cult of the Virgin is the most characteristic
flower of medieval religion and nothing is more striking than

the rapidity with which is spread and the dimensions which it
assumed.  She was already supreme by the eleventh century, and
supreme she remained until the end of the Middle Ages.  Great
pilgrimages grew up to her shrines and magnificent cathedrals
were reared and decorated in her honour, while in almost every
church not specifically her own she had a lady chapel.  In the
thirteenth century—about the same time that Philippe de Novaire
was deciding that girls must not be taught to read—Albertus
Magnus debated the scholastic question whether the Virgin Mary
possessed perfectly the seven liberal arts and resolved it in
her favour.  Her miracles were on every lip, her name was sown
in wild flowers over the fields, and the very fall of humanity
became a matter for congratulation, since without it mankind
would not have seen her enthroned in heaven.

> Ne hadde the appil take ben,
>   The appil taken ben,
> Ne hadde never our lady
>   A ben hevene quene.
> Blessed be the time
>   That appil take was.
> Therefore we moun singen
>   'Deo gracias'.

    The cult of the lady was the mundane counterpart of the
cult of the Virgin and it was the invention of the medieval
aristocracy.  In chivalry the romantic worship of a woman was
as necessary a quality of the perfect knight as was the worship
of God. As Gibbon puts it, with more wit than amiability, "The
knight was the champion of God and the ladies—I blush to
unite such discordant terms," and the idea finds clear expres-
sion in the refrain of a French *ballade* of the fourteenth cen-
tury, "En ciel un dieu, en terre une déesse."[1]  One of its most
interesting manifestations was the development of a theory of
"courtly love," strangely platonic in conception though in many
ways as artificial as contemporary scholasticism, which inspired
some of the finest poetry of the age, from the Troubadours and
Minnesingers of France and Germany to the singers of the "dolce
stil nuovo" and Dante himself in Italy.  It is obvious that a
theory which regarded the worship of a lady as next to that of
God and conceived her as the mainspring of brave deeds, a
creature half romantic, half divine, must have done something
to counterbalance the dogma of subjection.  The process of
placing women upon a pedestal had begun, and whatever we may
think of the ultimate value of such an elevation (for few human
beings are suited to the part of Stylites, whether ascetic or

---

[1]"In heaven a God, on earth a goddess."

romantic) it was at least better than placing them, as the
Fathers of the Church had inclined to do, in the bottomless pit.
Nevertheless, as a factor in raising the position of women too
much importance must not be attributed to the ideal of chivalry.
Just as asceticism was the limited ideal of a small clerical
caste, so chivalry was the limited ideal of a small aristocratic
caste, and those who were outside that caste had little part in
any refining influence which it possessed.  Even in the class in
which it was promulgated and practised, it is impossible not to
feel that it was little more than a veneer.  Not only in the
great *chansons de geste*,[2] but in the book which the fourteenth-
century knight of La Tour Landry wrote for the edification of
his daughters, gentlemen in a rage not infrequently strike
their wives to the ground, and the corporal chastisement of a
wife was specifically permitted by canon law.  The ideal of
*l'amour courtois*,[3] too, rapidly degenerated and its social was
far less than its literary importance.  It had a civilizing
effect upon manners, but the fundamental sensuality and trivial-
ity beneath the superficial polish is to be seen clearly enough
in the many thirteenth-century books of deportment for ladies,
which were modelled upon Ovid's *Ars Amatoria*,[4] so severely con-
demned by Christine de Pisan.  It is probable that the idea of
chivalry has had more influence upon later ages than it had
upon contemporaries.  As a legacy it has certainly affected the
position of women in modern times, for whatever its effect upon
medieval practice, it was one of the most powerful ideas evolved
by the Middle Ages, and though it owed something to Arab influ-
ences, it was substantially an original idea.

Such, then, was the medieval theory as to the position of
woman, an inconsistent and contradictory thing, as any general-
ization about a sex must be, teaching simultaneously her
superiority and her inferiority.  It was, as has been said,
formulated by the two classes which were in power at the out-
set of the period, the Church and the Aristocracy.  It is true
that from the thirteenth century onwards a new force was added
to these; the Bourgeoisie began to make itself increasingly
felt, and in some respects the Bourgeoisie showed a greater
sense of the normal personality of women than did either the
Aristocracy or the Church; borough law had to take account of
the woman trader, and in many towns there existed "customs" for
the treatment of a married woman carrying on a trade of her own
as a *femme sole*.[5]  These are in striking contrast with the laws

---

[2]Heroic songs.

[3]Courtly love.

[4]*The Art of Love.*

[5]Single woman.

regulating the position of the married woman under the common
law, and although they were intended for the protection of the
husband they were also an effective improvement in the status
of the wife.   But in the main the Bourgeoisie rose to importance
in a world in which law and opinion had already hardened into
certain moulds, and it accepted as a dispensation of nature
those ideas about women and about marriage which it found in
existence.   Indeed the Bourgeois note in literature, which first
makes itself felt in the *fabliaux*,[6] is if anything rather more
hostile to women than the clerical note and far more so than the
courtly note, for except in the great mercantile families, whose
wealth enabled them to move in the circle of the aristocracy,
*Frauendienst* found little welcome.   Nevertheless, the woman of
the *fabliaux*, odious as she is, shows something of the practical
equality which prevailed between men and women in the middle and
lower classes; for if she is in subjection, the subjection is
very imperfectly maintained, and the henpecked husband is a sus-
piciously favourite theme.   There is a sort of poetic justice in
the fact that men whose ideal wife was Patient Griselda not in-
frequently found themselves married to the Wife of Bath.

Two great bodies of opinion remained wholly unexpressed.
The working classes, "whose shoulders held the sky suspended"
above Church and Aristocracy and Bourgeoisie alike, were to
remain inarticulate for many centuries to come.   That busy
world of men and women, of which we catch a glimpse in court roll
and borough record, rarely raised its voice above the whistle of
the scythe or the hum of the loom.   One other class, too, re-
mained all but inarticulate, for we hardly ever hear what women
thought about themselves.   All the books, as the Wife of Bath
complained, were written by men.

> Who peyntede the leoun, tel me who?
> By God, if wommen hadde writen stories
> As clerkes han with-inne hir oratories,
> They wolde han writen of men more wikkednesse
> Than all the mark of Adam may redresse!

Works written by women are rare (apart from the passionate love-
letters of Héloïse and the outpourings of the great women mys-
tics) and such poetesses as the troubadour Countess Beatrice de
Die and the famous writer of *lais*, known as Marie de France, in
no way detach themselves from the poetic convention of their day.
The Legends of Good Women which sprang up to counteract the
books of "wikked wyves," the somewhat jejune *Biens des Fames*
which replied to the much more vigorous *Blastenges des Fames*,

---

[6]Tales in verse.

were probably all the work of men.  It is not until the end of
the fourteenth century that there appears a woman writer to
take up the cudgels for her sex and lead a party of revolt
against the prevalent abuse of women.  Christine de Pisan was
skilled in all the courtly conventions, for she made her living
and supported three children by her pen; but there is both
idealism and reality in her attack on the *Roman de la Rose*, and
in the educational treatise, *Le Livre des Trois Vertus*, which
she wrote for the use of women.

For the rest we must deduce the woman's point of view from
an occasional *cri du cœur* or half-humorous comment, preserved
not in literature but in real life.  St. Bernardino of Siena,
in one of his vividly colloquial sermons, urges husbands to help
their wives and strengthens his plea by one woman's words to him.
"Mark thy wife well," he says, "how she travaileth in childbirth,
travaileth to suckle the child, travaileth to rear it, travail-
eth in washing and cleaning by day and night.  All this travail,
seest thou, is of the woman only, and the man goeth singing on
his way.  There was once a baron's lady, who said to me:  'Me-
thinks the dear lord and master doth as he seeth good and I am
content to say that he doth well.  But the woman alone beareth
the pain of the children in many things, bearing them in her
body, bringing them into the world, ruling them, and all this
oftentimes with grievous travail.  If only God had given some
share to man; if only God had given him the child-bearing!'
Thus she reasoned and I answered:  'Methinks there is much rea-
son in what you say.'"  Something of the same spirit inspires an
anonymous fifteenth-century song, which strikes a note of naïve
and genuine feeling:

> I am as lyghte as any roe
> To praise womene wher that I goo.
> To onpreyse womene yt were a shame,
> For a womane was thy dame;
> Our blessed Lady beryth the name
>   Of all womene wher that they goo.
>
> A woman is a worthy thyng,
> She dothe washe and dothe wrynge,
> 'Lullay! Lullay!' she dothe synge,
>   And yet she has but care and woo.
>
> A womane is a worthy wyght,
> She serveth a man both daye and nyght;
> Therto she puttyth all her myght,
>   And yet she hathe but care and woo.

Only rarely was the prevalent theory, ascetic or romantic,
broken by this domestic strain.

But the theory about women, inconsistent and the work of a small articulate minority as it was, was only one factor in determining their position and it was the least important factor. The fact that it received a voluminous and often striking literary expression has given it a somewhat disproportionate weight, and to arrive at the real position of women it is necessary constantly to equate it with daily life, as revealed in more homely records. The result is very much what common sense would indicate, for in daily life the position occupied by woman was one neither of inferiority nor of superiority, but of a certain rough-and-ready equality. This equality was as marked in the feudal as in the working classes; indeed it allowed the lady of the upper classes considerably more scope than she sometimes enjoyed at a much later period, for example, in the eighteenth and early nineteenth centuries. In order to estimate it, we may with advantage turn from theories to real life and endeavour, if possible, to disentangle some of the chief characteristics of the existence led by three typical women, the feudal lady, the bourgeoise, and the peasant. The typical woman must be taken to be the wife and more generally the housewife, but it must not be imagined that marriage was the lot of every woman and that the Middle Ages were not as familiar as our own day with the independent spinster. Then as now the total number of adult women was in excess of that of men. Reliable statistics are sadly to seek, but here and there poll-tax and hearth-tax lists afford interesting information. In the fourteenth and fifteenth centuries certain of the German towns took censuses, from which it appears that for every 1,000 men there were 1,100 women in Frankfort in 1385, 1,207 women in Nuremberg in 1449, and 1,246 women in Basel in 1454; the number of women was, it is true, swelled in these towns, because it was customary for widows from the country round to retire there, but a disproportion between the two sexes certainly existed. It is, indeed, to be expected on account of the greater mortality of men in the constant crusades, wars and town and family factions, and the discrepancy was aggravated by the fact that the celibacy of the clergy removed a very large body of men from marriage.

Medieval records are, indeed, full of these independent women. A glance at any manorial "extent" will show women villeins and cotters living upon their little holdings and rendering the same services for them as men; some of these are widows, but many of them are obviously unmarried. The unmarried daughters of villeins could always find work to do upon their father's acres, and could hire out their strong arms for a wage to weed and hoe and help with the harvest. Women performed almost every kind of agricultural labour, with the exception of the heavy business of ploughing. They often acted as thatcher's assistants, and on many manors they

did the greater part of the sheep-shearing, while the care of
the dairy and of the small poultry was always in their hands.
Similarly, in the towns women carried on a great variety of
trades.  Of the five hundred crafts scheduled in Étienne
Boileau's *Livre des Métiers* in medieval Paris, at least five
were their monopoly, and in a large number of others women were
employed as well as men.  Two industries in particular were
mainly in their hands, because they could with ease be carried
on as by-industries in the home.  The ale, drunk by every one
who could not afford wine, in those days when only the most
poverty-stricken fell back upon water, was almost invariably
prepared by women, and every student of English manorial court
rolls will remember the regular appearance at the leet of most
of the village alewives, to be fined for breaking the Assize of
Ale.  Similarly, in all the great cloth-working districts, Flor-
ence, the Netherlands, England, women are to be found carrying
out the preliminary processes of the manufacture.  Spinning was,
indeed, the regular occupation of all women and the "spinster's"
habitual means of support; God, as the Wife of Bath observes,
has given three weapons to women, deceit, weeping, and spinning!
Other food-producing and textile industries were also largely
practised by them, and domestic service provided a career for
many.  It must, of course, be remembered that married as well
as single women practised all these occupations, but it is clear
that they offered a solution to the problem of the "superfluous"
women of the lower classes.  Nevertheless, this equality of men
and women in the labour market was a limited one.  Many craft
regulations exclude female labour, some because the work was
considered too heavy, but most for the reason, with which we
are familiar, that the competition of women undercut the men.
Then, as now, women's wages were lower than those of men, even
for the same work, and the author of a treatise on *Husbandry*
was enunciating a general principle when, after describing the
duties of the daye or dairywoman, he added:  "If this is a
manor where there is no dairy, it is always good to have a woman
there at a much less cost than a man."

The problem of the unmarried girl of the upper class was
more difficult, for in feudal society there was no place for
women who did not marry and marry young.  It was the Church
which came to their rescue, by putting within their reach as
brides of Christ a dignity greater than that which they would
have attained as brides of men.  The nunnery was essentially a
class institution.  It absorbed only women belonging to the
nobility, the gentry, and (in the later Middle Ages) the bour-
geoisie, and in practice (though not in strict canon law) it
demanded a dowry, though a smaller dowry than an earthly hus-
band might have required.  But the spinsters of the working
class were absorbed by industry and the land and did not need
it.  To unmarried gentlewomen monasticism gave scope for

abilities which might otherwise have run to waste, assuring them
both self-respect and the respect of society.  It made use of
their powers of organization in the government of a community,
and in the management of household and estates; it allowed nuns
an education which was for long better than that enjoyed by men
and women alike outside the cloister; and it opened up for them,
when they were capable of rising to such heights, the supreme
experiences of the contemplative life.  Of what it was capable
at its best great monastic saints and notable monastic house-
wives have left ample record to testify.  Even if it suffered
decline and sheltered the idle with the industrious and the
black sheep with the white, it was still an honourable profes-
sion and fulfilled a useful function for the gentlewomen of the
Middle Ages.  In the towns, and for a somewhat lower social
class, various lay sisterhoods, grouped in their *Béguinages*,
*Samenungen*, *Gotteshäuser*, offered the same opportunities.

But what of the well-born girl who was not destined for a
nunnery?  Of her it may be said that she married, she married
young and she married the man selected for her by her father.
The careful father would expect to arrange for his daughter's
marriage and often to marry her before she was fourteen, and if
he found himself dying while she was still a child he would be
at great pains to leave her a suitable dowry *ad maritagium suum*
in his will.  A girl insufficiently dowered might have to suffer
that disparagement in marriage which was so much dreaded and so
carefully guarded against, and even in the lowest ranks of
society the bride was expected to bring something with her be-
sides her person when she entered her husband's house.  The
dowering of poor girls was one of the recognized forms of medieval
charity and, like the mending of bad roads, a very sound one.  The
system, of course, had its bad side.  Modern civilization has
steadily extended the duration of childhood, and to-day there
seems something tragic in the spectacle of these children,
taking so soon upon their young shoulders the responsibilities
of marriage and motherhood.  Similarly, since marriage is to-day
most frequently a matter of free choice between its participants,
the indifference sometimes shown to human personality in feudal
marriages of the highest rank appears shocking.  They were often
dictated solely by the interests of the land.  "Let me not to
the marriage of true fiefs admit impediments" may be said to
have been the dominating motive of a great lord with a son or
daughter or ward to marry, and weddings were often arranged and
sometimes solemnized when children were in their cradles.

Medieval thinkers showed some consciousness of these dis-
advantages themselves.  The fact that all feudal marriages were
*mariages de convenance* accounts for the fundamental dogma of
*l'amour courtois*, so startling to modern ideas, that whatever
the respect and affection binding married people, the sentiment
of love could not exist between them, being in its essence
freely sought and freely given and must therefore be sought

outside marriage. . . . Langland, again, inveighs against the
"modern" habit of marrying for money and counsels other consider-
ations; "and loke that loue be more the cause than lond other
[or] nobles."

It is more rarely that the woman's view of a loveless mar-
riage finds expression, but once at least, in the later Middle
Ages, the voice of a woman passes judgement upon it, and with
it upon the loneliness, the *accidia* (as monastic writers would
have called it) of that life which medieval literature decks in
all the panoply of romance.  The Saxon reformer, Johann Busch,
has preserved in his *Liber de reformatione monasteriorum*
(1470-5) a poignant dialogue between himself and the dying
Duchess of Brunswick.

> "When her confession, with absolution and penance
> was ended," he writes, "I said to her, 'Think you,
> lady, that you will pass to the kingdom of heaven when
> you die?'  She replied, 'This believe I firmly.'  Said
> I, 'That would be a marvel.  You were born in a fortress
> and bred in castles and for many years now you have lived
> with your husband, the Lord Duke, ever in the midst of
> manifold delights, with wine and ale; with meat and veni-
> son both roast and boiled; and yet you expect to fly away
> (*evolare*) to heaven directly you die.'  She answered:
> 'Beloved father, why should I not now go to heaven?  I
> have lived here in this castle like an anchoress in a
> cell.  What delights or pleasures have I enjoyed here,
> save that I have made shift to show a happy face to my
> servants and to my maidens?  I have a hard husband, as
> you know, who has scarce any care or inclination towards
> women.  Have I not been in this castle even as it were in
> a cell?'  I said to her, 'You think, then, that as soon
> as you are dead God will send his angels to your bed to
> bear your soul away to Paradise and to the heavenly king-
> dom of God?' and she replied, 'This believe I firmly.'
> Then said I, 'May God confirm you in your faith and give
> you what you believe.'"

But it is unnecessary to suppose that the majority of
feudal marriages turned out badly.  The father is not human who
does not wish to do his best for his daughter, and it was only
in the most exalted rank that worldly could entirely outweigh
personal considerations.  Moreover, the fact that most wedded
couples began life together while they were both very young was
in their favour.  Human nature is extremely adaptable, and they
came to each other with no strongly marked ideas or prejudices
and grew up together.  The medieval attitude towards child mar-
riages was that to which Christine de Pisan gave such touching
expression when she recalled her own happy life with the hus-
band whom she married before she was fifteen and who left her

at twenty-five an inconsolable widow with three children. . . .
Certainly medieval records as a whole show a cameraderie between
husband and wife which contrasts remarkably both with the picture
of woman in subjection which the Church delighted to draw and
with that of the worshipped lady of chivalry.  An obscure Flem-
ish weaver of the sixteenth century, writing to his wife from
England, signs himself with the charming phrase "your married
friend," and of medieval wives as a whole it may be said with
truth, that while literature is full of Griseldas and *belles
dames sans merci*,[7] life is full of married friends.  The mothers,
wives, and daughters of the barons and knights of feudalism are
sturdy witnesses to the truth of Mrs. Poyser's immortal dictum,
"God Almighty made 'em to match the men."  If feudal marriages
submitted them completely to their fiefs, they could inherit
and hold land, honours, and offices like men, and are to be found
fighting for their rights like men, while widows, in their own
right or as guardians of infant sons, often enjoyed great power.
Blanche of Champagne waged war for fourteen years (1213-27) on
behalf of her minor son, and Blanche of Castile governed a king-
dom as regent for the boy Louis IX.  Indeed, the history of the
early thirteenth century is strongly impressed with the charac-
ter of those two masterful and energetic sisters, in beauty,
talent, and iron strength of purpose the worthy granddaughters
of "the eagle," Eleanor of Aquitaine, Blanche, the mother of
Saint Louis of France, and Berengaria, the mother of Saint
Ferdinand of Castile.
    Throughout the Middle Ages, too, the social and physical
conditions of life, the constant wars, and above all the slow
communications, inevitably threw a great deal of responsibility
upon wives as the representatives of their absent husbands.  It
has been asserted in all ages that the sphere of woman is the
home, but it has not always been acknowledged that that sphere
may vary greatly in circumference, and that in some periods and
circumstances it has given a much wider scope to women than in
others.  In the Middle Ages it was, for a variety of reasons, a
very wide sphere, partly because of this constantly recurring
necessity for the wife to take the husband's place.  While her
lord was away on military expeditions, on pilgrimages, at court,
or on business, it was she who became the natural guardian of
the fief or manager of the manor, and Europe was full of compe-
tent ladies, not spending all their time in hawking and flirting,
spinning and playing chess, but running estates, fighting law-
suits, and even standing sieges for their absent lords.  When

---

[7]"Beautiful women without mercy."  The French phrase is
used in medieval poetry and is the title of a poem by John Keats
(1815).

the nobility of Europe went forth upon a crusade it was their wives who managed their affairs at home, superintended the farming, interviewed the tenants, and saved up money for the next assault. When the lord was taken prisoner it was his wife who collected his ransom, squeezing every penny from the estate, bothering bishops for indulgences, selling her jewels and the family plate. Once more it was these extremely practical persons and not the Griseldas, or the

> store of Ladies whose bright eies
> Rain influence and judge the prise,

who were the typical feudal women.

Christine de Pisan, in her *Livre des Trois Vertus*[8] (*c.* 1406), sets down the things which a lady or baroness living on her estates ought to be able to do. She must be capable of replacing her husband in every way during his absence; "because that knights, esquires and gentlemen go upon journeys and follow the wars, it beseemeth their wives to be wise and of great governance, and to see clearly in all that they do, for that most often they dwell at home without their husbands, who are at court or in divers lands." The lady must therefore be skilled in all the niceties of tenure and feudal law, in case her lord's rights should be invaded; she must know all about the management of an estate, so as to supervise the work of the bailiff, and she must understand her own métier as housewife, and be able to plan her expenditure wisely. The budget of a great lady, Christine suggests, should be divided into five parts, of which one should be devoted to almsgiving, one to household expenses, one to the payment of officials and women, one to gifts, and one should be set apart to be drawn upon for jewels, dresses, and miscellaneous expenses as required. The good management of a housewife is sometimes worth more to a lord than the income from his tenants; and in every class of life it is the wife's function to dispose wisely of her husband's resources according to his rank, whether it be the baron's patrimony or the labourer's wage. Christine de Pisan was writing about how a lady ought to behave, but from many records we know that the ideal was carried out in practice. No more striking witness to the confidence reposed by husbands in the business capacity of their wives is to be found than the wills and letters of the later Middle Ages. It is impossible to read through any great collection of medieval wills, such as the *Testamenta Eboracensia*, published by the Surtees Society, without observing the number of cases in which a wife

---

[8] *The Book of Three Virtues.*

is made the executrix of her husband's will, sometimes alone
and sometimes as principal in conjunction with other persons.
More than once a touch of feeling enlivens the legal phraseol-
ogy, as when John Sothill of Dewsbury bids his executors, "I
pray you, pray Thomas my son in my name and for ye lufe of
God, yat he never strife with his moder, as he will have my
blissyng, for he sall fynd hir curtos to del withall." Let-
ters tell the same tale. The Paston Letters, for example, give
a remarkable picture of the hard-headed business woman in fif-
teenth-century England. No one could really like Margaret
Paston, who bullied her daughter and kept the only soft corner
in a peculiarly hard heart for her husband, but she was exceed-
ingly competent and managed his property for him with the
utmost success, collecting rents, keeping accounts, and out-
witting enemies, and she seems to have taken it as part of the
day's work to be besieged in her manor, and to have the walls
of her chamber pulled down about her ears by armed men.

But it was not only on exceptional occasions and in the
absence of her husband that the lady found a weight of respon-
sibility upon her shoulders. It is true that her duties as a
mother were in some ways less arduous than might have been sup-
posed. Large families were general, and the death-rate among
children was high (as may be guessed from many a medieval tomb-
stone, in which little shrouded corpses are ranged with living
children behind their kneeling parents), but the new-born child,
in the upper classes at least, was commonly handed over to a
wet nurse and it is sometimes mentioned as a sign of special
affection in a mother that she should have fed her own children
at the breast. Again, the training of the young squire often
took him at an early age from his mother's society, and it was
customary to send both boys and girls away to the households of
great persons to learn breeding, although no doubt they often
remained at home. In any case the early marriages of the day
meant short childhoods. Books of deportment are singularly
silent, as a whole, on the subject of maternal duties; they
were (as might be inferred from the shocking behaviour of
Griselda) overshadowed by those of the wife. But if the nursery
was not a great burden, housekeeping in the Middle Ages, and
indeed in all ages prior to the Industrial Revolution, was a
much more complicated business than it is to-day, except for the
fact that domestic servants were cheap, plentiful, and unexact-
ing. It was no small feat to clothe and feed a family when
households were large, guests frequent, and when much of what is
to-day made in factories and bought in shops had to be prepared
at home. The butter and cheese were made in the dairy and the
beer in the brewhouse, the candles were made up and the winter's
meat salted down in the larder, and some at least of the cloth
and linen used by the household was spun at home. The lady of
the house had to supervise all these operations, as well as to

make, at fair and market or in the nearest town, the necessary
purchases of wine and foodstuffs and materials which could not
be prepared on the manor.

The country housewife, too, was expected to look after the
bodies of her household in sickness as well as in health, and
it was necessary for her to have a certain skill in physic and
surgery.  Life was far less professionalized in the Middle Ages;
a doctor was not to be found round every corner, and though the
great lady in her town house or the wealthy bourgeoise might
find a physician from Oxford or Paris or Salerno within reach,
some one had to be ready to deal with emergencies on the lonely
manors.  Old French and English metrical romances are full of
ladies physicking and patching up their knights, and household
remedies were handed down with recipes for puddings and per-
fumes from mother to daughter; such knowledge was expected of
them, as it was expected of the "wise woman," who mingled it
with charms and spells.  There exist also various treatises on
the diseases of women which are obviously written or translated
for their own use, and in an English version of the *De Mulierum
Passionibus* (attributed to Trotula), the translator asserts him-
self to have undertaken the work in order that women shall be
able to diagnose and treat their own diseases; "and because
whomen of oure tonge donne bettyr rede and undyrstande thys
langage than eny other and euery whoman lettyrde rede hit to
other unlettyrd and help hem and conceyle hem in here maledyes
wt.owtyn shewyng here dysese to man, i have thys drauyn and
wryttyn in englysh."  If, however, a woman set up practice as
a physician outside the limits of her home and pretended to some-
thing more than the skill of an amateur or a witch, there forth-
with arose an outcry which seems to foreshadow the opposition of
the medical profession to the entrance of women in the nine-
teenth century.  The case of the doctors was a respectable one;
the women had no medical degrees and therefore no knowledge or
training.[9]  Nevertheless there were women here and there who
acquired considerable fame as physicians.  The most interesting
of them is the well-born lady Jacoba Felicie, who in 1322, being
then about thirty years of age, was prosecuted by the Medical
Faculty at Paris on a charge of contravening the statute which
forbade any one to practise medicine in the city and suburbs
without the Faculty's degree and the Chancellor's license.
Various witnesses were called to testify that she made use of
all the usual methods of diagnosis and treatment, and several of
them said that they had been given up by various doctors before
being cured by her and set forth the names of these legitimate

---

[9]Trotula and the famous women doctors of Salerno are rapid-
ly melting away under the cruel searchlight of modern research.

but unsuccessful practitioners, which was perhaps a little hard on the profession. Her skill seems to have been undoubted, one witness stating that "he had heard it said by several that she was wiser in the art of surgery and medicine than the greatest master doctor or surgeon in Paris." Nevertheless she was inhibited, although she made an eloquent and sensible defence; but as she had already disregarded a previous inhibition and a heavy fine, she probably continued as before to practise her healing profession.

The lady was thus obliged not only to be housewife in her own capacity, but amateur soldier and man-of-the-house in her husband's absence, and amateur physician when no skilled doctor could be had. She was also obliged to be something rather more than an amateur farmer, for the comprehensive duties of a country housewife brought her into close connexion with all sides of the manorial economy. It is plain from medieval treatises that a general supervision of the manor farm was expected of her, over and above that of the dairy, which was her special province. Christine de Pisan's great lady must understand the choice of labourers, the seasons for the different operations, the crops suitable for different soils, the care of animals, the best markets for farm produce. Stoutly clad, she must tramp up and down the balks, . . . and through the young coppices, to oversee her cornfields and pastures and woods. She must have a watchful eye upon her labourers, too. "Let her go often into the fields to see how they are working, . . . and let her be careful to make them get up in the morning. Let her wait for no one, if she be a good housewife, but let her rise up herself and throw on a houppelande, and go to the window and shout until she see them come running out, for they are given to laziness." . . .

An equally good portrait of a town housewife, belonging to the *haute* bourgeoisie, is to be found in the remarkable book which an elderly citizen, the Ménagier de Paris, wrote about 1392-4 for the instruction of his child wife. The tenderness of its tone and the extremely practical nature of the information contained in it, make this treatise unique among the innumerable didactic works addressed to women in the Middle Ages. The Ménagier explains to his young wife that he has undertaken the work in response to her request that he would teach her and because she would certainly marry again after his death, in which case it would be a great reflection *upon him* if she were not wise in all that concerned the care of house and husband! And truly the second husband of the Ménagier's wife must have been a happy man; if, indeed, he did not suffer the penalty described by another fourteenth-century bourgeois, Paolo di Certaldo of Florence, who says: "If thou art able, beware of taking a widow woman for thy wife, because thou wilt never be able to satisfy her, and every time thou refusest her

anything she may ask of thee, she will say, 'My other husband
did not treat me thus!'  Yet truly, if thou hast already had
another wife thou mayst take her with greater safety, and if
she saith, 'My other husband did not treat me thus,' or 'Blessed
be the soul of So-and-so,' thou canst reply 'Blessed be the soul
of Madonna So-and-so, who did not cause me this tribulation
every day!'"  The Ménagier planned his book in three sections.
The first deals with the lady's moral and religious duties, de-
portment, and duty towards her husband; "because these two
things, to wit the salvation of your soul and the comfort of
your husband, are the two things most chiefly necessary, there-
fore are they placed first."  The second and most interesting
section deals with household management, the choice and treat-
ment of servants, the best methods of airing, mending, and
cleaning dresses and furs, the best recipes for catching fleas
and other "familiar beasts to man"  and for keeping bedrooms
free of mosquitoes and barns of rats, the art of gardening, and
above all the choice and preparation of menus suitable for
every sort of meal.  "The fourth article is that you, as sove-
reign mistress of your house, may know how to order dinners,
suppers, meats and dishes and be wise concerning butchers' and
poulterers' lore and have knowledge of spicery, and the fifth
article teaches you how to command, order and devise and have
made all manner of soups, stews, sauces, and other viands, and
the same for invalids."  He is truly the Mrs. Beeton of the
Middle Ages; and it may be remarked that his ideas as to quan-
tity in ingredients are very similar.  The book closes with a
third section, planned but unfortunately unfinished, which deals
with the lady's amusements.
     The Ménagier's book tells us more about the domestic econ-
omy of a wealthy citizen's home than any other medieval record.
One of its most valuable characteristics is the particularity
of his instructions for dealing with domestic servants.  In the
management of her ménage his young wife is assisted by a steward,
Master Jehan *le dispensier*, and by a sort of duenna-housekeeper,
Dame Agnes *la béguine*, and the choice of servants is left en-
tirely in her hands, with their assistance.  There were in Paris
at the time *recommanderesses*, or women keeping what would to-day
be called registry offices, and the great ordinance of 1351,
which fixed wages after the Black Death, allowed them 18$d$. for
placing a chambermaid and 2$s$. for a nurse. . . .  The Ménagier
warns his wife to engage no chambermaids "until you first know
where their last place was and send some of your people to get
their character, whether they talked or drank too much, how
long they were in the place, what work they were wont to do and
can do, whether they have homes or friends in the town, from
what sort of people and what part of the country they come, how
long they were in the place and why they left."  On engaging a
girl she is to cause the steward to enter in his register her

name and that of her father and mother and kinsfolk, the place
where they live, the place of her birth and her references.
The closest supervision is to be maintained over the manners
and morals of maidservants and their mistress should set them
a good example in all things.  They are to be well fed and
allowed due time for recreation, young and foolish girls are
to sleep in a room adjacent to her own and without low win-
dows looking on to the road, and "if one of your servants fall
ill, do you yourself, laying aside all other cares, very lov-
ingly and charitably care for him or her."  The daily work of
the servants is set down with even greater care, the sweeping
and cleaning of the house in the morning, the feeding of pet
dogs and cage birds, the airing of sheets, coverlets, dresses
and furs in the sunshine so as to preserve them from moths,
together with sundry recipes for getting rid of spots, the
weekly inspection of wines, vinegars, grains, oils, nuts, and
other provisions by the steward, and the admonishment of
Richard of the kitchen to cleanliness.  Every man and maid
must have his or her specific work to do, and the steward,
the housekeeper and the young mistress must watch carefully
that they do it.

But the work of the bourgeoise housewife is by no means
confined to running her house and managing her servants, for
she, no less than the lady of a manor, must be ready, if need
be, to take her husband's place; and she commonly knows a great
deal about his business.  William Warner of Boston, trading in
Zealand, habitually sends home to his wife Iceland stockfish
and other goods, that "she shulde putte the marchaundise to sale
as she dydde other marchaundise."  Almost all guild regulations
forbidding employment of women make exception for the craftsman's
wife and daughter, who are expected to help in the workshop and
need no formal apprenticeship.  The training thus acquired en-
abled a widow to carry on her husband's trade and to complete
the training of his apprentices and thus we find widows not
only engaged in small crafts but in mercantile operations on a
large scale, like Margery Russell of Coventry, who obtained
letters of marque against the merchants of Santander and seized
two of their ships. Nor was it only as their husband's repre-
sentatives or widows that married women came into the labour
market, for they frequently carried on separate businesses as
*femmes soles,* and it has already been pointed out that many
town regulations took cognizance of this fact and allowed them
to be sued for debts and punished for misdeeds as though they
were single women.  With single women they shared in the tex-
tile and food-producing industries, and there were other women
besides the Wife of Bath who carried on the business of clothiers—

Of cloth making she hadde swiche an haunte
She passed hem of Ypres and of Gaunt,—

though possibly they did not all wear out five husbands in their spare time, like that redoubtable lady.

The lower we move in the social scale the more laborious, naturally, was the housewife's life, because she would commonly be obliged to help with her husband's craft or to carry on some by-industry of her own, as well as caring for house and children. Below the ranks of the gentry and the richer bourgeoisie few housewives were able to concern themselves solely with their homes, which were frequently supported by the earnings of wife as well as of husband. Most laborious of all was the lot of the peasant woman living upon the land. Of her indeed the proverbial adage was true:

> Some respit to husbands the weather may send,
> But huswiue's affaires haue neuer an end.

It is true that manorial customs usually exempted the villein's wife from the obligation to labour on the lord's land, but her toil could rarely be spared upon her husband's holding, the inevitable by-industry occupied what time she could spare from the fields, and in her one-roomed or two-roomed cottage, dark and smoky and often shared with the animals, as Chaucer has drawn it in his tale of Chauntecleer and Pertelote, she must labour unceasingly. There are few passages in medieval literature more poignant than that in which Langland has described "the wo of these women that wonyeth in cotes."

Nevertheless, the life had its compensations. In Western Europe at least the small cultivator of the village advanced steadily in freedom and prosperity during the Middle Ages, and *fabliaux* often show us the well-to-do villein. . . . If manorial custom looked upon women mainly as replenishers of the estate with labour and forced the villein to pay merchet and leyrwite for his daughter, it also not infrequently showed special consideration for his wife while she was fulfilling her essential function. Sometimes the villein's wife in childbed is excused the annual tribute of the Shrovetide hen, sometimes she may claim a load of firewood, sometimes she may even fish for herself in the lord's strictly preserved brook. At Denckendorf in Württemberg each lying-in bondwoman received two measures of wine and eight white loaves at the christening of her child. Harsh and coarse and laborious as it was, the peasant woman's life had its rude gaieties. . . .

This tale of busy and hard-working lives lived in lord's manor, in burgess's house, and in peasant's cottage has taken little account of the amusements of the medieval woman. Yet there were many. The Ménagier de Paris, a wealthy man with a house in the country as well as in Paris, could plan for his wife the characteristic diversions of the upper class, and the third section of his book shows us the lady at play. He has

already, in a previous section, said something about his wife's
employment in her hours of ease: "Know that it doth not dis-
please, but rather pleases me, that you should have roses to
grow and violets to care for, and that you should make chaplets
and dance and sing; and I would well that you should so continue
among our friends and those of our estate, and it is but right
and seemly thus to pass the time of your feminine youth, pro-
vided that you desire and offer not to go to the feasts and
dances of lords too great, for that is not seemly for you, nor
suitable to your estate and mine." Romances and miniatures
both show how fond medieval ladies were of feasting and dancing,
and of making garlands in gardens with stiff raised beds, foun-
tains, arbours, and "flowery medes," such as the pleasaunce with-
in a fortress so charmingly described in the *Roman de la Rose*,
or the "garden fair" in which King James of Scotland saw the
lady Johanna Beaufort walking. Apart from these pleasures, the
Ménagier wishes his wife to take her part in the other outdoor
and indoor amusements suitable to her station. In fair weather
she will go hawking and his third section therefore contains a
detailed treatise on that art. In foul weather she will sit
indoors with other ladies of her age and rank, and they will
play, not only at chess and tables, but at games which we have
long since relegated to the nursery, blind man's buff, or *pince-
merille*, and innumerable question-and-answer games and riddles,
like the favourite games known as *Le roi qui ne ment pas*[10] and
"Ragman's roll." Or else they will sing and tell stories to
each other, for the setting of Boccaccio's *Decameron* was a com-
mon one in the Middle Ages and every well-educated lady must
have a store of such tales at her finger-tips, and must be able
to play her part wittily in the long "debates" and "*tençons*,"
in which love was ever the favourite theme. It was the
Ménagier's intention to complete his book by a collection of
games and riddles, but either death interrupted him or he
wearied of his task, for his third section lacks the two "arti-
cles" which were to have contained them. But at all events his
wife must have shone in the telling of tales, for all his
admonitions to her are illustrated by stories, *exempla* as the
preachers called them. He apologizes to his wife for including
the tale of Griselda with the explanation, "know that it never
befel so, but thus the tale runs and I may not correct nor
alter it, for a wiser than I made it; and it is my desire that,
since others have read it, you also may know and be able to
talk about everything, even as other folk do."

Oral narratives, indeed, played a great part in the amuse-
ments of the age and took the place which is filled by books
to-day. Although such collections as the Paston and Stonor

---

[10] "The king who does not lie."

letters make it clear that the fifteenth-century gentry, both
men and women, could read and write, books were rare before the
invention of printing, and the wills of layfolk show very few
besides service books of one sort or another, primers, psalters,
and the like.  But occasionally we hear of others.  Sir Thomas
Cumberworth (1451) leaves to his fortunate niece Annes "my boke
of the talys of cantyrbury"; Joan, widow of Sir Robert Hilton of
Surrie (1432), leaves her sister Katherine Cumberworth "unum
librum de Romanse incipientem cum Decem Preceptis Alembes" and
her niece "unum librum de Romanse de Septem Sages."  Sir John
Morton of York (1431) leaves Joan Countess of Westmoreland "unum
librum de Anglico vocatum Gower pro remembrancia," and John
Raventhorp, a York chaplain (1432), leaves "librum Angliae de
Fabulis et Narracionibus" to Agnes of Celayne, his servant for
many years.  In general, however, the imagination of a medieval
lady was fed by the telling of tales, whether by preacher,
*jongleur*, or by her companions, rather than by the reading of
books.

For the town housewife there were a multitude of amuse-
ments, such as those in which the Wife of Bath delighted,

> visitaciouns
> To vigilies and to processiouns,
> To preching eek and to thise pilgrimages,
> To pleyes of miracles and mariages.

Women readily flocked to hear sermons, when a good preacher was
at hand.  Indeed, if Bernardino of Siena or Berthold of Regens-
burg were at all typical (which it is to be feared they were not)
sermons must have been as entertaining as they were instructive.
They were always interlarded with *exempla*, and some moralists
(among them Dante himself) complained that these anecdotes were
often trivial, not to say improper, and crowded out the solid
teaching which should have informed the sermon, "but one half-
pennyworth of bread to this intolerable deal of sack."  Often,
however, the listening women would find their foibles scourged,
particularly their too gay attire, their crested shoes, long
trains, bare bosoms, and horned headdresses.  Sometimes excit-
able ladies took these admonitions seriously.  "As in the days
when the Breton Thomas Couette preached," says Mr. Owst, "and
French womenfolk, stung to the heart, made public bonfires of
their favourite ornaments and vanities, so two centuries later
their sisters of Italy were wont to do the same in the piazzas
of Siena and Florence at St. Bernardino's bidding.  'Tables,
cards, dice, false hair, rouge-pots, and other tribulations,
even to chess boards' had been known to enter the flames.  But
with the enthusiasm of the sermon over and the preacher gone,
they were liable to that same reaction which befel certain
remorseful ladies once driven to make good the loss of their

horned headdresses, of whom it was written that 'like snails in
a fright they had drawn in their horns, but shot them out again
as soon as the danger was over.'"  But St. Bernardino deserved
well of the women who flocked to hear him.  He was always urg-
ing their husbands to show them consideration and praising
their housewifely virtues, while he scolded their vanities.  He
even declared on one occasion that "it is a great grace to be a
woman, because more women are saved than men," and on another
he drew a heartrending picture of the discomfort of the bache-
lor's unkempt home, ending up, "knowest thou how such a man
liveth?  even as a brute beast.  I say that it cannot be well
for a man to live thus alone.  Ladies, make your curtsey to
me!"  And it is to be hoped that they did.

Such, then, was the daily existence of some typical medi-
eval women.  If medieval civilization is to be judged by it,
it must be admitted that it comes well out of the test.  It is
true that the prevalent dogma of the subjection of women,
becoming embedded in the common law and in the marriage laws,
left to future generations a legacy which was an unconscionable
time in dying.  It is true that woman was not legally "a free
and lawful person," that she had no lot or share then, or in-
deed until the twentieth century, in what may be called public
as distinct from private rights and duties, and that the higher
grades of education were closed to her.  On the other hand, she
had a full share in the private rights and duties arising out
of the possession of land and played a considerable part in
industry, in spite of the handicap of low wages and sometimes
of masculine exclusiveness.  The education of the average lay-
woman compared very favourably with that of her husband, and
some ladies of rank were leaders of culture, like the royal
patronesses of the troubadours, and occasionally bluestockings,
like Christine de Pisan.  Although there was small place in
the society of the upper classes for the independent unmarried
woman, she found an honourable occupation for her activities in
monasticism.  In every class of the community the life of the
married woman gave her a great deal of scope, since, as has
already been indicated, the home of this period was a very wide
sphere; social and economic conditions demanded that a wife
should always be ready to perform her husband's duties as well
as her own, and that a large range of activities should be car-
ried on inside the home under her direction.  Finally, while
the Middle Ages inherited the doctrine of the subjection of
women, in some degree at least, from the past, it evolved for
itself and handed down to the modern world a conception of chiv-
alry which has had its share in the inspiration of poets, the
softening of manners, and the advance of civilization.  Taking
the rough with the smooth and balancing theory against practice,
the medieval woman played an active and dignified part in the
society of her age.

# HUMANISM AND THE RENAISSANCE EDUCATION OF WOMEN

*The late fourteenth century was a period of turmoil and anxiety. Between England and France raged the Hundred Years' War. The great plague known as the Black Death left famine and disoriented people all over Europe. The papacy was evicted from its century-old headquarters in Rome and found a new base in Avignon, and its eventual split into two rival factions was known as the Schism of the Church (1378-1417). Ordinary men and women as well as clerics, monks, and nuns lost confidence in the Church, its institutions, and its doctrine. Philosophical studies in the universities became narrow, repetitious disputations. Reacting against all these trends, a new breed of scholars and philosophers emerged both within the Church and outside it. These scholars are known as humanists, and their basic aim was to return to classical Greek and Roman and to original Christian ideals, which they felt had been lost or submerged in medieval life and thought. Hence they urged the study of ancient Latin, Greek, and Hebrew and with the study of these languages a return to classical and original biblical sources. They thought that concentration on history, poetry, education, natural phenomena, and the nature of man would bring new life and hope to the staleness and despair of their time. They hoped to develop a new purity and dignity of mankind that would not only lead to a heavenly life in the next world but would improve man's condition in this one.*

*The first of the great humanists was the Italian poet Petrarch (1304-74), and the greatest of them was Erasmus of Rotterdam (1466-1536). The humanist movement might be called the spiritual nerve center of the Renaissance. It spread from poets, scholars, and philosophers to architects, painters, and sculptors. It also spread from its home base close to classical sources and artistic classical examples in Italy to Spain and across the Alps to France, Northern Europe, and England. The whole of Europe was criss-crossed with a network of humanist scholars and artists by the middle of the sixteenth century.*

*Humanists emphasized the value of education because they felt that it led to virtue. The more learned a person was, the more virtuous. For this reason they were concerned equally*

with the education of boys and girls.  For the first time in
Western history men stressed the fact that females should be
educated.  The Platonic orientation in humanist thought may
have spurred them to do so.

Very early in the development of humanism (in 1405) Leonardo
Bruni (1369-1444), the Florentine city secretary and the author
of many works, wrote the first of the humanist treatises on the
education of women.  He dedicated it to a daughter at the court
of Urbino, which became one of the most brilliant models of
Renaissance thought, art, and manners within the next hundred
years.  A number of other well-known Italian humanist scholars
were employed as tutors to their daughters by fifteenth century
Renaissance princes.  For example, Beatrice (1475-97) and
Isabella (1474-1539) d'Este were educated by the humanist
Guarino di Verona, and the daughters and prospective daughters-
in-law of the court of Mantua attended the famous school of
Vitorino de Feltre (1378-1446).

With the reverberation of humanist thought throughout Europe
in the following century, the concept of education for women was
embraced by some of the great scholars, thinkers, and writers of
the North.  Juan Luis Vives (1492-1540), working mostly in the
Netherlands and England, wrote a number of treatises on the
subject.  Sir Thomas More (1478-1535) enthusiastically wove this
idea into his conception of an ideal state, Utopia (1516).  Vives,
More, and the great Erasmus all envisioned a world wherein women
of the middle classes and not merely those of the nobility would
be well educated.  Although they stipulated that women should
read specific books in preference to others read by men, this
was for the sake of morality and fitness for women's roles in
the world and not because they thought women were mentally
inferior.

Basically, Vives and Erasmus still read Paul's view of
women's role as correct for Christian life.  In his Utopia, how-
ever, Sir Thomas More suggested that older women and widows
might be priestesses—a tremendous leap after almost 1500 years
of contrary Christian practice.

## A.   LEARNING LEADS TO VIRTUE AND WISDOM

The humanist scholar Juan Luis Vives (1492-1540) grew up in
Spain.  There the humanist atmosphere of the court of Queen
Isabella and her four well-educated daughters had set the stage
for learned women.  When Vives approached one of these daughters,
Catherine of Aragon, the first ill-fated wife of Henry VIII of
England, Catherine engaged her countryman to write a textbook
for her child, the Princess Mary.

Vives' textbook was translated from the Latin as A Plan of

Studies for Girls *in 1907.  Some of his other works were so popular that they were translated by humanist scholars in England in Vives' lifetime.  The famous treatise,* Instruction of a Christian Woman *(1523), which Vives dedicated to Queen Catherine, was translated into English in 1529 by Richard Hyrde, tutor to Thomas More's household.*  The Duties of Husbands *(1529) was published in English translation by one of Vives' students in 1550. Selections from these three translations are reprinted below.*

*These selections highlight Vives' basic Christian philosophy and his typically humanist preoccupation with the study of ancient languages and classical authors.  The selections further emphasize the humanists' interest in the education of women (as in that of men) because learning leads to the ultimate good. As mothers and fathers should instruct their daughters, so husbands should help in the education of untutored wives.  Educated wives will then be true fellows in marriage, not menials to be treated as servants.  Vives' depth of understanding of the human condition is shown in the passage on the mother's charge and care of children.*[1]

## INSTRUCTION OF A CHRISTIAN WOMAN

Juan Luis Vives

### OF THE LEARNING OF MAIDS

Of maids, some be but little meet for learning:  likewise as some men be unapt, again some be even born unto it, or at least not unfit for it.  Therefore they that be dull are not to be discouraged, and those that be apt, should be heart[en]ed and encouraged.  I perceive that learned women be suspected of many:  as who saith, the subtlety of learning should be a nourishment for the maliciousness of their nature.  Verily, I do not allow in a subtle and crafty woman, such learning as should teach her deceit, and teach her no good manners and virtues:  not with standing the precepts of living, and the examples of those that have lived well, and had knowledge together of holiness, be the keepers of chastity and pureness,

---

[1]Regarding the writing of this passage, Vives' own wife's childlessness should be considered as a factor.

Juan Luis Vives, *Vives and the Renaissance Education of Women*, ed. by Foster Watson (New York:  Longmans Green and Co., 1912), pp. 48-55.  Reprinted by permission of Edward Arnold Publishers Ltd.

and the copies of virtues, and pricks to prick and to move folks
to continue in them. . . . And she that hath learned from inborn
disposition or from books to consider this and such other things,
and hath furnished and fenced her mind with holy counsels shall
never find [from them stimulus] to do any villainy. For if she can
find in her heart to do naughtily, having so many precepts of
virtue to keep her, what should we suppose she should do, hav-
ing no knowledge of goodness at all? And truly if we would
call the old world to remembrance, and rehearse their time, we
shall find no learned woman that ever was [ev]ill: where I
could bring forth an hundred good: as Cornelia, the mother of
Gracchus, which was an example of all goodness and chastity, and
taught her children her own self. And Portia, the wife of
Brutus, that [par]took of her father's wisdom. And Cleobula,
daughter of Cleobulus, one of the seven wise men, which Cleobula
was so given unto learning and philosophy, that she clearly
despised all pleasure of the body, and lived perpetually a maid:
from whom the daughter of Pythagoras the philosopher took exam-
ple, which after her father's death was the ruler of his school,
and was made the mistress of the college of virgins. . . .

And in St. Jerome's time all holy women were very well
learned. Would God that nowadays, many old men were able to be
compared unto them in cunning. St. Jerome writeth unto Paula,
Laeta, Eustachia, Fabiola, Marcella, Furia, Demetrias, Salma,
Hierontia. St. Ambrose unto other[s]; St. Augustine unto
other[s]: and all marvellous witted, well learned and holy.
Valeria Proba, which loved her husband singularly well, made
the life of our Lord Christ out of Virgil's verses. Writers
of chronicles say that Theodosia, daughter to Theodosius the
younger, was as noble by her learning and virtue, as by her
empire: and the making that be taken out of Homer, named
*Centones* be called hers. I have read epistles and cunning works
of Hildegarde, a maid of Almaine. There hath been seen in our
time the four daughters of Queen Isabel, of whom I spake a lit-
tle before, that were well learned all. It is told me with
great praise and marvel in many places of this country, that
dame Joan, the wife of King Philip, mother to Carolus [Charles]
that now is, was wont to make answer in Latin, and that without
any study, to the orations that were made after the custom in
towns, to new princes. And likewise the Englishmen say by
their queen, sister to the said dame Joan. . . .

. . . For the study of learning is such a thing that it
occupieth one's mind wholly and lifteth it up into the knowl-
edge of most goodly matters: and plucketh it from the remem-
brance of such things as be foul. . . . But here, peradventure,
a man would ask, what learning a woman should be set unto, and
what shall she study? I have told you, the study of wisdom,
which doth instruct their manners, and inform their living, and
teacheth them the way of good and holy life. As for eloquence,

I have no great care, nor a woman needeth it not, but she need-
eth goodness and wisdom.  Nor it is no shame for a woman to hold
her peace, but it is a shame for her and abominable, to lack dis-
cretion, and to live ill.  Nor I will not here condemn eloquence,
which both Quintilian, and St. Jerome following him, say, was
praised in Cornelia, the mother of Gracchus, and in Hortensia,
the daughter of Hortensius.  If there may be found any holy and
well learned woman, I had rather have her to teach them; if
there be none, let us choose some man, either well aged, or
else very good and virtuous, which hath a wife, and that right
fair enough, whom he loveth well, and so shall he not desire
another.  For these things ought to be seen unto, for as much
as chastity in bringing up a woman, requireth the most dili-
gence, and in a manner altogether.  When she shall be taught to
read, let those books be taken in hand, that may teach good
manners.  And when she shall learn to write, let not her example
be void verses, nor wanton or trifling songs, but some sad sen-
tences prudent and chaste, taken out of holy Scripture, or the
sayings of philosophers, which by often writing she may fasten
better in her memory.  And in learning, as I [ap]point none
end to the man, no more I do to the woman:  saving it is meet
that the man have knowledge of many and divers things, that may
both profit himself and the commonwealth, both with the use and
increase of learning.  But I would the woman should be altogether
in that part of philosophy, that taketh upon him [*i.e.*, it] to
inform, and teach, and amend the conditions. . . .

## A PLAN OF STUDIES FOR GIRLS
### (for the Princess Mary)

Juan Luis Vives

### THE PRACTICE OF WRITING LATIN

Let her begin to turn short speeches (*oratiunculae*) from
English into Latin.  At first they should be easy; then, by
degrees, more difficult, in which there should occur all kinds
and forms of words.  Let these partly be serious and religious,
and in part joyful and courteous. . . .
. . . Let her have a dictionary, Latin and English, which
she may often consult, and get to know what each word signifies.

Juan Luis Vives, *Vives and the Renaissance Education of
Women*, ed. by Foster Watson (New York:  Longmans Green and Co.,
1912), pp. 48-55.  Reprinted by permission of Edward Arnold
Publishers Ltd.

When she does not understand anything let it be explained by a
teacher.  Let her not learn words of disgraceful and improper
matters.  Neither let her read them, if it is possible, nor
hear them.  Let her provide herself with a little book of blank
paper, in which, with her own hand, she may write little sen-
tences which she will commit to memory and which will serve
her as an enchiridion.

[Then follows a return in more exact detail to former
grammatical points.]

### LATIN CONVERSATION

Let the princess speak with her tutor and fellow-pupils
in Latin.  Of fellow-pupils let her have three or four; for it is
not good to be taught alone.  But do not let them be many, and
let the few be most carefully chosen, and most piously and
liberally educated, from whom she will not hear or learn any-
thing which would injure her morals; for conduct (*mores*) ought
to be the first care.  Let her be stimulated now by small
rewards, now by emulation.  Let her herself be praised, and
let others be praised in her presence.  Let her attempt to
express (in Latin) what she has been reading in her authors,
and in the same manner let her listen to others speaking of
what they have been reading.  To those whom she thinks to be
learned, let her give most close attention, and so let her
herself speak; for this is *imitation*—a method of no small
usefulness, especially in a tender age which takes to nothing
more willingly or to better purpose than imitation.  But not
only should she imitate the words, but also all pronunciation,
so as not to err in correct accent.

[Then follows a paragraph on correct accent, and its
more general rules in Latin speaking.]

### ANNOTATIONS

Let her get a somewhat large note-book (*librum vacuum*) in
which she may jot down with her own hand, first, words if
(whilst reading important authors) she comes across any words
useful for daily conversation, or rare or elegant words; next,
let her note forms of speaking, expressions which are witty,
graceful, neat, erudite; next, examples of *sententiae*, weighty
amusing, deep, polite, imaginative, and practical, from which
she may seek example for her life.  Let her note also where,
and in what manner, the rules of grammar are kept, and where
neglected.  For the grammatical art is born from the practice

of authors; so this is to be preferred in authority to the grammatical art itself when the two (the practice of authors and the rules of grammatical text-books) differ. Yet the art of grammar is necessary, whilst it gathers its rules from observation as to what is the right and correct way to speak.

## AUTHORS

The authors in whom she should be versed are those who, at the same time, cultivate right language and right living: those who help to inculcate not only knowledge, but living well. Of this kind are Cicero, Seneca, the works of Plutarch (the last named has been translated into Latin by several hands), some dialogues of Plato—especially those which concern the government of the State. Then the epistles of Jerome, and some works of Ambrosius and Augustine, should be read. Further, the *Institutiones Principis*, the *Enchiridion*, the *Paraphrases* [of Erasmus], and many of the works useful to piety, and the *Utopia* of Thomas More. . . .

This is only, in my view, a rough sketch of studies. Time will admonish her as to more exact details, and thy singular wisdom will discover for her what they should be.

## THE DUTIES OF HUSBANDS (*De Officio Mariti*)

### Juan Luis Vives

. . . The woman, even as man, is a reasonable creature and hath a flexible wit both to good and evil, the which with use and counsel may be altered and turned. And although there be some evil and lewd women, yet that doth no more prove the malice of their nature than of men, and therefore the more ridiculous and foolish are they that have invied [inveighed] against the whole sect [sex] for a few evil. . . .

. . . Shall the woman, then, be excluded from the knowledge of all that is good, and the more ignorant she is, be counted better? Some there be too rude and dull, the which esteem those to be best that are most ignorant. I would counsel all such rather to beget asses than men, or to give

Juan Luis Vives, *Vives and the Renaissance Education of Women*, ed. by Foster Watson (New York: Longmans Green and Co., 1912), pp. 198-202, 209. Reprinted by permission of Edward Arnold Publishers Ltd.

their diligence and labour to extinguish the figure and force
that God hath given them to know good and worthy things withal,
and to make them liker beasts than men, for so they shall be
even such as would have them.  If erudition and learning be
noiful unto honesty and goodness, and hurtful to be brought
up among those that be learned, then it shall be better and
most convenient to nourish and bring them up in the country
than in the city, and much better in a forest than in a village
among men.  But experience doth declare the contrary, and that
children should be brought up among those that be best learned
and have best experience.

     But to return and to think of women as I began.  I by
experience have seen and known the contrary, and that all lewd
and evil women are unlearned and that they which be learned are
most desirous of honesty, nor I cannot remember that ever I saw
any woman of learning or of knowledge, dishonest.  Shall not
the subtle and crafty lover sooner persuade [as] it pleaseth
him the ignorant, than her that is fortified with wit and learn-
ing.  This is the only cause, why all women for the most part,
are hard to please, studious and most diligent to adorn and
deck themselves, marvellers of trifles, in prosperity proud and
insolent, in adversity abject and feeble, and for lack of good
learning, they love and hate that only, the which they learned
of their unlearned mothers, and examples of the evil, leaning
to that part only, that the ponderous and heavy body is inclined
and given unto.  Nor men should not be far different from
beasts, if they were left unto their own nature, corrupted with
the spot of sin, what beast would be more cruel, or so far from
the nature and condition of man, as man himself if he were not
learned? . . . The Lord doth admit women to the mystery of his
religion, in respect of which all other wisdom is but foolish-
ness, and he doth declare that they were created to know high
matters, and to come as well as men unto the beatitude, and
therefore they ought and should be instructed and taught, as
we men be.  And that these are no better, it is our fault,
inasmuch as we do not our duties to teach them.  If the husband
be the woman's head, the mind, the father, the Christ, he ought
to execute the office to such a man belonging, and to teach the
woman:  for Christ is not only a saviour and a restorer of his
Church, but also a master.  The father ought to nourish and to
teach his children.  And what need is it to reason of the mind
and of the head?  In the mind is wit, counsel, and reason.  In
the head are all the senses wherewith we do guide and rule this
life, and therefore he doeth not his duty that doth not instruct
and teach his wife.  And the self-same Socrates doth say, that
men should be ruled by public and common laws, and women by
their own husbands.  And Paul forbidding women to speak in the
congregation, and commanding that they, if they doubted of
anything, should ask their husbands at home, doth bind them to

teach their wives.  To what effect or purpose should she ask her
husband, that he neither will nor can teach her?

Oh how great wars hath there been made for women?  We
take great pains and labour to see that they lack nothing, and
that our daughters may have a convenient dowry, and yet we flee
and avoid the easy works, by the which they may be the better,
for if they were so, their flagitiousness should not cause us
to war, nor they being content with a little, should need
nothing, but allure many to love them with the beautifulness of
their virtue.  A woman after my judgment ought to know herself,
of what beginning she was made of, and to what end, what the
order and use of things be, and specially what Christ's reli-
gion is, without the which nothing can be well done nor justly.
But yet it must be by religion and no superstition, to the end
she may know what difference there is between them.  Religion
doth make them very simple and good, and superstitition very
hypocrites and molestious. . . .

## THE FRUITS OF A WELL-INSTRUCTED WOMAN

A woman well brought up is fruitful and profitable unto
her husband, for so shall his house be wisely governed, his
children virtuously instructed, the affections less ensued and
followed, so that they shall live in tranquillity and virtue.
Nor thou shalt not have her as a servant, or as a companion of
thy prosperity and welfare only, but also as a most faithful
secretary of thy cares and thoughts, and in doubtful matters
a wise and a hearty counsellor.  This is the true society and
fellowship of man, not only to participate with him over pains
and travails, but also the affections and cares of our mind
the which do no less trouble the body, than to plough, to dig,
to delve, or to bear any heavy or weighty burden, for if their
full and burning hearts should not declare and open themselves,
they would none otherwise break than a vessel replenished with
fire that hath no vent, for carefulness and thoughts are fire
that doth inflame and consume the heart.  And therefore we see
certain men, the which (as though they were with child through
care and commotions of the mind) do seek for some one, upon
whom they may discharge them of their burden.

OF THE CHARGE AND CARE OF CHILDREN

Juan Luis Vives

Whereto have you so great a desire of children, you women?
For if the cares and sorrows that children cause unto their
mothers were painted you in a table, there is none of you so
greedy of children, but she would be as sore afraid of them as
of death, and she that hath any would hate them like cruel wild
beasts or venomous serpents.  What joy or what pleasure can be
in children?  Whiles they be young, there is nothing but tedious-
ness; and when they be elder, perpetual fear what ways they will
take; if they be [ev]ill, everlasting sorrow; and if they be
good, there is perpetual care lest they should die or some harm
bechance them, and lest they should go away or be changed.
Moreover, if thou have many, then hast thou greater care, where
the unthriftiness of one shall wipe away all the joy that thou
hast of the rest.  Now to speak of the daughters.  What a tor-
ment of care is it to keep them?  And in marrying them, what
pain shall she have?  Beside [is] this, that few fathers and
mothers see good children of their own.  For very goodness
which is never without wisdom, cometh not but in discreet age.
Plato calleth him happy that may attain in his last age unto
wisdom and good life.  But when the children be of that age,
fathers and mothers be turned to dust.  O unkind woman, that
dost not acknowledge how great a benefit thou hast had of God,
that either did never bear children or else lost them before the
time of sorrow!

## B.  THE ABBOT AND THE LEARNED LADY

*Erasmus wrote a series of "colloquies" highlighting in
witty dialogue the serious matters that concerned his thoughts.
One of these,* The Abbot and the Learned Lady, *written in 1524
in Latin, is reprinted in translation.  Much of Erasmus' work
deals with the reactionary denseness of contemporary members of
the monastic orders.  Unflattering tales about monks and nuns
were a favorite sport of humanist writers.  In this colloquy
Erasmus uses a particularly unpleasant example of an abbot as a
foil to display the charm and wisdom of an educated married
woman.  His model for Magdalia was probably Margaret Roper, the*

Juan Luis Vives, *Vives and the Renaissance Education of
Women*, ed. by Foster Watson (New York:  Longmans Green and Co.,
1912), pp. 121-22.  Reprinted by permission of Edward Arnold
Publishers Ltd.

*favorite and extremely learned daughter of Sir Thomas More.*
*Margaret translated Erasmus' exposition of the Lord's Prayer*
*into English, among other scholarly activities.  Erasmus had*
*spent much of his time during visits to England in the More*
*household, where he could observe his friend Thomas' enjoyment*
*of his well-tutored daughters and daughters-in-law.  He refers*
*to the More daughters in the colloquy and also to some of the*
*famous educated German women of this period (the Pirckheimer*
*and the Blauer girls).*

    *Erasmus' views on educated women are formulated in some of*
*his letters and in his* Institutio Christiani Matrimoni *as well*
*as in this colloquy.*

## THE ABBOT AND THE LEARNED LADY

Erasmus

### ANTRONIUS, MAGDALIA

    *Antronius.*  What furnishings do I see here?
    *Magdalia.*  Elegant, aren't they?
    *Ant.*  How elegant I don't know, but certainly unbecoming
both to a young miss and a married woman.
    *Magd.*  Why?
    *Ant.*  Because the whole place is filled with books.
    *Magd.*  Are you so old, an abbot as well as a courtier, and
have never seen books in court ladies' houses?
    *Ant.*  Yes, but those were in French.  Here I see Greek
and Latin ones.
    *Magd.*  Are French books the only ones that teach wisdom?
    *Ant.*  But it's fitting for court ladies to have something
with which to beguile their leisure.
    *Magd.*  Are court ladies the only ones allowed to improve
their minds and enjoy themselves?
    *Ant.*  You confuse growing wise with enjoying yourself.
It's not feminine to be brainy.  A lady's business is to have
a good time.
    *Magd.*  Shouldn't everyone live well?
    *Ant.*  Yes, in my opinion.

---

    Erasmus, *The Colloquies of Erasmus*, trans. by C. R. Thompson (Chicago:  University of Chicago Press, 1965), pp. 219-23. Reprinted by permission of the University of Chicago Press.

*Magd.*  But who can have a good time without living well?

*Ant.*  Rather, who can enjoy himself if he *does* live well?

*Magd.*  So you approve of those who live basely if only they have a good time?

*Ant.*  I believe those who have a good time are living well.

*Magd.*  Where does this good time come from?  From externals or from within?

*Ant.*  From externals.

*Magd.*  Shrewd abbot but stupid philosopher!  Tell me:  how do you measure good times?

*Ant.*  By sleep, dinner parties, doing as one likes, money, honors.

*Magd.*  But if to these things God added wisdom, you wouldn't enjoy yourself?

*Ant.*  What do you mean by wisdom?

*Magd.*  This:  understanding that a man is not happy without the goods of the mind; that wealth, honors, class make him neither happier nor better.

*Ant.*  Away with that wisdom!

*Magd.*  What if I enjoy reading a good author more than you do hunting, drinking, or playing dice?  You won't think I'm having a good time?

*Ant.*  *I* wouldn't live like that.

*Magd.*  I'm not asking what *you* would enjoy most, but what *ought* to be enjoyable.

*Ant.*  I wouldn't want my monks to spend their time on books.

*Magd.*  Yet my husband heartily approves of my doing so. But exactly why do you disapprove of this in your monks?

*Ant.*  Because I find they're less tractable; they talk back by quoting from decrees and decretals, from Peter and Paul.

*Magd.*  So your rules conflict with those of Peter and Paul?

*Ant.*  What *they* may enjoin I don't know, but still I don't like a monk who talks back.  And I don't want any of mine to know more than I do.

*Magd.*  You could avoid that by endeavoring to know as much as possible.

*Ant.*  I haven't the leisure.

*Magd.*  How come?

*Ant.*  Because I've no free time.

*Magd.*  No free time to grow wise?

*Ant.*  No.

*Magd.*  What hinders you?

*Ant.*  Long prayers, housekeeping, hunts, horses, court functions.

*Magd.*  So these are more important to you than wisdom?

*Ant.*  It's what we're used to.

*Magd.*  Now tell me this:  if some heavenly power enabled

you to turn your monks and yourself too into any animal whatever,
would you change them into hogs and yourself into a horse?

*Ant.* Not at all.

*Magd.* But by doing so you'd prevent anybody's being wiser
than you.

*Ant.* I shouldn't much care what sort of animal the monks
were, provided I myself were a human being.

*Magd.* Do you think one is human if he's neither wise nor
wants to be wise?

*Ant.* I'm wise enough—so far as I'm concerned.

*Magd.* And swine are wise enough so far as *they're*
concerned.

*Ant.* You strike me as a sophistress, so keenly do you
dispute.

*Magd.* I won't say how you strike me!  But why do these
furnishings displease you?

*Ant.* Because distaff and spindle are the proper equipment
for women.

*Magd.* Isn't it a wife's business to manage the household
and rear the children?

*Ant.* It is.

*Magd.* Do you think she can manage so big a job without
wisdom?

*Ant.* I suppose not.

*Magd.* But books teach me this wisdom.

*Ant.* Sixty-two monks I have at home, yet you won't find
a single book in my cell.

*Magd.* Those monks are well provided for!

*Ant.* I could put up with books, but not Latin ones.

*Magd.* Why not?

*Ant.* Because that language isn't fit for women.

*Magd.* I want to know why.

*Ant.* Because it does little to protect their chastity.

*Magd.* Therefore French books, full of the most frivolous
stories, do promote chastity?

*Ant.* There's another reason.

*Magd.* Tell me plainly, whatever it is.

*Ant.* They're safer from priests if they don't know Latin.

*Magd.* Very little danger from you in that respect, since
you take such pains not to know Latin!

*Ant.* The public agrees with me, because it's a rare and
exceptional thing for a woman to know Latin.

*Magd.* Why cite the public, the worst possible authority
on conduct?  Why tell me of custom, the mistress of every vice?
Accustom yourself to the best; then the unusual will become habi-
tual; the harsh, enjoyable; the apparently unseemly, seemly.

*Ant.* I hear you.

*Magd.* Is it fitting for a German woman to learn French?

*Ant.* Of course.

*Magd.*   Why?

*Ant.*   To talk with those who know French.

*Magd.*   And do you think it unsuitable for me to know Latin in order to converse daily with authors so numerous, so eloquent, so learned, so wise; with counselors so faithful?

*Ant.*   Books ruin women's wits—which are none too plentiful anyway.

*Magd.*   How plentiful *yours* are, I don't know.  Assuredly I prefer to spend mine, however slight, on profitable studies rather than on prayers said by rote, all-night parties, and heavy drinking.

*Ant.*   Bookishness drives people mad.

*Magd.*   The company of boozers, jesters, and mimes doesn't drive you mad?

*Ant.*   Not at all.  It relieves boredom.

*Magd.*   Then how could such delightful companions as mine drive me mad?

*Ant.*   That's what people say.

*Magd.*   But the plain fact of the matter says something else.  How many more we see driven mad through intemperate wining and dining, night-long bouts of drunkenness, uncontrolled passions!

*Ant.*   I'm sure I wouldn't want a learned wife.

*Magd.*   But I congratulate myself on having a husband different from you.  For learning renders him dearer to me, and me dearer to him.

*Ant.*   Learning costs immense toil, and after all you must die.

*Magd.*   Tell me, my dear sir:  if you had to die tomorrow, would you rather die more foolish or more wise?

*Ant.*   If wisdom came without hard work—

*Magd.*   But man gets nothing in this life without hard work. And yet whatever he does win, with however much labor, must be left behind.  Why should we hesitate to take pains in the most precious thing of all, the fruits of which accompany us to another life also?

*Ant.*   I've often heard the common saying, "A wise woman is twice foolish."

*Magd.*   That's commonly said, yes, but by fools.  A woman truly wise is not wise in her own conceit.  On the other hand, one who thinks herself wise when she knows nothing is indeed twice foolish.

*Ant.*   I don't know how it is, but as packsaddles don't fit an ox, so learning doesn't fit a woman.

*Magd.*   But you can't deny that packsaddles would fit an ox better than a miter would fit an ass or a swine.—What's your feeling about the Virgin Mother?

*Ant.*   I reverence her.

*Magd.*   Didn't she read books?

*Ant.*    Yes, but not these.

*Magd.*    What did she read, then?

*Ant.*    The canonical Hours.

*Magd.*    According to which use?

*Ant.*    The Benedictine.

*Magd.*    Very likely!  What about Paula and Eustochium?
Didn't they read the Sacred Scriptures?

*Ant.*    But that's rare nowadays.

*Magd.*    So was an unlettered abbot a rare bird once upon a
time!  Nowadays nothing's more common.  Once upon a time princes
and emperors excelled as much in learning as in might.  But even
now this isn't so rare as you suppose.  In Spain and Italy there
are not a few women of the highest rank who can rival any man.
In England there are the More girls, in Germany the Pirckheimer
and Blauer girls.  If you're not careful, the net result will be
that we'll preside in the theological schools, preach in the
churches, and wear your miters.

*Ant.*    God forbid!

*Magd.*    No, it will be up to *you* to forbid.  But if you
keep on as you've begun, geese may do the preaching sooner
than put up with you tongue-tied pastors.  The world's a stage
that's topsy-turvy now, as you see.  Every man must play his
part or—exit.

*Ant.*    How did I run across this woman?  When *you* come
calling on *us*, I'll treat you more politely.

*Magd.*    How?

*Ant.*    We'll dance, drink as much as we please, hunt,
play games, and laugh.

*Magd.*    For my part, I feel like laughing even now.

# RENAISSANCE WOMEN AND REFORMATION INFLUENCES

*The Renaissance spanned roughly two centuries. During the fifteenth century it grew to full bloom in Italy, and by the sixteenth century it had spread to other European countries and had developed strong national characteristics. One of the major trends of this period was the growth of strong monarchies and other states, the origin of the international power play that became an intrinsic part of modern European political history. The humanist philosophy (discussed in Part 5) stressed man's condition in this world, emphasizing the importance of the individual. This Renaissance emphasis was a change from the previous medieval stress on community (monasteries, guilds, urban communes, the European "Christian Community," and so on). Perhaps the clearest evidence of Renaissance individualism was the upsurge of portrait painting that left a personal record of thousands of Renaissance men and women. In contrast, apart from the exceptional few, we know very little about the personalities of medieval individuals. The Renaissance kings and heads of state were fascinated by the new humanist ideals, which they nurtured and advanced throughout their realms.*

*In some instances these princes had elevated themselves into positions of nobility; for example, Francesco Sforza, the duke of Milan, was a former mercenary military commander, or condottiere. Some were heads of state by virtue of their financial power, such as the head of the great Medici banking house of the republic of Florence. Other Italian princes of the fifteenth century, such as the Gonzagas of Mantua and the Montefeltros of Urbino, had a long history of feudal power. The Italian principalities were territorially quite small. However, large territories had been drawn together into nation-states either by military conquest or by politically expedient marriages across the Alps, specifically in Spain, France, Burgundy, and England. By the sixteenth century the princes of these nations—Philip II of Spain, Francis I of France, and Henry VIII of England—were very powerful individuals indeed, and their influence was magnified by their patronage of humanist philosophers and artists and their employment of humanist scholars as tutors to their children.*

*This use of power in the interest of humanistic ideals was
exhibited by Renaissance men and equally by their women.* The
two Renaissance centuries are in fact notable for a number of
outstanding, powerful women whose intrinsic strength and grasp
of the new ideas made them formidable rivals to the great men
of their time. In Italy the sisters Beatrice (1475-97) and
Isabella (1474-1539) d'Este stand out, Beatrice for her poli-
tical acumen and Isabella for her management of her husband's
impoverished Gonzaga inheritance and her skillful recognition
and patronage of some of the greatest poets and artists and
the printers like Aldus Manutius.

In Spain the great Renaissance queen, Isabella (1451-1504),
was behind the achievements of her reign. Among these achieve-
ments was the unification of her kingdom of Castile with that
of her husband's, Aragon, and her successful government of both,
which demanded her complete attention even on the battlefield.
Her breadth of vision led the Columbus expedition across the
Atlantic to the opening up of the New World and led to the
foundation of new universities and the subsidy of scholars who
worked, for example, on the simultaneously published translation
of the Bible into Greek, Hebrew, and Latin texts. Her firm
religious belief led her to strengthen the Church to such an
extent that the Reformation that affected most European nations
did not gain a foothold in Spain. She well deserved her title,
Isabella the Catholic. She insisted on a formidable education
for her daughters, and one of these, Catherine of Aragon, in-
herited her mother's strength of purpose and intellect and was
thus able to withstand with great fortitude the crises in her
life as queen of England.

In France the regent Anne de Beaujeu (1460-1522) and Queen
Anne of Brittany (1477-1514) dominated the political and cultur-
al scene at the turn of the fifteenth and sixteenth centuries.
Anne de Beaujeu's influence was extensive not only on the poli-
tics of her time (for example, the incorporation of Brittany
into the state of France) but also on various great women who
as children were educated under her auspices. One of these,
the astute Margaret of Austria (1480-1530), was to become
regent of the Netherlands; another, Louise of Savoy (1476-1531),
worked with Margaret of Austria on the "Ladies' Peace" of 1529,
a treaty that ended the war between France and the Holy Roman
Empire.

Marguerite of Angoulême (1492-1549), who is perhaps the
most appealing feminine product of Renaissance humanism, was
the daughter of Louise of Savoy and sister to Francis I, king
of France. Although the general trend in France was to maintain
the religious status quo, Marguerite of Angoulême was deeply
interested in the humanist and Reformation elements in Western
Europe. She surrounded herself with humanist scholars and let
some persecuted Reformers, such as John Calvin, find refuge at

*her court.   Basically a poet of mystical piety, she also wrote
a book of stories in the manner of Boccaccio's* Decameron.  *Her
stories, the* Heptameron, *were decried by nineteenth-century
historians and social critics as unsuitable for a lady to com-
pose or to read.   In fact, although the stories are as crude as
the writings of male authors of the period, the* Heptameron *shows
Marguerite's reformatory spirit by describing in a lively and
literary form the abuses of the Church and the monasteries, a
popular humanist practice of her day, in which she followed
Rabelais and Erasmus (6 C).   Marguerite d'Angoulême was older
than her brother Francis, and according to Brantôme, the six-
teenth-century courtier, she would have been the better king.
In his memoirs Brantôme deplored the law that excluded women
from the succession to the French crown and described how Mar-
guerite on many occasions dealt successfully with statesmen and
ambassadors on her brother's behalf.*

*In the latter part of the sixteenth century two powerful
women dominated Western Europe—Catherine de Medicis (1519-89),
niece of the Medici pope, Clement VII, and queen mother and
regent of France; and Elizabeth I (1533-1603), queen of England,
daughter of Henry VIII and Anne Boleyn (6 D).   Both of these
women were well educated, although Elizabeth's education was of
a far higher caliber.   She was tutored by the great Cambridge
humanist scholar Roger Ascham, whereas Catherine's early school-
ing took place in an undistinguished convent in Florence.   Both
women loved art; both managed to keep at bay the powerful and
aggressive King Philip II of Spain; both were shrewd and calcu-
lating rulers.   But whereas Catherine de Medicis' loyalty was
basically to her sons and the royal Valois dynasty of France,
Elizabeth, very much a Tudor, worked for England.   The achieve-
ments of the two queens in the political development of their
countries pose a dramatic contrast—for France:  political and
religious civil wars, the St. Bartholomew's Day Massacre of
1572, and a decrease in international power; for England:  peace,
a reasonable mutual tolerance of religiously opposed factions,
a solid defense against and defeat of the powerful Spanish
Armada in 1588, and wide international respect.   The spectacular
upsurge of cultural activity in Elizabethan England, boasting
such names as Bacon, Spenser, Marlowe, and Shakespeare, hardly
requires comment.*

*One cannot brashly say that humanist Leonardo Bruni's
treatise on the importance of education for women, written as
early as 1405 for a member of one of the great Italian Renais-
sance families, was the seed for the later harvest of feminine
force and intellect.   However, one can say that the daughters
of the early Renaissance princes, buoyed by the learning and
self-confidence bestowed by their humanist tutors, matured into
forceful and accomplished women of the later fifteenth and six-
teenth centuries.*

*The section on humanism and the foregoing pages have indicated the religious dissension that underlay much of the fifteenth and sixteenth centuries. The cultural and political arm of humanism is known as the Renaissance; its religious arm is called the Reformation. The humanist stress on a return to original sources and the emphasis on individual power progressed logically to the Lutheran insistence on adherence to the original biblical "word" and on individual faith, prayer, and preaching. Some Christian humanists, such as Erasmus, More, and Vives, stopped short of breaking with the Catholic Church, but the most prominent Reformers, such as Luther (1483-1546), Calvin (1509-64), and Zwingli (1484-1531), turned their backs on the pope and introduced an evangelical reform movement which led to a schism in Christendom. Western European countries (except Spain) were split on the Protestant issue, and a number of them, notably the German and Scandinavian states, the Netherlands, and England, adopted Protestantism as their official religion for a variety of politically expedient reasons.*

*In the long run the effect of Protestantism on women was beneficial, for its leaders insisted that all girls should be taught to read and write so that they would be able to interpret the Bible for themselves and, as mothers, for their children. Thus Luther and his followers were the first to recommend public elementary schooling for girls. Throughout the centuries following the Reformation the overall literacy rate of Protestant women compared with that of women in Catholic communities (outside of nunneries) was high. In the nineteenth century these literate women of Protestant countries were the backbone of the movements that aimed to give women opportunities for higher education, to enter professions, to administer their own earnings, and to vote.*

*In the short run, however, the vision of the sixteenth century Reformers did not fulfill for women the great promise that it extended to mankind. The Protestant emphasis on the individual's faith as the pivot for salvation did, in theory, apply equally to women and men. Luther maintained that priests were unnecessary intermediaries between God and man and that every man could be his own intermediary (priest), although specially designated male preachers spread the word and watched over the flock. But the sixteenth-century Reformers—the German, Luther; the Frenchman, Calvin; and the Scot, Knox—were narrowly restricted to the Pauline view of women that had already overwhelmed the Church Fathers in the early Christian centuries (see Part 2). Women were to be obedient to their husbands, to keep silent in public, and to busy themselves with their households.*

*The early Christian Fathers and the sixteenth-century Reformers differed widely on the question of sex. The Reformers did not believe that either men or women should be celibate, nor did they decry sex within marriage. However, they abhorred*

*adultery and demanded fidelity equally from the husband and from
the wife.* This interest in masculine fidelity is a notable
shift from the earlier unquestioning acceptance of the double
standard. Reformers were aware of the unhappiness of nuns who
had been forced to enter convents by impecunious parents wanting
to avoid the payment of marriage dowries. Some, like Melanchthon,
were sympathetic to those nuns who had been used to a sheltered
monastic existence and were suddenly left to fend for themselves
when the nunneries were dissolved as part of the Reformation. Almost
all of the Protestant Reformers married; like Luther, many mar-
ried former nuns.

Reformers and Reformation preachers throughout the six-
teenth century took to pen and pulpit and wrote and preached
searing sermons. People traveled far and wide to hear well-
known preachers, and the recent invention of printing, coupled
with the new emphasis on literacy, made the published distribu-
tion of the sermons a powerful vehicle of the Reformation. As
for women, the Reformation preachers thunderously addressed
themselves to erring wives, and the great part of their sermons
dealing with women is not much more than advice to husbands on
how to keep wives in their place. The original humanist stress
on feminine learning and the development of the intellect for
virtue's sake was lost in the Reformers' insistence on the
"word," which in the case of women returns full cycle to Paul
of Tarsus' narrow view.

## A.  UPPER-CLASS WOMEN IN RENAISSANCE ITALY

Jacob Burckhardt's The Civilization of the Renaissance in
Italy (1860) is an important landmark in the history of women
in Western society. Burckhardt is one of the first (if not the
first) historian who included specific information on the women
of the period of his concern. Books isolating the history of
women had been written before Burckhardt, but his contribution
was to include women in an overview of history because he knew
that a picture of society that excluded the lives and contribu-
tions of women was incomplete. Burckhardt included several
passages on women in The Civilization of the Renaissance in
Italy, and although Burckhardt's general format found many ad-
mirers, the inclusion of women in history books has not pro-
gressed as rapidly since 1860 as one might have expected.

Burckhardt's comments on the position of women emphasize
the importance of Renaissance education, describe the admirable
qualities of the "virago" of the fifteenth and sixteenth cen-
turies, and investigate the varieties of courtesans and prosti-
tutes and the artistic achievements of Italian Renaissance
women in literature. His comparison of the writings of

*Renaissance women with that of women of his own (Victorian) era
adds an interesting sidelight.  It is obvious that for Burck-
hardt the Victorian woman's (sentimental) writing is the norm
to be expected from women and that the Renaissance woman's
"masculine" writing is the exception.*

## THE CIVILIZATION OF THE RENAISSANCE IN ITALY

Jacob Burckhardt

The education of the women in the upper classes was essen-
tially the same as that of the men.  The Italian of the Renais-
sance did not have the slightest misgiving about putting sons
and daughters alike under the same course of literary and even
philological instruction.  Indeed, since he viewed this ancient
culture as the chief treasure of life, he was glad that his
girls should have a share in it.  We have seen what perfection
was attained by the daughters of princely houses in writing and
speaking Latin.  Many others must have been able at least to
read it, in order to follow the conversation of the day, which
turned largely on classical subjects.  Many actively engaged in
Italian poetry through *canzoni*, sonnets, and improvisations,
whereby a large number of Italian women, from the time of the
Venetian Cassandra Fedele (about the close of the fifteenth
century), made themselves famous; in fact, Vittoria Colonna
can even be called immortal.  If any proof were needed of the
assertion made above, it would be found in the manly tone of
this female poetry.  The love sonnets like the religious poems
are so precise and definite, and so far removed from the tender
twilight of sentiment and all the dilettantism we commonly find
in the poetry of women, that we should not hesitate to attribute
them to male authors, if names, reports, and definite external
evidence did not prove the contrary.
For with education, the individuality of women in the
upper classes was developed in the same way as that of men,
whereas outside Italy, till the time of the Reformation, the
personality of women, even of royal rank, does not stand out
very much.  Exceptions such as Isabella of Bavaria, Margaret of
Anjou, and Isabella of Castille, are the result of very unusual,

---

Jacob Burckhardt, *The Civilization of the Renaissance in
Italy*, ed. by Irene Gordon (New York:  Mentor Books, The New
American Library, Inc., 1961), pp. 280-83.  Reprinted by per-
mission of The New American Library, Inc.

actually, forced, circumstances.  In Italy, throughout the en-
tire fifteenth century, almost all the wives of the rulers, and
still more those of the *condottieri*, have a distinct, recogniz-
able personality, and take their share of notoriety and glory.
Gradually there was a crowd of famous women of the most varied
kind, even if their sole distinction lay in the fact that their
beauty, disposition, education, virtue, and piety combined to
render them harmonious human beings.  There was no question of
"woman's rights" or "emancipation," simply because the thing
itself was a matter of course.  The educated woman of that time
strove, exactly like the man, after a characteristic and com-
plete individuality.  The same intellectual and emotional
development that perfected the man was demanded for the per-
fection of the woman.  Active literary work was not demanded
of her, and if she were a poet, some powerful utterance of
feeling, rather than the confidences of the novel or the diary,
was expected.  These women had no thought of the public; their
function was to influence distinguished men, and to moderate
male impulse and caprice.

The highest praise that could be given at that time to the
great Italian women was that they had the mind and courage of
men.  We have only to observe the thoroughly manly bearing of
most of the women in the heroic poems, especially those of
Boiardo and Ariosto, to realize that we are looking at a defi-
nite ideal.  The title *virago*, which is an equivocal compliment
in the present day, at that time implied nothing but praise.
It was borne in all its glory by Caterina Sforza, wife and
later widow of Girolamo Riario, whose hereditary possession,
Forlì, she gallantly defended first against his murderers and
then against Cesare Borgia.  Though finally vanquished, she
retained the admiration of her countrymen and the title *prima
donna d'Italia*.  This heroic vein can be detected in many of
the women of the Renaissance, though none found the same oppor-
tunity of showing their heroism to the world.  In Isabella
Gonzaga this type is clearly recognizable.

Women of this stamp could listen to novels like those of
Bandello without social intercourse suffering by it.  The rul-
ing genius of society was not, as now, womanhood, that is, the
respect for certain presuppositions, mysteries, and suscepti-
bilities, but the consciousness of energy, of beauty, and of a
social state full of danger and opportunity.  And for this
reason we find, side by side with the most measured and polished
social forms, something our age would call immodesty because we
can no longer imagine the counterbalance—the powerful charac-
ters of the women who were exposed to it.

That in all the dialogues and treatises put together we can
find no absolute evidence on these points is only natural, how-
ever freely the nature of love and the position and capacities
of women were discussed.

What seems to have been lacking in this society were the young girls who, even when not brought up in the convents, were still carefully kept away from it.  It is difficult to know whether their absence was the cause of the greater freedom of conversation, or whether they were removed because of it.

Even the intercourse with courtesans seems to have assumed a more elevated character, as if the relation of the ancient Athenians to their hetaerae were being revived.  The famous Roman courtesan Imperia was a woman of intelligence and culture, had learned from a certain Domenico Campana the art of composing sonnets, and was not without musical accomplishments.  The beautiful Isabella de Luna, of Spanish extraction, who was reckoned amusing company, seems to have been an odd compound of a kind heart and a shockingly foul tongue.  At Milan, Bandello knew the majestic Caterina di San Celso, who played and sang and recited superbly.  And so on.  All this makes it clear that the distinguished people who visited these women, and occasionally lived with them, demanded from them a considerable degree of intelligence, and that the more famous courtesans were treated with the greatest respect.  Even when relations were broken off, their good opinion was still desired, because departed passion had left behind a permanent significant impression.  But on the whole this intellectual intercourse is not worth mentioning alongside that sanctioned by the recognized forms of social life, and the traces it has left in poetry and literature are for the most part of a scandalous nature.  We may well be astonished that among the 6,800 persons of this class, who were to be found in Rome in 1490—that is, before the appearance of syphilis—scarcely a single woman seems to have been remarkable for any higher gifts.  Those whom we have mentioned all belong to the subsequent period.  The mode of life, the morals and philosophy of the public women who, with all their sensuality and greed, were not always incapable of deeper passions, as well as the hypocrisy and devilish malice shown by some in their later years, are best set forth by Giraldi, in the novels that form the introduction to the *Hecatommithi*.  Pietro Aretino, on the other hand, gives us, in his *Ragionamenti*, a picture of his own depraved character rather than of this unhappy class of women as they really were.

The mistresses of the princes, as has already been pointed out, formed the subject matter of poets and artists, and have thus become personally familiar to their contemporaries and to posterity.

*In the following passage Burckhardt discusses the importance of a society that formed the intelligent and critical testing ground for art and philosophy.  This type of society*

*and women's place in it is historically significant as the
prototype for the French salons in the following centuries.*

## THE HIGHER FORMS OF SOCIETY

Jacob Burckhardt

This society, at least at the beginning of the sixteenth
century, had an ordered beauty, and rested on tacit, and often
avowed, rules of good sense and propriety, which are the exact
opposite of all mere etiquette.  In less polished circles,
where society took the form of a permanent corporation, there
were statutes and a prescribed mode of entrance, as for exam-
ple, those wild sets of Florentine artists of whom Vasari tells,
who were capable of giving representations of the best comedies
of the day.  In the easier intercourse of society it was not
unusual to select some distinguished lady as president, whose
word was law for the evening.  Everyone knows the introduction
to Boccaccio's *Decameron*, and looks on the presidency of
Pampinea as a graceful fiction.  That it was so in this parti-
cular case is a matter of course, but the fiction was based on
a practice that often occurred in reality.  Firenzuola, who
nearly two centuries later prefaces his collection of tales in
a similar manner, certainly comes nearer to the truth when he
puts into the mouth of the queen of the society a formal
speech on the mode of spending the hours during the stay in the
country which the company proposed to make:  first, a philosophi-
cal morning hour during a stroll among the hills; then, break-
fast, with music and singing; next, in some cool spot, the reci-
tation of a new poem, the subject of which had been given the
night before; in the evening, a walk to a spring where all sit
down and each one tells a tale; finally, supper and lively con-
versation "of such a kind that we women may listen to it with-
out shame and you men may not seem to be speaking under the
influence of wine."  Bandello, in the introductions and dedi-
cations to single novels, does not, it is true, give us such
inaugural discourses, since the groups before which the
stories are told are represented as already formed; but he
gives us to understand in other ways how rich, how manifold,

Jacob Burckhardt, *The Civilization of the Renaissance in
Italy*, ed. by Irene Gordon (New York:  Mentor Books, The New
American Library, Inc., 1961), pp. 272-74.  Reprinted by per-
mission of The New American Library, Inc.

and how charming the conditions of society were.  Some readers
may hold that no good was to be got from a world that was will-
ing to be amused by such immoral literature.  It would be juster
to wonder at the secure foundations of a society that notwith-
standing these tales, still observed the rules of order and
decency, and knew how to vary such pastimes with serious and
solid discussion.  The need of noble forms of social intercourse
was felt to be stronger than all others.  To convince ourselves,
we are not obliged to take as our standard the idealized society
that Castiglione depicts at the court of Guidobaldo of Urbino,
and Pietro Bembo at the castle of Asolo, as discussing the lofti-
est sentiments and aims of human life.  It is the society of a
Bandello, with all its frivolities, that gives us the best no-
tion of the easy and polished dignity, of the urbane kindliness,
of the intellectual freedom, of the wit and graceful dilettant-
ism that distinguished these circles.  A significant proof of
the value of such society lies in the fact that the leading
women could become famous and illustrious without in any way
compromising their reputation.  Among the patronesses of Ban-
dello, for example, Isabella Gonzaga (born an Este) was talked
of unfavorably not through any fault of her own, but because of
the dissolute young ladies who filled her court.  Giulia
Gonzaga Collona, Ippolita Sforza married to a Bentivoglio,
Bianca Rangona, Cecilia Gallerana, Camilla Scarampa, and others
were either completely irreproachable, or their social fame
threw into the shade whatever they may have done amiss.  The
most famous woman of Italy, Vittoria Colonna, enjoyed the repu-
tation of a saint.  It is difficult to describe the unconstrained
intercourse of these circles in the city, in the country, at the
spas in a way that would furnish literal proof of the superiority
over the rest of Europe.  But let us read Bandello, and then ask
ourselves if anything of the same kind would have been possible,
say, in France, before this kind of society was introduced there
by people like himself.—Certainly the supreme achievements of
the human mind were produced without the help of such salons;
but it would be unjust to rate their influence on art and poetry
too low, if only because that society helped shape that which
existed in no other country—a widespread interest in artistic
production and an intelligent and critical public opinion.  And
apart from this, this kind of society was in itself a natural
flower of that life and culture which was then purely Italian,
and which since then has extended to the rest of Europe.

## B.   WOMEN WORKERS AND SCHOLARS
    IN RENAISSANCE ITALY

*The following selection from William Boulting's* Woman in
Italy *(1910) supplements Burckhardt's excerpts on the women of
the Renaissance in Italy.   Boulting's book covers the fourteenth,
fifteenth, and sixteenth centuries.   In the passages reprinted
here, Boulting describes women workers ranging from water car-
riers to painters to governesses.   Marietta Robusti, Tintoretto's
daughter, is by no means the earliest known woman painter; we
know from medieval monastic records that women worked on book
illustrations.   However, in accordance with the Renaissance
emphasis on individual work, Marietta Robusti's name is known.*

*Boulting touches briefly on the subject of women in guilds
and mentions a number of women tutors or governesses in the
Italian Renaissance.   This is interesting because humanist
writers (for example, Vives) expressly stated that women should
not become teachers except to their own children.   Boulting
further describes in greater detail than Burckhardt the efforts
of female scholars of the Italian Renaissance.   He points out
that they were mediocre and that their fame is due more to the
uniqueness of their being women than to the excellence or orig-
inality of their scholarship.   It should be borne in mind,
however, that much Renaissance male scholarship is also criti-
cized for its repetitiveness and for its parrotlike imitation
of classical authors.   Boulting concedes finally that the spread
of education among women raised the overall cultural standards
of both sexes.*

### WOMAN IN ITALY

### William Boulting

Throughout all the centuries of which we treat, the women
of the *popolo basso* remained in wretched poverty; the contrast
between their misery and the cumulative wealth and luxury of
the ladies of princes and merchants grows ever more hideous.
When they got a little work to do they thanked God heartily;
often they had to beg for bread.   Before the fifteenth century
but few women were employed as indoor servants; there were

William Boulting, *Woman in Italy* (London:   Methuen and
Co., 1910), pp. 336-39, 318-24.   Reprinted by permission of
Methuen and Co., Ltd.

charwomen, and the washing of the household linen was sent to
washerwomen; it was never done indoors.  The supply of water for
the family was brought by female water-carriers.  Many poor
women competed with men as hawkers, having the poor for customers.
The ordinary retail dealers who belonged to well-organized asso-
ciations held their itinerant rivals, male and female, in bitter
hatred; to them they were the marauding Bedouins of trade; they
oppressed all those that had no trade-guild at their back to
defend them; hence we find male and female hawkers at Siena
forming themselves into a guild, which allied itself, for pro-
tection, to the more powerful association of innkeepers.  In
early times there were women-barbers, who—so Barberino hints—
would seem to have been disposed to flirt with their customers.
Women kept taverns for high as well as low company, and some
prostitutes kept brothels.  Women earned their living as shoe-
makers as well as at dressmaking, millinery, embroidery, and
plain stitching, and a few were professional cooks.  Women-
weavers formed guilds, and by the statutes of Lucca (1362) none
were admitted to membership who could not count; this regulation
was introduced so that their tally might agree with that of the
merchant who employed them.  Not to spin might be visited by
excommunication, and bad workmanship was open to the same eccle-
siastical penalty after the third warning.  Happy were they who
enjoyed the protection of a guild.  As time went on and guilds
of the less skilled labourers were formed, women were grudgingly
admitted to membership by the men, and their voice was unattended
to.  We find the Government supervising the wares sold by hawkers
very strictly, and cases are recorded where women, selling dis-
eased or rotten meat, were severely punished.  In Venice they
may have plied the oar, for Bembo tells us that, when Beatrice
d'Este came thither on a diplomatic visit, a boat-race of women
was organized as a compliment to her.

Few female painters appear before the sixteenth century.
The painter had the wages and social position of a mere artisan
prior to the High Renaissance, and probably his womankind were
too busily occupied at housework and clothes-mending to assist
him; then, again, the guild was a jealous corporation; women-
painters only came to the front when guilds were decaying.  There
was a Caterina Vigri, however, whose pictures are preserved at
S. Giovanni Bragna and the Accademia at Venice and at the
Pinacoteca at Bologna; she flourished in the first half of the
fifteenth century.  Like Marietta Robusti and Lavinia Fontana,
the woman-artist was usually the daughter of an artist, and
received her training in her father's studio.  Canova said that
the early death of Properzia Rossi was one of the greatest
losses Italian art had suffered; and Marietta Robusti, who died
at 30, had a better reputation as a portrait-painter than her
brother.  The learned Irene di Spilimbergo was a promising pupil
of Titian, but she died before she was 20.  The lady-artists

of the sixteenth century enjoyed an excessive reputation in
their own day.  They exhibited a certain measure of power, but
it is evident that their contemporaries overpraised them; to
none can be granted more than a respectable, but quite inferior
position in the Walhalla of Art.  None the less the appearance
of woman at the easel marks a further stage in the process of
emancipation.

At the end of the fifteenth century we find the governess
installed at the Palace.  Highly educated ladies, trained by
male scholars, were, to a certain extent, substituted for men
in the training of girls, probably because they were better
qualified to look after young children in other ways than in
merely instructing them.  We find Violante de Pretis writing
to her employer, the Marquis of Mantua, at the end of that
century:  "Your Highness will learn by this that the princesses
are well, willing and obedient.  I think very well of them;
they are anxious to learn and even to be industrious.  When
they desire amusement they ride their pony, one taking the sad-
dle and the other being *en croupe*; and I follow them in a little
conveyance while a horseman rides beside them."  In the early
part of the sixteenth century the novel profession was adorned
by the famous Olympia Morata (1526-55), whom the Duchess Renée
of Ferrara chose to be the companion of the little Princess Anna.
Olympia was but 13, the princess five years younger.  In two
years' time we find her teaching the Princesses Lucrezia and
Leonora, who became famous in story owing to the friendly protec-
tion of Tasso by the former and the entirely unfounded romance
of his love-passages with the last-named lady.  Olympia's father
was the learned Pellegrino Morato, also an instructor of princes,
and the daughter became a fine classical scholar.  She instructed
her pupils in Ovid, Aristotle, Ptolemy, Erasmus, Euclid, the
spheres, and the map of the known world; but they took lessons
of male teachers also and received instruction in the accomplish-
ments proper to their sex. . . .

. . . When, with an undue respect for antiquity, classical
attainments were deemed to be the necessary foundation for all
mental ability of the highest order, and the only gateway to
respect and renown, girls as well as boys were put under the
same mental discipline and educated together by the same mas-
ters.  No essential distinction between the sexes as to charac-
ter, taste or ideas was recognized.  Yet, even at the height of
the Renaissance, there were women who passed their lives over
embroidery and were left under guardianship and espionage.  No
dame, not even the most highly instructed, ever neglected her
domestic duties.  Most women merely skimmed the cream from lit-
erature and life:  in the most glorious period Bembo spoke of
the advisability of a girl learning Latin "since it added to
her charm," and Antonio Galeato advised Bona of Savoy to aim
at mental cultivation "to please men, being born to command

them." But the opening of opportunity to women aroused their
interest and awakened dormant faculties, and we find them exhib-
iting an extraordinary and insatiable interest in all the phenom-
ena of human life. They strove to give refinement to the home.
A proof of their emergence is that, in the fifteenth century,
they began to inspire the painters.

Some women were stung as by a divine gadfly; more women
chiefly desired fame—a passion imitative of the pagan writers
of old, and supported by the sort of immortality they had
achieved. This was a genuine passion, felt by all *literati* of
the period, and neither the fiery denunciation of moralists nor
the level voice of common sense could quell it. The damsels of
the upper classes were instructed by the most famous men of
their time, and some, throwing aside both the natural modesty
and the acquired self-repression of their sex, set themselves
to imitate and excel. They set a fashion, and in the fifteenth
and sixteenth centuries many women of very mediocre intelli-
gence swelled the ranks of authorship and presented the world
with works that bear all the marks of overstrained and over-
educated powers.

The list of female scholars from Dorotea Bucca (1400-36),
who was learned in classics, mathematics, and philosophy, down
to Felicia Rasponi (1523-79), who wrote comments on the authors
of antiquity and the Fathers of the Christian Church, is pro-
digiously long—remarkable, indeed, in this respect only, for
to the literary output of these ladies no very high value can
be attributed. All were precocious, many were the daughters
of learned sires; proud fathers and teachers appear to have
unduly forced their mental growth. Young girls spouted Latin
orations before great dignitaries. Ippolita Sforza declaimed
before Pope Pius II (1459), Battista Malatesta before the Em-
peror Sigismund (1433). But the glory of motherhood, potential
as well as actual, carries limitations with it; the rapid forc-
ing of the brain of a girl, who passes so much more rapidly
into puberty than a boy does, and who suffers no fewer demands
on vital resources than he during that critical period, cannot
fail to be deleterious; incessant strain seems to have proved
fatal to many, for it is recorded of several of the most promis-
ing young women that they died when very young. Jacopo da
Bergamo, speaking of Trivolzia of Milan, at the close of the
fifteenth century, says: "when her parents noticed their child's
extraordinary endowments they dedicated her in her seventh year
to the Muses." Irene, the infant prodigy of the noble house of
Spilimbergo, placed by Il Carrer among the "seven gems of Venice,"
a girl equally remarkable for her attainments in letters, music,
and painting, perished before she was twenty, and a painful list
of similar premature deaths among female scholars might be
supplied.

They were proud of their accomplishments. They rummaged

antiquity for suitable pseudonyms; trumpets were blown with
amazing vigour; compliments flew about like confetti; male
scholars affected an extravagant admiration of their powers.
Cassandra Fedele, born in 1465, at Venice, the daughter of an
erudite father, took Greek philosophy and theology as serious
studies and turned to the writing of poetry and to music for
recreation; she secured the admiration of all scholars who
visited Venice, corresponded with Pontano, Pico and Poliziano,
would have accepted the invitation of Isabella of Castile to
adorn her Court but that the Republic refused to part with her,
and was overwhelmed with letters of adulation, in one of which
she was informed by a scholar, who knew better, that she was
"seated beside the Muses and equal to the most celebrated dames
of antiquity." Other female scholars received no less extrava-
gant praise.

They were not without parts; they blazed bravely enough in
the high heavens of their age, but for the most part they lent
but a passing glory to the constellations—they were ephemeral
stars and now are but names. They were merely cultivated women
who copied their masters, and the strong influence of the clas-
sical revival prevented their masters from giving the world
much more than the copied style of Greek and Latin masterpieces.
Isotta Nogarola, one of the most famous of them, robbed phrases
right and left, especially from Guarino and Bevilacqua. If
their male preceptors lacked originality the female pupils
showed no trace of that quality. The grace of Filelfo, the
charm of Pontano, or the broad, bold imagination of Pico della
Mirandola is not to be found in their writings; every weakness,
all the misplaced rhetoric of the scholars of the period, is
faithfully reproduced, nay, even the coarse vituperation in which
philosophers, disappointed of preferment at the Papal Court,
voided their wrath. At a time when it had become fashionable to
bespatter an opponent with the vilest abuse we find Laura da
Creto (a Brescian humanist who died in 1469, under the age of 30)
prepared to "tear out the tongue and lacerate the heart of any
one who denies that women can excel in letters." They have the
excuse that they were subject to the rivalry of both sexes, and
it must have been very painful to have that unctuous adulation
withdrawn by which and for which they chiefly lived. This
fashion of flattery was paid to and welcomed by women of far
smaller attainments in the sixteenth century. Dominichi speaks
of Elena Barozzi Zantanias "like a Greek in beauty; like Roman
Lucretia in virtue," and of Madonna Cecilia Cornaro as "excel-
ling other ladies in beauty as the sun doth the stars."
Giovamballista Dragoncino da Fano in his "Praise of noble
Venetian ladies," 1547, addresses the wife of the Magnifico
Antonio Zantani as "a new Helen, born on earth not indeed to
fire another Troy, but to make sweet war on lovers, who have
buried their souls alive in thee, whose beauty opens and closes

that third heaven where few prayers are heard." A multitude of volumes were issued in various cities, and therein servile, and perhaps needy, men flattered all the leading ladies in the town with adroit and well-balanced but extravagant and vulgar panegyric. These precious productions were the "society journals" of the age, and afforded the same kind of satisfaction.

Prigs and *précieuses ridicules* abounded. Morata Orsini, who enjoyed a proud reputation for wisdom and learning in the fifteenth century, did her utmost to reach a very lofty standard indeed. At her wedding she turned her guests aside from the frivolities of the dance and indulged them with the graver and more improving occupation of reading instructive treatises aloud. At a *festa*, given in honour of the Emperor Frederick III, she reproved the ladies of Siena for appearing in fine dresses, telling them that they should strive after modesty, not ostentation; and when asked what cavalier she thought made the handsomest appearance, replied that she had eyes for her husband only. When Irene di Spilimbergo was a young child a gentleman wanted to kiss her, and the precocious little damsel told him that only those should use such an endearment who were ignorant of its implication.

All these cultivated women were ladies of good birth and position, and this, together with the fact that they were exceptions to their sex, probably accounts for the excessive adulation they received. They took themselves much too seriously, perhaps, but there can be no doubt that the highly educated lady exerted an immense influence over the arts, literature and social life. Dante, his group, and Boccaccio wrote in the vernacular to reach a circle of female readers; and, after the first strenuous enthusiasm for the ancients had subsided we again find authors writing for ladies in their own tongue. In the middle of the fifteenth century Pulci wrote his Morgante Maggiore at the instigation of the mother of Lorenzo Il Magnifico. Breaking away from the dominant classical influences of his age, Pulci attempted a work that should prove equally pleasing to ladies and men, and became the father of a school of courtly poets who delighted their patronesses with tales wherein marvel mingles with absurdity, high imagination with satire, delicate fancy with irony.

We have seen that the mistress of Bernabò held a Court of her own, and that the cultivated courtesan, at the end of the fifteenth century, opened her *salon* to men of wit and position. Whether the educated gentlewoman was stimulated by the social successes of the courtesan or the courtesan copied a *salon* already instituted by the Court lady the author is unable to determine, but it is very certain that a rivalry, which improved education and developed the powers of women, existed between the two classes.

## C.  A TALE CONCERNING A BOATWOMAN

*The tale of the boatwoman is part of the collection of
stories known as* The Heptameron *by Marguerite of Angoulême.
Marguerite arranged her book so that the stories were told by
a group of travelers who were held up in their journey when
unable to cross a flooded stream.  Each traveler told a story,
which in turn reminded another traveler of a tale to recount.
After each tale the travelers discussed its merits and signi-
ficance.  The setting of this book is a good example of the
cultural milieu described by Burckhardt in* The Civilization of
the Renaissance in Italy *(Part 6, section A).*

*The tale of the boatwoman well depicts the society of the
first half of sixteenth-century France.  The heroine is a mar-
ried woman who works at what in the twentieth century would be
considered a masculine trade; the dissoluteness of monastic
orders is symbolized by the behavior of the two Franciscan
friars ("cordeliers"); the attitude of the villagers who cap-
tured the cordeliers is indicative of the general feeling of
Western Europe against the abuses perpetrated by the Church and
the monastic orders.  Marguerite's wit is apparent from the
dialogue of the travelers, who in discussing the hypocrisy of
the friars consider them "well made, strapping fellows, [who]
can talk like angels, and are for the most part importunate as
devils."*

THE HEPTAMERON

Marguerite of Angoulême (1492-1549)

There was in the port of Coulon, near Niort, a boatwoman,
who did nothing day and night but convey people from point to
point.  Two Cordeliers of Niort crossed the river alone with
her.  As it is one of the widest ferries in France, they took
it into their heads to make love to her, for fear she should
grow dull by the way.  She gave no more ear to them than they
deserved; but the good fathers, who were neither fatigued by
the labor of the passage, nor chilled by the coldness of the
water, nor abashed by the woman's refusal, resolved to force
her, or throw her into the river if she was refractory.  But

---

*The Heptameron of Marguerite of Angoulême,* trans. by Walter
K. Kelly (London:  Henry G. Bohn, 1864), pp. 34-37.

she was as good and as shrewd as they were wicked and witless,
and said to them, "I am not so ill-natured as you might suppose;
only grant me two things I have to beg of you, and you will see
I am not more willing to satisfy you than you are to be satis-
fied." The Cordeliers swore by their good St. Francis there was
nothing they would not grant her to have from her what they
wanted. "Well, then," said she, "I ask you, in the first place,
to promise and vow that living man shall never know from you
what passes between us." This they did with great readiness.
"The second thing I ask is, that you will have to do with me
one by one, for I should be too much ashamed if it was done in
presence of you both. Settle between yourselves which is to
have me first." The Cordeliers thought that fair enough, and
the younger of them yielded precedence to the elder.

Running the boat ashore at a little island, she said to the
younger one, "Say your prayers there whilst your comrade and I
go to another island. If he is satisfied with me when we come
back, we will leave him, and you and I will go away together."
The younger friar jumped ashore at once, and the boatwoman rowed
away with his companion to another island. When they reached it,
she pretended to be making her boat fast, whilst she said to
the monk, "See if you can find a convenient spot." The Cordelier,
like a booby, stepped out of the boat to do as she told him, and
no sooner was he ashore, than setting her foot against a tree,
she shot the boat out into the stream, and left the two good
fathers in the lurch. "Wait there, my masters," said she, "till
God's angel comes to console you, for you will get nothing from
me." The duped Cordeliers went down on their knees, and begged
her, for Heaven's sake, not to serve them so, but take them to
the port, upon their solemn oath they would ask nothing of her.
"A pretty fool I should be," she replied, still rowing away,
"to put myself into your hands again once I have got out of
them."

When she got home to the village, she told her husband
what had occurred, and applied to the ministers of justice to
come and capture those two wolves from whose fangs she had con-
trived to escape. The ministers of justice set out for the
purpose, well accompanied, for there was no one, great or small,
but was bent on taking part in this hunt. The poor friars,
seeing such a multitude coming after them, hid themselves each
on his island, as Adam did from the sight of God when he had
eaten the apple. Half dead with shame and the fear of punish-
ment, they were caught and led away prisoners, amid the jeers
and hootings of men and women. "These good fathers," said one,
"preach chastity to us, and want to foul our wives." "They
dare not touch money," said the husband, "but they are ready
enough to handle women's thighs, which are far more dangerous."
"They are sepulchres," said others, "whitened without, but full
of rottenness within." "By their fruits you shall know the

nature of these trees."  In short, all the passages of Scripture
against hypocrites were cast in the teeth of the poor prisoners.
At last the warden came to the rescue.  They were given up to
him at his request, upon his assuring the magistrate that he
would punish them more severely than secular justice itself
could do, and that by way of reparation to the offended parties,
they should say as many masses and prayers as might be desired.
As he was a worthy man, they were chaptered in such a manner,
that they never afterwards passed over the river without cross-
ing themselves, and beseeching God to keep them out of all temp-
tation.

If this boatwoman had the wit to trick two such bad men,
what should they do who have seen and read of so many fine
examples?  If women who know nothing, who scarcely hear two
good sermons in a year, and have no time to think of anything
but earning their bread, do yet carefully guard their chastity,
what ought not others of their sex to do who, having their
livelihood secured, have nothing to do but to read the Holy
Scriptures, hear sermons, and exercise themselves in all sorts
of virtues?  This is the test by which it is known that the
heart is truly virtuous, for the more simple and unenlightened
the individual, the greater are the works of God's spirit.
Unhappy the lady who does not carefully preserve the treasure
which does her so much honor when well kept, and so much dishonor
when she keeps it still!
"It strikes me, Geburon," said Longarine, "that it does
not need much virtue to refuse a Cordelier.  On the contrary,
I should rather think it impossible to love such people."
"Those who are not accustomed to have such lovers as you
have," replied Geburon, "do not think so contemptuously of
Cordeliers.  They are well-made, strapping fellows, can talk
like angels, and are for the most part importunate as devils.
Accordingly, the *grisettes* who escape out of their hands may
fairly be called virtuous."
"O by my faith!" exclaimed Nomerfide, raising her voice,
"you may say what you will, but for my part I would rather
be flung into the river than go to bed with a Cordelier."

## D.  ELIZABETH I:  THE GREATEST WOMAN OF RENAISSANCE AND REFORMATION ENGLAND

*Elizabeth's reign (1558-1603) was the high point of the
English Renaissance.  The queen was the embodiment of humanist
ideals for women, and while she was in power the Protestant
Reformation was firmly rooted in English life.  The second of
Henry VIII's daughters and the third of his children to succeed,*

*she came to the throne after much blood had been shed over the
Catholic-Protestant issue.  It is greatly to her credit that
this question was resolved during her reign with a minimum loss
of life.  (Mary Queen of Scots was one of the few unfortunate
victims.)*

    *In the following selections we see Elizabeth as a woman
and as a queen.  First, the famous scholar and Elizabeth's
tutor, Roger Ascham, describes her (in 1550) as a humanist
school girl.*

## ELIZABETH THE STUDENT

### Roger Ascham

    The Lady Elizabeth has accomplished her sixteenth year; and
so much solidity of understanding, such courtesy united with dig-
nity, have never been observed at so early an age.  She has the
most ardent love of true religion and of the best kind of liter-
ature.  The constitution of her mind is exempt from female weak-
ness, and she is endowed with a masculine power of application.
No apprehension can be quicker than hers, no memory more reten-
tive.  French and Italian she speaks like English; Latin, with
fluency, propriety, and judgment; she also spoke Greek with me,
frequently, willingly, and moderately well.  Nothing can be
more elegant than her handwriting, whether in the Greek or
Roman characters.  In music she is very skillful, but does not
greatly delight.  With respect to personal decoration, she
greatly prefers a simple elegance to show and splendor, so
despising "the outward adorning of plaiting the hair and of
wearing of gold," that in the whole manner of her life she
rather resembles Hippolyta than Phaedra.

    She read with me almost the whole of Cicero, and, a great
part of Livy:  from these two authors, indeed, her knowledge of
the Latin language has been almost exclusively derived.  The
beginning of the day was always devoted by her to the New Testa-
ment in Greek, after which she read select orations of Isocrates
and the tragedies of Sophocles, which I judged best adapted to
supply her tongue with the purest diction, her mind with the
most excellent precepts, and her exalted station with a defence
against the utmost power of fortune.  For her religious

    Joseph M. Levine, ed., *Elizabeth I:  Great Lives Observed*
(Englewood Cliffs, N.J.:  Prentice-Hall, Inc., 1969), pp. 13-14.
ⓒ 1969.  Reprinted by permission of Prentice-Hall, Inc.

instruction, she drew first from the fountains of Scripture, and afterwards from St. Cyprian, the "Common places" of Melancthon, and similar works which convey pure doctrine in elegant language. . . . By diligent attention to these particulars, her ears became so practised and so nice, that there was nothing in Greek, Latin, or English, prose or verse, which according to its merits or defects, she did not either reject with disgust, or receive with the highest delight. . . .[1]

*Elizabeth's famous speech, delivered in 1588 on the eve of the most serious foreign attack that had threatened England in centuries, is reprinted below. This speech rallied her people against the naval forces of Philip II of Spain, known in history as "the Armada." Although Elizabeth surrounded herself with the wisdom of capable men whom she used with discretion, she had the charisma that gave her the overwhelming support of the people at large. This speech indicates how the queen used her own personality.*

## THE QUEEN'S SPEECH

### Elizabeth I

My Loving People:  We have been persuaded by some that are careful of our safety, to take heed how we commit ourselves to armed multitudes, for fear of treachery; but I assure you, I do not desire to live to distrust my faithful and loving people.

Let tyrants fear; I have always so behaved myself, that, under God, I have placed my chiefest strength and safeguard in the loyal hearts and good will of my subjects, and therefore, I am come amongst you, as you see, at this time, not for my recreation and disport, but being resolved in the midst and heat of the battle, to live or die amongst you all, to lay down for my God, and for my kingdoms, and for my people, my honor and my blood, even in the dust.

---

[1]From Lucy Aikin, *Memoirs of the Court of Queen Elizabeth*, 1 (London, 1818), 95-96.

Joseph M. Levine, ed., *Elizabeth I:  Great Lives Observed* (Englewood Cliffs, N.J.:  Prentice-Hall, Inc., 1969), pp. 66-67. ⓒ 1969.  Reprinted by permission of Prentice-Hall, Inc.

I know I have the body but of a weak and feeble woman; but I have the heart and stomach of a king, and of a king of England too; and think foul scorn that Parma or Spain, or any prince of Europe should dare to invade the borders of my realm; to which rather than any dishonor shall grow by me, I myself will take up arms, I myself will be your general, judge, and rewarder of every one of your virtues in the field.

I know already, for your forwardness you have deserved rewards and crowns; and we do assure you in the word of a prince, they shall be duly paid you.  In the meantime, my lieutenant-general shall be in my stead, than whom never prince commanded a more noble or worthy subject; not doubting but by your obedience to my general, by your concord in the camp, and your valor in the field, we shall shortly have a famous victory over those enemies of my God, of my kingdoms, and of my people.[2]

*The Venetian ambassador described a contemporary pope's admiration of the queen.  Because the pope was certainly Elizabeth's religious and political opponent, his assessment of her abilities was not flattery and can be taken seriously.*

## A POPE'S ADMIRATION

### The Venetian Ambassador

The Pope said he had news from Spain that the Armada was ready.  But the English too, are ready.  "She certainly is a great Queen," he said, "and were she only a Catholic she would be our dearly beloved.  Just look how well she governs; she is only a woman, only mistress of half an island, and yet she makes herself feared by Spain, by France, by the Empire, by all.  She enriches her kingdom by Spanish booty, besides depriving Spain of Holland and Zealand. . . ."  He went on with pleasure to dwell on the praises and the valor of the Queen.[3]

---

[2]From W. Scott, ed., *Somers Tracts*, 1 (London, 1809), 429-30.

Joseph M. Levine, ed., *Elizabeth I:  Great Lives Observed* Englewood Cliffs, N.J.:  Prentice-Hall, Inc., 1969), p. 41. ©1969.  Reprinted by permission of Prentice-Hall, Inc.

[3]From *Calendar of State Papers Venetian*, 8 (London, 1894), 345-46.

*As head of the Church of England, Elizabeth followed the tradition, started in her brother's reign, of authorizing the publication of set sermons (or homilies) to be preached on specific occasions throughout the year.  She added some sermons to the existing number, notably the "Homily on Matrimony."  The influence of this particular homily was profound.  It was to be used officially by preachers throughout the Church of England on the occasion of the marriage ceremony but also on many other occasions—for example, if a village couple was in need of marital advice or counseling.  Had she been inclined to do so, Elizabeth, as the most powerful person in England, might have totally changed the status of women within marriage by guiding the trend of this sermon.  In fact, the homily rammed home the power of husbands and the absolute obedience required of wives.  If Elizabeth truly believed the sentiments expressed in this homily, which was distributed under her auspices, it is not surprising that she was adamant about remaining a spinster.*

*A summary of the "Homily on Matrimony" made by the historian Doris Stenton is given below.*

## On the "HOMILY ON MATRIMONY"

## Doris Stenton

. . . The homily on the state of matrimony forced even the people of remote villages to consider the relations between husband and wife.  The homily begins by stating the divine purpose of matrimony, "instituted of God to the intent that man and woman should live lawfully in a perpetual friendship, to bring forth fruit, and to avoid fornication."  After dwelling a little on the horrors of fornication, quoting from St. Paul "Neither whoremongers, neither adulterers, shall inherit the kingdom of God," the author points out how the devil will try to sow discord between man and wife.  "How few matrimonies there be," he says, "without chidings, brawlings, tauntings, repentings, bitter cursings, and fightings."  He points out that it is "a miserable thing to behold, that yet they are of necessity compelled to live together, which yet cannot be in quiet together."  He adjures married folk to pray to God to govern their hearts

---

Doris Stenton, *The English Woman in History* (New York: The Macmillan Co., 1957), pp. 105-7.  Reprinted by permission of George Allen & Unwin Ltd.

and then turns to address the husband in the words of St. Peter.
"You husbands deal with your wives according to knowledge, giv-
ing honour to the wife, as unto the weaker vessel." "The hus-
hand," he says, "should be the leader and author of love, in
cherishing and increasing concord: which then shall take place,
if he will use moderation, and not tyranny, and if he yield
something to the woman. For the woman is a weak creature not
endued with like strength and constancy of mind; therefore they
be the sooner disquieted, and they be the more prone to all
weak affections and dispositions of the mind, more than men be;
and lighter they be, and more vain in their phantasies and
opinions." It is not a token of womanish cowardice for a man
to remember these things, for "a woman must be spared and borne
with, the rather that she is the weaker vessel, of a frail
heart, inconstant, and with a word soon stirred to wrath."
    The author then turns to the woman: "What shall become
her? Shall she abuse the gentleness and humanity of her hus-
band, and, at her pleasure, turn all things upside down? No,
surely: for that is far repugnant against God's commandment:
for thus doth St. Peter preach to them 'Ye wives be in subjec-
tion to obey your own husbands.' To obey is another thing to
control or command, which yet they may do to their children and
to their family: but as for their husbands, them they must
obey, and cease from commanding, and perform subjection." A
woman should endeavour in all ways to content her husband, do
him pleasure and avoid what may offend him. Even so, "it can
scantly be, but that some offences shall sometime chance be-
twixt them; for no man doth live without fault, specially, for
that the woman is the more frail party." Women should there-
fore readily acknowledge their fault "not only to avoid strife
and debate, but rather in respect of the commandment of God, as
St. Paul expresseth it in this form of words: 'Let women be
subject to their husbands, as to the Lord: for the husband is
the head of the woman, as Christ is the head of the church.'
Here you understand that ye should acknowledge the authority of
the husband, and refer to him the honour of obedience." Women
must obey their husbands "as Sarah obeyed Abraham, calling him
lord." The author admits that it is upon the women that the
grief and pains of matrimony fall, for they "relinquish the
liberty of their own rule." They have to bear children and
bring them up. But the woman is again exhorted to obey her
husband and take heed of his requests. She is reminded that
the cap which she wears upon her head signifies that "she is
under covert or obedience of her husband." The husband is
again exhorted to bear with his wife even if "she is a wrath-
ful woman, a drunkard, and beastly, without wit and reason."
He is reminded that beating will only make her worse and that
he will have a great reward if "where thou mightest beat her,
and yet for the respect and fear of God thou wilt abstain and

bear patiently her great offences."

A single reading of this homily from the pulpit of the village church would have assured every married man in the congregation of his right to demand obedience from his wife. Since ministers of religion were exhorted to choose the homily which fitted the occasion it is very likely that the homily on matrimony was often chosen for reading. It would certainly be suitable when any married couple in the village were known to be on bad terms or any wife was reported to be a scold. Men who had not ever considered the basis of the relationship between man and wife were now forced to think of it. Male authority was driven home with all the authority of the Church.

## E. RELIGIOUS WOMEN RADICALS IN THE SEVENTEENTH CENTURY

*A generation after Queen Elizabeth's death England suffered one of the stormiest periods in her history. Civil war was unleashed by political, religious, and economic forces. Members of Parliament were enraged at the absolutism of King Charles I; Puritans were dissatisfied with the establishmentarianism of the Anglican state church; and the rising middle class was at odds with the entrenched landowning aristocracy. At the war's end King Charles was executed (1649), and the Puritan Oliver Cromwell ruled England during the "Interregnum," but the monarchy was voluntarily reestablished with the "Restoration" of King Charles II in 1660.*

*In the wake of the Reformation of the sixteenth century came the development of splinter groups or sects whose attitudes were often far more radical than that of the major Reformers. A number of these groups emerged in England, where the monarch was the head of the reformed Anglican Church. This church still closely followed much of the Roman Catholic ritual and organization, but the sects sought to adopt the basic reform concept of individual salvation through faith.*

*In his article "Women and the [English] Civil War Sects," Keith Thomas analyzes the part played by women in these sects in the mid-seventeenth century. He points out that women have been prominent in all heretical movements since the beginning of orthodox Christianity, particularly during the Middle Ages, when outside the cloister women were excluded from clerical affairs. He finds that the sects in the seventeenth century wanted spiritual equality for women. The behavior and evidence of some of the women involved indicates that they were dissatisfied with their social as well as their spiritual position, but the general tenor of seventeenth-century life, with its self-sufficiency of domestic production, did not allow a revolutionary change in*

*woman's place within the family structure. Neither men nor women who were active in the sects envisaged a role of politi- cal equality for women to parallel the spiritual equality they endorsed at the time. Nevertheless, the involvement of women in these seventeenth-century sects is a major landmark in the history of Western women. It leads in a straight line to the outstanding contribution of nineteenth-century American and English women Quakers and to the beginning of the movements for women's rights. Two hundred years of emphasis on spiritual equality and the opportunity to take an official part in the religious life of the community had laid a strong foundation for the expansion of social equality for women when the political and economic climate became ripe.*

## WOMEN AND THE CIVIL WAR SECTS

### Keith Thomas

In the seventeenth century, as at most other times, the family was the lowest unit of English society, but then espe- cially it formed an intimate framework for the activity of everyone. "Who anywhere," asked a preacher in 1608, "but is of some man's family, and within some man's gates?" Great efforts were made by the State and by local authorities to see that everybody was attached to a household, and the government displayed a strong prejudice against bachelors and masterless men. Upon the good management of families, it was universally agreed, the well-being of the commonwealth depended, an opinion which the inadequacy of contemporary methods of police and local government did much to justify. Those who thought about such things, moreover, knew from Aristotle and the Old Testa- ment that the family was the oldest political society and that out of it emerged all subsequent government, either, as the Royalists were to hold, through the King's inheritance of original patriarchal power, or, according to more liberal thinkers, through the heads of families covenanting together to form a commonwealth. But one did not have to be a philosopher to realize that the father still retained much of his power.

Keith Thomas, "Women and the Civil War Sects," in *Crisis in Europe, 1560-1660*, ed. by Trevor Aston (New York:  Basic Books, Inc., 1965), excerpted from pp. 317-22, 323-31, 334-35, 337-39, and 340.  ©️ Routledge & Kegan Paul, Ltd., 1965; Basic Books, Inc., Publishers, New York.  Reprinted by permission of Basic Books, Inc., without footnotes.

He was entitled to exact complete obedience from all his house-
hold and particularly from his children in such matters as
choice of a career or marriage, for which his permission was
essential.   Indeed it was doubtful how far the State could
interfere with the exercise of his powers within the family.
As for matters outside the household, the master's voice spoke
for all.   In the seventeenth century references to "popular
consent" usually meant the consent of householders, and this
class was smaller than one might think.   The size of a house-
hold would, of course, vary according to the importance of the
householder, but, to take an admittedly extreme example, Shef-
field in 1615 was said to have a total population of 2,207:   of
these, only 260 counted as householders, women, children, ser-
vants and the poor making up the remainder.

Since the Reformation the family had also become the lowest
and most essential unit of government in the Church.   The head
of the household was required to see that his subordinates
attended services and that children and servants were sent to
be catechized.   He was expected, moreover, particularly by the
Puritans, to conduct daily worship at home and to see to the
general spiritial welfare of all in his household.   In return,
the Church used its jurisdiction to preserve domestic order.
The master was both king and priest to his household and upon
his functioning adequately as such, it was felt, depended both
the prosperity and the obedience of his family.

The place of women was determined in theory, and to a
great extent in practice, by a universal belief in their infer-
ior capacity and by reference to the specific commands for
their subjection to be found in Genesis and the Epistles of
St. Paul.   Woman's destiny was marriage, preferably at an early
age, and then the hazards of continual childbearing.   She was
allowed a voice in neither Church nor State, and it was expected
that she should stay at home and busy herself with the (admitted-
ly considerable) affairs of the household.   As a married woman
she could own no property, at least not by common law; her chief
ornament was silence, and her sole duty obedience to her husband
under God.   The Puritans, by their exalted conception of family
life, their protests against wife-beating and the double stand-
ard of sexual morality, and their denunciation of the churching
of women, with its origin in the primitive view of woman as
shameful and unclean, had done something to raise women's status,
but not really very much.   If the wife was a partner, she was
still an inferior one.   As for the much-vaunted Puritan love, it
should be remembered that it came after marriage, not before;
and that, as a popular manual remarked, "we would that the man
when he loveth should remember his superiority."

This patriarchal view of the family was given added meaning
by the widely prevailing system of domestic production and by
the practical self-sufficiency of most country households.   It

was seen as natural and reasonable, for, in the absence of a
science of anthropology, and with the experiences of foreign
travel still ill-digested, no one seriously imagined that any
other form of family unit could exist; and finally it was
invested with divine sanction by all the religious teaching of
the day.  If Christ's own remarks on the subject of the family
had been ambiguous, none the less, later Christian teaching had
taken it as fundamental and He himself had drawn upon it to
symbolize the ideal relationship of God with man and of men
with each other.  And by contrast perhaps with the Middle Ages,
the "insistent theme" in Puritanism is that of God's Fatherhood.
"The word *Father*," wrote Sibbes, "is an epitome of the whole
gospel."  The family was an integral part of what Dr. Tillyard
has called the Elizabethan World Picture.  This picture, if we
leave out the astronomical trappings and take its main theme,
which was that the structure of society in all its details
was divinely ordained and must never be tampered with, was as
much Caroline as Elizabethan.  It stood for those twin concepts
which had so powerful an emotive force for contemporaries—
order and unity.  To question the family, the place of women,
or any other part of the social order, was to flaunt nature,
reason and, above all, the will of God.  It could only result
in chaos and anarchy.

In this paper I wish to discuss the impact upon this
patriarchal family in general and on women in particular of the
Civil War sects.  By these I mean the successors of the separ-
atists who first appeared in Elizabethan England, who emigrated
to Holland or to America to set up their independent congrega-
tions, or who continued to meet at furtive conventicles in this
country, until they reappeared in great numbers in the early
days of the Long Parliament, after which they enjoyed a large
measure of practical toleration throughout the Interregnum.
They were known by a variety of names—Brownists, Independents,
Baptists, Millenarians, Familists, Quakers, Seekers, Ranters—
and they represented a wide diversity of theological opinion.
What they had in common was that they all were *sects*, that is,
they believed in a pure Church, they made spiritual regeneration
a condition of membership and insisted upon separation from a
national Church which contained ungodly elements.  More often
than not they believed in the complete self-government of indi-
vidual congregations; they usually thought in terms of direct
inspiration by the Holy Spirit; and they tended to depreciate
the role of a ministry, of "outward ordinances" and of human
learning.  Their assertion of the spiritual equality of all
believers led to an exalted faith in private judgement, lay
preaching, a cult of prophecies and revelations, and culmi-
nated in the Quaker doctrine of the spirit dwelling in all men.

It is well known how in political matters this conscious-
ness of direct relationship with God proved a great source of

strength and these beliefs with their frequently democratic
implications became a powerful solvent of the established
order.  I wish to argue here that their impact was felt not
only by the State but also by the family.

From the very beginning the separatists laid great empha-
sis upon the spiritual equality of the two sexes.  Would-be
members of a congregation had to give proof of their individual
regeneration, women as well as men.  There was no reason to
believe that women were any less likely to pass this test, nor
were there any grounds for denying that a woman might be regen-
erate when her husband was not.  And once admitted to the sect
women had an equal share in church government.  "It followeth
necessarily," wrote John Robinson, "that one faithful man, yea,
or woman either, may as truly and effectually loose and bind,
both in heaven and earth, as all the ministers in the world."

Furthermore, women were numerically extremely prominent
among the separatists.  It is impossible to obtain a very accu-
rate view of the size of the various sects in the seventeenth
century, and even harder to ascertain the relative proportion
of females in the overall total.  Nevertheless, what evidence
we do have is extremely suggestive.  In the episcopal returns
and indulgence documents of the reign of Charles II conventiclers
are frequently described as being "chiefly women," "more women
than men," "most silly women" and so on.  During the Civil War
period it was a favourite gibe against the sectaries that their
audience consisted chiefly of the weaker sex.  Information ex-
tant about individual congregations suggests that it was quite
usual for women to preponderate.  At Norwich in 1645, for
example, the congregation contained thirty-one men and eighty-
three women.  Of the twelve founder members of the Baptist
church at Bedford in 1650, eight were women.  From the beginning
of the eighteenth century individual church covenants and church
books are more plentiful and afford numerous examples of the
women being in a majority.  This, of course, was by no means the
rule and it is quite easy to produce instances of congregations
where the opposite was the case.  We should remember too the
importance of women in religious bodies which were not sects—
among the Scottish Presbyterians, and the Roman Catholics in
England, where, for a time, the law made it easier for a woman
than a man to be a recusant.  It is possible indeed to hold for
the seventeenth century a theory of the greater natural religi-
osity of women.  Many of them had more time for piety; they were
less used to saving themselves by their own exertions, and their
experiences in child-birth made them far more conscious of the
imminence of death.  Yet, when all the obvious objections have
been made, it still remains true that in the sects women played
a disproportionate role; and they received from them correspond-
ingly greater opportunities.

There were said to be more women than men in the first

large body of English separatists, in London in 1568; and we
know that later many left their husbands to go overseas to the
Netherlands with Browne and Harrison.  These were not women of
exceptional education or opportunity.  Many, no doubt, had
never left home before and there is evidence to suggest that
well over three-quarters of them were illiterate.  The sectaries
attracted persons who in all probability had previously never
been active members of any church.  Coming from a lower order of
society, they were perhaps more used to mixing with women on a
basis of rough and ready equality—or perhaps they were influ-
enced by the greater freedom enjoyed by women among the Dutch—
at all events the upshot was that the separatist churches made
considerable concessions to women in the sphere of church
government.

For this there was a good deal of precedent.  In the Middle
Ages anti-clerical movements frequently ended by exalting the
claims not only of laymen but of lay women.  The Lollards, for
example, encouraged women to read the Bible and to recite the
Scriptures at their meetings; several deposed on examination
that perfect women were capable of the priesthood, and there
is some evidence of actual preaching by Lollard women.  Even
Occam admitted the possibility of some future occasion when the
whole male sex might err and the true faith maintain itself
only among pious women.  After the Reformation it was not un-
usual for Protestant leaders to admit that under exceptional
circumstances, in a heathen country, for example, women might
be allowed to preach as a temporary expedient.  But this con-
clusion was reluctant and largely theoretical and it was left
to the radical sects to work out the logical consequences of
the extreme Protestant position. . . .

. . . In the formation of small independent congregations
women often played a leading part and in the outbreak of lay
preaching they joined with enthusiasm.  Many of the London
Independent congregations far outstripped the practice of the
sectaries on the Continent by allowing all their members,
women included, to debate, vote and, if not preach, then
usually at least to prophesy, which often came to much the same
thing.

Preaching by women had thus probably begun among certain
Baptist churches in Holland and was to be found in Massachusetts
by 1636.  When it became common in England in the 1640s its main
centre, like that of most sectarian activity, was London.  A
woman preached weekly at the General Baptist church in Bell
Alley in Coleman Street, but we also know that there were women
preachers outside London, in Kent, Lincolnshire, Ely, Salisbury,
and Hertfordshire, and as far afield as Yorkshire and Somerset.
Indeed one of the most advanced Baptist churches in this respect
was probably that of John Rogers in Dublin, where women held
all the privileges (though not the offices) of male members.

Rogers was forthright in his condemnation of any attempt to
exclude women from Church government. "Most men do arrogate a
sovereignty to themselves which I see no warrant for," he wrote.
But, even among the Baptists, men showed a marked reluctance to
relinquish this sovereignty and, even in Dublin, Rogers' views
on the place of women seem to have alienated half his congre-
gation.

It was of course among the Quakers that the spiritual
rights of women attained their apogee. All the Friends were
allowed to speak and prophesy on a basis of complete equality,
for the Inner Light knew no barriers of sex. Fox and his fol-
lowers declared that women's subjection, decreed at the Fall,
had been eradicated by the sacrifice of the Redeemer. "Man
and Woman were helps meet . . . before they fell; but after
the Fall, in the Transgression, the Man was to rule over his
Wife; but in the restoration by Christ . . . they are helps
meet, Man and Woman, as they were before . . . the Fall." As
for the ministry of women, it is held, as a modern Quaker puts
it, that "those Scriptures which enjoin silence upon women
. . . refer to local or temporary conditions which have now
passed away." The women who walked under the Spirit were not
under the Law. Women were priests as much as men. Christ was
one in male and female alike.

As a result the female sex played so large a part among
the Quakers that it was rumoured at first that the sect was
confined to them alone. Women were the first Quaker preachers
in London, in the Universities, in Dublin and in the American
colonies; and from 1671 regular Women's Meetings, organized on
a country-wide basis, gave women their share in church govern-
ment. It should not be thought that all this was accomplished
without serious opposition from within the Society of Friends
itself. The Women's Meetings developed only slowly and even
at the beginning of the eighteenth century women did not
really enjoy completely equal status, at least not in matters
of discipline anyway. Nonetheless, the significance of the
Quaker contribution to women's emancipation is enormous.

The main scriptural obstacle in the way of women preachers
was, of course, the prohibition of St. Paul, but this could be
countered by reference to the prophet Joel; and so we read of a
lace woman prefacing her sermon by remarking, "That now those
days were come, and that was fulfilled which was spoken of in
the Scriptures, that God would pour out of his Spirit upon the
handmaidens, and they should prophesy."

Not unnaturally the principle that the Spirit bloweth
where it listeth proved itself an extremely powerful solvent of
the established order. Under the outpourings of even its most
extravagant female adherents we can detect, if in exaggerated
form, the claims of women to be heard in their own right. In
sixteenth-century Switzerland an Anabaptist had given "herself

out for the Queen of the World and Messias for all women."
In seventeenth-century England Richard Hubberthorne encountered
"an impudent lass that said she was above the apostles." Jane
Holmes, a Quaker, had a fever which transformed her into "a
wild eyrie spirit, which . . . kicked against reproof, and
would not come to judgement." Women claimed to be able to per-
form miracles, like Susannah Pearson, who acted the part of
Elisha and tried to raise a young man from the dead. Great
feats of endurance were performed, such as that of Sarah Wight
in 1647, who was believed to have fasted for fifty-three days.
Many claimed the power of prophecy as did the irrepressible
Lady Eleanor Douglas. Others like Anna Trapnel were gifted with
an almost endless capacity for the composition of ecstatic reli-
gious verse. It is difficult for us to recapture the apocalyptic
atmosphere in which all this took place, but the challenge
offered by these events to traditional ideas on the passive and
subordinate role of women in the Church and in society is obvious.
As Anna Trapnel remarked, "Whom the Son makes free, they are free
indeed." And it is clear that the horrified chorus of opposition
to these women preachers and mystics derived its fury from some-
thing more than their defiance of St. Paul. The greatest offense
of Mrs. Anne Hutchinson, the leader of Antinomianism in Massachu-
setts, was not a purely theological one. As Hugh Peters said to
her, "You have stepped out of your place; you have rather been a
husband than a wife, and a preacher than a hearer; and a magis-
trate than a subject, and so you have thought to carry all
things in Church and Commonwealth as you would, and have not
been humbled for this." Anne Wentworth, who wrote delirious
verse, was regarded as "an impudent hussy, a disobedient wife
. . ., one that run away from her husband, and the like." And
it is interesting to remember that a hundred years earlier the
same had been said of Anne Askew, the Protestant martyr. Forced
into a loveless marriage against her will, she had left her
husband and reverted to her maiden name.

It should not be thought that all women visionaries of this
period were ardent feminists. Elizabeth Warren, for example,
who was one of the most prominent writers of the 1640s, pub-
lished reluctantly, "conscious to my mentall and sex-deficiency,"
dilated upon women's greater susceptibility to error, and urged
obedience to all whom God had placed in lawful authority. But
she was exceptional and most of these women declared without
hesitation that the Spirit of God was to be revealed "as soon
to his handmaids as his men servants."

With the sectarian women also were popularly associated
advanced views on marriage and divorce.

> 'We will not be wives
> And tie up our lives
> To villainous slavery'

was the chorus of a ribald skit on the "holy sisters," a form of literature which had great vogue at this time.  After the Reformation matrimony was no longer regarded as a sacrament, and this had left the way open for the Brownist view of marriage as a purely civil contract, and hence one which could be terminated on the non-performance of either of the two parties. Moreover, the rigid application of the sectarian view that it was necessary to separate from the ungodly and to join the regenerate gave an added sanction to divorce and re-marriage, as the Brownists had also demonstrated.  The Anabaptists had held "that wives of a contrary religion may be put away, and that it is lawful for them to take others."  This, however, could work in reverse, and Milton's writings on divorce had left loopholes of which women could avail themselves.  In New England the followers of the Ranter, Gorton, asserted "that it is lawful for a woman who sees into the mystery of Christ, in case her husband will not go with her, to leave her husband and follow the Lord's House; for the Church of God is a Christian's home, where she must dwell . . . and in so doing, she leaves not her husband, but her husband forsakes her." Such behaviour was not confined to New England and from the early 1640s we find evidence of sectary women casting off their old husbands and taking new, allegedly for reasons of con- science.  The most celebrated instance was that of Mrs. Attoway. This formidable lady after one of her sermons, we are told, approached two gentlemen and "spake to them of Master Milton's doctrine of divorce, and asked them what they thought of it, saying it was a point to be considered of; and that she for her part would look more into it, for she had an unsanctified hus- band, that did not walk in the way of Sion, nor speak the lan- guage of Canaan."  Shortly afterwards, she attached herself to one, William Jenney, who, it appears, had also been troubled by an unsanctified consort, but who resolved his dilemma by deduc- ing "from that Scripture in Genesis where God saith *I will make him an help meet for him*, that when a man's wife was not a meet help, he might put her away and take another; and when the woman was an unbeliever (that is, not a sectary of their church) she was not a meet help, and therefore Jenney left his wife, and went away with Mistress Attoway."  Nor was this an isolated case.

There was, of course, nothing new about this association of women and small religious sects.  "From the Montanist move- ment onwards," wrote R. A. Knox, "the history of enthusiasm is largely a history of female emancipation."  Women seem to have played a disproportionate role in the history of mysticism and spiritual religion.  Almost all the medieval sects from the Manichaeans to the Waldenses, the Donatists to the Cathars, received to a marked degree the support of women and welcomed them, sometimes as influential patronesses, but more often, and

more to our purpose here, as active members on a basis of prac-
tical equality.  To contemporaries this represented nothing
more than Satan working through his usual channels, but to us
it is hardly surprising that women were attracted to those
groups or that form of religion which offered spiritual equality,
the depreciation of educational advantages, and that opportunity
to preach or even to hold priestly office which they were other-
wise denied.  Membership of the sects outside the Church or
mysticism within it allowed women self-expression, wider
spheres of influence and an asceticism which could emancipate
them from the ties of family life.

The same factors must have operated among the women of the
Civil War sects.  They could play no active part in the Church
of England nor in the Catholic Church, several of whose leaders
had publicly lamented that the Reformation had placed Bibles in
hands which would have been better occupied with a distaff.
The Presbyterians campaigned for the minor office of church
widow, and all Puritans agreed that women could and should
instruct their families in religious matters.  But that was all
and it is not to be wondered at that for some women the sects
proved more attractive. . . .

. . . The separatists seldom maintained that they wanted
more from the family than liberty of conscience and worship.
Apart from this the web of obedience was to be maintained
intact.  "No difference, or alienation, in religion, how great
soever," John Robinson had said, "either dissolves any natural
or civil bond of society; or abolisheth any the least duty
thereof."  This commonplace of contemporary political theory
was urgently reiterated in the writings of the leading separ-
atists and in the official confessions of the Congregational
and Baptist churches.  Just as the ungodly magistrate must be
obeyed unless his commands were directly contrary to the word
of God, so was obedience due on the same terms from wives,
children and servants to their superiors.  As William Gouge had
remarked much earlier, "Though an husband in regard of evil
qualities may carry the image of the devil, yet in regard of
his place and office, he beareth the Image of God."  It was
completely in accordance with their stated principles that as
soon as they took on institutional form even the most radical
sects became conservative as regards the organization and dis-
cipline of the family.  The Quakers were notoriously patriar-
chal and the Baptist churches continued to punish rebellious
wives and servants.  For the sects, as for the Presbyterians,
spiritual equality was to remain strictly spiritual only.

Yet it would be misleading to pretend that all was as it
had been.  Religious divisions within the family had repro-
duced in miniature the dilemma created by the same divisions
with the State. . . .

During the Civil War and Interregnum the very foundations

of the old patriarchal family were challenged in a number of
ways which have not been mentioned in this paper.  Among them
may be numbered the Civil Marriage Act, the lively discussion
of polygamy and of marriage within the forbidden degrees, and
the unusual part played by women in war, litigation, pamphle-
teering, and politics; the appearance in English of continen-
tal feminist writings, and the attacks, sometimes by women
themselves, on their limited educational opportunities, their
confinement to domestic activity, their subjection to their
husbands, and the injustices of a commercial marriage market.
We should remember also the campaign against entails and primo-
geniture, the emergence of a political theory which took as its
primary unit not the family but the individual and, in the back-
ground all the time, a slow decline in the self-sufficiency of
the country estate and in the household as a unit of production.

In this paper only one of the influences which led to
rescrutiny of the nature and purpose of the family has been
discussed—the impact of the religious sects.  Their numbers
were never great, they affected only certain classes and certain
areas to any extent, and their social radicalism was undoubtedly
much exaggerated by their opponents.  Even Thomas Edwards, their
most voluble opponent, admitted that he was concerned less with
actual happenings than with what he thought would be long-term
consequences, scarcely perceived by the separatists themselves.
In company with much other contemporary thought, the more radi-
cal views on the family went underground at the Restoration.
The old apocalyptic vision was dimmed and in the stolid and
respectable dissenters of the eighteenth century it is hard to
recognize the fervent separatists of our period.

As regards the place of women, the long-term effects of
separatism were probably small.  Appeal to divine inspiration
was of very questionable value as a means of female emancipa-
tion.  The whole emphasis was placed upon the omnipotence of
God and the helplessness of his chosen handmaid should she be
thrown upon her own resources.  "I am a very weak, and unworthy
instrument," wrote Mary Cary in the preface to one of her Fifth-
Monarchy pamphlets, "and [I] have not done this work by any
strength of my own, but have been often made sensible, that I
could do no more herein . . . of myself, than a pencil, or pen
can do, when no hand guides it:  being daily made sensible of
my own insufficiency to do anything as of my self."  We should
not overemphasize this objection:  after all, Cromwell said the
same sort of thing about his victories in battle without it
noticeably diminishing their impact; but it does seem in this
case that the language in which such writing was couched must
have served to perpetuate the legend of women's inferiority.
In addition, it is probable that the more exotic and extravagant
of these female prophets and preachers only served to do harm to
their own cause, since for most people they illuminated by

contrast the virtues of the Marthas who stayed at home.

Nor does the sectarian insistence upon women's spiritual
equality seem to have been of very great importance in the
later history of female emancipation in general.  It is true
that the energy and resourcefulness of Nonconformist women was
to be very evident in subsequent generations, but, for the most
part, future feminist movements were to base their arguments
less upon any renewed assertion of women's spiritual equality
than upon natural right and a denial of any intellectual differ-
ences between the sexes.  No plea for female suffrage was put
forward during this period, so far as I can discover.  The
sectaries protested strongly against the view that "the vote
of the husband, or his joining to this or that true church,
[doth] include the vote and joining of his wife and children
under his government."  Yet they failed to challenge the exclu-
sion of women from political suffrage, even though that exclu-
sion was based upon exactly the same grounds.  Either they
failed to see the analogy, or the strength of deeply rooted
traditional ideas was too great to allow them to perceive its
implications. . . .

But this at least can be said.  The Civil War sects con-
tributed to the later development of the family by their con-
tribution to the general process of substituting secular for
divine sanctions for the arrangements of society.  The orthodox
arguments and texts for woman's exclusion from church office had
been identical with those for her subordination in general.  It
was impossible now to attack the one without weakening the other.
And in the family the demand for religious toleration led to the
redefinition of the limits of paternal power.  New standards of
utility and reason were being sought to justify the subordina-
tion of men and women to each other.  It was a search from which
in the long run both women and the family were to benefit.

# 7

## WOMEN IN THE CENTURY OF THE FRENCH REVOLUTION

*At the end of the eighteenth century the French Revolution
promised mankind individual human liberty, equality, and brother-
hood. Women, who might have expected to be included in this
rousing slogan, were initially disappointed. Neither politi-
cians[1] nor the rank and file of the revolutionaries seriously
included women in their claims for the rights of man. It is
particularly ironic that this should have been so, for indirect-
ly it was largely due to the women of the salons, who encouraged
discussion of new ideas, that the stage for the Revolution was
set during the eighteenth century.*

*Historical events and ideas in the two centuries after the
Reformation paved the way for the French Revolution of 1789.
In an effort to prevent discord after the stormy religious and
political civil wars of the sixteenth and early seventeenth cen-
turies, the French monarchy became increasingly absolute. Fin-
ally the Sun King, Louis XIV (1643-1715), declared during his
reign, "l'etat c'est moi" (I am the state). In England a deter-
mined combination of long-standing and newly elevated aristocrats
foiled attempts at absolutism by the Stuart kings who followed
Elizabeth I. Charles I was beheaded (1649), and his son James II
was forced to abdicate in the "glorious (bloodless) revolution"
of 1688. The English parliamentary system developed constitu-
tional strength, and in the eighteenth century French thinkers,
notably Voltaire (1694-1788), were unstinting in their praise of
the English example.*

*The Church in France had remained virtually unreformed.
After several attempts at official toleration of Protestant
(Huguenot) believers, Louis XIV came down firmly against them
with the Revocation of the Edict of Nantes (1685). Protestants
from France now joined British religious extremists who were
dissatisfied with Anglican Protestantism as prescribed by the
official Church of England, and they emigrated to the New
World.*

---

[1]See S. H. Lytle, "The Second Sex, 1793," *Journal of Modern
History*, 27 (1955), 14-26.

232

The political thinkers who reacted against the royal and
clerical absolutism in France were backed by an equally strong
scientific reaction that developed against religion—both against
the superstition of the old faith and against the new Protestant
emphasis on faith and biblical interpretation.   Lutheran expec-
tations that faith and the biblical word would unify mankind had
not worked out in practice.   Different interpretations of the
Bible had led to the creation of multiple factions and disagree-
ment about the "true faith."   Philosophers rested their hopes
for the future of mankind in "nature" and science.   They felt
that natural science would lay a sure foundation for "natural
religion" and moral philosophy.   The English poet Alexander
Pope summarized the background of this belief in his couplet:

> Nature and Nature's Laws lay hid in night,
> God said, Let Newton be! and all was light.

"Light," or the Enlightenment of the eighteenth century,
was the collective label for the many ideas and reactions
against previous beliefs, institutions, and conventions.   The
English scientist Isaac Newton (1642-1727) laid the scientific
foundation; John Locke (1632-1704), the political scientist,
translated the new ideas of natural and civil laws into a blue-
print for civil government; the Scot, Adam Smith (1723-90),
contributed to the economic picture of society by his theories.
In his Wealth of Nations he stated that an invisible hand would
guide the single law of supply and demand, automatically direct-
ing all resources precisely to the uses in which they would
most contribute to human happiness.   The American Thomas Jeffer-
son (1743-1826) put into words the basic enlightenment concept
that liberty and property were natural rights and that con-
straint or unquestioning acceptance of tradition were unnatural:
"endowed by their Creator with certain unalienable rights, that
among these are life, liberty, and the pursuit of happiness."

Stimulating the growth of these intermingled philosophies
from the Old World and the New World was the accessibility of
the New World, which added a new dimension to the contemporary
fascination with nature—an admiration of the simple life of
the "noble savage."   The honesty of simplicity was for the
world of eighteenth-century France a particularly admirable
contrast to the contrived stiltedness of the court and the pomp
and "infamy" of the Church.

The French "philosophes," entranced with enlightened
ideas and determined that these ideas should be translated into
reality in France, included Voltaire (1694-1778), Diderot (1713-
84), d'Alembert (1717-83), and Rousseau (1712-88).   These men
are also known as the Encyclopedists, for they were co-authors
and editors of a vast reference work that undertook to enlighten
all literate Frenchmen—an attempt to "assemble the knowledge
scattered over the face of the earth."

*The concept of such an encyclopedia was an extention of that influential seventeenth and eighteenth century French institition, the salon. The prototype of the salon can be found in the Italian Renaissance; as Burckhardt describes it (Part 6, section A), groups of people began critical discussion of the latest literature and ideas, thus forming educated public opinion. The concept of the salon was transplanted to France with the exuberance of Renaissance internationalism, and there it struck particularly fertile soil.*

*Some royal salons existed in France throughout the sixteenth century, such as that of Marguerite of Angoulême or the later one of Marguerite, wife of Henri IV. But they also emerged gradually among the lower strata of society, and by the early seventeenth century the first of the famous French salons, the Salon Bleu of Madame de Rambouillet (1558-1665), an Italian by birth, was established. The main aim of the Salon Bleu was to instill manners in the rude society of the sixteenth century. By the time of the great salons of the eighteenth century—those of Madame Geoffrin and Madame du Deffand—manners and their by-product, artificiality, reigned supreme.*

*In the time between Madame de Rambouillet's Salon Bleu and the French Revolution salons proliferated throughout France. More than one hundred women's names are associated with leadership of these establishments, including official mistresses of kings, like Madame de Montespan (1635-1719), mistress of Louis XIV, and Madame de Pompadour (1721-64), mistress of Louis XV; women of the aristocracy like Madame de Tencin (1681-1749); women of illegitimate antecedents like Mademoiselle de Lespinasse (1732-76); and women of the middle class like Madame Geoffrin (1699-1776) (Part 7, section B).*

*In their day the salons played the essentially social function of the press. They were the medium in which new ideas fermented and developed and by which the ideas were spread through society. They were the focal point of literary, political, and artistic criticism. Philosophy, religion—every subject had its own coterie, and every subject was discussed at some time in someone's drawing room. The atmosphere of the salon had an effervescent quality (see 7 A).*

*The lady of the salon had much influence and responsibility. She was almost invariably a woman of middle age, at least forty years old and often much older. Her essential characteristics were cleverness, tact, and charm. She needed to be neither beautiful nor well educated (although many of these women were both). If she was wealthy, had aristocratic connections, and could provide delectable meals she was at an advantage, but these assets were not nearly as important as the cleverness, tact, and charm. Her main function was to draw out her guests, to make them sparkle, and thus to set in motion that vital*

*elucidation and interchange of ideas which gradually percolated throughout society and, as it happens, toppled the ancien* regime *and the entire prerevolutionary French mode of life.*

*The salons were the havens in which thinkers, scientists, writers, poets, and artists discussed their latest ideas before and after publication. Distinguished men of the period wandered from one salon to another, often attending specific salons at regular hours on regular days. Thus, for example, Pascal and La Rochefoucauld were to be found at the salon of Madame de Sablé, Montesquieu at the salon of Madame de Tencin, Voltaire at the salon of Madame du Deffand, and d'Alembert at the salon of Mademoiselle de Lespinasse.*

*A number of the women associated with the salons of these two centuries were intellectually creative in their own right. Madame de la Fayette (1634-93) and Mademoiselle de Scudery (1607-1701) wrote some of the first novels during the seventeenth century; Madame de Sévigné's (1626-96) letters are literary masterpieces; Madame du Châtelet was a mathematician and astronomer; and Madame de Staël (1766-1817) was considered one of the greatest literary figures of the eighteenth century, both in France and in the rest of Europe. However, creativity was not required or in fact desired of the women by the majority of seventeenth- and eighteenth-century men. "Inspire, but do not write" was the poet LeBrun's advice to women, intimation of the full force of Jean Jacques Rousseau's passionate affirmation that women existed merely to nurture and to comfort men (7 C).*

## A. THE ENLIGHTENMENT AND THE SOUL OF WOMAN

*The brothers de Goncourt were social and literary historians of eighteenth-century France. Selections from their book,* The Woman of the Eighteenth Century, *first published in French in 1862, are reprinted. Analyzing the different activities, traits, and enthusiasms exhibited by French women of the eighteenth century, Edmond and Jules de Goncourt found the lives of women spiritually empty. They found women in positions of great power behind men, women perfecting the art of letters and exhibiting tremendous ebullience and wit, women leading lives of exhausting nervous energy and frivolity, women searching for deeper meaning in life and immersing themselves in the pursuit of knowledge. But the de Goncourts concluded that all these activities were a frantic cover-up for a lack of spiritual fulfillment, and they imply that the romanticism of Jean Jacques Rousseau filled the void, with a fanfare of trumpets, prescribing for women sensitivity, love, passion, and the all-powerful fulfillment of motherhood.*

## THE DOMINATION AND INTELLIGENCE OF WOMAN

Edmond and Jules de Goncourt

As in the case of the individual, each human age or century appears, in the eyes of posterity, to have been dominated by a distinctive character, by an intimate, superior, unique and rigorous law, derived from its customs, ordering its facts and from which, at a distance, history would seem to originate.  At first glance, a study of the eighteenth century discloses this general, constant and essential character, this supreme law of a society which is its culmination, its physiognomy and its secret.  The soul of this age, the center of this world, the point from which all things radiate, the summit from which all things descend, the image upon which all things are modeled, is Woman.

Woman was the governing principle, the directing reason and the commanding voice of the eighteenth century.  She was the universal and fatal cause, the origin of events, the source of things.  She presided over Time, like the Fortune of her history. Nothing escaped her; within her grasp she held the King and France, the will of the sovereign and the authority of public opinion—everything!  She gave orders at Court, she was mistress in her home.  She held the revolutions of alliances and political systems, peace and war, the literature, the arts and the fashions of the eighteenth century, as well as its destinies, in the folds of her gown; she bent them to her whim or to her passions.  She could exalt and lay low.  When she would create grandeurs or efface them, hers were the hand of favor and the thunders of disgrace.  No catastrophe, no scandal, no lofty deed but emanated from her during a century that she filled with prodigies, wonderment and adventure, throughout a history in which she set the surprises of a novel.  From the elevation of Dubois to the Archbishopric of Cambrai down to the dismissal of Choiseul, there lurked, behind each rise and fall, a Fillon or a Du Barry, a woman, always a woman.  From one end of the century to the other, government by woman was the only visible and appreciable government, possessing the consequences and mechanism, the reality and activity of power, without fail, apathy, or interval.  There was the government of Madame de Prie; the government of Madame de Mailly; the government of Madame de Château-roux; the government of Madame de Pompadour; the government of

Madame du Barry.  And later, when friendships succeeded mis-
tresses, there was the government of Madame de Polignac.

The imagination of woman sat down at the Council table.
Woman dictated domestic and foreign policies according to her
tastes, her likes and her dislikes.  She gave ministers her
own instructions, she inspired ambassadors.  She imposed her
ideas and her desires upon diplomacy; the language of states-
manship assumed her tone, her tongue and the informality of her
dainty graces to the point of adopting words of the boudoir and
familiarities of gossip in the despatches of Bernis.  Not only
did she wield the interests of France, but she disposed of its
blood; willing to leave absolutely nothing even to man's execu-
tion, which she had not planned and executed, marked with the
imprint of her genius and signed, on the corner of a dressing-
table, with the seal of her sex, she actually ordered the
defeats of the French army with those plans of battle sent to
headquarters, those plans on which the various positions are
indicated by *mouches*![1]

Woman touched everything.  She was everywhere.  She was
the light and also the shadow of this age. . . .

If woman ruled in the state, she was likewise mistress in
the home.  The power of her husband was subject to her as was
the power of the King, as were the power and credit of the min-
isters.  Her will decided and triumphed in domestic matters
just as in public affairs.  The family depended upon her; the
home seemed to be her possession and her kingdom.  The house-
hold obeyed her and received her orders.  Formulas, hitherto
unknown, invested her with a sort of property-right, from which
her husband was excluded, over the people and things of the com-
munity.  In the language of the age, everything was expressed,
no longer in the husband's name but in his wife's.  Service was
carried on in the woman's name:  people went to see Madame,
they went to Madame's reception, they dined with Madame, Madame's
dinner was served.—These were new expressions; their mere
existence gives a sufficient idea of the decrease of the hus-
band's authority and of the progress of his wife's.

To what shall we attribute this influence, this unparalleled
domination, this sovereignty of almost divine right?  Where is
the key to it?  How shall we explain it?  Did the woman of the
eighteenth century owe her power simply to the qualities pecu-
liar to her sex, to the charm of her nature, to the habitual
attraction of her person?  Did she owe it altogether to her age,
to human fashion, to that reign of pleasure which brought her
power in a kiss and allowed her to rule everything since she

--------

[1]*Mouches*:  artificial beauty spots popular among the
ladies of the eighteenth century.

commanded love?  Doubtless woman drew a natural strength and a
facility for authority from her perennial charms, as well as
from the milieu and dispositions peculiar to her century.  But
her empire originated above all in her intelligence and in so
singularly superior a type of woman that only her ambition and
the span of her power equaled it.  We have but to pause before
the portraits of the age, before the paintings and pastels of
Latour:  intelligence dwells in these women's heads and in
their faces.  The brow is meditative.  The shadow of a reading
or the caress of a thought flows over it, ever so lightly.
The eye follows one with its glance as it might follow one
with its thought.  The mouth is delicate, the lips thin.  In
all these faces there is the determination and flash of a
virile thought, a depth in their very *mutinerie*, an indefinable
quality of meditation and penetration, that blending of the man
and the stateswoman, whose features are to be found even in the
face of an actress, of La Sylvia.  As we study these faces,
which grow serious as we look at them, a clear and decided
character reveals itself under their grace.  The discernment,
the coolness, the intellectual energy, the power and resiliency
of woman, which these portraits but half veil, emerge.  Experi-
ence of life and knowledge of all its lessons come to light
under their sportive air and their smile seems to hover on
their lips like the subtlety of their reason and the menace of
their wit.

Pass from these portraits and turn to history, the genius
of the woman of the eighteenth century does not give the lie to
this portrait.  We find her adapting herself to the greatest
rôles, we observe her broadening, growing, becoming masculine
enough, or, at least, serious enough, through application, study
and will power, to explain, to vindicate practically her most
astonishing and scandalous usurpations.  She rose to the govern-
ment of the gravest interests and events; she undertook minis-
terial affairs; she interfered in the quarrels of the great
bodies of state and in the troubles of the kingdom; she cap-
tured the responsibility and the will of the King; she climbed
to the heights, and descended to the depths of the fearful and
complicated art of government, undeterred by ennui, untroubled
by giddiness, unforsaken of her strength.  Woman brought her
passions into politics, but she also brought to them unparal-
leled talents and quite unexpected ones.  Like her countenance,
her intellect displayed certain features of the statesman; we
are astonished at times to see the King's mistress playing the
part of his Prime Minister with such dignity. . . .

Thus the woman of the eighteenth century possessed all the
subtle qualities of sagacity that a contemporary calls "leading-
strings for men."  Her eye allowed nothing to escape it, in the
recesses of self-esteem, the secrets of modesties, the lies of
great reputations; in affectations of nobility, in what men

conceal and simulate, in all their manners of frivolity and the
slightest nuances of their moral countenances.  Because they
were continually occupied; because they were forced by the
exigencies of their domination, by their place in society, by
the interest of their sex and by their very inaction to carry
on an incessant and almost unconscious work of judgment, compari-
son and analysis, the women of that age attained a sagacity that
gave them the government of the world.  It permitted them to
strike straight at the heart of the passions, interests, and
weaknesses of everyone.  The women of the day acquired this pro-
digious tact so speedily and at such slight cost that it appeared
almost as a natural sense in them.  It might well be said that
there was intuition in the experience of so many young women with
this admirable contemporary gift of knowledge without study, of
that knowledge which caused the *savantes*[2] to know a great deal
without being erudite, of that knowledge which made women of
Society know everything without having learned anything.  "Young
intelligences divined far more than they learned," said Sénac de
Meilhan, in a profound epigram.

This genius, this habit of perception and penetration, this
rapidity and sureness of vision instilled in woman a rationale
of conduct, a quality frequently hidden by the outward aspect
of the eighteenth century, yet easily discernible in all the ex-
pressions that escaped it.  This quality was the personality and
property of judgment brought back to the reality of life:  the
practical spirit.  When we fathom the intelligence of the con-
temporary women, beyond her frivolity we find a firm, cold and
arid field where all prejudice, all illusions and often all
belief ceased.  "Sound common sense" was the soul of this intel-
ligence; no emotion warmed it, yet it illuminated everything
about it.  If a man sought counsel of it, the common sense of
woman advised him "to make friends with women rather than men.
For through women, you can do all you wish with men; and then
men are either too distracted or too preoccupied with their
personal interests not to neglect yours, whereas women think
of them, if only through idleness.  But beware of being anything
more than a friend to those women you believe can be useful to
you." . . .

Such was the moral worth of the woman of the eighteenth
century.  Let us now examine her intellectual, mental and
literary worth.  A word, a book, her letters, the tastes of her
sex will disclose it to us.

The first feature of this feminine intelligence in the com-
prehension and judgment of mental phenomena was a sense corre-
sponding to her moral faculties:  the critical sense.  The

---

[2] (Female) scholars.

counsel of a woman of the eighteenth century to a beginner who
had read her a comedy reveals, better than any appreciation, in
all its extent and in all its force, this sense, rare and appar-
ently contrary to the temperament of woman.  "At your age," this
woman said to him after the reading, "you can write good verse
but not a good comedy; for comedy is not only the work of talent,
but also the fruit of experience.  You have studied the theater,
but, unfortunately for you, you have not yet had leisure to study
the world.  You cannot paint portraits without models.  Mingle
in society.  Where the ordinary man sees only faces, the man of
talent distinguishes characters; but do not believe that you
need live in the world of society in order to know it; look
about you well, you will notice the vices and affectations of
every estate.  In Paris especially, the stupidities and extrava-
gances of great men are quickly communicated to the lower ranks
of society; the comic author has perhaps more to gain in observ-
ing them there, by the very fact that they show themselves there
with less artifice and in a less diluted form.  At every period,
there are a particular character and a dominating color in man-
ners that must be well grasped.  Do you know the most signal
trait of our present morals?"—"It seems to me to be gallantry,"
said the neophyte.—"No, it is vanity.  Pay careful attention,
you will see it mingling with everything, spoiling everything
that is great, degrading passions and even going so far as to
weaken vices." . . .

But books in this age were but a chance manifestation of
feminine genius.  Woman's power of thought, her strength and
penetration of judgment, the subtlety of her observation, her
vivacity of idea and of comprehension are incessantly and far
otherwise expressed in the instantaneous sally of speech.  The
woman of the eighteenth century reveals herself above all in
her conversation.

This science which defies all analysis, whose principles
its contemporary commentators all elude—Swift no less than
Moncrif, Moncrif no less than Morellet—this indefinable talent,
undemonstrable and natural as grace itself, this social genius
of France, the art of conversation, was the particular genius
of the women of the period.  They brought to it all their wit
and charm, that desire of pleasing which is the essence of
sociability and politeness, the prompt and delicate judgment
which, at a glance, embraces and adapts every convention to the
rank, age, opinions, and degree of self-esteem of each individ-
ual.  They ban pedantry and dispute, personalities and preemp-
tions.  They make of it an exquisite pleasure given and partaken
of by all.  They give it the freedom, the zest, the fleeting
movement of ideas winging from hand to hand.  They endow it with
a tone of inimitable perfection, neither ponderous nor frivolous,
wise, gay without excess, polite without affectation, gallant
without insipidity, witty without impropriety.  Maxims and

sallies, flattery and blandishments, quizzing and irony trip
through this *causerie*[3] which seems to blend wit and reason on
the lips of woman.  No dissertations; in a flight of words and
a hurdle of questions, to skim a subject was to judge it.  Con-
versation runs, rises, drops, glides and returns; rapidity
gives it effect, precision lends it elegance.  What feminine
ease, what facility of speech, what abundant views, what fire,
what verve go to make this swift-flowing conversation which
sweeps every subject, veering from Versailles to Paris, from
the pleasantry of the day to the event of the moment, from
the ridiculousness of a minister to the success of a play, from
word of a marriage to the publication of a book, from the
silhouette of a courtier to the portrait of a famous man, from
society to government!  For everything was within the span and
competence of woman's conversation.  Raise a grave subject or
a serious question, and her delicious frivolity curtsies to her
profound judgment; she amazes by this sudden revelation of un-
expected knowledge and observation, as witness this startled
confession of a philosopher:  "A point of morals would not be
better discussed in a company of philosophers than in that of
a pretty woman of Paris."

How to recover now the conversation of the woman of the
eighteenth century, a speech as dead now as her voice?  In an
echo, in that whispered confidence slipped in the ear of his-
tory by the spirit of the time:  in letters.

The accent of her conversation, the echo of the eighteenth
century lie there slumbering but alive.  The letter, that relic
of woman's grace, was her conversation to the life.  It retained
its expressions, its gossip, its carelessness and happy babble.
The life of the age seemed to sparkle under the impatient hand
of women, who rode roughshod over penmanship and spelling; as
they seize and reflect it on the wing, wit overflows from their
pen like a foaming supper-wine.  It was a devil-may-care style,
roving, meandering, losing itself, recovering itself, a style
never listening yet ever replying, an improvisation without
design, full of sound, color and caprice, confounding words,
ideas and portraits, and leaving of this world's activity a
thousand images like the fragments of a broken looking-glass.
. . .

Breathless verve, sparkling chatter and dizzy wit were not
the chief characteristics, however, of these women's letters.
Even more than their conversation, their correspondence showed
a faculty of depth and earnestness.  The usual inspiration of
the epistolary art was no longer a picture, description or
painting as in the preceding century.  Letters are now filled
with observations and thought:  analysis, judgment, ideas
appear in them and assume the foremost place.  The prattle of

---

[3]Chatter.

the world drifts through them, songs and anecdotes find an echo
here, but in one corner, at the turn of the page, and, as it
were, in postscript.  What dominates these letters is moral
speculation.  The letter, like the woman writing it, shows what
Madame de Créqui called "substantial flashes."  Do but turn
these light, tremulous leaves fallen from the hands of the most
fashionable and seemingly irresponsible of women; and see her
mind raising the most important and delicate questions.  She is
constantly questioning human nature in her own nature, rising
to reflections on happiness; defining and indicating the tastes
and passions which lead to it.  She appreciates and weighs every
social prejudice. . . .

## THE SOUL OF WOMAN

### Edmond and Jules de Goncourt

Once the eighteenth century through its conventions, its
examples, its good taste, the good tone of society and the
lessons of life, has completely renewed the education and
almost the nature of woman; once these forces have stripped
her of all naturalness, timidity and simplicity, she becomes
that type of social manners: *la caillette*. . . .
. . . As this artificial creature appears to us, she
might well be the model doll of the tastes of that extreme
civilization.  Her entire person is a prattling, mincing,
refined elegance of manners; it breathes an exquisite corrup-
tion of sentiment and expression.  By dint of continual exer-
tion, she succeeds in personifying in herself "that quintessence
of daintiness and charm" which, at that time, represents the
perfection of elegance in people and the absolute of beauty in
things.  She brings forth from herself, as from out of a coarse
envelope, a new social being, to whom a more subtle sensibility
reveals a whole order of impressions, of pleasures and of suf-
ferings unknown to preceding generations, indeed to all human-
ity before 1700.  She becomes the woman with intoxicated nerves,
made feverish by the world, by the paradoxes of its supper-
tables, by its scintillating conversation, by the noise of its

---

Edmond and Jules de Goncourt, *The Woman of the Eighteenth
Century*, trans. by Jacques LeClercq and Ralph Roeder (London:
George Allen & Unwin, Ltd., 1928), pp. 267, 268-69, 270-71, 271-
73, 275-76, 279-85, 286-89.  Copyright 1927 by Minton, Balch &
Company.  Reprinted by permission of G. P. Putnam's Sons.

days and nights, carried headlong in its whirlwind.  At the end
of it, she finds that mad and coquettish intoxication of eigh-
teenth century graces:  *le papillotage*[1]—a word discovered by
the age to paint what is most precious in its amiability and
most subtle in its feminine genius.

Under this fever of manners, under all these dissipations
of imagination and of life, there remains something unappeased,
unsatiated and empty in the heart of the woman of the eighteenth
century.  Her vivacity, her affectation, her enthusiasm for fan-
tasy seem to be a worry; and the impatience of a disease appears
in this continual search for gayety, in this frenzied appetite
for pleasure.  But she struggles, she searches around her for a
sort of deliverance in vain; she gains no end by plunging, by
drowning herself in what the age calls "an ocean of worlds," by
taking the first step towards distractions and new faces,
towards those passing *liaisons*[2] with chance friends for which
the century invents the word *connaissances.*[3]  The ever-changing
spectacle of dinners, suppers, entertainments, pleasure trips,
tables ever filled, salons ever amurmur; of a continuous proces-
sion of people; of the variety of the news, of faces, of masks,
of toilettes and of eccentricity, cannot entirely absorb woman
with its tumult.  Let her burn her nights out by candlelight,
let her summon more activity about her increasingly as she grows
older, she always finishes by falling back upon herself.  She
finds herself in seeking to escape herself, and under her breath,
she confesses to herself the suffering that gnaws her.  She rec-
ognizes *ennui* in her, the secret and irremediable evil this cen-
tury bears in itself and drags about with it everywhere,
smiling. . . .

Through the exigencies of her instincts, through the sub-
tlety of her moral sensibilities, through the volatility of her
entire being, woman was to suffer from this disease of the cen-
tury more than man.  When Walpole called the woman of the
eighteenth century "a débauchée of wit," he defined and ex-
plained her.  "I have a stupid admiration for all that is witty,"
one woman confesses in the name of all.  Woman is all mind, and
it is because she is all mind that she feels within her, as it
were, a desert.  She knows no sentiment, no superior force up-
holding her, no spring of tenderness to slake her thirst;
nothing save an activity of mind, a sort of libertinage of
thought which plunges her back into the disenchantment of life
at every moment.  Her heart floats without anchor to which it

---

[1]Dazzle, glitter.

[2]Intimacies.

[3]Acquaintanceships.

may moor.  At the same time her faculties lack a link to unite
them and a superior purpose to govern them; they lack faith,
devotion, one of those great currents that make woman triumph
over the weaknesses of her moral will.  Hence that aridity she
cannot remedy which leaves her disconsolate.  Hence that singu-
lar prostration, that feeling of weariness deadening her con-
science, that nervousness in pleasure, that flavor of ashes in
everything she tastes. . . .

Correspondences, *mémoires*, confessions, all the documents,
all the familiar revelations of the time betray and affirm that
inner discomfort of women.  There is no effusion, no letter
where the complaint of *ennui* fails to return as a refrain, as
a moan.  It is one continual lament on this state of indiffer-
ence and passivity, on this torpid lack of all curiosity and
vital energy depriving the mind even of desire, of liberty
and activity, leaving it no patience other than sloth and cow-
ardice.  *Ennui*, for the women of that age, is the chief evil,
it is what they themselves call the "enemy."  We need but listen
when they mention and acknowledge it:  their language, otherwise
so exact, so little given to declamation, thereupon adopts
enormous expressions to describe the immensity of their discour-
agement.  *Le néant* (nothingness)—such is the word they find,
without judging it too strong, to depict that death-slumber to
which they succumb:  "I have fallen into *le néant*.  I have fal-
len back into *le néant*."  Such is the phrase that these women
of taste and balance wrote currently, naturally, finding it at
their pen's end whenever they wish to speak of their *ennui*, so
much does their suffering appear to them impossible to express
better than by comparison with the oblivion that follows death.
The most noble and courted of women utter cries of disgust like
those of a dying man as he turns his head to the wall:  "The
living all bore me! . . . Life bores me!"  Some of them go so
far as to envy trees, because they cannot feel *ennui*.  And the
great letter-writer of the day, Madame du Deffand, will be the
great painter of *ennui*.  This *ennui* of heart and soul reacted
on the body of woman.  It gave her a suffering, a weakness, a
languor, a sort of physical sadness and atonity, the muffled
discomfort that the age vaguely christened "vapors."  "The
vapors are *ennui*" said Madame d'Épinay.  The eighteenth century
saw nothing but affectation in this ailment.  Weary of seeing
women without energy, without will-power, stretched out on a
chaise longue, barely strong enough to tie knots, complaining
so inertly of being "exhausted," the age believed, or wished to
believe, that there was no motive in an illness which had be-
come in good taste and modish. . . .

Basically, all these reasons for the vapors of the eigh-
teenth century were but secondary.  There was one which
dominated them all:  society, society and its life.  Her
enervation came from her night-life, from a life which won

the name of *lamps* for women, from a society which lived by night and went to bed by day.   It derived from the resultant fever, from that torment of the nights of the century, insomnia. Already under the Regency, women had tossed about on their beds until seven in the morning and now we hear Madame du Deffand and Mademoiselle de Lespinasse complaining, in utter despair of their inability to sleep. . . .

Meanwhile, even if she sought a balm for her physical ills of medicine and of charlatans, woman also sought in herself a remedy for her moral discomfort.   Returning to the source of all her sufferings, to the principle of her disease, what did she find?   Inactivity of ideas amid excitement, dispersion of self, that scattering of the mind which makes for dissipation. Whence came that flavor of the *néant* which everything, even pleasure itself, took on at her touch?   From the nothingness within herself, from the emptiness she concealed under a nervous frivolity; from the cold activity that distributed her mind in every direction, without interesting it particularly in anything, giving it movement without elasticity.   The cardinal evil, the poison in her life, the wretchedness of her condition were, in a word, a lack of what she herself called "an object."

Thus an object in life became her pursuit throughout the entire century.   Thus passionately, in a frenzy of infatuation, heedless of eccentricity or ridicule, she went seeking the serious, solid mental foundation, the intellectual interests, the basis and end and weight she lacked, not in the pastimes of the mind within her reach, but in the extremes opposed to the talents and aptitudes of her sex, in studies that attracted her apparently because of their seriousness, their immensity, their depth, indeed by virtue of their horror, by virtue of all that absorbs and possesses the intellect of man.

Novels disappeared from the dressing-tables of women; only treatises of physics and chemistry appeared on their *chiffonnières*.   The greatest ladies and the youngest took up the most abstract of subjects, rivaling Madame de Chaulnes who embarrassed the academicians and savants who came to her husband's house.   By 1750, Maupertuis was already the "wheeze" of women; it was already the thing for the *petites-maîtresses* to rave over the séances of the Abbé Nollet, to watch him draw fire— audible fire—from the chin of a tall lackey by scratching it. In the salons at the end of the century, groups were formed of twenty or twenty-five people for courses in Physics, in Chemistry applied to the Arts, in Natural History, in Myology. Not to attend the lectures of Monsieur Sigault de la Fond or of Monsieur Mittouard invited a blush; did not the names of Madame d'Harville, of Madame de Jumilhac, of Madame de Chestenet, of Madame de Mallette, of Madame d'Arcambal, of Madame de Meulan figure among those who flocked to them?   A woman no longer had

herself painted on a cloud of Olympus but in a laboratory.
When Rouelle, the brother of the famous Rouelle, conducted
experiments on the fusion and volatilization of diamonds, he
numbered among his spectators the Marquise de Nesle, the Com-
tesse de Brancas, the Marquise de Pons, the Comtesse de Polignac
and Madame Dupin, whose curious and attentive eyes followed the
diamond flashing under the fire of the muffle-furnace, twinkling
for one last time and exuding light.  A newspaper arose to fill
the need of the times and cater to the tastes of woman.  Ming-
ling science and ornamental arts, side by side with Poetry it
discussed items of philanthropy, varieties and the play; it
furnished descriptions of machines, remarks on Astronomy,
letters on Physics, excerpts on Chemistry, research in Botany
and Physiology, Mathematics, Domestic Economy, Rural Economy,
Agriculture, Navigation, Naval Architecture, History, Legisla-
tion and the Proceedings of the Academy.  This was the *Journal
Polytypique*.  Men such as Pilastre du Rozier and La Blancherie
exploited the same idea and the same craze.  Paying academies
and *museums* arose, their success assured by a public of women
who applauded everything offered to their inspection, even to
the tomes of Gébelin on the bull Apis!  Museums and lyceums
filled Paris with amiable knowledge and attractive erudition.
And what prettier picture than all those pretty heads turned
towards the doctor enthroned in his curulian chair, at the end
of a long table laden with crystallizations, globes, insects
and minerals?  The burr of his voice, the nicety of his diction,
are elocutionary charms for the circle of women forming the
first row of the audience, their cheeks innocent of rouge and
wan no doubt with long watching, their heads resting negligently
on three compass-like fingers, rapt in attention or with grave
eye and hand applying the points of the discourse to the objects
spread out on the table before them.
     But lyceums were too little.  In 1786 the Royal College,
that school of all the arts and sciences, frequented heretofore
only by serious students, the Royal College itself found its
doors stormed by women, vanquishing the vigorous opposition of
the Abbé Garnier, by the aid and intrigues of their friend
Lalande.  Alas for the delicate maxim of Madame de Lambert:  "On
the subject of science, woman must maintain a modesty as deli-
cate as towards vice"!  No science repels her; the most virile
sciences seem to exercise a temptation and a fascination.  The
passion of Medicine is almost universal in society; the craze
for Surgery is frequent.  Many women learn how to wield the
lancet, even the scalpel.  Others are jealous of the grand-
daughter of Madame Doublet, the Comtesse de Voisenon.  From the
physicians received at her grandmother's, she had learned some-
thing of the art of healing, and she practiced her cures, at
her country seat, among her friends, on anyone she could lay
hands on; until at last certain jokers, by inserting a notice

in the *Journal de Savants*, made her believe she was elected
President of the College of Medicine.  The Marquise de Voyer
was keenly interested in lessons of Anatomy and took pleasure
in following the course of the chyle in the viscera.  For, at
this period, Anatomy is among the chief feminine fads.  Certain
women of fashion even dream of having, in a corner of their
gardens, a little boudoir containing those *delights* of Made-
moiselle Biheron, the great artist in anatomic subjects, made
of wax and of *chiffons*, a glass case filled with corpses!  A
young miss of eighteen, in fact, the Comtesse de Coigny, was
so passionately fond of this horrible study, that she would never
travel without taking in the seat of her coach a corpse to dis-
sect, as one takes a book to read.

The dream of the woman of the eighteenth century was uni-
versal knowledge, and a compendium of talents, inspired by an
example of genius, the alert and light genius of Voltaire,
who seemed to embrace whatever he touched and who, by way of
relief from sifting a world of passions, took to dabbling in that
of science for sport.  What was it to produce?  Merely a dainty
monstrosity, a woman who knows how to blood-let and to pluck a
harp-string, to teach geography and to play-act, to plot a novel
and to draw a flower, to herborise, to preach and to rime, the
perfect type of what that age called *une virtuose*:  Madame de
Genlis.

Of these two great currents of the mode, one drew woman
towards the refined coquetries of caprice, of affectation and
frivolity, of *préciosité*, of lightness and of mobility.  It
carried her outside real life, almost out of the earth.  The
other current bore her, in the wake of Madame de Châtelet,
towards the *bel esprit* of the sciences, to that sphere of chemi-
cal and physical entertainment where Newton is named Algarotti,
in brief, towards the vanity and superficiality of all knowledge.

There was one woman in the eighteenth century who resisted
these two opposite movements in the minds of women.  But, while
she waged war on both foibles, this woman could not conquer the
latter:  the vogue of the lyceums was to survive her, to spread
and grow, to withstand even the Revolution, and to reappear
under the Directoire in all the brilliance of its extravagance.

Not so, however, with the exaggeration, and, if we may say
so, the hectic cult of grace;  she scanned and discredited it
almost completely.  From the heights of her influential *salon*,
this woman—a *bourgeoise*—punctured this fashionable inflation
with a pin-prick; she led the soul of woman back to truth and
redirected her coquetry into the paths of nature.  To the
originality and the affected charm sought by the woman of the
day in labored sentiments and forced language she opposed
simplicity, a basic simplicity, a simplicity of vocation, of
tradition and of nature which she drew from her birth and her
temper, from the order from which she sprang as well as from

the tendency of her tastes, of her mind, of her cold reason, of
her orderly soul, of her pitiless common-sense.  Simplicity was
not only her character, it was the study of her life, her pre-
occupation and her vanity; she perfected it, she pondered and
polished it.  She made of it a weapon against the realities and
appearances of the world of that age.  All those about her
sought to shine and to dazzle; the mode was to catch the eye
or attach the minds of others.  Amid this universal mania of
dramatizing oneself to the world, which at this time made the
epithet reserved a killing condemnation and a cruel insult,
she assumed the negative quality of reserve as her rule; and
the motto of her person was the motto of her apartment:  *Rien
en relief* (nothing conspicuous).  She made a show of "simpli-
city"; she played it against her century, going so far as to
search for trivial images, household comparisons, metaphors
drawn from the lowly objects in order to deprive her most ingen-
ious ideas of any pretensions.  In this age where the soul
seemed unable to do without manners; where in life, in thought,
in love, in everything rule and order were cast aside; where
woman demanded a sort of frenzy of her sensations, this woman
stood erect and firm, her soul remained wholly compounded of
reason, she affected the earthy, she flaunted her ignorance,
limiting the system and plan of happiness to the repose of the
individual.  Instead of emerging from herself, she took refuge
within herself.  Fleeing from all effort, sorrow, and shock,
she urged her faculties towards a certain nonchalance, she
inclined her desires towards a sort of laziness.  She maintained
her peace, which was a philosophical renunciation, by leading a
constant and regular life, strengthened by maxim and axiom.
Moderation, the middle course in all things, was the secret of
the tranquil, perfect equilibrium she established even in the
grave movements of her sage heart.  She evaded even the emotion
of charity; one day she declared, in a cold phrase, like a
breath of icy air:  "I mistrust no one, for that is to act and
judge; but I trust no one, for that is never embarrassing!"
    *Papillotage* could not long resist the protest of this
serene, clear, dry figure who in her own person brought her sex
back to the reality of life and to the necessity of common-
sense.  Without fascination, without wit, ironical only in the
example and contrariness of her mode of life, this woman,
Madame Geoffrin, had the honor of momentarily altering her sex
and of fashioning it after her own image.  She silenced the cry
of the woman of the eighteenth century:  "If ever I could be
calm, then, I dare swear, then I should find myself on the
wheel!"  She pacified her sex; she restored its serenity; she
drew it out of the state of convulsion and intoxication in which
Madame de Prie had taught it to live.  And, with calm, she
brought back *truth* into a society that had lost all notion of it.
Her authority restored to honor sincerity of thought and

naturalness in conversation.  Soon these became social charms
superior to all others.  When she compares herself to ladies of
society more beautiful than herself, gifted with more personal-
ity, animated by a lively desire to please; when she asks her-
self the reason of her superiority over these women, less
sought after, less busy and less surrounded by the flatteries
of the world, Mademoiselle de Lespinasse answers herself, say-
ing that her success consists precisely in the fact that "she
has always seen the *true* in everything" and that, to this merit,
she has joined that of "being *true* in everything." . . .

One evening after supper, at the Palais Royal (it was one
of those *petits jours* which brought intimate company together)
the ladies were working about the round table.  The Duchesse de
Chartres, Madame de Montboissier and Madame de Blot were ravel-
ing; Madame de Genlis, seated between Monsieur de Thiars and the
Chevalier de Durfort, was making a purse; the Duc de Chartres
was walking up and down the salon with three or four men.  The
conversation fell upon the *Nouvelle Héloïse*.  Madame de Blot,
ordinarily circumspect and self-contained, began so lively and
emphatic a eulogy that the Duc de Chartres and the men walking
about with him drew near.  A circle formed around the table.
Madame de Blot developed her argument boldly, conscious of her
audience and of the eyes of the Duc de Chartres fixed upon her;
and, excited by her own eloquence, she ended by exclaiming,
"only the loftiest virtue could keep a woman of true sensibility
from devoting her life to Rousseau, if she were certain he would
love her passionately."

The cry of this woman was the cry of the woman of her
century.  The lips of this prude utter the great voice of her
age and of her sex.  Rousseau's prodigious influence; the
magnetism of his genius; the intoxication of his books; his
reign over the feminine imagination; the enthusiasm, the grati-
tude, the amorous and religious worship this imagination con-
centrated even about his person—Madame de Blot shows these
with the vivacity and sincerity of public opinion, with the
consciousness of all these women buying like a relic a bilbo-
quet of Rousseau's, or kissing his writing in a little copy-
book.

It was fitting that Rousseau inspire this cult and this
adoration in woman.  What Voltaire was to the mind of the man
of the eighteenth century, Rousseau was to the mind of the
woman.  He emancipated it and refreshed it.  He gave it life
and illusion; he led it abroad and he elevated it; he called
it to liberty and to suffering.  He found it empty and he left
it filled with ecstasy.  Here was a moral revolution, immense
in depth and scope, one which involved the future!  When
Rousseau appeared, it was Moses touching the rock; every living
spring flowed forth again in woman.

He restored the strength and virtues of vitality to a

world worn out by pleasure, weary of soul, ravaged by the steril-
ity and selfishness of a society at its highest point of refine-
ment and subtle corruption.  What did this misanthropic apostle
bring, this providential man, long-awaited by woman, invoked by
the ennui of her heart summoned by this age suffering from lack
of love, dying because it would not devote itself?  A flame, a
tear:  passion!—passion, which in spite of the opinion of the
man who brought it to the eighteenth century, was to become, in
the nineteenth century, so congenial to the very intellect of
woman, that it formed the genius of the two great writers of
her sex and the inspiration of their masterpieces.

At the breath of Rousseau, woman awakened.  A tremulous-
ness passed through the most secret recesses of her being.  She
vibrated to sensations, to emotions, to a thousand troublous
thoughts.  Tendernesses and voluptuousness were born anew within
her, they penetrated to her very consciousness.  Her imagination
flooded her heart.  Love appeared to her as a new sentiment,
resuscitated and sanctified.  Possession and the ravishment of
love succeeded the love that was gallantry, the light and bril-
liant love of the eighteenth century.  Love was no longer a
whim amusing itself in good taste, it was an enthusiasm, min-
gled with a folly almost religious.  Love became passion, and
naught else but passion.  It took on a language of flame, accents
that might be those of a hymn.  Seeing perfection in the beloved,
Love made of it an idol and seated it in heaven.  Love hovers
in a thousand pictures and in a thousand divine ideas:  paradise,
angels, the virtues of saints and the delights of the heavenly
sojourn.  Love writes on its knees; on a paper bathed with
tears.  Love exalts itself in the battle of remorse and in the
intoxication of sin.  It grows noble through sacrifice, it puri-
fies itself in expiation, it effaces weakness by duty. It is its
own absolution, a virtue rendering all others unnecessary; it
saves the soul of woman, in her strongest impulses, from the
degradation of her body, by leaving her taste, appetite or
regret for Purity and Beauty.  Here was a sacred delirium, an
ideal full of temptations, to which the *Nouvelle Héloïse* in-
vited all the senses of the soul of woman, her faculties and her
aspirations, in pages tremulous as the first kiss of Julie, and,
like it, piercing, burning to the very marrow of her bones.

But it was not enough to restore to love this heart of
woman "melted and liquefied" in the fire of his novels:  Rousseau
further restored it to motherhood.  He brought the child back to
the breast of woman; he made her nourish it with the milk of her
heart; once again he attached it to her entrails; and he taught
the mother, as a woman has said, to recapture through this little
creature huddled against her, and warming her soul "a second
youth, hope of which recommences when her first youth is van-
ished."  Rousseau did more:  he revealed to the mother of the
eighteenth century the duties and the joys of that moral

motherhood that is education.  He inspired her with the idea of nurturing her children with her mind, as she has nurtured them with her body, and of watching them grow up beneath her kisses. Of the home he made a school.

He brought about the universal return of society towards the order of sentiments expressed by a word which seems to rise from every heart to every lip:  sensibility, the sensibility to which usage soon linked the epithet "expansive."  A new language was created, a new moral and sentimental code with no basis or principle other than the sensibility everywhere expressed and paraded, and bringing so great a change to the physiognomy of this world, to its exterior, to the very coquetries of woman. Sensitive—this was all woman wished to be; it was the only praise she coveted.  To feel and to appear to feel, became the interest and the occupation of her life; she no longer fell into ecstasy over anything save sentiment, which, she said, she "needs more than the air she breathes."

## B.  A LADY OF THE SALON

*In the twentieth century the old Parisian townhouse of Madame de Sévigné, the famous seventeenth-century lady of letters, was made into a museum of the history of Paris from the Renaissance to the empire.  A series of lectures on the women of the great literary salons of the seventeenth and eighteenth centuries inaugurated the opening of Madame de Sévigné's apartments.  Excerpts from the lecture on the salon of Madame Geoffrin (1699-1777), one of the best known prerevolutionary ladies of the salon, are reprinted below.*

*The speaker, M. Nozière, considered Madame Geoffrin a brilliant woman; he commented with irony on her manipulation of society and her exploitation of her own personality.  He stressed Madame Geoffrin's native intelligence, her lack of education, her gift of drawing out the wit and brilliance of others, her ready assessment of what was artistically valuable, her sex appeal, and her sensible recognition that the way to open a philosopher's mind is through his stomach.*

*Madame Geoffrin demonstrates how through the salon a middle-class woman could rise to the upper echelons of society in the eighteenth century.  No longer were inheritance and education essential, although her marriage to a wealthy man was a basic factor in Madame Geoffrin's personal worldly success.*

*M. Nozière's portrait is a valuable sketch of a great figure of the prerevolutionary salon.  However, his sweeping generalizations on the subjects of women's contempt for women and the jealousies among women are clichés that need examination.*

## THE SALON OF MADAME GEOFFRIN

Fernand Nozière (Ernest Weyl)

If you wish to see the place where Mme Geoffrin lived for more than sixty years, make a pilgrimage to the Rue St. Honoré and stop before No. 372. At the time of writing his valuable memoir of Mme Geoffrin, the Marquis de Ségur visited the house and found it already shorn of its old-time splendour. He noticed, not without regret, that a dealer in antiquities, M. Seligmann, occupied the first floor and had cut the large room that was once the illustrious salon in two. . . .

Madame Geoffrin's education prepared her to preside over a literary, philosophic and artistic salon. She was born in 1699 and her mother died a year later in giving birth to a son, Louis. She lost her father in 1706, when she was only seven. The two children were confided to the care of their maternal grandmother, Mme Chemineau.

The father of the little girl who will one day become Mme Geoffrin was named Pierre Rodet and he had been a valet of the wardrobe at Court. His wife, Mlle Chemineau, was of higher social position for she was the daughter of a small banker. She had a certain talent for painting, and thought seriously about developing the gifts of her daughter when the child was six weeks old. This makes me fear that Mme Pierre Rodet must have been an intellectual bore, but there is good reason to suppose her mother more sensible: she prepared her granddaughter marvellously well for the part she was one day to play, although she cannot have suspected it. Who could foresee that the daughter of a valet would receive in her salon men of letters, philosophers, painters, foreign noblemen, would correspond with the Empress of Russia, would be warmly welcomed by the sovereigns of Austria, and that the King of Poland would call her "Mamma"? To what qualities did this middle-class woman owe her extraordinary destiny? Probably to the fact that she knew how to receive intellectual men and artists, and it was for this that her grandmother instinctively prepared her when she decided that the little girl should be taught nothing. No, I exaggerate; she taught her to read. As for writing, there were copies and pothooks that she could imitate when she had leisure and the fancy seized her, but Mme Geoffrin always remained ignorant of the mysteries of spelling. Mme Chemineau

From Mabel Robinson, trans., *The Great Literary Salons*, Lectures of the Musée Carnavalet (London: Thornton Butterworth, 1930), pp. 137, 138, 139-40, 141, 142-43, 143-44, 144-45, 146, 146-47, 147-48, 149-52, 152-53, 154-55, 156-63, 163-64, 165-67, 170-71, 174-75, 175-77.

pinned her faith to natural intelligence and mother-wit.

Ignorance forces a woman who is not stupid to make great use of her brains.  She must train herself to talk dexterously about things she does not understand.  She must apply herself to guessing what her interlocutor wishes her to say.  She must learn to enter into the feelings of men and women.  When there is danger that her ignorance will be discovered, she must have wit enough to change the conversation and with a laughing answer escape the risks of a serious response.  A blue-stocking is not on her guard in this way:  she relies on her knowledge: she may be tempted to discourse on subjects with which she is familiar.  She wants to shine, esteeming this the just reward of her studies.  But to direct a literary salon successfully it is necessary that a woman be profoundly ignorant.  Thus she does not compete with her guests:  she listens to them with unfeigned attention instead of with a politeness that ill conceals her impatience to have her say; she knows that she has everything to learn.  She does not raise objections that may be untimely, or make protests:  one speaks before her in perfect security, and that is the desire of every man and every woman who aspires to live in the atmosphere of literary and artistic salons.  Thus I think that we have proved that the woman who would surround herself with the intellectual *élite* of her times must be ignorant, and we see how much Mme Geoffrin owed to the sagacious and prophetic education of her worthy Grandmother Chemineau.

But Mme Chemineau decided that this education must be religious.  She recommended pious reading, and the little girl fulfilled all her religious duties in her parish church, St. Roch. . . .  The Church had a great influence on the youthful Thérèse, for it was in St. Roch's that she attracted the attention of François Geoffrin.  She was fourteen and he was forty-eight.  An idyll.  Geoffrin had worked all his life in the mirror trade; he was not a workman but a clerk of a company in which he became head cashier, and he retained this post when the company became the Compagnie de Saint-Gobain, which to our own day is the most considerable glass manufactory of France. . . .

Geoffrin . . . devoted himself to making his [first] wife happy, and she testified to her gratitude by dying before very long, bequeathing to him all her worldly goods, including the house in the Rue St. Honoré.  Geoffrin wisely placed the money in the Compagnie de Saint-Gobain of which he thus became a director.  No doubt, by marrying a little girl of fourteen after being the husband of an old woman he thought to strike an average.  He bore so good a reputation that one cannot suspect him of perversity:  Thérèse had won his heart (as he had won his wife's heart) by her piety and her sweetness, and he said to himself that this little girl would be peaceable and docile.

Moreover, she brought him 185,000 livres to add to the 250,000 that he possessed, plus the house.  You will protest that with her dowry Thérèse could have found a younger husband.  But François Geoffrin was greatly respected in the parish.  He would be a father to her and also to her brother Louis.  The two children would be very much alone in the world should they lose their grandmother.  You must remember, too, that Thérèse was pious:  it may be that she followed the advice that Orgon gives his daughter Marianne in Tartufe:  "Mortify your senses in marriage." . . . The couple lived a quiet life, very simply in the Rue Saint Honoré.  In 1715 a daughter, Marie-Thérèse was born (she became in due course Marquise de la Ferté-Imbault.)  Two years later a son appeared, but he died when he was ten.  The grandmother Chemineau had not lived to see him, and the little Mme Geoffrin—she was eighteen—had to look after her two children and her brother Louis, a great gawk. . . .

At this juncture Mme de Tencin came to live in the Rue Saint Honoré:  she was modestly lodged near the Oratory in a house that had serious inconveniences, among them that of being below the level of the street so that when the Seine overflowed its banks one had to reach Mme de Tencin by boat.  She was still a pleasing woman.  In our day she would have been accounted young, for at the death of the Regent in 1723 she was only thirty-eight, and maturity does not seem to have disturbed the proportions of the perfect figure that she displayed so gener-ously to the admiration of that prince.  Everyone knew the manner of Mme de Tencin's life, it was she who organized for the Regent and Dubois the notorious fêtes of Saint-Cloud.  We dare not describe these orgies. . . .

One would have supposed that Mme Geoffrin could never set foot in the house of such a woman as Mme de Tencin. . . .  It is evident that against all that could be anticipated, Mme Geoffrin went to Mme de Tencin's and struck up a friendship with her. . . .  We must resign ourselves to the fact that Madame Geoffrin was an honest woman.  True, the men whom she met at Mme de Tencin's were not of those who excite a woman's imagination unduly, and though young Montesquieu had shown an extreme, almost senile, taste for licentiousness in his *Lettres persanes*, the criticism of society had been the base of this fantasy and the author soon became absorbed in such irreproachable topics as *Considerations on the Causes of the Greatness and Decay of Rome*.  With Montesquieu Mme de Tencin received Saurin, author of some philosophic tales of extreme heaviness, and Mme Geoffrin was also privileged to meet La Motte-Houdard and Fontenelle, scholars who likewise contributed a philosophic-scientific decorum to the entertainments of the Duchesse de Maine at Sceaux.  They were stricken with *Modernism* as we should say in these days. . . .

Such men as these could not stir the feelings of a young woman.  Moreover, Fontenelle was over seventy when Mme Geoffrin made his acquaintance.  She was under his influence during the thirty years that he had still to live, or rather the coldness of his logic harmonized with the reasonable mind of the charming and prudent young lady philosopher.  When she came to know Fontenelle and the rest of Madame de Tencin's friends, Mme Geoffrin was about thirty, and we may suppose her to have had the appearance immortalized by Nattier a few years later, in 1738.  It is certain that Nattier did not malign his sitters, but adorned them with mythological beauty.  However, in the case of Mme Geoffrin the features were really regular and refined and the form of the face was agreeable although very intellectual. The forehead was large and luminous, the eyes shone under their imperious arch, the nose was purely chiselled and the mouth charming.  The hands are elegant, and the body is sufficiently unveiled for us to admire the rounded shoulders, a bust such a is no more to be found in these days, and limbs harmoniously robust.  Such a woman would scarcely be admired by modern dressmakers, nor by you, ladies; she has not the modern line; but she will please men, even those of our own day, for they do not share your enthusiasm for the scarecrow type and admire female charms in woman.  Mme de Tencin's friends must have looked with interest at this young, unblemished, and wealthy visitor.  Mme de Tencin was ageing and she was not rich:  men of mind were not indifferent to little presents:  she could only offer them a length of velvet for their breeches on New Year's Day, and her table was not sumptuous.  Mme Geoffrin offered the possibility of better things and all aspired to be received in her house.

It is at this juncture that the tribulations of the worthy M. Geoffrin begin.  Mme Geoffrin's house is his house too.  Is his spouse going to fill it with writers, philosophers and scholars so heretical as to smell of burning?  The pious M. Geoffrin trembles.  No!  Perish the thought!  His door shall be shut against such miscreants.  Now and henceforward, as in the past, he will receive only honest and respectable fellow-parishioners.  But Mme Geoffrin, since she has discoursed with Mme de Tencin's friends, can no longer endure the chatter of these worthy folk.  Do you need to be told what happened? Need I tell you that M. Geoffrin gave way, for it is always the husband's part to submit?  Moreover, in this case, the husband, who is good-natured to the point of weakness, will soon be seventy, and his wife is only just turned thirty.  He gave way; but he had not yet foreseen the full extent of his misfortune. His wife was not slow to learn that to attract writers, philosophers and scholars it is well to offer succulent repasts:  a personage in Oscar Wilde's *Dorian Gray* says of a lion-huntress whose house is thronged with men of letters and artists:  "She

owes her success to her *cook*.  She hasn't a salon but a dining-
room."  Mme Geoffrin was no fool, and her modesty suggested to
her imagination that the bait of a good dinner might be attrac-
tive to thinkers and to creators of the beautiful.  It is so
even in our own times:  every woman who prides herself on
attracting men of talent takes care to feed them well.  'Tis a
method worthy of encouragement, but it has its disadvantages.
Seduced by the excellence of the food and wine, certain guests
forget to talk and disappoint the hopes of their kind hostess,
who, secretly resentful of their silence, thinks of the mag-
nificence of the menu and says to herself that it was so much
money wasted. . . .
    It was necessary to engage more servants, increase the
stock of linen, porcelain and silver.  Those blessed guests
stayed on till evening, for after the repast they were at
leisure to converse—indeed, this was the very object of the
institution.  Every week M. Geoffrin protested:  "Never again!
I will never give another ha'penny." . . . M. Geoffrin's mis-
fortunes did not prevent him living to the age of eighty-four.
He died at the end of 1749, and soon afterwards a guest who had
returned from a journey enquired what had become of the old
gentleman he had always seen at the table and who never said
anything.
    "It was my husband," said Mme Geoffrin.  "He is dead."
    I have a great weakness for M. Geoffrin.  It is difficult
to be the husband of a brilliant woman:  he felt this, and
after having vainly tried to keep Mme Geoffrin in the shade
with him, he resigned himself to obscurity and silence.  Per-
haps he said to himself that Mme Geoffrin was as ignorant of
all the subjects of those long conversations as he was, and
yet that did not prevent her from treating them with authority.
When he compared the ignorance of his spouse with the admira-
tion she inspired, he may, perchance, have tasted a serenely
magnificent enjoyment.  It is not easy to be the Queen's hus-
band.  M. Geoffrin played the part with gentle resignation.
Let us honour his memory!
    The real master of the house was Fontenelle.  He had
become very deaf, an infirmity that may sometimes seem envi-
able to those who have let themselves be decoyed into certain
literary circles.  He had the help of his ear-trumpet which
he used only when the conversation seemed to him worthy of
interest—a thing he divined from the expressions of the faces
or the quality of the talkers. . . .
    . . . Mme Geoffrin lived prudently.  She was always very
disinterested in money matters, and we like her for having
refused the fortune which Mairan bequeathed to her.  But then
she was very rich:  she did not spend her income which the
Marquis de Ségur has estimated at 150,000 livres.  She was
always orderly and energetic.  Most of her fortune was invested

in the glass manufactory of Saint-Gobain.  At one time the
business was in a bad way, and Mme Geoffrin, who was a director,
pointed out which member of the staff would have ability to pull
the business round.  Her surmise was correct:  prosperity was
restored, and it was Mme Geoffrin who roused the other members
of the board and compelled them to reward the man according to
his deserts.  She had plenty of sense, and understood that
there must be no cheese-paring economies on the salaries of
those from whom a maximum output is demanded.

     She applied the same principle to her dealings with
artists whom she attached to her by paying a good price for
their pictures, statues, writings.  The originality of her
salon was that she received painters, sculptors and engravers
as well as men of letters, an innovation for which she appears
to have awaited the death of M. Geoffrin.  By thus enlarging
her circle she outran Mme de Tencin, who had set her the exam-
ple and who, like M. Geoffrin, died in 1749.  At this time Mme
Geoffrin was fifty.  The Wednesday dinners were supplemented
by Monday dinners, which she begged M. de Caylus, artist and
archæologist to organize for her.  The influence of M. de Caylus
and of his friends on the fine arts was deplorable, for to it we
owe that imitation of antiquity which weighed so heavily on the
end of the eighteenth and the beginning of the nineteenth cen-
tury.  Their clique was not exclusively responsible for this
infatuation, for the discovery of Herculaneum in 1711 had
roused an interest that became an infatuation after the excava-
tion of Pompeii in 1755.  Vien, who was the master of David,
worked for Mme Geoffrin, and so did Boucher, La Tour, Joseph
Vernet, Lagrenée, Drouais, Carl Van Loo, Greuze, Oudry,
Leprince, Hubert Robert.  Not a bad list!  Between 1750 and 1770
she had more than sixty pictures painted for her.  She took
pleasure, too, in collecting knick-knacks and (like all women)
in discovering antiques and curiosities, which she bought cheap.
This is a quality possessed by every woman of the world worthy
of the name!  With her caressing hand she knows how to appraise
old wood and antique copper.  She is not of those who can be
taken in, and Mme Geoffrin certainly would not have missed the
bargains to be picked up in marine stores and *flea fair* had
those treasuregrounds existed in her day; but in addition to
antiques she gave employment to contemporary artists, who have
the right to live, since some day their works, faded, dis-
coloured, worm-eaten and cracked will become antiques.  After
the death of Van Loo, she bought for 4,000 livres two of his
pictures, for which a Russian prince soon afterwards offered her
50,000 livres.  She accepted, but sent the difference of price
to the widow of the artist, an anecdote proving that she did
not try to make money when she bought paintings and resold them.
She had them painted for the pleasure of looking at them, and
she suggested the subject and the size because she wished to
adorn this or that room in her house.

Her authority was sometimes exasperating.  Boucher flatly
refused to follow her instructions in the matter of a scene
from the life of Scipio.  Greuze could not bear her reflections,
and threatened to paint her as a school mistress, rod in hand,
to frighten all children present and to come.  She *was* rather
a prig—it is the besetting sin of ladies who have a literary
salon.  In the beginning, they are diffident:  little by little
they grow bolder, till, encouraged by friendly or interested
praise they come, in all good faith, to believe themselves the
intellectual equals of the artists and men of letters who sur-
round them.  They even suppose themselves the superiors of the
creatures who, through politeness, are weak enough to submit
their works to them.  Thus they become the school-marm, claim-
ing the right to be the teacher who corrects.  Sometimes—most
comical of all—they consider themselves to be muses.

It must be difficult to resist this intoxication.  Just
think of this daughter of the Court manservant Rodet.  Not
only does she receive authors, philosophers, and artists in her
house of the Rue Saint Honoré, but every distinguished foreigner
wishes to be presented to her and to contemplate in her circle
the intellectual lights of France.  Ambassadors who represent
their country at Paris learn lessons in her drawing-room and
gather information that they are glad to pass on to their sove-
reigns.  They present to Mme Geoffrin the best among their
compatriots who pass through Paris, and these, in their turn,
venture to introduce their family and friends.  The fame of
Mme Geoffrin soon becomes world-wide.  She is obliged to take
note of all these foreigners whom she receives and whom she
classes according to their country.  She must keep some reminder
of them lest they should return or should send some introduction.
And there is a crowd!  Mme Geoffrin must have acquired a royal
memory—which is to be able to refer quickly to notes that are
carefully indexed.  In 1758 Prince Cantémir, the Russian Ambas-
sador to France, presented the Princess of Anhalt-Zerbst, who
had just arrived in Paris.  Mme Geoffrin delighted the princess,
who talked to her new friend about her wonderful daughter, the
grand-duchess, she who was afterwards Catherine the Great.  We
have often seen Catherine on our stage and on our films of
late years; Mr. Bernard Shaw has given us a powerful caricature
of her; and M. Marcel Achard, in his adaptation of M. Dupuy-
Mazuel—*The Chess Player*—sketches her impressively.  She
seized the reins of government in conditions that alarmed public
opinion.  Those who read her correspondence in French with her
mother's friend, Mme Geoffrin, will see in the first place that
she is not a savage and also that she is mistress of their
tongue.  They will see, too, that she has not the prejudice of
caste, that she is liberal-minded.  How can anyone suspect of
crimes a woman who knew how to write such pretty letters?  How
suspect of tyranny one who banishes all ceremonial between

herself and Mme Geoffrin?  For several years letters were ex-
changed regularly between Catherine the Great and Mme Geoffrin,
and if at times the correspondence languishes, it is because
Mme Geoffrin delays her answer.

Mme Geoffrin has no longer the aspect of the mythological
divinity portrayed by Boucher.  She is a sexagenarian whose
portrait Chardin has painted:  a woman who does not try to
hide her age, who dresses simply in sombre colours, whose eye
keeps an intelligent glance and her mouth a quizzical expression.
Look at her well.  A woman sure of herself, perfectly conscious
of her value, who would with serenity give advice to all young
women, even to Catherine the Great.  She does not fail to do
so, and the sovereign, with extreme nicety lets her feel her
mistake.

She had not time to blunder with the King of Sweden,
Gustavus III, whose sojourn in Paris was brief, and who kept
an agreeable remembrance of the Rue Saint Honoré; but she
seems at times to have gone too far, as in the case of Hume,
the philosopher, when he was secretary at the British Embassy.
Hume, no doubt, would have been wiser had he abstained from
flirting with the fair.  Still, we feel a certain shock in
reading the notes in which Mme Geoffrin addresses him as *dear
rascal* or *old scamp*.  Hume, on his return to London, presented
Franklin to her, but the American did not speak French and made
no impression on Mme Geoffrin.  Horace Walpole, too, was intro-
duced by Hume, but he soon showed himself hostile to Mme
Geoffrin, in whom he had vaguely perceived from the first a
spice of absurdity.  But she almost lost her head when Stanislas-
Augustus Poniatowski became King of Poland, for she had been his
guide in Paris and paid his debts when he was a lad of nineteen,
and he called her "Maman." . . . After having carefully prepared
her expedition and had her travelling carriage built for her, we
find her rolling towards Warsaw at the age of sixty-seven.  She
did not pass through Berlin as Grimm advised, for she considered
Frederick a poor creature and maintained that in fifty years his
existence would be forgotten.  Such was the perspicacity of her
judgment.  She would go through Vienna, and there she was very
well received, and presented to the Empress.  The grace of the
little Archduchess Marie Antoinette impressed her, and she
greatly wished that she could see her in France.  As we know,
this hope was realized; but Mme Geoffrin cannot be felicitated
on her foresight. . . .

Shortly before her visit to Poland, Mme Geoffrin had begun
to interest herself in Mlle de Lespinasse.  She felt esteem,
sympathy and admiration for this woman who possessed such a rare
and sensitive intelligence, and she was glad to give this proof
of friendship to d'Alembert, who, as we know, was much attached
to Mlle de Lespinasse and who had pleaded to Mme Geoffrin in her
favour.  But, above all, she was delighted to annoy Mme du Deffand,

who had always despised her salon.  Women who patronize artists
and authors are usually separated from one another by hatred
and jealousies, and to come to the rescue of the companion whom
Mme du Deffand had just turned out of her house, to afford the
young lady the means of receiving the friends of the Marquise,
was an undreamed-of delight to Mme Geoffrin.  She gave Mlle de
Lespinasse the wherewithal to furnish prettily the flat she had
found in the Rue Saint-Dominique, and before long d'Alembert
installed himself in the floor above her.  Mlle de Lespinasse
received a yearly pension of three thousand livres from Mme
Geoffrin, who also pensioned d'Alembert; but no one knew of
these liberalities until her papers were examined after her
death.

Mlle de Lespinasse's salon has been defined as the labora-
tory of the Encyclopædia.  As she was free to take all her
friends to Mme Geoffrin's, it followed that the older woman,
too, received the Encyclopædists.  She had not waited to know
Mlle de Lespinasse before interesting herself in the publica-
tion that let loose the ire of the religious party, for it was
she who had provided funds the first time that the publication
was suspended when d'Alembert retired from it leaving everything
to the charge of Diderot.  Mme Geoffrin had never admitted
Diderot to her salon because of his queer manners:  his habit
of button-holing his interlocutor and his wild gestures.  It was
said that Catherine the Great was covered with bruises at the
close of the conversation she had granted him, and he would have
been a formidable guest at the Wednesday dinners.  However, Mme
Geoffrin gave him a charming surprise:  having ventured into
the dwelling of the great man and found it miserably poor she
had it transformed, furnished and hung with pictures in his
absence.  We cannot too highly recommend Mme Geoffrin's methods
to ladies who admire philosophy and letters.

After the journey to Poland, Mlle de Lespinasse filled a
great place in the house.  She was admitted to both the Monday
and the Wednesday dinners.  This was a complete revolution, for
never before had a woman guest partaken of those dinners, and
never after was any other woman invited.  It is a fashion that
the hostesses of literary, artistic, philosophic and financial
Salons have a tendency to preserve.  They assemble men only
round their table, each hostess believing, doubtless, that she
alone among women can appreciate brilliant and profound intel-
ligence and that, by inviting other women she would lower the
level of the conversation.  I do not approve the reasoning:
only women can show such a contempt for women. . . .

. . . Mme Geoffrin always imposed on her guests the tone
of the best society.  She knew how to stop conversations that
wandered on dangerous ground.

She distrusted politics too:  or, rather, she had a horror
of them.  Energetically did she resist that folly of the age.

She would not allow political discussion in her house, and
Raynal, Turgot, Marmomtel and Morellet had to postpone their
debate to the hour when they left her and could chatter freely
in the Tuileries.  In January, 1770, Grimm protests gaily that
Mme Geoffrin forbids all her devotees every subject of conver-
sation.  His comical enumeration seems to foretell the mono-
logue of Figaro.

    In 1772, the last volume of the Encyclopædia was pub-
lished, and there must have been great rejoicing in the house
of the Rue Saint Honoré, where d'Alembert and Mlle de Lespinasse
reigned.  But part of the house was occupied by Mme Geoffrin's
daughter, the Marquise de la Ferté-Imbault, and she was an
adversary of the Encyclopædists and gathered their sworn enemies
about her.  There was never any open quarrel but a long hostility
between the mother and daughter.  Mme Geoffrin was only sixteen
years the elder, and for a long time she looked younger than her
daughter. . . .

    . . . [In 1776 Mme Geoffrin] took a chill in the cold
church of Notre Dame and was impotent thenceforth.  It was
natural that her daughter should watch by her bedside and
natural, too, that she should try to keep d'Alembert and his
free-thinking friends out of the sick-room.  On the day that
the sacraments were administered she closed the house door
against them all, and when d'Alembert said that he would never
desert Mme Geoffrin she did not allow him to cross the threshold.
That was a scandal, and of course the Encyclopædia supported
d'Alembert and denounced Mme de la Ferté-Imbault.  After a time,
Mme Geoffrin recovered her lucidity.  Did she ask to see her
friends the philosophers?  Mme de Ferté-Imbault asserts that her
mother approved all the measures she had taken.  We are willing
to believe her, still we know on her own evidence that the
invalid wished to see a brilliant society in her room and that,
as her sight had failed, her daughter contrived to make the
footmen and maid-servants move about the room so as to give the
effect of a social gathering.  We cannot help thinking that
Mme Geoffrin would have liked to see and hear her friends, but
at all events she had the consolation of receiving the visit
of the Emperor of Austria who was staying in Paris and spent
two hours with her. . . .

    . . . Mme Geoffrin died on October 6th, 1777.  The
Sovereigns with whom she had been in correspondence expressed
their sympathy and the Philosophers wrote her praise.  But she
was soon forgotten; and, doubtless, she left the most cherished
remembrance with the Abbé Galiani who so loved her salon that
he said that he merely existed since he had been obliged to
return to Naples.  He it was who had written to her:  "I have
lost Paris and all my teeth.  For that matter, I no longer need
to talk:  here no one understands me and no one is inclined to
listen to me."

Certainly she possessed the art of making her guests shine.
The Abbé de Saint Pierre, surprised at his success in her salon,
said that he was merely an instrument that she could play.
What a resource for a talker to be animated by such a woman!

I have tried to make her a little known to you.   Thanks
to Hubert Robert, we have surprised her at her hearth:   at
chocolate-time, and at the moment when the artist, all-a-tremble,
submits one of his paintings to her.   You can look at the perfume
burner executed for her by Guathière and called by her "a little
monument of antique ivory, marble and ormolu."   You know the
dinner-service offered by the Empress Marie Thérèse.   We can con-
jure up the table laid with Mlle de Lespinasse, d'Alembert, the
Encyclopædists and the painters gathered round it, for we are
miraculously transported into the house in the Rue Saint Honoré.
You have seen, too, the account-books in which she set down her
expenses, the addresses of good trades people and the visits
she ought to make.   Her life was very full.   She had to keep up
a huge correspondence and to organize two large dinner parties
every week, so she rose at five, and no chambermaid entered her
room before she was washed and dressed.   You say to yourselves
that she must have consecrated long hours to reading.   Let me
undeceive you:   she read very little.   She was not fond of books!
She seems to have had only a very few in her house—and those
were mediocre!   This last trait completes the portrait of Mme
Geoffrin who loved authors so efficiently and so well.

## C. WOMAN'S PLACE IN ROMANTICISM

*The Enlightenment, with its emphasis on "natural science,"
carried within itself the reactionary seeds of romanticism.
Jean Jacques Rousseau (1712-78), the arch-romanticist, advocated
a total overthrow of civilization and a return to a state of
nature.   Voltaire was horrified by Rousseau's enthusiasms and
wrote to him: "Never has anyone employed so much genius to
make us into beasts.   When one reads your book, one is seized
at once with a desire to go down on all fours."*

*In the selections from Émile (1762) reprinted below,
Rousseau prized the complementary nature of the contrast between
the natural woman and the natural man.   He felt that the differ-
ences should be emphasized, because the natural woman had much
to offer.   Moreover, she was "especially constituted to please
man."   Rousseau's woman is a practical creature who should con-
centrate on practical efforts and leave reasoning to the genius
of man.*

*Mary Wollstonecraft took Rousseau to task as early as 1792
in* A Vindication of the Rights of Woman. *She considered him a
writer who rendered women as objects of pity bordering on*

*contempt. Almost two hundred years ago Mary Wollstonecraft
attacked the practice whereby young girls were given dolls
rather than schoolbooks to challenge their intellect. This
practice was endorsed by Rousseau as preparing girls to become
contented mothers, happy to serve their husbands and children.
In one of her more trenchant passages, Mary Wollstonecraft
wrote: "How could Rousseau dare to assert, after giving [his]
advice, that in the grand end of existence, the object of both
sexes should be the same, when he well knew that the mind,
formed by its pursuits, is expanded by great views swallowing
up little ones, or that it becomes itself little?"[1]*

## ÉMILE

### Jean Jacques Rousseau

. . . A perfect man and a perfect woman ought no more to
resemble each other in mind than in features; and perfection
is not susceptible of greater and less.

In the union of the sexes each contributes equally toward
the common end, but not in the same way. Hence arises the
first assignable difference among their moral relations. One
must be active and strong, the other passive and weak. One
must needs have power and will, while it suffices that the
other have little power of resistance.

This principle once established, it follows that woman is
especially constituted to please man. If man ought to please
her in turn, the necessity for it is less direct. His merit
lies in his power; he pleases simply because he is strong. I
grant that this is not the law of love, but it is the law of
Nature, which is anterior even to love.

Plato, in his Republic, enjoins the same exercises on
women as upon men, and in this I think he was right. Having
excluded private families from his ideal state, and not knowing
what to do with the women, he sees himself compelled to make
men of them. This great genius had arranged everything, fore-
seen everything, and had anticipated objections which perhaps
no one would have thought of making; but he has poorly resolved

---

[1]Mary Wollstonecraft, *A Vindication of the Rights of Woman*
(New York: W. W. Norton, 1967), p. 138.

W. H. Payne, ed., *Rousseau's Émile* (New York: D. Appleton
and Co., 1895), pp. 260-63, 281, 303.

one which has been raised against him.  I do not speak of that
ordained community of wives, the censure of which, so often
repeated, proves that those who make it have never read him;
but I speak of that civil intermingling which everywhere con-
founds the two sexes in the same employments, the same duties,
and can not fail to engender the most intolerable abuses; I
speak of that subversion of the sweetest feelings of nature,
sacrificed to an artificial feeling which can not exist save
through them.  Just as though a natural power were not neces-
sary in order to form conventional ties!  As though the love we
have for our neighbors were not the basis of that which we owe
the state!  As though it were not through the little community,
which is the family, that the heart becomes attached to the
great!  And as though it were not the good son, the good hus-
band, and the good father, who makes the good citizen!

The moment it is demonstrated that man and woman are not
and ought not to be constituted in the same way, either in
character or in constitution, it follows that they ought not
to have the same education.  In following the directions of
Nature they ought to act in concert, but they ought not to do
the same things; their duties have a common end, but the duties
themselves are different, and consequently the tastes which
direct them.  After having tried to form the natural man, let
us also see, in order not to leave our work incomplete, how
the woman is to be formed who is befitting to this man.

Would you always be well guided?  Always follow the
indications of Nature.  All that characterizes sex ought to
be respected or established by her.  You are always saying that
women have faults which you have not.  Your pride deceives you.
They would be faults in you, but they are virtues in them; and
everything would not go so well if they did not have them.
Prevent these so-called faults from degenerating, but beware
of destroying them.

All the faculties common to the two sexes are not equally
divided, but, taken as a whole, they offset one another.  Woman
is worth more as a woman, but less as a man; wherever she im-
proves her rights she has the advantage, and wherever she
attempts to usurp ours she remains inferior to us.  Only excep-
tional cases can be urged against this general truth—the usual
mode of argument adopted by the gallant partisans of the fair
sex.

To cultivate in women the qualities of the men and to
neglect those which are their own is, then, obviously to work
to their detriment.  The shrewd among them see this too
clearly to be the dupes of it.  In trying to usurp our advan-
tages they do not abandon their own  but from this it comes to
pass that, not being able to manage both properly on account
of their incompatibility, they fall short of their own possi-
bilities without attaining to ours, and thus lose the half of

their value.  Believe me, judicious mother, do not make of
your daughter a good man, as though to give the lie to Nature,
but make of her a good woman, and you may be sure that she will
be worth more for herself and for us.

Does it follow that she ought to be brought up in com-
plete ignorance, and restricted solely to the duties of the
household?  Shall man make a servant of his companion?  Shall
he deprive himself of the greatest charm of society?  The
better to reduce her to servitude, shall he prevent her from
feeling anything or knowing anything?  Shall he make of her a
real automaton?  No, doubtless.  Nature, who gives to women a
mind so agreeable and so acute, has not so ordered.  On the
contrary, she would have them think, and judge, and love, and
know, and cultivate their mind as they do their form:  these
are the arms which she gives them for supplementing the
strength which they lack, and for directing our own.  They
ought to learn multitudes of things, but only those which it
becomes them to know.  Whether I consider the particular des-
tination of woman, or observe her inclinations, or take account
of her duties, everything concurs equally to indicate to me the
form of education which befits her.

On the good constitution of mothers depends, in the first
place, that of children; on the care of women depends the
early education of men; and on women, again, depend their
manners, their passions, their tastes, their pleasures, and
even their happiness.  Thus the whole education of women ought
to be relative to men.  To please them, to be useful to them,
to make themselves loved and honored by them, to educate them
when young, to care for them when grown, to counsel them, to
console them, and to make life agreeable and sweet to them—
these are the duties of women at all times, and what should be
taught them from their infancy.  So long as we do not ascend
to this principle we shall miss the goal, and all the precepts
which we give them will accomplish nothing either for their
happiness or for our own. . . .

The search for abstract and speculative truths, principles,
and scientific axioms, whatever tends to generalize ideas, does
not fall within the compass of women; all their studies ought to
have reference to the practical; it is for them to make the
application of the principles which man has discovered, and to
make the observations which lead man to the establishment of
principles.  All the reflections of women which are not immedi-
ately connected with their duties ought to be directed to the
study of men and to that pleasure-giving knowledge which has only
taste for its object; for as to works of genius, they are out of
their reach, nor have they sufficient accuracy and attention to
succeed in the exact sciences; and as to the physical sciences,
they fall to that one of the two which is the most active, the
most stirring, which sees the most objects, which has the most

strength, and which exercises it most in judging of the rela-
tions of sensible beings and of the laws of nature.  Woman, who
is weak, and who sees nothing external, appreciates and judges
the motive powers which she can set to work to offset her weak-
ness, and these motive powers are the passions of man.  What-
ever her sex can not do for itself, and which is necessary or
agreeable to her, she must have the art of making us desire.
She must therefore make a profound study of the mind of man,
not the mind of man in general, through abstraction, but the
mind of the men who surround her, the mind of the men to whom
she is subject, either by law or by opinion.  She must learn to
penetrate their feelings through their conversation, their
actions, their looks, and their gestures.  Through her conver-
sations, her actions, her looks, and her gestures she must
know how to give them the feelings which are pleasing to her,
without even seeming to think of them. . . .
     . . . A woman of wit is the scourge of her husband, her
children, her friends, her servants, of everybody.  In the
sublime elevation of her fine genius she disdains all the duties
of woman, and always begins by making a man of herself, after
the example of Mademoiselle de l'Enclos.  Away from home she is
always the subject of ridicule, and is very justly criticised,
as one never fails of being the moment she leaves her proper
station and enters one for which she is not adapted.  All this
pretense is unworthy of an honorable woman.  Were she the
possessor of real talents, her pretension would abase them.
Her dignity is in leading a retired life; her glory is in the
esteem of her husband; her pleasures are in the happiness of
her family.  Readers, I appeal to you on your honor—which
gives you the better opinion of a woman as you enter her room,
which makes you approach her with the greater respect:  to see
her occupied with the duties of her sex, with her household
cares, the garments of her children lying around her; or, to
find her writing verses on her dressing-table, surrounded with
all sorts of pamphlets and sheets of notepaper in every variety
of color?  If all the men in the world were sensible, every girl
of letters would remain unmarried all her life.

## D.  WORKING WOMEN IN THE FRENCH REVOLUTION

*While Madame de Staël, the greatest French woman writer of
the eighteenth century, complained that since the Revolution men
had reduced literary or intellectual women "to the most absurd
mediocrity,"[1] the urban women of the working and lower middle*

---

[1]*On Politics, Literature, and National Character*, trans. and
ed. by Monroe Berger (New York:  Doubleday and Co., 1964), p. 235.

*class suffered their own particular anguish.  These women found*
*that far from enhancing their liberty, the Revolution robbed*
*them of their livelihood, of food for their children, and of*
*the company of their husbands.*
    *The article by historian Olwen Hufton excerpted below*
*shows how the urban working women of revolutionary France*
*handled themselves in this time of crisis.  It also offers*
*insight into the reasons why women are active during riots,*
*a recurring feature that has been noted by historians.*

## WOMEN IN REVOLUTION 1789-1796

### Olwen Hufton

    . . . This short study is an attempt to begin to redress
something of the balance by isolating a type of woman on whom
information abounds, the working woman of the towns; the sort
of woman the *sans culotte* most likely went home to, the sort of
girl the married soldier at the front most probably left behind;
the woman of the bread riots, of the revolutionary crowds, the
"mother heroine" figure of the *fêtes nationales*, carrying her
banner with the proud device, *"J'ai donné un (deux, trois,*
*quatre, cinq, six) citoyen(s) à la République"* (I have given a
citizen to the Republic) and ultimately the worn-out, disillu-
sioned, starving hag who sank to her knees in the Year III to
demand pardon of an offended Christ.
    To appreciate the nearness of women to the Revolution one
must understand their rôle in the family economy, an apprecia-
tion crucial to our theme.  One must start with the recognition
that the family economy of the working classes, whether in town
or country, was their natural economy:  the family needed the
work of each of its component members to support the whole.
Hence, in a rural context, the man who had sufficient land to
provide for the wants of his family had sufficient to employ
that family.  In the event of his not having enough, he or his
family or both must seek an alternative source of income.  In
the case of the towns this was doubly true, for nowhere could

    Olwen Hufton, "Women in Revolution 1789-1796," *Past and*
*Present*, November, 1971, pp. 90-94, 95, 96-98, 99-104, 105-8.
World copyright:  The Past and Present Society, Corpus Christi
College, Oxford, England.  This article is reprinted with the
permission of the Society and the author from *Past and Present*,
a journal of historical studies, No. 53.

the wage-earner, unless he practised some highly specialized
craft, expect to earn more than he needed for his own per-
sonal maintenance, the rent of a shelter and possibly the up-
keep of one child—a fact which the *Comité de Mendicité* spelt
out in 1790 for all who cared to read its debates.  Once this
has been recognized, then the importance of the earning capa-
city, the labour and the sheer ingenuity of women and chil-
dren becomes readily apparent.  They were expected by their
efforts to make a contribution and an important one to the
family economy.  Female labour can be easily categorized:
for the unmarried, domestic service where payment was largely
in the form of food and shelter but where a girl might raise
enough to purchase the sheets and household linen which com-
monly constituted the dowry of the working girl; for the mar-
ried, domestic industry in the form of spinning wool and
cotton and the manufacture of lace.  The last employed the
largest numbers at least in Northern and Central France and
in the country as well as town.  The value of lace lay almost
entirely in the handiwork, for the quantity of linen or silk
thread involved was slight and no expensive equipment was
needed.  Highly dependent upon the dictates of fashion, a
luxury industry with an aristocratic and an international
clientèle, it was on the eve of the Revolution, the most
flourishing female industry in France even if the lacemaker
only received a pittance for labours which would ultimately
take her sight.  In towns, women made up the bulk of the gar-
ment trades—seamstresses, milliners, corset-makers, embroider-
ers, ribbon-makers, glove-makers and so on—and lastly, in any
community, poor women, the lowest cipher on the employment
market, performed the heavy and distasteful tasks such as load
carrying.  Nothing was too menial.  They carried soil, heavy
vegetables to and from market, water, wood—anything.  In the
large cities, they found employment as rag sorters, cinder
sifters, refuse collectors, assistants to masons and bricklayers
—one can so easily multiply the examples.  Where work could
not support the family, then the mother had to have recourse to
ingenuity.  She taught her children how and where to beg or
hired them out for a minor fee to other women who wanted to
elicit pity at markets and fairs by the appearance of a large
family or trailed her infants round from door to door with long
and pathetic stories.  She had a whole legacy of mendacity to
to bestow if nothing else:  the children of Rodez, Richeprey,
Necker's emissary in the Rouergue declared, are taught indi-
vidual hard-luck stories by their mothers to impose on the
passer-by to demonstrate a special claim to assistance.  In the
salt court of Laval alone, 2,000 women, mothers of families, were
brought to trial annually for petty salt smuggling between Brit-
tany, an area of free salt, and the Maine, against a mere 150 of
the opposite sex.  The importance of the mother within the family

economy was immense; her death or incapacity could cause a family
to cross the narrow but extremely meaningful barrier between
poverty and destitution.

A contemporary feminist, Madame de Coicy, concerned to draw
the attention of middle-class and aristocratic women to their
subservient position in the household, emphasized the equality
achieved within the working class home of the mother of the
family because of her important participation in the family
economy.  Indeed one might, considering the importance of her
rôle, go further than Madame de Coicy, and claim for her social
supremacy within the limited context of the family.  Restif in
*La vie de mon père* has painted a patriarchal society but it is
comfortable landowning society which is thus depicted.  In its
lower echelons society was far from being so.  The strains
involved in keeping a family together were immense.  Poverty is
an acid:  it corrodes or dissolves human relationships.  But it
was easier for a father to opt out than for a mother to do so—
easier for him to return home via the *cabaret* suitably anesthe-
sized with cheap alcohol to the squalor of home and hungry
children and easier for him as well to clear off altogether, to
turn temporary migration into permanent disappearance, or in
the words of the Curé d'Athis, "They lose heart:  they weary of
the strain of keeping a family on a wage barely adequate for
one person and having done so they gather their few remaining
garments into a bundle and hit the road, never to be seen again
by their families."  The divorce lists of the Year II confirm
just this factor:  in Metz, for example, 268 working women
sought divorce, the grounds, separation, the duration of that
separation commonly nine or five years, coinciding perfectly
with the strains of dearth in 1785 and 1789.  The results of the
inquiry conducted by the bishops into the state of their dioceses
in 1740 and 1770-4 are no less explicit:  I am overwhelmed, wrote
the *curé* of Bort, near Clermont, with women who come to me not
only beseeching bread but accusing their husbands of threatening
them that if they do not let the youngest children perish they
will leave them and that alone they can manage but that even
working all day they cannot feed their families; while a *curé*
of Tours described a hierarchy of hunger in which he referred
not merely to rich and poor.  Women, he said, are not the first
to die but they feel the pangs of hunger first because they
deprive themselves to feed husband and children, and he made
the inevitable and lengthy comparison with the pious pelican of
the *adoro te* who gave her blood to feed her young.  This is not
to say that women did not drink, thieve, lie, prostitute them-
selves, indulge in every criminal practice one can think of, but
that in general they clung more devotedly to their families and
that this was widely recognized.

Indeed in time of dearth the importance of the mother with-
in the family grew beyond measure.  It was not merely that her

deviousness, her relationship with baker, pawnbroker and priest
became more important than before—there was no laicized parish
rate as in Protestant countries and the poor had to depend on
the voluntary alms of the faithful administered by the *curé*—nor
just her assiduity in rooting out what food there was but that
when all else failed it was she who had the right to spill over
into riot, not the father of the family. . . .

The bread riots of the French Revolution then, whether the
march to Versailles on 5-6 October 1789 or, to a less extent,
the *journées* of Germinal and Prairial of Year III were *par
excellence* women's days.  Where bread was concerned this was
their province:  a bread riot without women is an inherent
contradiction.  How much they understood of the political impli-
cations is more open to speculation.  Between October 1789 and
Germinal Year III a lot happened to them however which was
strongly to influence what ensued.  It is their revolutionary
experience in so far as it can be examined collectively that
must now be outlined.  Where did the Revolution impinge on the
family economy of the poor:  how did it alter the often deli-
cate balance between poverty and destitution:  and how far did
these issues affect the attitude of women to Revolution? . . .

. . . If a veil of ignorance as yet persists here, one
can state more categorically the almost uniform drying up of
luxury industries, many of them the preserve of women—partly
due to the emigration of a wealthy clientèle, partly to the
suspension of international trade and partly to the emergence of
much more austere fashion.  The lace industry, for example,
depended on fichus, cravats, ruffles, petticoat edging, the
paraphernalia of a girl on a swing in a *fête galante*.  The econ-
omy of the working population of Le Puy, Chaise Dieu in the
Massif, innumerable Norman towns and several in Flanders simply
collapsed:  hence the Norman and Velay lace riots of the Year
II.  Velvet, silk brocade, ribbons, embroideries—all these
ceased to command a clientèle.  In the classical gown alone is
succinctly expressed the decline of at least five industries.
Straight, austere, untrimmed by lace or ribbon, made of lawn,
cambric or wool over a straight shift, it hid the waist and
even put the stay maker out of business.

The second categorical statement that can be made is that
ultimately when dearth and disease came in 1794 all the poor
were to be affected by the total failure of French Revolution-
ary legislation on poor relief.

This legislation was to be the culmination of the enlight-
enment, the creation of a social utopia in which the poor were
to be legislated away.  Reduced to its simplest what was aimed
at was:  the assumption of the property of the *hospices* which
catered for the old, the sick and the orphaned as *biens
nationaux* and the direction and financing of them by the state;
the total abolition of almsgiving, and *bureaux de charité* and

the creation instead of work projects to employ the able-bodied poor at wage rates slightly below those current in the particular locality, that is work for the unemployed adult male; lastly, an annual subvention to the fathers of large families based on the numbers and age of the children. On paper it was at the time unparalleled in the history of philanthropy but those who drew it up neither had an idea of the numbers or kinds of people involved—they imagined a problem of unemployment, not a problem of the living wage; nor had they any conception of the value of the property of the *hospices*—they imagined it was huge and that just as the property of the church would allow the financing of the constitutional clergy so the assumption of hospital property would go a good way to financing both the new *hospices* and the work projects. Two years were spent in compiling some sort of reliable figures but when this was realized, it became apparent that the issue was not mainly unemployment but the subvention of the huge numbers of women and children, figures so immense that the *comité* saw that it did not have the means to cope. Even before the war came to reduce government finances to havoc, the government tacitly admitted failure in this respect. The net result was that the traditional methods of according relief were destroyed without any substitute. Moreover, in its need to raise money in 1795 the government assumed the property of the *hospices,* and the hospitals were made totally dependent upon the state just at the time when the war was demanding every penny the government could muster; many, especially in small towns, were simply obliged to close and that on the eve of the epidemics which chronic malnutrition inevitably brings in its wake. The frail safety valves of a society facing dearth were taken out. . . .

In 1792 [the working woman] emerges in anger at the interruption of supplies, particularly milk, which the country failed to deliver to the town, and increasingly her voice is heard as the protagonist of price fixation. From mid-1792 local attempts were made to stabilize prices and in Lyons and the large cities of the east, Besançon, Chalons, Vesoul, the impetus came from the local *club des femmes* whose recruitment expanded in the course of that year and changed rapidly in character from the rather precious early women's associations. Until they were forcibly closed by the Convention about a fortnight after the elimination of the Hébertistes, this was the common platform of the *clubs des femmes* and "any other business" was confined to the war effort. Indeed it is with the war in the spring of 1792 that one really gets an indication that women had come to have an emotional investment in the Revolution and an intense one at that. Something of this investment is reflected in the tons of household linen—often the main assets of a working class family, the woman's dowry intended to last for life—which were sacrificed as bandages for the wounded. Chalons gathered

together 20,000 pounds of sheets for this purpose; Bergerac
in the Dordogne ran a close second and when the deputy of
the area asked the Convention for a public expression of thanks
he was told that instances of such patriotism were too common
for special mention. Women of Pontarlier, a frontier town, con-
tributed their wedding rings—the most pawnable piece of property
any woman had—to clothe volunteers; in Besançon street walkers
and women who had toiled all day turned up when they had put
their children to bed to knit stockings for the soldiers at the
front. In the summer of 1792 when war fever ran high, innumer-
able addresses were drawn up and sent to the Assembly wherein
women stressed their patriotism and swore to feed their children
the right sort of milk: the milk of "bons principes, amour de
la constitution, haine des tyrans" ("good principles, love of
the constitution, hatred of tyrants"), or more specifically hat-
red of the Austrians, and the Piedmontese, milk of liberty and
equality, or the uncompromising mixture on which the mothers of
Clermont swore to nourish their young "un lait incorruptible et
que nous clarifions à cet effet avec l'esprit naturel et agré-
able de la liberté" ("a milk we shall purify with the natural,
sweet spirit of liberty"). Moreover and much more significantly,
they undertook personally to conduct the internal war while
their husbands and sons went to the front: the war against
traitors at home and not only actual traitors but potential ones,
the children of traitors. On the outbreak of war against Austria
the women of Lons le Saulnier, Mâcon and the Côte armed them-
selves with pitchforks and pans and declared they would defend
their homes and children in the absence of their men, and if
their men were defeated (the Legislative took exception to the
implication) then they would make a last stand. The women of
the district of Tarbes in the summer of 1792 armed themselves
with kitchen knives and their children with ladles and set out
to meet the Spanish. The women of Port en Bessin erected
coastal defences lest the English should take them unawares.
As early anticipated victory turned into early defeat, antipathy
turned more and more against those suspected of internal con-
spiracy. There is little to equal in hatred and vindictiveness
the venom poured out by women on fleeing priests and the rela-
tions of *émigrés*. September 1793 saw a spate of professions and
declarations, a popular theme "Comment peupler la terre avec
d'autant de Marats" ("how to people the country with so many
Marats") wherein women volunteered to breed little spies who
would report on their playmates who were not being brought up on
principles of *civisme* so that these unpatriotic mothers and chil-
dren could be not corrected but *exterminated* and France's
progeny could hence be purified. Old ladies called out in Lady-
Macbeth-type language that children at the breast of a traitor
should have their brains dashed out. When Pourvoyeur, a police
official, spoke in the Year II of the bestialization of women

and compared them to tigresses and vultures anxious for blood, the language seems rather strong but the evidence to support it is not lacking.  Citoyenne Defarge, *tricoteuse*, the one stock image on which anyone can draw of women in Revolution, the hag knitting stockings for the war effort as the internal conspiracy is annihilated before her eyes, is a grim expression of the same thing and she is undoubtedly real.  In every outward manifestation in 1793 women were more frenzied, more intense, doubly gullible, doubly credulous, doubly vindictive and the only exception to this is that they were less publicly garrulous than their men—but here it may merely be a question of lack of opportunity.

But how far was all this emotion a cover for the uneasy realization that circumstances were rapidly deteriorating?  How far was she transferring her discontent, seeking some scapegoat, some acceptable explanation for the suspension of trade, the drying up of luxury industries, the very evident economic dislocation which was by now only too visible?  Initially war can seem to unite a society in opposition to a common enemy and anticipated victory can too often seem the panacea to current economic problems.  Both respects are deceptive:  the last doubly so.  The unity involved at a national level is a dissolvent at a personal level.  War strikes at the family:  it takes fathers and sons and what death does not destroy can be left to the effect of a long separation.  This was certainly the hard lesson of the French Revolution.  Moreover, the *sans culotte* was not too generous in sharing his new-found political importance:  as the backbone of the local *sociétés populaires*, his evenings in the autumn of 1793 and the winter of 1794 were spent outside the home, in endless verbal demonstrations of patriotism and gratitude for liberty.  The *sans culotte*, Chaumette said when he dissolved women's clubs in October 1793, had a right to expect from his wife the running of his home while he attended political meetings:  hers was the care of the family:  this was the full extent of her civic duties.  Others have lingered on the pride of the *sans culotte* in his new-found importance in *société populaire*, section or as a professional revolutionary on commission, but in the meanwhile what was happening to his wife in isolation; how did she respond when he returned drunk on dubious alcohol and the vocabulary of liberty?  Obviously the *sans culotte* in his home is a somewhat closed book, but at least one can know that the wife was steadily accumulating experience which was to sour her on the Revolution and all it stood for; that she was to turn against it sooner and with far greater intensity than her man, and in a way which was totally original, totally hers.  In 1794 and even more so in 1795 she was to be confronted with the sort of crisis which was to try her particular rôle in society:  with a famine which as usual was to hit her strikingly in her family and in her own health.  It was to

confront her with watching the unit she fought to maintain spill-
ing over into the ranks of the destitute.  While her husband was
still talking she in some areas had joined the food queues and
the minute she did that her loyalty was potentially suspect.
For a time it might well intensify her hatred of the internal
conspiracy:  nourish her antipathy towards malevolent land-
owners intent upon starving the people for their own gain by
this artificial dearth and hence increase the violence of her
disposition.  But her nerves, her patience, her physical strength
were already being stretched.  At what point would she turn
against the administration for its failure to cope?  Some evi-
dently were put more to the test than others.  If the maximum in
1794 largely worked in Paris and ensured basic food at a reason-
able price, the same could not be said for the little towns and
villages of Normandy, for example, where the reluctance of the
peasantry to turn over their food at a fixed price coupled with
a deflection of resources to feed the troops in the Vendée and
the great gaping mouth of Paris put women into food queues from
February 1794 while the black market thrived.  When real famine
came with the failure of the harvest of Northern France and the
great wheat belt later that year she had already been struggling
for eight months to keep her family fed and that in a totally
inadequate fashion.  The death toll of 1795-6 was the result of
*cumulative weakening*—not just the shortage of one year.  The
lifting of the maximum in December 1794 and the rocketing of
prices only universalized a problem which in some areas was
already advanced.  By May 1794, seven months previously, the
women of Masannay were already demanding the annihilation of
people over sixty in order to increase the ration for the young.
The first lace riots had already occurred in the Velay, and the
women of Le Puy (if not the men who lived off them) were already
identifying the cessation of the lace industry with the dis-
appearance of the Church.
    The woman had both to procure the food and to cook it; all
her husband had to do was eat what she prepared and judge
whether he was hungry or not.  What she got was often the re-
sult of *hours* of waiting.  She stood in the endless queues,
each one a hotbed of discontent hoping that when her turn came
something would be left and even then her troubles were not at
an end.  Often what she was confronted with was beyond her
knowledge or resources to prepare.  Rice was first introduced
to Normandy at this time.  Some did not have the fuel to boil
it; others did not know that it required boiling and merely
soaked it in water—what both tried to eat was a hard gritty
substance in no way digestible.  Then there were the queues
for which the only reward was a ration of salt fish which had
already begun to go off with the rising temperature of the
summer months and which when boiled yielded a stench like
ammonia.  Just what of all this was a fit meal for a child?

Even if the food ration consisted of vegetables, turnips or swedes, fears were not totally allayed for a pure vegetable diet was associated in the popular mind with the advent in children of summer diarrhoea which was a heavy killer of the young. And when malnutrition hardened into real starvation in 1795, when the government had abandoned price fixation and could be identified with the hardship, and when obviously the rich were still well fed, when the family's small saleable possessions had either been disposed of or dumped at the *mont de piété*, and when the riots of Germinal and Prairial had failed to bring relief, then the usual "sexually selective" manifestations of dearth became apparent. It is perhaps unnecessary to recall the classical manifestations of famine: the death of the weakest, the young and the aged, the increases in the number of miscarriages and the number of still births—but one should bear in mind that the latter are the fate of women, that the whole female body is a grim metering device registering degrees of deprivation. A premature termination of pregnancy or infertility through malnutrition are the best things under these circumstances to be hoped for: better than knowing that one is carrying a dead child, motionless within one or that if one gives birth one will not have the milk to feed it. The mothers of Caen in 1795 were allaying the cries of their new born children with rags dipped in water—that way they did not take long to die. Then there was watching one's children grow too feeble to cry. The *silence* of the hungry household was something that struck St. Vincent de Paul in 1660 but it also moved observers in 1795. . . .

There can be no over-emphasizing that the revolts of Germinal and Prairial mark that frontier, that psychological watershed, that last weapon in the armoury—whichever metaphor one chooses to express the final woman's protest before watching herself and her family spill over into the silent twilight world of the weak and the worn out which is so difficult to fathom because so largely inarticulate: it was her last defence of her human relationships. One can perhaps discount the accompanying cries of *vive le roi*, or the Parisian one for the days of Robespierre, the rivers of blood and the time of cheap bread or the Bayeux one of "quand le bon Dieu était là nous avions du pain" ("when God was there we had bread"), as more an expression of opposition to the present than hankering for the past; though one should take more seriously the women's cries for peace in Rouen and even more in the frontier towns of the East like Besançon and Vesoul where war fever had run so high in 1792. The cry for peace was one for normalcy: to call a halt—their great grandmothers had done the same in 1709 under exactly the same physical conditions.

The aftermath of Germinal had been indicated in terms of suicides, the daily occurrence of women and children fished out

of the Seine, economically and emotionally bankrupt, but one
might more profitably linger on another aspect:  the revival
of popular catholicism, perhaps one of the most striking char-
acteristics of popular history in the last five years of the
eighteenth century and one in which the rôle of women was
decisive.

The intensity of religious fervour that emerged from 1792
was without parallel in the eighteenth century.  Much remains
to be explored of the quality of religious belief under the
*ancien régime*:  indications point to a general formal adherence
to the faith without the existence of any marked degree of fer-
vour and of areas where even formal adherence was diminishing—
perhaps that most particularly in the cities which attracted
the rural immigrant and where the pattern of religious worship
was most easily eroded.  Certainly anti-clericalism could
always find popular support in the towns perhaps because here
the wealth of the higher clerics was most conspicuously on
view.  Moreover the anti-clericalism which surrounded the
implementation of the civil constitution of the clergy was an
end in itself:  it was not part of a wider movement, part of a
programme for the achievement of religious purity.  Latreille
noted the falling off of observance in the towns from mid-1791
when clerics became involved with the pros and cons of oath-
taking and the framework of religious worship became clouded.
Without doubt, the equation of the "non-juror" with "traitor,"
the result of the panic surrounding the outbreak of war, made
the non-juring church the object of popular violence in which
women undoubtedly played their part.  The constitutional church
never secured any widespread loyalty and a couple of years'
absenteeism from worship was the background to the image break-
ing and desecration of places of worship in which women were
often predominant during the Jacobin period.  In short, the
women of this study could feel they had actively participated
in the disintegration of the Roman Catholic Church:  they had
done enough to feel guilty, and the existence of this guilt is
crucial to an appreciation of why, in 1796, women ended up on
their knees and from then on worked wholeheartedly for the
restoration of formal religion within France, the Roman
Catholic religion of the *ancien régime*, but endowed with a new
vigour from below.

When Citoyenne Defarge, ex-*tricoteuse*, put down her
needles and reached for a pair of rosary beads, an image to
linger on if ever one was, she had to search out her priest
and even force the opening of a church.  From late 1795 on-
wards, even in cities which had demonstrated the most intense
anti-clericalism, like Paris, this is exactly what women did.
They brought back the formal worship of God.  Nor can this be
shrugged off superficially as both Aulard and Mathiez did in
terms of women turning from the *fanatisme* of their particular

clubs to the *fanatisme des prêtres*.   This is only a half truth.
They were not trying to revenge themselves on the Revolution.
The cycle of dearth, disease, devotion is a common enough one:
one has only to think what fruitful ground the hardship of 1816
would provide for the priests of the mission, but in 1795 there
was something extra, contrition.   The catholicism of 1795-
onwards was the visceral kind:  it owed its strength to the
rigours of the times, the imminence of death from disease or
undernourishment, disillusionment, shame, failure, the sense
of contrition which sought as solace the *confiteor* and the
*viaticum* and as such the sort of expiatory religion which
defies rooting out.   Women at Vidouville, in the Calvados,
queued to have their tongues scraped free of the contamination
of the masses of a constitutional priest and ensuing blasphe-
mies; the wife of a fishmonger of St. Patrice, also in the
Calvados, scrubbed out the parish church which her husband had
bought for a song as national property to use as a fishmarket
and which probably represented his one solid gain from the
Revolution, and she and the women of the parish handed it back
to a non-juror emerging from exile while her husband couched
an impotent letter of protest to an equally impotent depart-
mental authority.   The women of Coutances fought with each
other over whose babies should be baptized first and the priest
in question resolved the problem by a personal estimate of which
ones were likely to be dead before he reached the end of the
queue; he misjudged in two cases but he sprinkled water not-
withstanding on their little corpses.   No government could hope
to eradicate a church drawing on emotions which ran as deep as
this:   there was certainly nothing so fundamental in circula-
tion in the last fifty years of the *ancien régime*.   Such a
movement had its vicious aspects.   It was an essential accom-
paniment of the White Terror, as in the diocese of Le Puy where
women sought out local Jacobin leaders, clawed them to death or
perhaps ripped them limb from limb while the churches of that
most clerical of cities were triumphantly reopened.   But oftener
the return to religion was quieter, less obtrusive, more sympto-
matic of the desire for a return to a way of life remembered.
    Women perhaps turned to the church too for another funda-
mental reason:  revolution, war, famine—these are the dissolv-
ents of the family while the church stood at least for its
integrity, its sanctity; the hallowing of birth, marriage, death;
the cement of something much more intrinsic than the social sys-
tem.   When the cards were down and the scores chalked up, what
really was the cumulative experience of the working woman from
1789-95?  How else could she assess the Revolution except by
examining her wrecked household; by reference to children
aborted or born dead, by her own sterility, by the disappearance
of her few sticks of furniture, by the crumbling of years of
effort to hold the frail family economy together and what could

her conclusion be except that the price paid for putative
liberty had been far too high?

# BIBLIOGRAPHY

GENERAL HISTORIES COVERING THE ENTIRE PERIOD

Adams, Elsie, and Briscoe, Mary Louise, eds. *Up Against the Wall Mother . . .: On Women's Liberation.* Beverly Hills, Calif.: Glencoe Press, 1971. (PB)

Bardèche, Maurice. *Histoire des Femmes.* 2 vols. Paris: Stock, 1968.

Beard, Mary R. *Woman as Force in History.* New York: Collier Books, 1962 (1946). (PB)

Beauvoir, Simone de. *The Second Sex.* New York: Alfred A. Knopf, 1953. (PB)

Figes, Eva. *Patriarchal Attitudes.* New York: Stein and Day, 1970. (PB)

Greer, Germaine. *The Female Eunuch.* New York: McGraw-Hill, 1970. (PB)

Hays, H. R. *The Dangerous Sex.* New York: Putnam, 1964. (PB)

Himes, Norman. *Medical History of Contraception.* New York: Schocken Books, 1972 (1936). (PB)

James, E. O. *Marriage Customs through the Ages.* New York: Collier Books, 1965. (PB)

Kamm, Josephine. *Hope Deferred: Girls' Education in English History.* London: Methuen and Co., 1965.

Throughout this bibliography (PB) denotes that a work is available in paperback. If the edition cited here is not the original, the date of the original is given in parentheses.

Putnam, Emily. *The Lady*.  Chicago:  University of Chicago
    Press, 1970 (1911).  (PB)

Rogers, Katherine M.  *The Troublesome Helpmate: A History of
    Misogyny in Literature*.  Seattle, Wash.:  University of
    Washington Press, 1966.  (PB)

Stenton, Doris M.  *The English Woman in History*.  New York:
    The Macmillan Co., 1957.

Sullerot, Evelyne.  *Histoire et Sociologie du Travail Feminin*.
    Paris:  Gonthier, 1968.  (PB)

_____. *Woman, Society and Change*.  New York:  McGraw-Hill,
    World University Library, 1971.  (PB)

Taylor, G. Rattray.  *Sex in History*.  London:  Thames, 1953.

## EARLY DEVELOPMENT, PREHISTORY, AND UNRECORDED HISTORY

Bachofen, J. J.  *Myth, Religion and Mother Right*.  Translated
    by Ralph Manheim.  Princeton, N.J.:  Princeton University
    Press, 1967 (1861).  (Nineteenth century anthropology.
    His theories are much disputed.)

Briffault, Robert.  *The Mothers: The Matriarchal Theory of
    Social Origins*.  New York:  The Macmillan Co., 1927.  (PB)
    (Early anthropological study of women's roles, now
    disputed.)

Darwin, Charles.  *Descent of Man*.  Vol. II.  New York:  D. Apple-
    ton, 1872.

Davis, Elizabeth Gould.  *The First Sex*.  New York:  G. P.
    Putnam's Sons, 1971.  (Fiercely partisan, a "female
    chauvinist" account of woman's role in Western history.)

Engels, Friederich.  *The Origins of Family, Private Property,
    and the State*.  Translated by Ernest Untermann.  Chicago:
    C. H. Kerr and Co., 1902 (1884).  (The basic socialist
    document on the early development of the status of women.)

Gough, Kathleen.  "The Origin of the Family."  *Journal of
    Marriage and the Family*, November, 1971.  (Good summing
    up of latest anthropological theories and research.)

Hays, H. R. *The Dangerous Sex: The Myth of Feminine Evil.*
London: Putnam, 1964. (PB) (Account of men's fear of
women.)

Lederer, Wolfgang. *The Fear of Women.* New York: Harcourt,
Brace Jovanovich, 1968. (PB) (An inquiry into the enigma
of woman and why men through the ages have both loved and
dreaded her.)

Mead, Margaret. *Male and Female.* New York: William Morrow
and Co., 1949. (PB) (Developing anthropological views.)

_____. *Sex and Temperament in Three Primitive Societies.*
New York: William Morrow and Co., 1935. (PB) (Develop-
ing anthropological views.)

Morgan, Elaine. *The Descent of Woman.* New York: Stein and
Day, 1972. (An original and unembittered feminist view
of evolution.)

Reik, Theodor. *The Creation of Woman.* New York: George
Braziller, 1960. (Archeological psychoanalysis—an analy-
sis of the Adam/Eve myth.)

Taylor, G. Rattray. *Sex in History.* London: Thames, 1953.

Tiger, Lionel. *Men in Groups.* New York: Random House, 1969.
(PB) (A recent sociological view.)

## EARLY PERIOD, ENDING WITH EARLY CHRISTIANS

Apuleius. *The Golden Ass.* Translated by Robert Graves.
New York: Pocket Library, 1954. (PB) (Satirical romance
written in the second century A.D.)

Aristophanes. *The Complete Plays.* Edited by Moses Hadas.
New York: Bantam Books, 1962. (PB) (Particularly
*Lysistrata, Ecclesiazusae* [Women in Assembly], and
*Themophoriazusae* [Women at Festival].)

Aristotle. *Politics.* New York: Viking Press, 1957. (PB)

_____. *Ethics.* Baltimore, Md.: Penguin Books, 1955. (PB)

Balsdon, J. P. V. D. *Roman Women: Their History and Habits.*
New York: John Day Co., 1963.

Bardèche, Maurice. *Histoire des Femmes*. Vol. I. Paris: Stock, 1968. (PB)

Beard, Mary R. *Woman as Force in History: A Study of Traditions and Realities*. New York: Collier Books, 1962 (1945). (PB)

Carcopino, Jerome. *Daily Life in Ancient Rome*. New Haven, Conn.: Yale University Press, 1940. (PB)

Castle, E. B. *Ancient Education and Today*. Harmondsworth: Penguin Books, 1961. (PB)

Clement of Alexandria. *Christ the Educator*. Translated by Simon P. Hood. New York: Fathers of the Church, 1954.

Contenau, G. *Everyday Life in Babylon and Assyria*. New York: St. Martin's Press, 1954. (PB)

Cottrell, Leonard. *Lady of the Two Lands (Five Queens of Ancient Egypt)*. New York: Bobbs-Merrill Co., 1967.

Culver, Elsie T. *Women in the World of Religion*. New York: Doubleday & Co., 1967.

Donaldson, James. *Woman: Her Position and Influence in Ancient Greece and Rome and among the Early Christians*. London and New York: Longmans, Green and Co., 1907.

Ehrenberg, V. *The People of Aristophanes*. Oxford: Basil Blackwell, 1951. (PB) (Particularly Chapter 8.)

Euripides. *Ten Plays*. Edited and introduced by Moses Hadas. New York: Bantam Books, 1960. (PB) (Particularly *The Trojan Women, Medea, Andromache, Electra, Iphegenia at Aulis*.)

Flacelière, Robert. *Daily Life in Ancient Greece at the Time of Pericles*. London: George Weidenfeld and Nicolson, 1965 (in French, 1959).

Gomme, A. W. *Essays in Greek History and Literature*. Oxford: Blackwell, 1937.

Haigh, A. E. *The Attic Theatre*. Oxford: Clarendon Press, 1855. (Partly reprinted in *The History of Popular Culture*, edited by Cantor and Werthman. New York: The Macmillan Co., 1968. [PB])

Himes, Norman. *Medical History of Contraception*. New York:
   Schocken Books, 1972 (1936). (PB)

James, E. O. *Marriage Customs through the Ages*. New York:
   Collier Books, 1965. (Originally appeared as *Marriage
   and Society*; interesting chapters on prehistory,
   Mesopotamia, Egypt, Rome, early Christianity.)

Jerome, Saint. *Select Letters*. Translated by F. A. Wright.
   London: Putnam, 1933.

Kelly, M. Jamesetta. *Life and Times as Revealed in the Writings
   of St. Jerome, Exclusive of His Letters*. Washington, D.C.:
   Catholic University of America Press, 1944.

Kiefer, O. *Sexual Life in Ancient Rome*. London: Abbey Library,
   1971 (1934).

Kitto, H. D. F. *The Greeks*. Harmondsworth: Penguin Books,
   1951.

Kramer, S. N. *The Sacred Marriage Rite*. Bloomington, Ind.:
   Indiana University Press, 1969. (Sumer, etc.)

Lacey, W. K. *The Family in Classical Greece*. Ithaca, N.Y.:
   Cornell University Press, 1968.

Licht, Hans. *Sexual Life in Ancient Greece*. London:
   G. Routledge and Sons, 1932. (Excerpts reprinted in *The
   History of Popular Culture*, edited by Cantor and Werthman.)

Macdonald, Elizabeth M. *The Position of Women as Reflected in
   Semitic Codes of Law*. Toronto: University of Toronto
   Press, 1931.

Marrou, H. I. *A History of Education in Antiquity*. London:
   Sheed and Ward, 1956.

Montagu, Ashley. *The Natural Superiority of Women*. Revised
   edition. New York: Collier Books, 1970 (1952). (Good
   on primitive anthropology.)

Montefiore, C. G., and Loewe, H., eds. *A Rabbinic Anthology*.
   New York: Meridian Books, 1963 (1938).

Neumann, Erich. *Amor and Psyche*. New York: Pantheon Books, 1956.

_____. *The Great Mother: An Analysis of the Archetype*. New
   York: Pantheon Books, 1963 (1952). (Jungian psychology.)

Ovid. *The Art of Love*. New York:  Grosset and Dunlap, 1959.
(Originally in Latin, 1 B.C.)

Patai, Raphael. *Family, Love and the Bible*. New York:  Fernhill
House, Ltd., 1960.

_____. *The Hebrew Goddess*. New York:  KTAV Publishing House,
1967.

Plato. *The Republic and Other Works*. Translated by B. Jowett.
New York:  Oxford University Press, 1954.  (PB)  (Particu-
larly Book 5 of the *Republic* and the *Symposium*.)

Plutarch. *Selected Essays:  On Love, the Family, and the Good
Life*. New York:  Mentor Books, 1957.

Putnam, E. J. *The Lady:  Studies of Certain Significant Phases
of Her History*. New York:  Sturgis and Walton Co., 1910.

Sanders, H. A.  "A Roman Marriage Contract." *Transactions of the
American Philological Association*, 69 (1938), 104-16.

Seltman, Charles. *Women in Antiquity*. London:  Thames and
Hudson, 1956.  (PB)

Slater, Philip E. *The Glory of Hera, Greek Mythology, and the
Greek Family*. Boston:  Beacon Press, 1968.  (PB)

Witt, R. E. *Isis in the Graeco-Roman World*. Ithaca, N.Y.:
Cornell University Press, 1971.

Wright, F. A. *Feminism in Greek Literature:  From Homer to
Aristotle*. London:  Routledge and Sons, 1923.

## MEDIEVAL PERIOD

Adams, Henry. *Mont-Saint-Michel and Chartres*. New York:
Collier Books, 1963 (1904).

Beard, Mary R. *Woman as Force in History*. New York:  Collier
Books, 1962 (1946).

Bennett, H. S. *Six Medieval Men and Women*. Cambridge:  Cam-
bridge University Press, 1955.  (Margaret Paston and
Margery Kempe.)

Bergendoff, Conrad. "A Critic of the Fourteenth Century:  St. Birgitta of Sweden." *Medieval and Historiographical Essays in Honor of James Westfall Thompson*. Edited by James L. Cate and E. N. Anderson. Port Washington, N.Y.:  Kennikat Press, 1966 (1938).

Bernards, Matthäus. *Speculum Virginum: Geistigkeit und Seelenleben der Frau im Hochmittelalter*. Köln-Graz: Böhlau-Verlag, 1955.

Butler-Bowden, W., ed. *The Book of Margery Kempe*. London: J. Cape, 1936.

Cames, Gerard. *Allegories et Symboles dans L'Hortus Deliciarum*. Leiden:  E. J. Brill, 1971.

Chaucer, Geoffrey. *The Canterbury Tales*. Modern English translation by Nevill Coghill. Baltimore, Md.:  Penguin Books, 1952.  (PB)

Cleugh, James. *Love Locked Out*. London and New York:  Spring Books, 1963.  (An account of sexual practices in Europe from A.D. 500-1500.)

Collis, Louise. *Memoirs of a Medieval Woman:  The Life and Times of Margery Kempe*. New York:  Apollo Editions, 1964. (Originally appeared under the title *The Apprentice Saint* in England.)

Coulton, G. G. *Medieval Panorama*. Cambridge:  Cambridge University Press, 1938.  (Chapters on woman's life, pp. 614-29; marriage and divorce, pp. 629-47.)

_____, ed. *Life in the Middle Ages*. 3 vols. New York: The Macmillan Co., 1910.  (Includes such items as la Tour de Landry's *Book of the Knight of the Tower* (1371); Bernardino de Siena's *Sermons* (1427); Johann Nider's *Formicarius* (1438); *Chronicle of Ralph, Abbot of Coggeshall*.)

Crump, C. G., and Jacob, E. F., eds. *The Legacy of the Middle Ages*. Oxford:  Clarendon Press, 1926.  (See especially Eileen Power, "The Position of Women.")

Dahlberg, Charles R. *The Romance of the Rose*. Princeton, N.J.: Princeton University Press, 1971.

Dawson, C. *Medieval Religion*. London and New York:  Sheed and Ward, 1933.  ("The Origins of the Romantic Tradition.")

Diehl, Charles. *Byzantine Empresses*. Translated by Bell and Kerpely. New York: Alfred A. Knopf, 1963.

Eckenstein, Lina. *Woman under Monasticism*. Cambridge: Cambridge University Press, 1896.

Facinger, Marion F. "A Study of Medieval Queenship: Capetian France, 987-1237." *Studies in Medieval and Renaissance History*, 5 (1968), 1-47.

Fuller, Harold de Wolf, trans. *Beatrice: A Legend of Our Lady*. Cambridge, Mass.: Harvard Cooperative Society, 1909.

Gardiner, Dorothy. *English Girlhood at School*. Oxford: Clarendon Press, 1929.

Gillet, Martin S. *The Mission of Saint Catherine*. St. Louis: Herder Book Co., 1954.

Haight, Anne L. *Hroswitha of Gandersheim*. New York: Hroswitha Club, 1965. (Life, times, and works, with comprehensive bibliography, of this outstanding woman of the tenth century.)

Heer, Friedrich. *The Medieval World, Europe 1100-1350*. Cleveland and New York: World Publishing Co., 1961. (PB) (Especially good on women in this period in the chapters on courtly love and literature; a special chapter on the position of women.)

Herlihy, David. *Women in Medieval Society*. Houston, Texas: St. Thomas College, 1970.

_____. "Land, Family and Women in Continental Europe, 701-1200." *Traditio*, 18 (1962), 89-120.

Huizinga, J. *The Waning of the Middle Ages*. New York: Doubleday Anchor Books, 1954 (1924). (PB)

Jorgensen, Johannes. *St. Bridget of Sweden*. 2 vols. New York: Longmans, Green and Co., 1954.

Kamm, Josephine. *Hope Deferred: Girls' Education in English History*. London: Methuen and Co., 1965.

Kelly, Amy. *Eleanor of Aquitaine and the Four Kings*. Cambridge, Mass.: Harvard University Press, 1950. (PB)

Kemp-Welch, Alice. *Of Six Medieval Women*. London:    The Mac-
    millan Co., 1913.    (Agnes Sorel, Christine de Pisan, etc.)

La Barge, Margaret Wade. *A Baronial Household of the Thirteenth
    Century*. London:    Eyre and Spottiswoode, 1965.    (PB)

Laigle, Mathilde. *Le Livre des Vertus de Christine de Pisan*.
    Paris:    H. Champion, 1912.

*The Laxdoela Saga*. New York:    Everyman Library, Dutton, 1964.
    (Thirteenth century Icelandic saga.)

Leclercq, J. *Leçons de droit naturel*. Vol. III. Namur:    La
    Famille, 1950.

Lehmann, A. *Le Rôle de la Femme dans l'Histoire de France au
    Moyen Age*. Paris:    Berger-Levrault, 1952.

McDonnell, E. W. *The Beguines and Beghards in Medieval Culture*.
    New Brunswick, N.J.:    Rutgers University Press, 1955.

McLeod, Enid. *Heloise:    A Biography*. London:    Chatto and
    Windus, 1938.

Mason, Eugene, trans. *Aucassin and Nicolette, and Other
    Medieval Romances and Legends*. New York:    E. P. Dutton
    and Co., 1958.    (PB)

Mead, Kate Campbell Hurd. *A History of Women in Medicine*.
    Haddam, Conn.:    The Haddam Press, 1938.

Newman, F. X., ed. *The Meaning of Courtly Love*. Albany, N.Y.:
    State University of New York Press, 1968.    (A collection
    of revisionist papers on the discussion of courtly love
    and chivalry.)

Oldenburg, Zoe. *Massacre at Montsegur*. London:    Weidenfield
    and Nicolson, 1961.    (PB)    (On Albigensian Crusade and
    Cathars, etc.)

Painter, Sidney. *French Chivalry*. Ithaca, N.Y.:    Great Seal
    Books, 1957 (1940).    (PB)

Parry, J. J., trans.    "The Art of Courtly Love of Andreas
    Capellanus." *Records of Civilization*. New York:    Columbia
    University Press, 1941.    (PB)

Power, Eileen. *Medieval English Nunneries, 1275-1535*.
    Cambridge:    Cambridge University Press, 1922.

_____. *Medieval People*. New York:  Doubleday and Co., 1954.
(PB)  (Madame Eglantyne, Chaucer's prioress in real life,
and the menagier's wife, a Paris housewife in the fourteenth
century.)

Procopius. *Secret History*.  Ann Arbor, Mich.:  Ann Arbor
Paperbacks, 1963.  (PB)  (Somewhat biased contemporary
account of Justinian's empress, Theodora.)

Putnam, E. J. *The Lady*.  New York:  Sturgis and Walton Co.,
1910.  (PB)

*The Revelations of Saint Brigitta*.  Oxford:  Oxford University
Press (Early English Text Society, 29, No. 135), 1929.
(Middle English, before 1475.)

Robertson, D. W., Jr.  *Abelard and Heloise*.  New York:  Dial
Press, 1972.

Staley, J. Edgcumbe.  *The Dogaressas of Venice*.  New York:
Charles Scribner's Sons, 1910.

Stenton, Doris M.  *The English Woman in History*.  New York:  The
Macmillan Co., 1957.

Straub, A., and Keller, G.  *Herrade de Landsberg, Hortus
Deliciarum*.  Strassburg:  N.P., 1901.

Sullerot, Evelyne.  *Histoire et Sociologie de Travail Feminin*.
Paris:  Editions Gonthier, 1968.

Taylor, H. O.  "Mystic Visions of Ascetic Women."  *The Medieval
Mind*.  New York:  The Macmillan Co., 1919.  Pp. 458-86.

Thomas, Keith.  "The Double Standard."  *Journal of the History
of Ideas*, 20 (1959), 195-216.

Trask, Willard R.  *Medieval Lyrics of Europe*.  New York and
Cleveland:  The World Publishing Company, 1969.  (An
unusual selection, emphasizing the medieval poetry of
women.)

## HUMANISM, RENAISSANCE, AND REFORMATION, 1400-1600

Alberti, Leon Battista.  *The Family in Renaissance Florence*.
Translated by Renée N. Watkins.  Columbia, S.C.:  Univer-
sity of South Carolina Press, 1969.

Bainton, Ronald H. *Women of the Reformation in Germany and Italy*. Minneapolis, Minn.: Augsburg Publishing House, 1971.

Boulting, William. *Women in Italy*. London: Methuen and Co., 1910. (Comprehensive analysis from chivalry to Renaissance days.)

Brantôme, P. de Bourdeille. *Lives of Illustrious Ladies (Vie des Dames, Illustrés, Francoises et Estrangeres)*. Translated for Royal Library Historical Series. London: Humphreys, 1908.

_____. *Lives of Fair and Gallant Ladies*. Translated by A. R. Allinson. New York: Liveright, 1933.

Breisach, Ernst. *Caterina Sforza: A Renaissance Virago*. Chicago: University of Chicago Press, 1967.

Bridge, John S. *History of France, 1483-1493*. Oxford: Clarendon Press, 1936. (Good chapter on Anne de Beaujeu.)

Burckhardt, Jacob. *The Civilization of the Renaissance in Italy*. New York: The Macmillan Co., 1908. (PB) (Valuable background book to the Renaissance in Italy—much on women.)

Byrne, M. St. Clare. *Elizabethan Life in Town and Country*. London: Methuen and Co., 1925. (PB)

Camden, Carroll. *The Elizabethan Woman*. New York: Elsevier Press, 1952.

Cannon, Mary A. *Education of Women during the Renaissance*. Washington, D.C.: National Capital Press, 1916.

Cartwright, Julia. *Isabella d'Este*. New York: E. P. Dutton and Co., 1903.

_____. *Beatrice d'Este*. New York: E. P. Dutton and Co., 1912.

Castiglione, Baldasar. *The Book of the Courtier*. Translated by George Ball. Baltimore, Md.: Penguin Books, 1967 (1527). (PB)

Chazaud, A. M., ed. *Les Enseignements d'Anne de France, a sa Fille Suzanne de Bourbon*. Moulins: Desrosiers, 1878 (c. 1520).

Chrisman, Miriam V. "Women of the Reformation in Strasburg, 1490-1530." *Archive for Reformation History*, 63, No. 2 (1972).

Claridge, Mary. *Margaret Clitheroe 1556-1586*. New York: Fordham University Press, 1966. (Sixteenth-century butcher's wife and martyr.)

Clavière, Maude. *The Women of the Renaissance*. New York: G. P. Putnam's Sons, 1900.

_____. *Louise de Savoy et Francois I*. Paris: N.P., 1895.

Ellet, Elizabeth F. *Women Artists in All Ages and Countries*. New York: Harper Bros., 1859.

Elyot, Sir Thomas. *The Boke Named the Governor*. Edited from the first edition of 1531 by H. H. S. Croft. London: C. Kegan Paul and Co., 1880.

Falk, F. "Literarische Gegnerinen Luthers." *Historisch-politische Blätter für das Katholische Deutschland*, 139 (1907), 375-85.

Fraser, Antonia. *Mary Queen of Scots*. New York: Delacorte Press, 1969. (PB)

Gregorovius, Ferdinand. *Lucrezia Borgia*. Stuttgart, N.P., 1875. (Based on documents and correspondence of her day.)

Harford, J. S. *The Life of Michael Angelo Buonarroti*. London: N.P., 1858. (Includes memoir of Vittoria Colonna.)

Heller, Henry. "Marguerite of Navarre and the Reformers of Meaux." *Bibliotheque d'Humanism et Renaissance*, 33 (1971).

Henderson, Helen W. *The Enchantress*. Boston and New York: Houghton Mifflin Co., 1928. (Diane de Poitiers.)

Hume, A. S. Martin. *Queens of Old Spain*. London: N.P., 1906.

Ilsley, M. H. *A Daughter of the Renaissance, Marie Le Jars de Gournay: Her Life and Works*. The Hague: Mouton and Co., 1963. (Literary feminist and friend of Montaigne.)

Iongh, J. *Margaret of Austria*. New York: Norton, 1958.

Jenkins, Elizabeth. *Elizabeth the Great*. New York: Coward-McCann, 1959. (PB)

Jenkins-Blaisdell, Charmarie. "Renée de France between Reform and Counter-Reform." *Archive for Reformation History*, 63, No. 2 (1972).

Kamm, Josephine. *Hope Deferred: Girls' Education in English History*. London: Methuen and Co., 1965.

Keating, L. Clark. *Studies on the Literary Salon in France, 1550-1615*. Cambridge, Mass.: Harvard University Press, 1941.

Kelso, Ruth. *Doctrine for the Lady of the Renaissance*. Urbana, Ill.: University of Illinois Press, 1956.

Lagno, Isadora. *Women of Florence*. London: Chatto and Windus, 1907.

Levine, J., ed. *Elizabeth I: Great Lives Observed*. Englewood Cliffs, N.J.: Prentice-Hall, 1969. (PB) (Primary and secondary sources on Elizabeth.)

Levton, Harry, and Valency, Maurice, eds. *The Palace of Pleasure*. New York: Capricorn Books, 1960. (PB) (Medieval and Renaissance tales, thirteenth to sixteenth centuries.)

Masson, Georgina. *Queen Christina*. London: Secker and Warburg, 1968. (Christina of Sweden, 1626-89.)

Mattingly, Garrett. *Catherine of Aragon*. New York: Random House, 1941. (PB)

Michelet, Jules. *Satanism and Witchcraft: A Study in Medieval Superstition*. Translated by A. R. Allinson. New York: Citadel Press, 1939. (PB)

More, Thomas. *Utopia*. New York: Appleton-Century-Crofts, 1949 (1516). (PB)

Murray, M. A. *The Witch-Cult in Western Europe*. Oxford: Clarendon Press, 1921. (PB)

Neale, J. E. *Queen Elizabeth I*. New York: Harcourt Brace Jovanovich, 1934. (PB)

Pearson, Lu Emily. *Elizabethans at Home*. Stanford, Calif.: Stanford University Press, 1957. (PB)

Pelicier, P. *Essay sur le Gouvernement de la Dame de Beaujeu*. Paris: Chartres, 1882.

Pinet, Marie J. *Christine de Pisan*. Paris: Librarie Ancienne Honoré Champion, 1927.

Powell, Chilton Latham. *English Domestic Relations, 1487-1653*. New York: Columbia University Press, 1917.

Power, Eileen. *Medieval English Nunneries, 1275-1535*. Cambridge: Cambridge University Press, 1922.

Ragg, Laura. *The Women Artists of Bologna*. London: Methuen and Co., 1907.

Reike, Emil. *Willibald Pirckheimer: Leben, Familie, Person-lichkeit*. Jena: Eugen Diedrichs, 1930.

Richardson, Lula McDowell. *The Forerunners of Feminism in French Literature of the Renaissance*. Part I. Baltimore, Md.: Johns Hopkins Press, 1929. (From Christine de Pisan to Marie de Gournay.)

Richardson, Walter. *Mary Tudor: The White Queen*. Seattle, Wash.: University of Washington Press, 1970. (Mary Tudor, wife of Louis XII of France, 1496-1533.)

Rochon, André. *La Femme de la Renaissance*. A volume in the series *Histoire Mondiale de la Femme*. Paris: Nouvelle Librarie de France, 1966.

Rodocanachi, E. *La Femme Italienne a l'Epoque de la Renaissance*. Paris: N.P., 1907.

Roeder, Ralph. *Catherine de Medici and the Lost Revolution*. New York: Vintage Books, 1964 (1937). (PB)

Roelker, Nancy L. *Queen of Navarre, Jeanne d'Albret, 1528-1572*. Cambridge, Mass.: Harvard University Press, Belknap Press, 1968.

_____. "The Role of Noblewomen in the French Reformation." *Archive for Reformation History*, 63, No. 2 (1972).

Rousselot, Paul. *La Pedagogie Feminine: Extraite des Principaux Ecrivains qui on Traite de l'Education des Femmes dupuis le XVI Siecle*. (Paris: C. Delagrave, 1881.

Sachs, Hannelore. *The Renaissance Woman*. New York: McGraw-Hill, 1971. (Art book, lavishly illustrated.)

Saintsbury, George. *The Heptameron of Margaret Queen of Navarre.* Translated and edited with a memoir of Louise of Savoy and her daughter Margaret d'Angoulême. London: Aldus Society, 1903. (Many other editions.)

Screech, Michael A. *The Rabelaisian Marriage.* London: Arnold and Co., 1958.

Scudder, Vida. *Saint Catherine of Siena as Seen in Her Letters.* New York: E. P. Dutton and Co., 1905.

Sparrow, Walter Shaw, ed. *Women Painters of the World, from the Time of Caterina Vigri (1413-1463) to Rosa Bonheur.* Art and Life Library, Vol. III. London: Art and Life Library, 1905.

Staley, John Edgcumbe. *Guilds of Florence.* London: N.P., 1906.

_____. *The Dogaressas of Venice.* New York: Charles Scribner's Sons, 1911.

Stenton, Doris M. *The English Woman in History.* New York: The Macmillan Co., 1957.

Stone, Lawrence. *The Crisis of the Aristocracy.* New York: Oxford University Press, 1965. (Particularly Chapter 11, "Women and the Family.")

Summers, Montague. *Maleus Maleficorum* (The Witches' Hammer). Revised edition. New York: Dover Publications, 1970 (1928). (PB)

Thompson, Craig, R. *The Colloquies of Erasmus.* Chicago: University of Chicago Press, 1965. (Especially "The Abbot and the Learned Lady" and "The Council of Women.")

Trollope, T. A. *The Girlhood of Catherine de Medicis.* London: Chapman and Hall, 1856.

_____. *The Life of Vittoria Colonna.* New York: N.P., 1859.

Utley, Francis Lee. *The Crooked Rib: An Analytical Index to the Argument about Women in English and Scots Literature to the End of the Year 1568.* Columbus, Ohio: Ohio State University Press, 1944.

Veith, Ilza. *Hysteria: The History of a Disease.* Chicago: University of Chicago Press, 1965.

Walsh, W. T. *Isabella of Spain: The Last Crusader.*
New York: McBride, 1930.

Watson, Foster, *Vives and the Renaissance Education of Women.*
London: Edward Arnold, 1912.

Willard, C. C. "Christine de Pisan's Audience." *Journal of the History of Ideas,* 27 (1966).

Williams, E. C. *Bess of Hardwick.* Toronto: Longmans, 1959.
(An Elizabethan lady-in-waiting who accumulated five husbands and their wealth.)

Winker, E. *Margarete von Österreich: Grande Dame der Renaissance.* München: Callwey, 1966.

Woodward, W. H. *Studies in Education during the Renaissance.*
London: Macmillan Co., 1906.

_____. *Vittorino de Feltre and Other Humanist Educators.*
Cambridge: Cambridge University Press, 1897. (Includes good chapter on Leonardo Bruni's treatise on the education of women.)

Wright, Louis B. *Middle-Class Culture in Elizabethan England.*
Chapel Hill: University of North Carolina Press, 1935.

Yates, Frances. *The French Academies of the Sixteenth Century.*
London: Warburg Institute, University of London, 1947.

## ENGLISH WOMEN IN THE SEVENTEENTH AND EIGHTEENTH CENTURIES

Adburgham, Alison. *Women in Print.* London: George Allen & Unwin, 1972. (A study of women's periodicals from the Restoration to 1800.)

Bingham, Caroline. "Seventeenth Century Attitudes toward Deviant Sex." *Journal of Interdisciplinary History,* Spring, 1971, pp. 447-72.

Bone, Quentin. *Henrietta Maria: Queen of the Cavaliers.*
Urbana, Ill.: University of Illinois Press, 1972.

Bouten, J. *Mary Wollstonecraft and the Beginning of Female Emancipation in France and England.* Amsterdam: University Of Amsterdam, 1922. (Useful on bluestockings and Augustans.)

Burney, Frances. *Diary and Letters*. New York: The Macmillan Co., 1893.

Clark, Alice. *Working Life of Women in the Seventeenth Century*. London: George Routledge and Sons, 1919.

Davis, Herbert. *Stella: A Gentlewoman of the 18th Century*. Toronto and London: The Macmillan Co., 1942. (On Swift's Stella.)

Donnelly, L. M. "The Celebrated Mrs. Macauley." *William & Mary Quarterly*, 3d series, 7 (1949). (Catherine Sawbridge Macauley [1731-91] was a political writer and historian much admired by Mary Wollstonecraft.)

Fussell, G. E., and Fussell, K. R. *The English Countrywomen: A Farm-House Social History, 1500-1900*. London: A. Melrose, 1953.

Hair, P. E. H. "Bridal Pregnancy in Rural England in Earlier Centuries Further Examined." *Population Studies*, 24 (1970), 59-70.

Halsband, Robert. *Life of Lady Mary Wrotly Montagu*. Oxford: Oxford University Press, 1956. (Literary figure and explorer of the eighteenth century.)

Harmon, Rebecca L. *Susanna: Mother of the Wesleys (1669-1742)*. London: Hodder & Stoughton, 1968. (Especially interesting for her child-rearing theories and practices.)

Hecht, J. J. *The Domestic Servant Class in 18th Century England*. New York: Humanities Press, 1956.

Hemlow, Joyce. *The History of Fanny Burney (1752-1840)*. New York: Oxford University Press, 1958.

Hole, Christine. *The English Housewife in the Seventeenth Century*. London: Chatto and Windus, 1953.

Jones, M. Gwladys. *The Charity School Movement: A Study of 18th Century Puritanism in Action*. Hamden, Conn.: Shoe String Press, 1964.

Kamm, Josephine. *Hope Deferred: Girls' Education in English History*. London: Methuen and Co., 1965.

Langer, William L. "Checks on Population Growth: 1750-1850." *Scientific American*, February, 1972, pp. 93-99. (Celibacy, infanticide, exposure.)

Laslett, Peter. *The World We Have Lost*. New York: Charles
    Scribner's Sons, 1965.

Macaulay, Thomas Babington. "Madame D'Arblay." *Edinburgh
    Review*, 1843. Reprinted in his *Critical, Historical and
    Miscellaneous Essays* . New York: D. Appleton, 1860.
    (A review of *The Diary and Letters of Fanny Burney* on
    their publication.)

Montagu, Lady Mary W. *Letters and Works*. 3d ed. Edited by
    Lord Wharncliffe. New York: A.M.S. Press, 1970.

Osborne, Dorothy. *Letters to Sir William Temple, 1648-54*.
    New York: E. P. Dutton, 1932.

Pinchbeck, Ivy. *Women Workers and the Industrial Revolution:
    1750-1850*. London: Routledge and Kegan Paul, 1930.

_____, and Hewitt, Margaret. *Children in English Society
    from Tudor Times to the Eighteenth Century* . London:
    Routledge and Kegan Paul, 1969.

Reynolds, Myra. *The Learned Lady in England (1650-1760)*.
    Gloucester, Mass.: Peter Smith, 1964.

Richardson, Mrs. Aubrey. *Famous Ladies of the English Court*.
    London: Hutchinson & Co., 1899. (Ladies of the court
    from the sixteenth to the eighteenth centuries.)

Ross, Isabel. *Margaret Fell: Mother of Quakerism*.
    London: Longmans, Green and Co., 1948.

Stenton, Doris M. *The English Woman in History*. New York:
    The Macmillan Co., 1975.

Swift, Jonathan. *Journal to Stella*. New York: E. P. Dutton,
    1924 (1768).

Thomas, Keith. "The Double Standard." *Journal of the History
    of Ideas*, 20 (1959), 195-216.

_____. "Women and the Civil War Sects." *Crisis in Europe,
    1560-1660*. Edited by Trevor Aston. New York: Basic
    Books, 1965. (PB)

Thompson, E. P. "The Moral Economy of the English Crowd in the
    18th Century." *Past and Present* , 50 (February, 1971).
    (Women in riots.)

Wallas, Ada.  *Before the Bluestockings*.  London:  Macmillan Co.,
    1925.

Wollstonecraft, Mary.  *A Vindication of the Rights of Woman*.
    New York:  W. W. Norton & Co., 1967 (1792).  (PB)

Woolsey, S. C., ed.  *The Autobiography and Correspondence of
    Mrs. Delany*.  2 vols.  Boston:  Roberts Bros., 1879.
    (A woman of the eighteenth century interested in education
    and literature, on the fringes of the bluestockings, and a
    lady of George III's court.)

WOMEN IN FRANCE IN THE SEVENTEENTH AND EIGHTEENTH CENTURIES

Ariès, Phillippe.  *Centuries of Childhood*.  Translated by
    Robert Baldick.  New York:  Vintage Books, 1962.  (PB)
    (Original French edition, 1960; a social history of family
    life.)

Barbard, H. C.  *Fénélon on Education*.  New York:  Cambridge
    University Press, 1966.

Bardéche, Maurice.  *Histoire des Femmes*.  Vol. II.  Paris:
    Stock, 1968.

Beard, Mary.  *Woman as Force in History*.  New York:  Collier
    Books, 1962 (1946).  (PB)  (Especially her bibliography.)

Bouten, J.  *Mary Wollstonecraft and the Beginning of Female
    Emancipation in France and England*.  Amsterdam:  Univer-
    sity of Amsterdam Press, 1922.  (Useful for salons and
    philosophes' attitude to women.)

d'Haussonville, Vicomte, ed.  *Le Salon de Mme Necker*.  2 vols.
    Paris:  N.P., 1882.

Edwards, Samuel.  *The Divine Mistress*.  London:  Cassell, 1971.
    (Life of Voltaire's mistress, Madame du Châtelet.)

Goncourt, Edmond, and Goncourt, Jules.  *The Woman of the Eigh-
    teenth Century: Her Life, from Birth to Death, Her Love
    and Her Philosophy in the Worlds of Salon, Shop and Street*.
    English translation by Le Clercq and Roeder.  London:
    George Allen & Unwin, 1928 (1862).

Gutwirth, Madelyn. "Mme de Staël, Rousseau, and the Woman Question." *Proceedings of the Modern Language Association*, 86 (January, 1971), 100-9.

Guyon, Jeanne Marie. *Autobiography*. Chicago: Moody Press, 1971. (PB) (English translation of the quietist religious thinker who influenced Fénélon.)

Haldane, Charlotte. *Mme de Maintenon: Uncrowned Queen of France*. New York: Bobbs-Merrill Co., 1970.

Herold, J. C. *Love in Five Temperaments*. New York: Atheneum, 1961.

_____. *Mistress to an Age*. New York: Bobbs-Merrill Co., 1958. (PB) (A life of Madame de Staël.)

Hufton, Olwen. "Women in Revolution, 1789-1796." *Past and Present*, November, 1971. (Discusses women of urban working families during the French Revolution.)

Hunt, David. *Parents and Children in History: The Psychology of Family Life in Early Modern France*. New York: Basic Books, 1970.

Lytle, S. H. "The Second Sex, 1793." *Journal of Modern History*, 27 (1955), 14-26. (Feminist demands and their defeat.)

Mason, Amelia Gere. *The Women of the French Salons*. New York: Century Co., 1891.

May, Gita. *Madame Roland and the Age of Revolution*. New York: Columbia University Press, 1970.

Michelet, J. *Women of the French Revolution*. Paris: N.P., 1855.

Mitford, Nancy. *Mme de Pompadour*. New York: Pyramid Books, 1966. (PB)

Picard, Roger. *Les Salons Littéraires et la Société Francaise (1610-1789)*. New York: Brentano, 1943.

Racz, Elizabeth. "The Women's Rights Movement in the French Revolution." *Science and Society*, 16 (1952).

Reynier, Gustave. *La Femme au XVII Siecle*. Paris: Tallandier, 1929.

Robinson, Mabel. *The Great Literary Salons of the XVII and XVIII Centuries*. Lectures of the Musée Carnavalet. London: Thornton Butterworth, 1930.

Segur, P. *Julie de Lespinasse*. London: Chatto & Windus, 1907.

Staël, Mme Germaine de. *On Politics, Literature, and National Character*. Translated and edited by Morroe Berger. New York: Doubleday and Co., 1964. (See also her novels.)

Stephens, Winifred. *Women of the French Revolution*. New York: E. P. Dutton and Co., 1932.

Strassburger, Ferdinand. "Die Mädcheneerziehung in der Geschichte der Paedagogik des 17 und 18 Jahrhunderts in Frankreich und Deutschland." Ph.D. dissertation, Strassburg, 1911.

Tallenture, S. G. *The Women of the Salons*. New York: G. P. Putnam's Sons, 1926.

# SUGGESTED FURTHER READING

GENERAL

Bridenthal, Renate, and Koonz, Claudia, eds. *Becoming Visible: Women in European History*. Boston: Houghton Mifflin Company, 1977.

Carroll, Bernice, ed. *Liberating Women's History: Theoretical and Critical Essays*. Urbana, Ill.: University of Illinois Press, 1976.

Christ, Carol P., and Plaskow, Judith, eds. *Womanspirit Rising: A Feminist Reader in Religion*. New York: Harper and Row, 1979.

Hartman, Mary S., and Banner, Lois, eds. *Clio's Consciousness Raised: New Perspectives on the History of Women*. New York: Harper and Row, 1974.

O'Faolain, Julia, and Martines, Lauro, eds. *Not in God's Image: Women in History from the Greeks to the Victorians*. New York: Harper and Row, 1973.

Okin, Susan Moller. *Women in Western Political Thought*. Princeton, New Jersey: Princeton University Press, 1979.

Osborne, Martha Lee, ed. *Woman in Western Thought*. New York: Random House, 1979.

Ruether, Rosemary, ed. *Religion and Sexism: Images of Women in the Jewish and Christian Traditions*. New York: Simon and Schuster, 1974.

_____, and McLaughlin, Eleanor, eds. *Women of Spirit: Female Leadership in the Jewish and Christian Traditions*. New York: Simon and Schuster, 1979.

## BIBLIOGRAPHIES AND REVIEW ESSAYS

Arthur, Marylin B.  "Classics--The Study of Women in Antiquity."
  *Signs*, 2 (Winter 1976).

Davis, Natalie Zemon. "Women's History in Transition:  The
  European Case."  *Feminist Studies*, 3 (Spring 1976).

_____, and Conway, Jill K.  *Society and the Sexes.  A
  Bibliography of Women's History in Early Modern Europe,
  Colonial America, and the United States*.  New York:  Garland
  Publishing Company, 1979.

English, Jane.  "Review Essay:  Philosophy."  *Signs*, 3 (Summer
  1978).

Erickson, Carolly, and Casey, Kathleen.  "Women in the Middle
  Ages:  A Working Bibliography."  *Medieval Studies*, 37
  (1975).

Kanner, S. Barbara, ed.  *The Women of England from Anglo-Saxon
  Times to the Present:  Interpretive Bibliographical Essays*.
  Hamden, Conn.:  Archon Books, 1979.

Lougee, Carolyn C.  "Modern European History:  Review Essay."
  *Signs*, 2 (Spring 1977).

## CLASSICAL ANTIQUITY AND EARLY CHRISTIANITY

Arthur, Marylin B.  "'Liberated' Women:  The Classical Era."  In
  Bridenthal and Koonz, eds., *Becoming Visible*.

Horowitz, Maryanne Kline.  "Aristotle and Woman."  *Journal of
  the History of Biology*, 9 (1976).

Lefkowitz, Mary R., and Fant, Maureen.  *Women in Greece and Rome*.
  Sarasota, Florida:  Samuel Stevens, 1977.

McNamara, JoAnn.  "Sexual Equality and the Cult of Virginity in
  Early Christian Thought."  *Feminist Studies*, 3 (Spring-
  Summer 1976).

Pagels, Elaine.  "What Became of God the Mother?:  Conflicting
  Images of God in Early Christianity."  In Christ and
  Plaskow, eds., *Womanspirit Rising*.

_____. *The Gnostic Gospels.* New York:   Random House, 1979.

Pierce, Christine.   "Equality:   'Republic V.'" *Monist,* 57
     (January 1973).

Pomeroy, Sarah B. *Goddesses, Whores, Wives, and Slaves:   Women
     in Classical Antiquity.* New York:   Schocken Books, 1975.

Treggiari, Susan.   "Jobs for Women." *American Journal of Ancient
     History,* 1 (May 1976).

## THE MIDDLE AGES

McNamara, JoAnn, and Wemple, Suzanne.   "The Power of Women
     Through the Family in Medieval Europe: 500-1100."   In
     Hartman and Banner, eds., *Clio's Consciousness Raised.*

_____.   "Sanctity and Power:   The Dual Pursuit of Medieval
     Women."   In Bridenthal and Koonz, eds., *Becoming Visible.*

Monter, E. William.   "The Pedestal and the Stake:   Courtly Love
     and Witchcraft."   In Bridenthal and Koonz, eds., *Becoming
     Visible.*

Morewedge, Rosemarie T., ed. *The Role of the Woman in the Middle
     Ages.* Albany, New York:   State University of New York
     Press, 1975.

Power, Eileen. *Medieval Women.* Cambridge:   Cambridge University
     Press, 1976.

Schulenberg, Jane T.   "Sexism and the Celestial Gynaeceum from
     500-1200." *Journal of Medieval History,* 4 (June 1978).

Stuard, Susan Mosher, ed. *Women in Medieval Society.*
     Philadelphia: University of Pennsylvania Press, 1976.

## THE RENAISSANCE, HUMANISM, AND EARLY MODERN EUROPE

Bainton, Ronald H. *Women of the Reformation in France and
     England.* Minneapolis, Minn.:   Augsburg Publishing House,
     1973.

_____. *Women of the Reformation: From Spain to Scandinavia.* Minneapolis, Minn.:  Augsburg Publishing House, 1977.

Bell, Susan Groag.  "Christine de Pizan (1364-1430):  Humanism and the Problem of a Studious Woman." *Feminist Studies,* 3 (Spring-Summer 1976).

Davis, Natalie Zemon.  *Society and Culture in Early Modern France.*  Stanford, Calif.:  Stanford University Press, 1975.

Douglas, Jane Dempsey.  "Women in the Continental Reformation." In Ruether, ed., *Religion and Sexism.*

Hogrefe, Pearl.  *Women of Action in Tudor England.*  Ames, Iowa: Iowa State University Press, 1976.

Kelly-Gadol, Joan.  "Did Women Have a Renaissance?"  In Bridenthal and Koonz, eds., *Becoming Visible.*

Khanna, Lee Cullen.  "No Less Real than Ideal:  Images of Women in More's Work." *Moreana,* 14 (December 1977).

King, Margaret L.  "The Religious Retreat of Isotta Nogarola (1418-1466): Sexism and Its Consequences in the Fifteenth Century." *Signs,* 3 (Summer 1978).

_____. "Book-Lined Cells:  Women and Humanism in the Early Italian Renaissance." In Labalme, P. H., ed., *Beyond Their Sex.*  New York:  New York University Press, 1980.

Wyntjes, Sherrin Marshall.  "Women in the Reformation Era."  In Bridenthal and Koonz, eds., *Becoming Visible.*

## THE SEVENTEENTH AND EIGHTEENTH CENTURIES

Abray, Jane.  "Feminism in the French Revolution." *American Historical Review,* 80 (February 1975).

Flandrin, Jean Louise.  *Families in Former Times: Kinship, Household, and Sexuality.*  Cambridge:  Cambridge University Press, 1979.

Graham, Ruth.  "Loaves and Liberty:  Women in the French Revolution."  In Bridenthal and Koonz, eds., *Becoming Visible.*

Hertz, Deborah. "Salonières and Literary Women in Late Eighteenth-Century Berlin." *New German Critique*, 5 (Spring 1978).

Hufton, Olwen. *The Poor in Eighteenth Century France.* Oxford: Oxford University Press, 1974.

Iltis, Carolyn Merchant. "Madame du Châtelet's Metaphysics and Mechanics." *Studies in History and Philosophy of Science*, 8 (January 1977).

Kleinbaum, Abby R. "Women in the Age of Light." In Bridenthal and Koonz, eds., *Becoming Visible.*

Legates, Marlene. "The Cult of Womanhood in Eighteenth Century Thought." *Eighteenth Century Studies*, 10 (Fall 1976).

Lougee, Carolyn C. "Noblesse, Domesticity, and Social Reform: The Education of Girls by Fénelon and Saint-Cyr." *History of Education Quarterly*, 14 (Spring 1974).

_____. *Le Paradis des Femmes: Women, Salons, and Social Stratification in Seventeenth Century France.* Princeton, New Jersey: Princeton University Press, 1976.

Mahl, Mary R., and Koon, Helene, eds. *The Female Spectator: English Women Writers Before 1800.* Bloomington, Indiana: Indiana University Press/The Feminist Press, 1977.

Petschauer, Peter. "Improving Educational Opportunities for Girls in Eighteenth-Century Germany." *Eighteenth Century Life*, 3 (December 1976).

Stone, Lawrence. *The Family, Sex, and Marriage: England 1500-1800.* New York: Harper and Row, 1977.

Tilly, Louise A., and Scott, Joan. *Women, Work, and Family.* New York: Holt, Rinehart and Winston, 1978.

Vann, Richard T. "Toward a New Lifestyle: Women in Preindustrial Capitalism." In Bridenthal and Koonz, eds., *Becoming Visible.*

# INDEX

Abbacies for women,
    decline of, 97. *See also*
    nunneries
Abortion:
    in classical Athens, 29
    in Middle Ages, 138
Absolutism in France, 232–233
Adultery, 200
    in Augustan Law, 58
    in Reformation England, 218
Aelflaed, 103, 106, 108
Agriculture, women in, 166–167
Alembert, Jean le Rond d',
    233, 235, 259, 261
Alewives, 154
Anabaptists, 226
Anatomy, study of as fad, 247
Anglicanism, 220, 232
Anne de Beaujeu (Anne of
    France), 197
Anne of Brittany, 197
Aphrodite and temple
    prostitution, 79
Apprenticing:
    of males to women traders, 155
    of orphan girls in Middle
    Ages, 156
Aquinas, St. Thomas, 118–119,
    121–122
Arcambal, Mme. d', 245
Aretino, Pietro, 203
Aristophanes, 34
Aristotle, 1, 8, 26, 29, 121,
    208, 221
    importance for female develop-
    ment, 9
    rediscovery in Middle Ages, 118
    view of women, 17–21
Armada, 198, 216, 217
Arria the Elder, 53-54

Artists patronized by
    Mme. Geoffrin, 257
*Art of Love*, 163
Asceticism, 72, 86, 89, 160
Ascham, Roger, 198, 215
Askew, Anne, 227
Aspasia, 26
Athenian democracy, 1
    drama in, 8
    homosexuality in, 23
    seclusion of women in, 25
Attoway, Mrs., 228
Augustan law against adultery,
    58
Augustine, St., 71, 85, 187

Bacon, Francis, 198
Bandello, Matteo, 202, 203, 204,
    205
Baptists, 223, 225
Barbarossa, Friedrich, 109
Barberino, 207
Beaufort, Lady Johanna, 178
Beauvoir, Simone de:
    on Roman women in the
    Empire, 48-49
    *Second Sex*, 6
Bede, Venerable, 103
Beeton, Mrs. (Middle Ages), 175
Bega, St., 103
*Belle Dame Sans Merci*, 159
Bembo, Pietro, 205, 207, 208
Benedict, St., 96
Bergamo, Jacopo, 209
Bernard of Clairvaux, 132
Bernardino of Siena, St., 165,
    179
Betrothal:
    in Middle Ages, 120
    in Roman Empire, 51

305